Images on the Page

Images on the Page

A Fashion Iconography

Sanda Miller

BLOOMSBURY VISUAL ARTS
LONDON · NEW YORK · OXFORD · NEW DELHI · SYDNEY

BLOOMSBURY VISUAL ARTS
Bloomsbury Publishing Plc
50 Bedford Square, London, WC1B 3DP, UK
1385 Broadway, New York, NY 10018, USA
29 Earlsfort Terrace, Dublin 2, Ireland

BLOOMSBURY, BLOOMSBURY VISUAL ARTS and the Diana logo are
trademarks of Bloomsbury Publishing Plc

First published in Great Britain 2022
Paperback edition first published 2022

Copyright © Sanda Miller, 2022

Sanda Miller has asserted her right under the Copyright, Designs and
Patents Act, 1988, to be identified as Author of this work.

For legal purposes the Acknowledgements on p. xiii constitute an extension
of this copyright page.

Cover design by Ben Anslow
Cover image: *Winter and Summer* from the Four Seasons, 1643–1644
by Wenceslaus Hollar (© Peter Horree / Alamy Stock Photo)

All rights reserved. No part of this publication may be reproduced or transmitted
in any form or by any means, electronic or mechanical, including photocopying,
recording, or any information storage or retrieval system, without prior
permission in writing from the publishers.

Bloomsbury Publishing Plc does not have any control over, or responsibility for, any
third-party websites referred to or in this book. All internet addresses given in
this book were correct at the time of going to press. The editor and publisher
regret any inconvenience caused if addresses have changed or sites have
ceased to exist, but can accept no responsibility for any such changes.

A catalogue record for this book is available from the British Library.

A catalog record for this book is available from the Library of Congress.

ISBN: HB: 978-1-3501-1533-0
PB: 978-1-3502-1692-1
ePDF: 978-1-3501-1534-7
eBook: 978-1-3501-1535-4

Typeset by Deanta Global Publishing Services, Chennai, India

To find out more about our authors and books visit www.bloomsbury.com and
sign up for our newsletters.

Contents

List of figures vi
Foreword viii
Acknowledgements xiii

1 Introduction: A new tool for the fashion image: Iconography 1

2 Renaissance books of clothes 45

3 The seventeenth century: A new profession – the gentleman journalist writing for *Le Mercure galant* 101

4 The eighteenth century: From the fashion doll to the fashion plate 133

5 Capturing modernity in nineteenth-century France and England 155

6 Modernism 185

Part One Fashion and art; is fashion art? 187

Part Two The photographed image on the page 213

Part Three The fashion show: Fashion as 'spectacle' 239

Conclusion 249

Bibliography 253
Index 261

Figures

1.1 Giorgione, *La Tempesta* (The Tempest) 23

1.2 Alexander McQueen and Isabella Blow 38

2.1 Villard de Honnecourt, *Wrestlers*. Graphite and light sepia ink (Folio 14V) 47

2.2 Villard de Honnecourt, *Lord and Lady* 48

2.3 *Il Libro del Sarto, Charles V, c.* 1560–1600 53

2.4 Alonso Sanchez Coello, *Portrait of Elizabeth of Valois, Queen of Spain, c.* 1560 57

2.5 *Il Libro del Sarto, Milanese lady in red dress, c.* 1560–1600 58

2.6 Gianekki Turiano (*c.* 1500–85), mechanical doll playing the lute, dated 1550s 60

2.7 *Il Libro del Sarto, Woman and Child, c.* 1560–1600 62

2.8 Hans Weigel, *The Emperor Maximilian II* 66

2.9 Hans Weigel, *The Turkish Sultan* 67

2.10 Hans Weigel, *French Peasant Woman* 69

2.11 Pieter Aertsen, *Market with Christ and the Woman Taken in Adultery*, 1559 70

2.12 Christoph Weiditz, (a) *Performance with a wooden block*, (b) *Indian and his defense* 78

2.13 Christoph Weiditz, *Morisco women* 79

2.14 Christoph Weiditz, *Morisco woman spinning* 80

2.15 Hans Weigel, *Morisco woman* 82

2.16 Matthäus Schwarz working as a clerk in the banking house of Jakob Fugger, Augsburg 95

2.17 Matthäus Schwarz in Nuremberg 98

3.1 Man in winter clothes, *Nouveau Mercure galant* (1677–8) 106

3.2 Nicolas Bonnart, *Homme en robe de chambre in Recueil,* France (1670–*c.* 1693) 112

3.3 Jean Dieu de Saint Jean, *Femme de qualité en déshabillé d'étoffe Siamoise,* France (1670–*c.* 1697) 115

3.4 Jean-Baptiste and Nicholas Bonnart, *La crieuse de balets,* France (1670–*c.* 1697) 116

3.5 Abraham Bosse, *The Ratcatcher* 119

Figures vii

3.6 Jusepe de Ribera, *The Clubfoot*, 1642 120
3.7 Wenceslaus Hollar, *Winter*, 1643 123
3.8 Marcellus Laroon, *Buy my Dutch biskets* 127
4.1 Woman in green dress, *Cabinet des modes*, November 1785 143
4.2 Three fashionable people, *Magazine des modes nouvelles françaises et anglaises*, December 1787 145
4.3 Constitution style dress, 1790 147
4.4 *Couturiere élégante* delivering panniers to her client, *La Gallerie des modes, et des costumes françaises* 152
5.1 Claude Monet, *Camille (The Woman in a Green Dress)*, 1866 157
5.2 Franz Xaver Winterhalter, *Empress Eugénie Surrounded by Her Ladies in Waiting*, 1855 163
5.3 Edouard Manet, *Autumn* (Portrait of Méry Laurent) 165
5.4 Royal and ducal costume, court, city and war costume 172
5.5 *Izba*, Dwelling of the *Muzhik* 173
5.6 Drawing with children's clothes in *Peterson's Magazine* 180
6.1 Paul Poiret, '*La Perse*' coat with woodblock print by Raoul Dufy, 1911 192
6.2 Raoul Dufy textile designs executed by Bianchini-Ferrér for Paul Poiret 193
6.3 Paul Iribe, *Les Robes de Paul Poiret racontées pour Paul Iribe* 196
6.4 Georges Barbier, *The Madness of the Day*, 1913 199
6.5 Thayaht, *Un manteau de Madeleine Vionnet*, 1922 205
6.6 Elsa Schiaparelli, *The Pavilion of Elegance* at the Universal Exhibition of 1937 207
6.7 Christian Dior, *the tailleur bar ensemble* 215
6.8 Terry Fincher, photograph of a fashion model wearing a dress and coat by Balenciaga 219
6.9 Jordan and Simon modelling punk clothes 224
6.10 Cover of New York art magazine *Artforum*, February 1982 228
6.11 Kristen McMenamy No. 3, London 1996 236
6.12 Alexander McQueen, spray paint image, spring/summer collection 1999 243
6.13 Hussein Chalayan, *Between*, fashion show, spring/summer 1998 246
6.14 Hussein Chalayan, *Afterwords* (table skirt), autumn/winter 2000 247
C.1 Indonesian models with gas masks and dresses designed by Hanna Farhana 251

Foreword

Fashion illustration and its relationship to wider visual systems has hitherto been a rather neglected area of research. Miller, an art historian well known for her authoritative study of the modern sculptor Brancusi but trained in the study of Renaissance art, brings to the topic her wide-ranging temporal and thematic grounding in this new study. Her latest work that you are about to read, entitled *Images on the Page* (not 'Fashion on the Page'), is framed as a series of questions and provocations that rethink many well-known episodes in fashion history and connect art and fashion in exciting new ways. As well as providing an extended study of the semiotic and iconographic workings of the fashion image over a very *longue durée* (1200–2020), the work provides a mini-treatise on the relationship of art and fashion from the medieval to modern period and beyond.

Miller restores a series of aesthetic questions that seem to be missing in much contemporary scholarship, which in her case are always married to wider social concerns. As she notes, the methodologies employed to analyse fashion images were necessarily 'purloined' from other disciplines, not least art history. Fashion has frequently been subject and object for the practice of art, and in the nineteenth and twentieth centuries, became a type of popular aesthetics, a concept first thought of by Elizabeth Wilson in the 1980s. Art forms as different as history painting, sculpture, portrait painting, print-making and the commercial art, ephemera and photography have depicted, created and promulgated fashions. Art often shows us fashions that might not survive in material form, as well as the set and pose of the dressed body. Fashion history itself has been constructed to a substantial degree through the representation of clothing in art, which scholars, ranging from art historians to sociologists, have used as a type of evidence. Modernist critics and writers

from the mid-nineteenth century engaged directly with the quixotic nature of everyday fashion as a new form of transient beauty, a challenge to orthodox academic theory. As the museum-going public expanded, critics suggested that ideas for the composition of a woman's toilette might be taken from the study of painted precedents and even aspire to the ambition of art, fuelling a new taste for historicism and a desire to describe fashion in terms of form and colouring. Photography and later cinema led to the so-called crisis of representation in which fashion and its popular culture was often implicated. Other significant nineteenth-century artists, such as those associated with the English Arts and Crafts Movement and its continental followers, signalled their distaste for the commercial culture that surrounded them. They proposed alternative dress fashions for both men and women based on their own aesthetic systems, sometimes even requiring that adherents wear particular clothes in certain room settings. Here they clashed with and rejected fashion, rather as youth culture of the 1960s did, creating powerful new fashion impulses in its wake. Beauty, standards and conventions were abandoned by art and fashion alike. New desires, moods and products were created in their stead.

Artists throughout the twentieth century intervened in fashion culture. No significant avant-garde art movement of the twentieth century ignored fashion. Some made clothing metaphoric subject matter, others saw it as central to ideological revolution, while others derived models for painterly abstraction from the changeability of urban dress. Many artists and writers used dress to intervene in official culture and prescribed value systems, creating counter-cultural clothing forms. Paul Poiret was twinned with the *Ballets Russes*. Coco Chanel was inspired by poets, music and artist film-makers such as Jean Cocteau. Elsa Schiaparelli worked with Salvador Dali. Yves Saint Laurent accessed art as wide ranging as Van Gogh, Monet and Mondrian. Pop artists such as Andy Warhol living through the youth-quake of the 1960s made fashion the very medium of their practice, continuing a modernist legacy that aimed to destroy distinctions between art and life, aesthetics and industry. Jean-Paul Gaultier revisited Dada. Vivenne Westwood worships the eighteenth century. When *Art Forum* put an Issey Miyake garment on its cover in 1982 it marked a new respect for fashion clothing.

Post-modern art practice also saw in fashion a cipher for the commodity culture with which it engaged. Collaborations with stylists from the music, film and advertising industries transformed the fashion landscape of the 1980s. Ironically if 'style' in art history went out of favour in this period (replaced with the new social history of art conjoined with post-structuralism) the 1980s saw the birth of the dedicated fashion 'stylist'. The 'MTV fashion effect' can be seen in the work of Thierry Mugler, Christian Lacroix and Gaultier, just as film, space and modernity had influenced the late Pierre Cardin in the 1960s. Much recent fashion photography is more akin to and is considered art rather than advertising. The lines are blurred. Mark Jacobs used artists such as Murakami to transform the Louis Vuitton heritage. Suddenly everyday women carried a little piece of contemporary Japanese art. Alexander McQueen worked with avant-garde artists including goldsmith Shaun Leane and the brand has more recently worked with artist Damien Hirst. Victoria Beckham blends the exhibition of Old Master portraits in Bond Street, London, in commercial arrangements with her fashion line. Fashion appears more and more in the museum, art gallery and beyond, upsetting many purists who feel that commercial culture driven by corporations and something as transient as fashion supplants the hard work of artists and critics. Artists today are viewed as the ideal collaborators with fashion designers and the fashion industry, injecting the type of cultural capital they embody into products that have become synonymous with innovation, novelty, new forms of 'masstige' (mass produced luxury) and the rise of experience culture around the world. No fashion student today could ignore art and no artist operates in ignorance of the fashion system.

The innovation of Miller's work in this monograph is to force us to consider temporal and thematic challenges from art as different as the medieval stone mason Villard D'Honnecourt's famous manuscript drawings, to the beginnings of the French fashion press in the work of the late-seventeenth-century French Bonnart brothers, to Raoul Dufy and Paul Poiret within French art deco, and Isabella Blow and Alexander McQueen in the last years of the last century. Touching on fields including costume and theatre design, Miller argues that 'An analogous relationship to that between painting and theatrical

costume and stage design can be found in fashion magazines in the way they used paintings to alter fashion images'. As she further notes, 'painters such as Ingres collaborated with photographers; Monet, Manet or Renoir made it their business to familiarize themselves with the world of haute couture, as did writers such as Marcel Proust, whilst Emile Mallarmé went a step further by publishing a fashion magazine'. Miller walks us through the dramatic changes that saw the eighteenth-century 'specialized fashion magazine' which covered all manner of products from dress fashions to furniture. It transformed again in the nineteenth century, influenced by factors such as the development of better printing techniques and the invention of photography. By the twentieth century, 'fashion photography not only challenged the printed image but also took over as the main mode of presenting the image on the page'.

Along the way we encounter a sparkling series of characters described in terms of the history of art, something uncommon for a subcultural group such the British punks. To Miller they are possibly the 'direct heirs of Dadaism' and even connected to high-style queer photographers such as Cecil Beaton rebelling against mainstream consumerism and the effects of austerity following the Second World War. Miller connects back 1990s Minimalism in fashion to the 1960s: it is 'a term purloined from "Minimal Art" invented by art critic Barbara Rose when she published in the 1965 issue of *Art in America* an article titled "More Is Less"'. Miller likes theory but she likes history more. She playfully notes that 'in the 1990s it became fashionable to provide a theoretical justification for the rapid expansion of fashion studies so as to render it a worthy academic subject, and the more complicated the theories, the better, and what can be more difficult than choosing Jacques Derrida . . . he fitted the bill'.

Here, then, is a book that offers fresh approaches to the history of the fashion image and investigates the embrace of art and fashion across time. Miller kindly mentions our former collaborations and reminds me that we almost might have written the work together. But now we have her new contribution to fashion research, art history and visual culture more generally. In preparing this foreword some time ago, I told Sanda I wished to say thanks for her extraordinary feeling, erudition and joy concerning both art and

fashion. She made it her recent life's mission to bring the fields more closely together, underpinned by the intellectual apparatus and practical skills drawn from her multi-faceted roles as art historian, critic, writer, broadcaster and observer of the city. As the book went to press, the very sad news of Sanda's sudden death in February 2021 was received. Friends and colleagues around the world were in shock that this bright star of collaborative scholarship and convivial gatherings was no more. I hope that many others will now go on to write theses, articles and books with Miller's new findings as both provocation and support. Along with her other contributions to European art and culture, they will form a lasting memorial.

Peter McNeil, Distinguished Professor of Design History, University of Technology Sydney

Acknowledgements

The genesis of this book is shrouded in the mists of time and the only certainty I have is that as an art historian I was always fascinated by iconography and its power to interpret the layered meanings of works of art. About two decades ago I decided to leave art history on a temporary basis and start research in a related field – history of dress – and to my delight a veritable treasure trove of images of costumes and fashion that I was able to trace as far back as the Middle Ages, specifically to Villard de Honnecourt, opened up for iconographical investigation. Villard's wonderful thirteenth-century portfolio, or 'sketchbook', which contains 250 drawings, relates to a wealth of subjects including architectural sketches, ecclesiastical artefacts, animals and people, some of whom appear to be attired in the latest 'fashions', revealing Villard's thorough knowledge about people's way of dress.

My book starts with Villard de Honnecourt and takes the reader through a voyage of discovery starting with the thirteenth century through to our times, of which the last image is a photograph taken on 22 March 2015 by Greenpeace activists as part of their campaign to address pollution in the Citarum River in Rancaekek (West Java).

I started to put together a proposal for a book which I submitted for consideration in 2017 to Frances Arnold, editorial director responsible for managing Bloomsbury's visual arts publishing, and she duly sent my draft proposal to the first two reviewers. They were, however, sceptical regarding the viability of my project, and, as I was not too sure about it myself, I was about to give up. At this point my first thanks must go to Frances Arnold because without her sustained encouragement this book would not have come into being.

Back to the drawing board for me and two years later, in 2019, I submitted a revised version of the manuscript, which was again sent out to be assessed by

two reviewers. But on this occasion I was fortunate because in both instances I benefited from their considered and helpful criticism, particularly regarding the last – and for me, the most difficult – chapter in the book dealing with the twentieth century, including contemporary developments.

I was now able to return to my manuscript full of confidence, and after another year – on 7 July 2020 to be precise – I was able to submit the final manuscript to Frances Arnold.

But this book needed illustrations. I realized that this was a complex task which needed professional expertise and this is how I was lucky to be put in contact with Renee Villanueva-Last, my wonderful picture researcher. For about one year we worked closely together and in the end she produced an impressive artwork tracker for Bloomsbury. Thank you, Renee!

I would also like to express my gratitude and thanks to the most wonderful institution in this country: The Warburg Institute and its equally wonderful library I regard as a 'second home'. The library was founded in Hamburg 1900 by art historian Aby Warburg. In 1929, it became the Warburg Institute, and Fritz Saxl, who became its director, was instrumental in moving it to safety to London in 1933. In 1944, the Warburg Institute became affiliated with the University of London.

When I embarked on writing *Images on the Page: A Fashion Iconography*, I was under the impression that I was the first to employ iconography for the study of fashion images by arguing that they too have stories to tell just like paintings do. But this was not the case! To my surprise (and delight) I discovered in the Warburg Library the most important antecedent I could have ever wished for: Fritz Saxl himself!

In 1936, Saxl announced his 'discovery' of an Italian tailor's book, *Il Libro del Sarto*, which lay forgotten in the Querini Stampalia Foundation in Milan. He published his findings in an essay titled 'Costumi é feste della nobiltà Milanese negli anni della dominazione spagnola' (see *The Proceedings of the British Academy*). In it Saxl describes his fortuitous discovery of *Il Libro del Sarto*, dated sometime between 1540 and 1560, but above all he makes a radical point which I – as an art historian – considered true and which informed my own book, namely that if art historians would have approached such images 'with more humility and fewer pretentions' by paying attention

to what they have to tell, they would have realized that they are worthy of their interest. This then is, in a nutshell, the premise on which *Images on the Page: A Fashion Iconography* is based. Moreover, I could not have wished to find a more perfect confirmation of my initial intention than the one coming from Fritz Saxl. To this extent, I consider my work to have been inspired not only by Erwin Panofksy but also by the entire scholarly community to which he belonged, including Fritz Saxl, Aby Warburg and Sir Ernst Gombrich. They were instrumental in founding and bringing to London the library that became the Warburg Institute. I regard its wonderful library as one of the finest bastions of learning in the world.

I would like to also mention that my attachment to the Warburg Library goes a long way back to the 1970s when I was a young MA student at the Courtauld Institute of Art, London University, working on my thesis which dealt with Venetian Quattrocento narrative painting. I chose to do my research at the Warburg instead of the Courtauld Library, and the reason was not only that the former is one of the most famous libraries regarding Renaissance studies but also for its welcoming atmosphere and serenity. From that time on the Warburg Library has been playing an important part in my research, and when I returned in 2017 to research my new book, it felt like coming home. One of the reasons for my joy of being able to spend so much time working in the library was that although the library is up to date in terms of new technology, it still allows researchers to go directly to the shelves and browse to their heart's content, and this is how I discovered Fritz Saxl's seminal article about *Il Libro del Sarto*.

I would like to thank all the staff at the library, in particular Celia Stevenson, who was so helpful regarding Renee's request for hi-res images and permission for reproduction of our extensive list of images needed for Chapter 2, which deals with the Renaissance.

I would also like to thank my dear and special friend of many years, Peter McNeil, who very kindly agreed to write the foreword to this book, for which I am not only grateful but also very proud. Over the years Peter and I collaborated on two books published by Bloomsbury: *Fashion Writing and Criticism: History, Theory, Practice* (2014); and *Fashion Journalism, History, Theory and Practice* (2018), and I sincerely hope that our professional collaboration will continue to blossom in the future with other projects and radical ideas.

I would also like to thank Michael Hall, editor of *The Burlington Magazine*, for his generosity: always finding the time in spite of his punitive editing schedule to provide guidance, advice and, above all, support. I had the privilege of starting to write for him in 2003 when he was editor of *Apollo* magazine, and when I suggested to this art magazine to review a fashion exhibition, Michael agreed. This was of course not just any fashion exhibition; this was a retrospective exhibition organized by the Musée de la mode et du textile, Louvre, of Elsa Schiaparelli, who always regarded herself, to Gabrielle Chanel's chagrin, as an artist rather than a couturiere. It was the starting point of a fruitful collaboration, and when Michael Hall became editor of *The Burlington Magazine* in 2017, this collaboration continued with my review of a magical exhibition of Cristobal Balenciaga organized by the V&A Museum, London. I consider myself fortunate to continue to work with and learn so much from Michael Hall.

Finally, a thank you to my family: Giulia, Neil and my granddaughter Noa, to whom this book is dedicated.

1

Introduction

A new tool for the fashion image: Iconography

Rationale

The idea for this book originates from a desire to transcend the still dominant descriptive approach to analysing fashion images and replace it with a method used in art history: iconography. This useful tool enables art historians to uncover the layered meanings encoded in images from the visual arts, and there is no reason why iconography cannot be applied to fashion images. The question is: Do we really need to? And the answer is a resounding yes!

The academic study of fashion with all its ramifications – including history, theory, the aesthetics of dress and the fashion images which 'translate' them on the pages of books and magazines – is a relatively recent newcomer to the field of academia and that explains why the methodologies employed to analyse them were purloined from other disciplines, not least art history.

Moreover, it has repeatedly been argued that clothes have been marginalized in the context of art history only to be used for dating purposes, but a lot more can be gleaned from them besides their ubiquitous function of identifying 'the message the sitter or artist wished to express':

This iconological reading of dress has not been fully acknowledged by art historians on the one hand, nor developed by the dress historians on the

other, with the result that at present, the way many art historians 'read' clothes often leads them to surprising observations and to conclusions that are all too frequently purely speculative and without foundations. (Winkel, 2006: 11)

Whilst iconography has successfully been applied to interpreting visual images in art history, Marieke de Winkel argued that with regard to its usefulness, fashion historians are lagging behind, and for that reason she decided to rectify the situation by providing such an iconographical analysis of dress. Selecting Rembrandt van Rijn's paintings as case study, she was also able to address another lacuna, namely that 'No modern comprehensive studies on seventeenth century Dutch dress exist', with two exceptions: Frithjof van Thienen and Johanna der Kinderen-Besier, whose books published in 1930 and 1950, respectively, are outdated and not always accurate (Winkel, 2006: 12).

Acknowledging her debt to Stella Mary Newton and Aileen Ribeiro, regarding their use of 'textual analysis and the knowledge of artistic conventions', Winkel embarked on her own analysis of clothes as represented by Rembrandt in his paintings. She started from 'the proper identification of a garment', gradually moving 'towards the understanding of the cultural context in which they were worn' (Winkel, 2006: 18). But unlike Newton and Ribeiro, Winkel selected iconography in order to apply the three levels of interpretation proposed by Erwin Panofsky – as synthesized in his seminal book *Studies in Iconology: Humanistic Themes in the Art of the Renaissance* first published in 1939 – in her own analysis of Rembrandt's representations of dress.

The first level, equivalent to Panofsky's 'pre-iconographical description', consists of just that – 'a surface or literal reading of clothes' followed at the secondary level by the 'iconographical analysis', which requires 'a more specialized knowledge' and 'familiarity with certain connotations and attitudes towards clothing (if available) and information about the identity of the person'. Finally the third level, equivalent to Panofsky's iconographical/ iconological interpretations, consists in relating the dress to 'artistic and literary traditions and ideas as well as symbolic conventions of the culture in which it was worn' (Winkel, 2006: 18–19).

The book is structured in five chapters, each consisting of a case study, and starts with the tabard, which the author regarded as 'one of the most dignified items of dress' (Winkel, 2006: 22).

Introduction

In order to transcend the first, descriptive level and proceed to the second and third levels, Winkel turned to Stella Mary Newton and Aileen Ribeiro, whom she considered 'much more indebted to the method of reading highly nuanced sartorial messages in works of art using textual analysis and the knowledge of artistic conventions' (Winkel, 2006: 13), tantamount with the second and third level of analysis proposed by Panofsky.

Indeed, a display of such a 'reading of highly nuanced sartorial messages in works of art' can be found in Aileen Ribeiro's recent (2017) book *Clothing Art: The Visual Culture of Fashion 1600–1914*, which constitutes the definitive paradigm of how to read such 'sartorial meanings' in works of art. The book also constitutes a radical departure from standard histories of dress: instead of starting from the clothes the artists painted – as any self-respecting fashion historian would do – Ribeiro reversed the process by considering first the artists who painted the clothes and their intention behind the way they represented them in a particular way and not another, but with the danger of falling into the trap of the 'intentional fallacy' notwithstanding, Ribeiro outlined her intention as follows:

> My intention is to look at dress mainly from the point of view of the artists who represent it, during a period that begins with the seventeenth century and ends with the First World War, although this time-frame is somewhat elastic and reference is made to art and clothing outside these boundaries. (Ribeiro, 2017: 30–1)

Ribeiro also selected Rembrandt as one of her case studies for Chapter I, titled 'Portraying Dress', in which she deals with portraits and self-portraits because 'portraits represent personal encounters between a sitter and the person painting, his or her portrait' (Ribeiro, 2017: 30). Starting from this premise, she ponders what are we to make of the way artists represent themselves?

In fact we can find a telling parallel with Instagram, which allows its users to manipulate their looks and post them in cyberspace for all to see, just as painters can manipulate their self-portraits and display them in a museum, a palace or a church, for all (or in some instances only for some) to see. What Instagram offers is a special way of documenting personal life, not that different from Rembrandt who painted in excess of 100 self-portraits

in different media, with the earliest documented dated 1626 and the last in 1669, the year of his death.

Ribeiro chose the *Self-Portrait at the Age of 34* in the National Gallery, and – like Winkel – she pointed out that in Rembrandt's representations of clothing, the boundaries between historical accuracy and what Winkel calls 'fancy' are fluid, rendering them difficult to interpret.

Several issues are addressed in Ribeiro's lengthy analysis of Rembrandt's self-portrait, which starts with the wider cultural context by linking it with Raphael's portrait of Baltassare Castiglione which Rembrandt saw when it was auctioned in Amsterdam in 1639. In this respect I argue that Ribeiro used iconography starting with the third *intrinsic meaning* or *content* level and worked her way backwards to the first, *primary* or *natural* subject matter level by providing an impressive analysis of Rembrandt's costume, of the kind only a costume historian can provide:

> The clothing is – as often with Rembrandt – deliberately difficult to 'read' because it is the rich, strange theatricality of the dress that appeals to the artist, rather than any antiquarian accuracy; nor is it possible to decide whether the costume is northern European or Italian. It seems likely that the various layers comprise, from the innermost garments outwards, a fine pleated shirt with gold embroidery, a doublet with a high collar and square front, and then either a long gown called a *tabard,* or – and this is more likely – a fur trimmed coat with paned sleeves of sombre grey-green silk over dark gold tissue; a black velvet bonnet trimmed with a gold chain completes the outfit. (Ribeiro, 2017: 40)

If we turn to art history, we get a radically different analysis as proved in the following example coming from three authorities on seventeenth-century Dutch art history: Jakob Rosenberg, Seymour Slive and E. H. ter Kuile. Like Ribeiro, they put iconography to good use, but they start with the *primary* or *natural* subject matter level and move to the third, *intrinsic meaning* or *content* level, which reveals Rembrandt's debt to classicism.

> The artist still represents himself in precious attire, as he did formerly. He wears a richly embroidered shirt and a heavy fur-trimmed velvet coat. More

important, however, is the seriousness, the reserved and critical glance of the man who has abandoned all signs of vanity and of sensational appeal to the spectator. . . .The arrangement of the figure is also changed. It is no longer close to the front lane, but recedes behind a stone sill. The figure has a firmer outline and can almost be inscribed into a triangle having the sill as a base. Instead of stressing the sweeping curvilinear silhouettes of the 1630s, here Rembrandt repeatedly emphasized the horizontal: in the sill, the position of the arm leaning on it, the main accents of the face, and even the position of the cap. These repeated horizontals lend the picture stability, firmness and calm. (Rosenberg, Slive and ter Kuile, 1972: 100)

And it is at the *primary* or *natural* subject matter level that the difference between the way dress and art historians describe the painting becomes apparent. Thus, Rosenberg, Slive and ter Kuile give clothes short shrift, emphasizing instead on how the painting 'works' by focusing on composition, balance, geometry and expression, which were in keeping with the requirements established by the synoptic tables published in 1680 by Henri Testelin for the newly founded French Academy in Paris. They proceeded next to the *intrinsic meaning* or *content*, focusing on aspects such as the influence of classicism and the Italian Renaissance – specifically Raphael – on Rembrandt's self-portrait.

What links Winkel with Ribeiro is that both chose their examples from painters and analysed the way they represented dress in their paintings. They are also linked by their use of iconography, with the difference being that Winkel adopted a clear stance regarding her choice of iconography as her preferred methodology, whereas Ribeiro's use of iconography could be described as pragmatic. Most important, both Ribeiro and Winkel use paintings as case studies, which further links them to the way art historians use iconography.

My book differs radically from both Marieke de Winkel's and Aileen Ribeiro's books, because it leaves art history behind altogether and turns to representations of costume and fashion.

Images on the Page: A Fashion Iconography starts with the poorly researched Renaissance tailors and costume books, based on the premise that Erwin Panofsky's iconographical model can be successfully employed as a methodology for the analysis of fashion images, because they too tell a

story. This has not been attempted before, or so I believed, until I discovered in the library of the Warburg Institute in London *Il Libro del Sarto*. Dated between the 1540s and the end of Cinquecento and published in Milan, it lay forgotten in the Querini Stampalia Foundation in Venice until it was 'discovered' in 1936 by none other than Fritz Saxl, who published his research in an essay titled 'Costumi é feste della nobiltà Milanese negli anni della dominazione spagnola'.

My aims and objectives are to 'borrow' iconography from art history and put it to good use for analysing fashion images, because after all we are dealing with visual images, be they paintings, sculptures, illuminated manuscripts or the fashion images themselves; they could come from a fashion plate, book, magazine, or photograph and even from a spatio-temporal event such as a fashion show, which also has a story to tell.

Iconography and its uses in the history of art

The use of iconography as a methodology to decode art historical images is associated with the name of Erwin Panofsky, but we can trace it further back to a book written in the aftermath of the Counter-Reformation in 1533 by Cesare Ripa titled *Iconologia*. In it he undertook to deal 'solely – to the exclusion of all others – with such images as were meant to *signify* something different from what they offered to view (like the image of "Beauty")' (Damisch in Preziosi, 1998: 239).

In a book titled *The Art of Art History: A Critical Anthology*, its editor Donald Preziosi provided a glossary in which he makes a distinction between *iconography* and *iconology*:

> Although the term 'iconology' was used during the Renaissance to suggest a systematic accounting for the appearance and variety of imagery, it was appropriated in the twentieth century by Erwin Panofsky in a systemic relationship with what he termed in complementary fashion 'iconography', referring to the study of subject-matter in art. Panofsky's iconology referred to the study of the deep meanings of artworks. (Preziosi, 1998: 5808)

But the way in which the terms have been employed is confusing, starting with Panofsky himself. Thus, in *Studies in Iconology: Humanistic Themes in the Art of the Renaissance* published in 1939, he provides in the opening paragraph a definition of iconography as 'that branch of the history of art which concerns itself with the subject matter or meaning of works of art, as opposed to their form' (Panofsky, 1972: 3), but the word 'iconology' is nowhere to be seen, including the synoptic table which outlines the three levels of interpretation proposed for analysing meaning in works of art.

In the first column titled 'Object of Interpretation', the vertical reading starts with the *primary* or *natural* subject matter, followed by the *secondary* or *conventional* subject matter and the third, which is the *intrinsic meaning* or *content*. In the second column titled 'Act of Interpretation' we have, corresponding to the three vertical levels in the first column, *pre-iconographical description* followed by *iconographical analysis*, and at the third level, *iconographical interpretation*.

This synoptic table is published again by Panofsky in 1955 in *Meaning in the Visual Arts*. The first chapter titled 'Iconography and Iconology: An Introduction for the Study of Renaissance Art' starts with the same definition of iconography as the 1939 book, but here we do have an important addition, a definition of *iconology*.

Iconology then is a method of interpretation which arises from synthesis rather than analysis.

And as the correct identification of motifs is the pre-requisite of their correct iconographical analysis, so is the correct analysis of images, stories and allegories the prerequisite of their correct iconological interpretation – unless we deal with works of art in which the whole sphere of secondary or conventional subject matter is eliminated and a direct transition from motifs to content is effected, as in the case with European landscape paintings, still life and genre, not to mention 'non-objective' art. (Panofsky, 1972: 58)

Iconology also makes an appearance in the synoptic table provided in the second column, 'Act of Interpretation': if we consider the vertical reading, the column titled 'Iconographical interpretation' is here replaced with 'Iconological interpretation' (Panofsky, 1972: 66).

It appears that Panofsky used the terms 'iconography' and 'iconology' interchangeably, and the reason may well be that he regarded the distinction between them as merely a matter of semantics. But this is certainly not the case, as Rafael Garcia Mahiques argued in a two-volume book titled *Iconografía é Iconología: La Historia del Arte como Historia Cultural* (2008).

In the opening paragraph, Mahiques makes exactly this point: 'Iconography and iconology are used in scientific terminologies as synonyms. Yet their intellectual origins and epistemological bases differ' (Mahiques, 2008: 21). Thus the word 'iconography' derives from the Greek word *eikon* meaning 'image', whilst 'iconology' derives also from a Greek word, *logos*, which means 'reason, speech', and they are interconnected in a specific manner:

> The transition from 'iconography' understood as the description and classification of images to 'iconology', as the discipline which is based on their historical interpretation and so a concrete epistemological approach is implicated here. (Mahiques, 2008: 33)

An exhaustive analysis of the history of the use of the concepts of *iconography* and *iconology* follows, beginning with Jacob Burckhardt and his venerable *The Civilization of the Renaissance in Italy*, first published in 1860, and he is considered a pioneer regarding the introduction of the concept of the Renaissance to cultural studies. What happened was that Burckhardt performed a shift from history of art to history of culture, arguing that 'all the phenomena of the Renaissance are interconnected and participate in the same spirit' (used here in the idealist sense of zeitgeist) (Mahiques, 2008: 50).

Aby Warburg and Erwin Panofsky are given pride of place – starting with the biographical outline of the former – when he presented his paper 'Italian Art and International Astrology' at the Congress of Art History held at Palazzo Schifanoia in Ferrara in 1912 (Mahiques, 2008: 65). He comments that the paper was considered eccentric by the arrogant art historians in attendance who were 'solidly connected' to the methodology of Giovanni Morelli and the philosophy of connoisseurship of Giovanni Cavalcaselle, whilst Warburg's thinking was steeped in the philosophy of Benedetto Croce.

Warburg's research focused on two related issues: (a) the relationship between the visual arts and poetry and (b) the function of figurative art

within the context of civilization leading him to the creation of the concept of *iconology*, which can be traced as far back as his PhD dissertation completed in 1891, whose subject was Sandro Botticelli's mythological paintings.

He returned to Botticelli later, choosing *The Birth of Venus* and *Primavera* for analysis, and he started with the impact of the classical antiquity on the paintings, given that Florentine art was directly related to the classical antiquity. That took him to the investigation of both literary and written art historical sources, and armed with a passage from Leon Battista Alberti's treatise *On Painting* – first published in Latin in 1435 – and the poetry of Ovid and Angelo Poliziano, Warburg proceeded to analyse Botticelli's mythological paintings, and this is how the essential coordinates of *iconology* were established:

> Firstly we find it in the relationship between images and poetic texts; between figurative creation and the spoken language and starting from this Warburg embarked on an investigation of the function of figurative creation (art) in the life of a civilization, positioning himself in a sphere of interest removed from the simple philological considerations of the sources of the images or the simple elucidation of their content, which belonged to the realm of pure iconography. (Mahiques, 2008: 100)

For Aby Warburg, this line of inquiry will acquire a peculiar nuance related, under the influence of Benedetto Croce's philosophy, to his interest in mental images and in their emotive content. His fascination with the interaction between the themes selected by the artist and the way they were visualized, became the central focus of his investigations. Warburg was also the first scholar to warn about 'the complexity and "untouchability" of the problem' (Mahiques, 2008: 101).

Thus, Panofsky was not the first to use *iconography* and *iconology* in his studies of the visual arts, but the reason why his three-tiered system of analysis for paintings belongs to Panofsky and not Warburg is because he codified and published it in 1939.

Panofsky's first demonstration of the use of *iconography* can be found in an essay published in 1936 'Et in Arcadia Ego: Poussin and the Elegiac Tradition' (published again in 1955 in *Meaning in the Visual Arts*) where he challenged the traditional interpretation of the shepherds who discover that death exists

even in Arcadia, replacing it with a melancholic reflection on mortality. But at this stage Panofsky does not make use of any technical terminology.

In 1939 when Panofsky published *Studies in Iconology: Humanistic Themes in the Art of the Renaissance* he introduced *iconography/iconology* as the standard methodology used by art historians to uncover the layered meanings encoded in paintings, 'destined to become the classical formulation of the *iconographical-iconological* method' (Mahiques, 2008: 236).

According to Panofsky the 'pre-iconographical' level 'has its object of interpretation that which is called *primary* or *natural subject matter*'; thus the hat-removing gesture of his courteous male acquaintance is what 'his eyes see' at the *formal* level of *forms* and *colours*, which belongs to the world of *motifs*. The second, *conventional* level links the 'pre-iconographical' *motifs* with *themes* and *concepts*: 'Motifs thus recognized as carriers of a *secondary* or *conventional* meaning may be called *images*, and combinations of images are what the ancient theorists of art called *invenzioni*' (Panofsky, 1972: 6). The viewer has to establish the required links between what he sees by giving it a meaning: thus he decodes the configurations of lines and colours as 'an object': a gentleman, tied to 'an event', a greeting. Panofsky also informs us (1972: 4) that this form of salute peculiar in the Western world is a residue of medieval chivalry: armed men used to remove their helmets to make clear their peaceful intentions and their confidence in the peaceful intentions of the others. This is the realm of *iconography* in the strict sense of the word.

Finally, at the third, *intrinsic meaning* or *content* level, the first level of *motifs* and the second level of *images, stories and allegories* are rolled into one 'as manifestations of underlying principles', which according to Panofsky 'reveal the basic attitude of a nation, a period, a class, a religious or philosophical persuasion – unconsciously qualified by one personality and condensed into one work'; here Panofsky turns to Ernst Cassirer's concept of *symbolic* values (Panofsky, 1972: 8). Finally, the correct analysis of *images, stories and allegories* is the prerequisite of a correct *iconographical interpretation in a deeper sense* (Panofsky, 1972: 8). In the 1939 book Panofsky calls the third level *iconographical interpretation*, but in the 1955 book it becomes *iconological interpretation*, and so Panofsky himself removes the confusion. At this point we return to Jacob Burckhardt, because Panofsky's major contribution is not

even so much the codification of *iconography/iconology* as a methodology for the study of the visual arts, but the introduction of cultural history to history of art.

Rafael Garcia Mahiques concludes by providing an explanation of *iconology*, worth quoting in full:

> This is how I understand *iconology*, as an *iconography* which should have been interpretative and which therefore converted itself as an integral part of the study of art, instead of continuing to be confined within the function of preliminary statistical record. Without doubt we need to recognize that there exists a certain danger in the fact that *iconology* can behave not as *ethnology* in opposition to *ethnography* but as *astrology* in opposition to *astrography*. (Mahiques, 2008: 279)

Structuralism and its uses in media and fashion studies

Erwin Panofsky was interested in linguistics and the writings of Ferdinand de Saussure and so too was Roland Barthes, who initially employed Saussure's structural analysis as a tool for literary criticism, but then decided to extend it to the world of popular culture and mass media. And both Panofsky and Barthes put some of Saussure's tenets he developed in *Course in General Linguistics* (published posthumously in 1916) to good use in their respective disciplines.

In 1957 Barthes published *Mythologie*, proposing a two-tiered system for the analysis of images from advertising and the media. The book consists of twenty-eight chapters, each dedicated to a separate subject, complemented by a postface titled 'Myth Today'. In it Barthes built creatively on Saussure's radical linguistic theory in which he challenged the established philosophical argument that there is a one-to-one relationship between words and the world, by arguing that this relationship is not fixed but flexible. To explain his theory Saussure postulated a world of 'signs', whereby each 'sign' consisted of a 'signifier' and a 'signified' he considered to be socio-cultural constructs resulting from the conflation between 'signifiers' (the world) and 'signifieds' (their flexible meaning). The first level of interpretation of this hybrid 'sign'

is the *denotation* (Panofsky's *secondary* or *conventional meaning*), followed by the second, the *connotation* (Panofsky's *intrinsic meaning* or *content*).

The link between iconography and semiotics

Ferdinand de Saussure's triad of concepts – 'signifier', 'signified' and 'sign' – is now a familiar old hat for media students. Thanks to Panofsky's introduction of *iconography/iconology* as the preferred methodology for the analysis of paintings, only the terminology differs. For that reason a case could be made for an analogy between art history and semiotics.

We start with 'what the eyes see', further expanded into the higher denotative and connotative levels of 'sign' and 'mega-sign', which is what Barthes calls 'myth'; they are the equivalents of Panofsky's *secondary* or *conventional* subject matter level and *intrinsic meaning* or *content* level, and it may even be that Barthes was influenced by Panofsky.

He was and confirmation comes from Barthes's biographer Louis-Jean Calvet who mentions the following event: during the winter of 1954 an infant died of cold. Consequently an old Capuchin monk turned vicar by the name of Henri Grouès, who during the Resistance assumed the pseudonym of Abbot Pierre, launched a campaign against poverty which took the media by storm. In January 1955, Barthes published an article: 'Iconographie de l'abbé Pierre' (reprinted in *Mythologies*, pp. 47–9).

With typical Gallic wit, he focused on the good monk's looks, arguing that 'the myth of Abbé Pierre' has at its disposal a precious asset: the fine physiognomy of the Abbé' which 'displays all the signs of apostleship: a benign expression, a Franciscan haircut, a missionary's beard . . . etc.' This 'look' was specifically chosen as a mean between 'a short hair cut' (an indispensable convention if one does not want to be noticed) and 'unkempt' hair (a state suitable to express contempt for other conventions). The reason? The Abbé's haircut becomes the capillary archetype of saintliness because the idea of fashion is antipathetic to the idea of sainthood. The Abbé then is conflated into St. Francis, or a St. Francis-like hero, because of 'the tremendous **iconographic** popularity of this haircut in illustrated magazines and seen in films' (Barthes, 1972: 47).

Introduction
13

But wait a little! As a good Marxist, Barthes was a severe critic of the capitalist system and what emerges at the *connotative* level is that he condemns the very institution of charity by condemning what happens when a society consumes it with such avidity

> that it forgets to ask itself questions about its consequences, its uses and its limits. And I then start to wonder whether the fine iconography of the Abbé Pierre is not the alibi which a sizeable part of the nation uses in order, once more, to substitute with impunity the signs of charity for the reality of justice. (Barthes, 1972: 48–9)

The fact that the epistemological bases of iconography and semiotics overlap did not go unnoticed: In an article titled 'Semiotics and Iconography' (1972), French philosopher Hubert Damisch analysed the relationship between the two, starting with 'the status of iconographic studies' defined by Panofsky as 'a method applicable to the history of art' and its putative connection with a semiotics of the visual arts (Damisch in Preziosi, 1998: 234). But Damisch accuses art history of turning iconography into a 'privileged methodology', whilst continuing to adhere 'to a logo-centric model'.

Damisch then proceeds by employing quantities of heavy-handed references, including Ferdinand de Saussure and Ludwig Wittgenstein, who in their respective subjects of linguistics and linguistic philosophy 'started to take notice of the image'. The reason? It enabled them to criticize the 'post World War II provinciality and parochialism of the art historical discipline as an abdication of its former close engagement with important intellectual issues' (Damisch in Preziosi, 1998: 228). What motivated Damisch's harsh words was a desire to provide a way 'for disciplinary change by reconnecting contemporary practice to its own intellectual history' (Damisch in Preziosi, 1998: 228). But if iconography – as the more traditional methodology – works well when applied to history of art, here defined as a humanistic discipline, the area which provides scope for a semiotics of art is to be found elsewhere, namely in modern art, 'from Cézanne to Mondrian, from Matisse to Rothko and Barnett Newman', who 'seem to carry out their work *on the near side* of the figure if not against it, *on the near side* of the sign, if not against it' (Damisch in Preziosi, 1998: 241). In plain words, it would not be possible

14 *Images on the Page*

to apply iconographical analysis to a painting by Mondrian or Rothko, and even some figurative paintings of say, Henri Matisse, because that would not yield exciting results. And why is that? Because the joie de vivre the images themselves convey, suffice!

In order to accept the concept of 'modern art' defined by Damisch as the appropriate field for semiotics, we need to turn to the definition of 'modernism', and if we further accept that the essential tenet of 'modernism' is 'the new', then this is what the avant-garde movements were all about: the 'new'. So far so good, but things become complicated with the emergence of 'post-modernism' and 'post-structuralism', associated with Jean-François Lyotard's rejection of explanations in favour of 'narratives' and Jacques Derrida's introduction of 'deconstruction' as a new tool for literary criticism.

But where does this leave us? In order to distinguish between 'modernism' versus 'post-modernism' and 'structuralism' versus 'post-structuralism', we turn to the encyclopaedia definitions. The first pair of concepts are defined as follows:

> Where modernist aesthetics had proposed a clear distinction between authentic art and the forms characteristic of mass culture, postmodernist aesthetics willingly embraces the art forms of the popular and mass markets, intentionally mingling the 'high' and the 'low'. The purpose of such mingling however, is not to effect a reconciliation but rather to heighten the sense of ironic play between them. (Cooper, 1995: 399)

The second pair of concepts are defined as follows:

> Structuralism is an aesthetic theory based on the following assumptions: all artistic artefacts (or 'texts') are exemplifications of an underlying 'deep structure'; texts are organised like a language, with their own specific grammar; the grammar of a language is a series of signs and conventions which draws a predictable response from human beings. The objectives of structuralist analysis is to reveal the deep structures of texts . . . Post-structuralism is a broad-based cultural movement embracing several disciplines, which has self-consciously rejected the techniques and premises

of structuralism, particularly the notion that there is an underlying pattern of events. (Damisch in Preziosi, 1998: 228)

We return to Damisch, who relegates iconography to the role of a traditional tool for the art historian, whilst semiotics becomes the preferred tool for analysing modern art. But what about popular culture and mass media, in which not even 'modernism' – still addressing only 'the authentic' artists, for example, the Cézannes and Rothkos of the art world – is of much use?

Well, not to worry for we now have 'post-modernism' and 'post-structuralism' which address these interests; as for mass media and popular culture, we have Barthes. In 1939, when Panofsky published his book on *iconography-iconology*, both 'modernism' and 'structuralism' were in circulation, but 'post-modernism' and 'post-structuralism' were yet to be formulated.

Iconography and the fashion images: Fritz Saxl's 'discovery' of *Il Libro del Sarto*

The premise on which this book is based is that Erwin Panofsky's methodology can successfully be employed to analysing fashion images, because they too tell a story and this has not been attempted before, or so I believed, until I discovered in the library of the Warburg Institute *Il Libro del Sarto*.

Dated between the 1540s and the end of the Cinquecento and published in Milan, it lay forgotten in the Querini Stampalia Foundation in Venice until it was 'discovered' in 1936 by none other than Fritz Saxl, who was taught at the University of Hamburg by the same professor as Erwin Panofsky. After the death of Aby Warburg, founder of the Warburg Library in 1900 in Hamburg, subsequently renamed in 1921 the Warburg Institute, Saxl became its director in 1929 and was instrumental in moving it to safety to London in 1933; in 1944 the Warburg Institute became affiliated with the University of London.

In 1936, Saxl published his research in an essay titled 'Costumi é feste della nobiltà Milanese negli anni della dominazione spagnola' (pp. 31–44) in vol. XVIII of *The Proceedings of the British Academy*, Humphrey Milford, Amen House E.C.

Saxl started his essay by telling the story of his fortuitous encounter with *Il Libro del Sarto*:

> Several years ago, I found in the Querini Stampalia Foundation a manuscript which as far as I was aware, escaped the attention of scholars. This fact is not surprising; because what I found was a common sample book, originating from a tailoring shop in Milan, dating from the second half of the sixteenth century. Regarding its content, one could find watercolours of clothes, ranging from the everyday to festive occasions but containing also drawings of objects of practical use such as curtains, harnessing (caparisons, trappings) embroideries and banners accompanied by instructions regarding the quantity and equality of the materials and the patterns to be used for their cut. (Saxl, 1987: 21)

Then Saxl proceeds to make his key point:

> But what could an art historian learn from a practical book conceived for workshop use and meant to attract the clientele of a tailor, from among public personalities whose names are listed by the captions in the book, indicating them to be the clients of an individual tailor. Moreover, from an artistic point of view, the illustrations are modest; at best copies from good quality originals very likely lost. But if they would have approached them with more humility and fewer pretentions, by paying attention to what they have to tell, they would have realized that they are worthy of their interest. (Saxl, 1987: 21)

What was unprecedented was that Saxl's analysis of examples from the book – to be discussed in Chapter 2 – which anticipated that of Panofsky, enabled him to demonstrate that without a deep knowledge of the historical and cultural context to which the garments belong, they will not tell us their stories.

Semiotics and the fashion image

For the subject matter of the twenty-eight short essays published under the title *Mythologies*, Barthes chose some colourful examples from the world of mass

media and popular culture, with titles such as 'The World of Wrestling', 'The Face of Garbo', 'Steak and Chips' and 'The Iconography of the Abbé Pierre' – already discussed – in which he employed the word 'iconography'.

But the key to their understanding is given in the final chapter 'Myth Today' (pp. 109–59) in which Barthes provides an example of structural analysis of an image from the cover of *Paris-Match*:

> I am at the barber's and a copy of *Paris-Match* is offered to me. On the cover, a young Negro in a French uniform is saluting, with his eyes uplifted, probably fixed on a fold of the tricolour. All this is the *meaning* of the picture. But whether naively or not, I see very well what it signifies to me: that France is a great Empire, that all her sons without any colour discrimination, faithfully serve under her flag, and there is no better answer to the detractors of an alleged colonialism than the zeal shown by this Negro in serving his so-called oppressors. I am therefore again faced with a greater seismological system: there is a signifier, itself already formed with a previous system (a black soldier is giving the French salute); there is a signified (it is here a purposeful mixture of Frenchness and militariness); finally, there is a presence of the signified through the signifier. (Barthes, 1972: 115)

At the *denotative* level there are no problems either with the 'signifier' (the black solider saluting) or the 'signified' (Frenchness and militariness), but the situation changes at the *connotative* level, where 'the myth' is embedded. If we consider the example of the black soldier in French military uniform saluting together with the example of Abbé Pierre's hairstyle, we have in both instances a hidden message to do with politics, ideology and Marxism but ultimately **deceit**: to put it simply, the black solider introduced as 'one of us' is not 'one of us', the hidden message being France's racism.

In 1967 Barthes turned his attention to fashion with his book *The Fashion System* in which he proposed to undertake 'the structural analysis of women's clothing as currently described by Fashion magazines' (Barthes, 1983: Foreword) by submitting the fashion magazine to structural analysis. In chapter I titled 'Written Clothing', he introduces the system of the 'three garments': the technological (the material object), the visual 'image clothing' and the text 'written clothing'.

This chapter starts famously with 'what the eyes see':

I open a fashion magazine; I see that two different garments are being dealt with here. The first is the one presented to me as photographed or drawn – it is image-clothing. The second is the same garment, but described, transformed into language; this dress, photographed on the right becomes on the left: *a leather belt, with a rose stuck in it, worn above the waist, on a soft Shetland dress*, this is the written garment. In principle these two garments refer to the same reality (this dress worn on this day by this woman) and yet they do not have the same structure, because they are not made of the same substances, and because, consequently, these substances do not have the same relations with each other: in one the substances are forms, lines, surfaces, colours, and the relation is spatial; in the other the substance is words, and the relation is, if not logical, at least syntactic; the first structure is **plastic**, the second **verbal**. (Barthes, 1983: 3)

Iconography and the fashion image

Fashion illustration emerged during the sixteenth century, long before the publication – during the eighteenth century – of the first fashion magazines. An important source of information for this date comes from François Boucher's *A History of Costume in the West* (Thames and Hudson 1997) in which he stated that fashion illustration appeared during the sixteenth century in the form of collections of engravings first published in 1520.

This date was subsequently adopted by other fashion historians such as Lou Taylor, who wrote in her book *Establishing Dress History* that 'between 1520 and 1610 over 200 collections of engravings, etchings and woodcuts were published in Germany, Italy, France and Holland, concerning clothes and personal adornment' (Taylor, 2004: 5), and Cally Blackman who stated in her book titled *100 Years of Fashion Illustration* that 'Between 1520 and 1610 more than 200 collections of engravings, etchings or woodcuts were published containing plates of figures wearing clothes peculiar to their nationality and rank' (Blackman, 2007: 6).

Introduction 19

Daniel Roche also mentioned Renaissance fashion images. In his book *The Culture of Clothing: Dress and Fashion in the Ancien Régime* (1994) he argued that the emergence of the fashion plate was the result of the large number of engravings and prints in circulation during the Renaissance. They were cheaper than books and therefore became 'a basic instrument in the wide diffusion of norms, patterns, processes and styles' (Roche, 1994: 11).

Stella Mary Newton, however, argues differently. In her book *Renaissance Theatre Costume and the Sense of Historical Past* she wrote that the earliest costume book, published in 1562, was François Desprez's *Recueil des habits qui sont le present en usage, tant des pays d'Europe, Asie é Isles Sauvages* (of which a copy is kept in the Wolfenhütel Library in Germany), followed in 1563 by Ferdinando Bertelli's *Omnium Fere Gentium Nostrae Aetatis Habitus* (Newton, 1975: 245).

Recent accounts provide different starting points for the date of the emergence of the earliest fashion images. Julian Robinson and Gracie Calvey regard Albrecht Dürer as the 'creator of the genre' of fashion illustration and in their book *The Fine Art of Fashion Illustration* they argue that he had 'like so many artisans who followed him' the skill to make good use of new technologies:

Dürer's work was influenced by the latest in everything, from ideas, books and technology to clothes, fabrics and luxury goods from far flung places. His love of the new and the fashionable is especially obvious in the self-portraits he painted at this time. In these portraits he used his seemingly casual but carefully put together look to impress potential clients, even employing a specialist to regularly wave and curl his hair. These paintings, of a young man fully aware of the power of fashion and confident in his use of the arts of self-promotion and self-expression through dress, show him as a consummate fashion illustrator and arbiter of taste. He showcases the clothes and, through the clothes, the mood and mind of the wearer of the time. Because of this, he is perhaps the first widely published fashion illustrator, the creator of the genre. (Robinson with Calvey, 2015: 36)

Whether Dürer can be so regarded remains a matter of debate, but Ulinka Rublack in *Dressing Up: Cultural Identity in Renaissance Europe* (2010)

analyses a pen-and-ink drawing of a costume study by Dürer dated 1495 which represents a Nuremberg and a Venetian lady side by side. The drawing was first published by Erwin Panofsky in *The Life and Art of Albrecht Dürer* (1943), and in it he provided a *paragone* between the Venetian *gentildonna* and the German *hausfrau*, who embodied the southern and the northern spirit.

In 1510, working for the Emperor Maximilian, Dürer created a book of masquerades and tournaments, the *Feydal*, which acquired international success, making him 'one of the early stars of an information revolution and all over Europe young artists, seeing his work, strove to emulate him' (Robinson with Calvey, 2015: 37).

Rublack introduces the notion of 'moral geography' defined as specific physical spaces which contain the people who inhabit it, arguing that Hans Weigel (with the help of Jost Amman) were the creators of 'this comparative moral geography in a global context'. In 1577 their *Trachtenbuch* published by Sigmund Feyerabend in Frankfurt was 'the first book that visually set out what is regarded as "the various cults" of dress in the German lands' (Rublack, 2010: 146).

Rublack too – like Stella Mary Newton – called François Desprez's book of clothing published by Richard Breton in 1562 'the first costume book' where he is 'revelling in the *diversité* of world clothing' incorporating 'Europe, Asia, Africa and the *isles sauvages* mixing 107 simple woodcuts on 56 sheets with guest appearances of monsters and marvels' (Rublack, 2010: 146).

She references two more books: the first is a manuscript found in the costume library of the Freiherr zu Lipperheide, in Berlin, assembled by a Nuremberg official called Sigmund Heldt.

> Heldt's album which has never been discussed in the scholarly literature and only rarely ever been referred to, provides us with a strong sense of the kind of self-reflection on familiar traditions and sobriety made possible by the awareness of cultural diversity across the globe.
>
> This is what scholars call trans-culturalization when your experience of another culture changes the way you think of your own. The manuscript evinced a conservative view, which affirmed that local customs should be preserved, but nonetheless was informed by a sense of Nuremberg's cultural

peculiarity. This perspective resulted from ethnographic knowledge. (Rublack, 2010: 200)

The images contained in the album included clerical dress, tournaments, carnival and German female costume as well as a few Venetian outfits, alongside 'Turkish, Polish, Russian, Greek, Moorish, African and Spanish dress', with the last hundred sheets (388–499) representing Nuremberg dress and within this section, forty-three sheets illustrated peasant dress (Rublack, 2010: 200).

The second book is by the young artist trained as a form cutter and sculptor, Christoph Weiditz. In 1529 he went to Augsburg to meet the Holy Roman Emperor Charles V, where he met other Augsburg artists, among them Mathäus Schwarz's illustrator, Narziss Renner. Weiditz produced 154 water-coloured pen drawings on heavy cardboard-like paper of ordinary people, later bound in an album by their owner, known as the 'Weiditz Book of Costumes' or the *Trachtenbuch*, described as a unique example of early European ethnographic observation.

> Weiditz depicted Indians recently brought back by Hernan Cortès as well as black slaves and slaves of Muslim origin – he pictured female criminals and Christianized Moorish inhabitants of Granada. He seems to have mostly stayed in Castile. Hence we can not be sure that he drew his numerous plates of Moriscos from life, as well as his vivid series of Basque people. But no other model for these drawings has been identified and they clearly cohere with his uniquely observant interest in people across society. (Rublack, 2010: 187–8)

Finally, Cesare Vecellio's *Degli habiti antichi et moderni di diverse parti del mondo* (first published in 1590 and again in 1598) was 'the culmination of a trend that began in the mid-sixteenth century, with a series of costume engravings by Enea Vico'. In the decades which separated Vico from Vecellio, at least ten costume books were published in Europe, and Vecellio used them for his own research. But what singles him out is his detailed and extensive commentary relating dress to social, economic, religious and political factors.

Not only do the images accompanied by texts provide a unique source of documentation, but they also tell stories just as paintings do – and

22 *Images on the Page*

aesthetic considerations aside – they are as informative, exciting and, yes, aesthetically pleasing.

Case study: Giorgione's *La Tempesta* and David LaChapelle's *Burning Down the House*

As already mentioned, this book is based on the premise that Erwin Panofsky's iconographical model can be applied equally to paintings and fashion images, given that both deal with *istoria* (storytelling), defined in 1435 by Leon Battista Alberti in his treatise *On Painting*:

> The greatest work of the painter is *istoria*. Bodies are part of the *istoria*, members are part of the bodies, planes are parts of the members. Circumscription is nothing more than a certain rule for designing the outline of the planes, since some planes are small as in animals, others are large as those of buildings and colossi. (Alberti (1435), 1970: 70)

Alberti also provided a list of rules and regulations as to how the painter might create the best *istoria*, starting with the 'composition of the bodies' which 'must harmonize together in the *istoria* both in size and function', followed by 'copiousness and variety':

> I say that *istoria* is most copious in which in their places are mixed old, young, maidens, women, youths, young boys, fowls, small dogs, birds, horses, sheep, buildings, landscapes and all similar things. I will praise any copiousness which belongs to that *istoria*. (Alberti, 1970: 75)

Copiousness in turn must be embellished by variety:

> In every *istoria* variety is always pleasant. A painting in which there are bodies in many dissimilar poses is always especially pleasing. There some stand erect, planted on one foot, and show all the face with the hand high and the fingers joyous. In others the face is turned, the arms folded and the feet joined. And thus to each one is given his own action and flexion of members; some are seated, others on one knee, others lying. If it is

allowed here, there ought to be some nude and others part nude and part clothed in the painting; but always make use of shame and modesty. (Alberti, 1970: 75)

Without being dogmatic, Alberti's advice to painters, offered with wit and humour, converges to create a painting that 'will capture the eyes of whatever learned or unlearned person is looking at it and will move his soul' (Alberti, 1970: 75). His tenets of how to achieve excellence in creating a good *istoria* continue to be used in figurative painting. But whilst Alberti provided the rules, Panofsky provided the tools for decoding it: *iconography-iconology*.

The two examples selected for analysis are taken from art history and fashion photography, respectively: the first is Giorgione's celebrated *The Tempest* (1510) and the second is a photograph by David LaChapelle titled *Burning Down the House*.

Giorgione's painting is still awaiting interpretation in spite of heroic attempts to unlock its 'mystery'. The earliest reference comes from the Venetian diarist

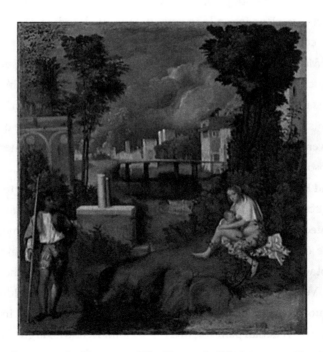

Figure 1.1 *Giorgione, La Tempesta (The Tempest). Oil on canvas. 83 × 73 cm. c. 1504–8. Gallerie dell Accademia, Venice.*

Marcantonio Michiel, who saw it in the collection of a Venetian nobleman, Gabriele Vendramin, in 1530 and described it as 'a little landscape with the tempest, with the gipsy and the soldier' (Michiel in Pignatti, 1971: 61). Terisio Pignatti himself describes 'what the eyes see' at the *primary* or *natural* subject matter level as follows:

> A summer storm bursts at sunset above the towers of a little town, by which runs a stream. The bridge and the grassy outcrops are reflected in the greeny-blue water and the thick foliage of the ilexes and acacias is shaken by a sudden gust, the leaves momentarily glistening in the light. The figures are as it were caught by chance, momentarily stilled in the fleeting light of the lightning flash. The spectator echoes some of the reaction within the image itself – the wonderment of the figure who stands amazed, almost stunned, before the spectacle of nature. (Pignatti, 1971: 61)

If we move to the *secondary* or *conventional* subject matter level of interpretation, few paintings in the history of art have succeeded in baffling so many art historians for so long and attempts at 'decoding' it abound. One suggestion coming from Maurizio Calvesi is that the painting represents the *Finding of Moses* in which the naked woman seated on the right, suckling her infant – described by Michiel as a 'gypsy' – represents the Pharaoh's daughter, whilst the standing male figure to the left referred to as 'the solider' is Hermes Trismegistus. But when the painting was X-rayed, a second female nude figure was discovered under the figure of the 'soldier' and Calvesi's interpretation became obsolete (Calvesi in Pignatti, 1971: 102). Could it be that, as Lionello Venturi and Kenneth Clark suggested, Giorgione 'intended simply to represent a pastoral scene in a landscape setting or a storm'? In his *Notizia d'opere di disegno* dated 1521, Marcantonio Michiel was the first to comment on the appearance of landscape as a specialized subject in Venetian painting. The manuscript was published in 1800 by Jacopo Morelli, librarian at the Marciana Library in Venice, but it was not until 1864 that its author was identified as Marcantonio Michiel. The first modern scholar to write about the importance of landscape in Venetian painting was Ernst Gombrich, who argued that it was in Venice rather than Antwerp, that the term 'landscape' was first applied to an individual painting. Michiel was 'the first person to use the term advisedly to

describe a painting of such a subject'. As early as 1521 'he noted *molte taveolette de paesi* in the collection of Cardinal Grimani' (Gombrich, 1966: 109). But how did Michiel regard Giorgione's landscape paintings? In reporting the presence of 'landscape' in the paintings of Giorgione, Michiel sees it either as a distinct but integral part of a painting, or as the main subject. *The Sleeping Venus* in Dresden illustrates the first case: 'The painting of the naked Venus sleeping in a landscape with cupids was by the hand of Zorzo de Castelfranco, but the landscape and the cupids were finished by Titian.' For the second case Michiel refers to an unidentified painting (a replica of which he himself owned): 'The nude in pen and ink in a landscape was by Zorzi, and the painted nude that I own is by the same Zorzi' (Facchinetti and Galansino, 2016: 72). If we turn to Giorgione's biography, our main source of knowledge is Giorgio Vasari, but like Michiel, Vasari does not constitute a primary source because the first edition of his *Lives of the Painters, Sculptors and Architects* was published in 1550. He only introduced the Venetian painters in the second enlarged edition of 1568 commenting that Giorgione, who was following 'Nature', did not only surpass Giovanni Bellini, but was competing with Tuscan masters:

> So closely did he follow Nature, and so carefully did he imitate her, that not only did he acquire the reputation of having surpassed Gentile and Giovanni Bellini, but he competed with the Tuscan masters, the authors of the modern style. Having seen and greatly admired some things of Leonardo, richly toned and exceedingly dark, as has been said, Giorgione made them his model, and imitated them carefully in painting in oils. (Gaunt, vol. 2, 1963: 169)

Vasari commented also on something even more important, relating to a commission Giorgione received to paint frescoes on the façade of the *Fondaco de'Tedeschi* (destroyed by fire in 1504), which could be the first attempt to provide an explanation of Giorgione's apparent lack of interest in producing an *istoria*.

> Accordingly Giorgione set to work but with no other purpose than to make figures at fancy to display his art, for I cannot discover what they mean, whether they represent some ancient or modern story, and no one has been

able to tell me. Here is a lady and there a man, in various attitudes, one has a lion's head hard-by, another an angel in the guise of a cupid, and I cannot tell what it means. (Vasari, 1970: 170)

Vasari seemed genuinely baffled that the frescoes were devoid of a narrative, and this may be the reason why Walter Pater calls Giorgione 'the inventor of *genre*', with the creation of 'those easily movable pictures which serve neither for uses of devotion, nor of allegorical or historic teaching – little groups of real men and women, amid congruous furniture or landscape – morsels of actual life, conversation or music or play, but refined upon or idealised, till they come to seem like glimpses of life from afar' (Pater, 1971: 133–4).

We may conclude that either the meaning of *The Tempest* is yet to be 'decoded' or it has no meaning in Alberti's sense of *istoria*. Instead Giorgione created a celebration of the harmonious relationship between man and nature, confirming Venturi and Clark's conclusion.

But it is at the *intrinsic meaning* or *content* level that we gain a deeper insight by analysing the historical and cultural context to which Giorgione belonged. He lived during a period marred by dramatic events, for in less than thirty years – between 1494 when the French invaded Italy and 1527 when the Roman Imperial Army sacked Rome – Italy emerged as a changed society. After years of political stability and economic prosperity, 'war sounded a terrible wakeup call for Italy' wrote Francesco Guicciardini in the opening pages of his *Storia d'Italia*:

It is obvious that ever since the Roman Empire, more than a thousand years ago, weakened mainly by the corruption of its ancient customs, began to decline from that peak which it had achieved as a result of marvellous skill and fortune, Italy had never enjoyed such prosperity or known so favourable a situation as that in which it found itself so securely at rest in the year of our Christian salvation 1490, and the years immediately before and after. The greatest peace and tranquillity reigned everywhere; the land under cultivation, no less in the most mountainous and regions than in the most fertile plains and areas; dominated by no power other than her own, not only did Italy abound in inhabitants, merchandise and riches, but she was also highly renowned for the magnificence of many

princes, for the splendour of so many most noble and beautiful cities, as the seat and majesty of religion and flourishing with men most skilful in the administration of public affairs and most nobly talented in all disciplines distinguished and industrious in all the arts. (Guicciardini in Faini, 2016: 26–7)

It was against this background that Giorgione's life and career evolved, and Vasari evidenced not only his talent as a painter but his exceptional qualities, which enabled him to become part of the exclusive aristocratic and humanist milieu of Venice:

His name is Giorgio, born in Castelfranco in the Trevisano in 1478, under the dogeship of Giovan. Mozzenico, brother of Doge Piero. From his stature and the greatness of his mind he was afterwards known as Giorgione (great George). Though he was of very humble origin, his manners were gentle and polished all his life. Brought up in Venice, he displayed very amorous propensities, and was exceedingly fond of the lute, playing and singing so divinely that he was frequently invited to musical gatherings and meetings of noble persons. He studied design, and was so fond of it, Nature assisting him to her utmost, and he was so enamoured of the beauty of that art, that he would never introduce anything into his works which he had not drawn from life. (Vasari, 1970: 168–9)

Giorgione painted a portrait of Caterina Cornaro, ex-queen of Cyprus, who held court both at her palace in Venice and at Castello di Asolo, which might have assured his access to her circle of philosophers and poets who congregated at Asolo, among them the influential humanist Pietro Bembo.

Bembo's dialogue, titled *Gli Asolani*, written as a homage to Caterina Cornaro and dedicated to love, brought him instant success. But what made him really famous was his decision to replace Latin with the fourteenth-century Tuscan vernacular dialect and he wrote *Prose della volgar lingua*, the first grammar of the modern Italian language.

Pietro Bembo came from aristocratic stock and grew up surrounded by wealth and privilege. Diplomat Philippe de Comines who visited Venice in 1494 as emissary of the French king Charles VIII, describes the beauty of a

city which took his breath away and declared the Grand Canal to be the most beautiful street in the world,

> with the best houses, very big and tall, the old ones of good stone, all painted; those built in the previous hundred years had façades in white marble from Istria, many with big pieces of porphyry and serpentine on the front. Inside, most had gilt ceilings, rich chimney mantelpieces of carved marble, gilt and painted bedsteads and fine furniture. (Lidwell, 2004: 3–4)

Pietro Bembo – the son of Bernardo, a diplomat, humanist and collector of rare manuscripts – was born and grew up in just such a palace facing the Grand Canal: *Ca' Bembo*. One of his first tasks was to edit a manuscript by Petrarch published by Aldus Manutius in the elegant new script, now known as *Italic*.

In 1478 father and son voyaged to Florence where Pietro befriended Marsilio Ficino and Angelo Poliziano, members of the Platonic Academy founded by Lorenzo Medici himself, an author of popular poetry and carnival songs written in the Tuscan vernacular (Lidwell, 2004).

Later that year they arrived at the court of Ferrara, ruled by Duke Ercole d'Este and considered as one of the most cultured courts in Italy. Ferrara was a centre of excellence for literature, where the poet Matteo Maria Boiardo wrote the chivalric poem *Orlando innamorato* and Ludovico Ariosto provided its sequel: *Orlando Furioso*. Both became Pietro Bembo's friends and very likely prompted him to write and the result was *Gli Asolani*. On 11 December 1497 Bembo wrote to Trefon Gabriele that 'he was spending most of his hours after daybreak on *Gli Asolani*' (Faini, 2016: 30).

Bembo wrote *Gli Asolani* (The People of Asolo) between 1497 and 1504, dedicating it to his lover, Lucrezia Borgia, wife of Alfonso d'Este. Centred on the theme of love, *Gli Asolani* is divided into three books consisting of dialogues which took place among Bembo's friends gathered at Caterina Cornaro's villa at Asolo. To the modern reader his style may appear cumbersome because it was modelled on Giovanni Boccaccio's *Decameron*, written in the *Treecento* vernacular Tuscan dialect.

The first authoritative representative, if not the initiator of this movement was Pietro Bembo, a non-Tuscan and a humanist. In his *Asolani* (1505) he gave the first outstanding example of a pure Tuscan prose written by a non-Tuscan, and in his *Prose della volgar lingua*, published in 1525 but composed soon after 1500, he defended this practice with theoretical arguments (Kristeller, 1965: 136).

Giorgione very likely belonged to the intellectual elite of the patrician families listed in Marcantonio Michiel's *Notizia*, which included Domenico Grimani, Patriarch of Aquileia; the great sixteenth-century art collector Taddeo Contarini; Gabrielle Vendramin; and Gerolamo Marcello, who owned three paintings by Giorgione, including *Venus Asleep* (Pignatti, 1971). And the following three examples selected for analysis may be relevant for establishing a link between Giorgione and the 'Asolani'.

The first is *Portrait of a Young Man with a Green Book* (dated between 1502 and 1510/15) in the Fine Arts Museum in San Francisco. The second is a double portrait: *Portrait of a Young Man and His Servant* (dated around 1502) in the Museo Nationale del Palazzo di Venezia, Rome. The third is *Portrait of a Young Man* (dated c. 1508–10), possibly Antonio Brocardo, in the Szépmüvészeti Museum, Budapest.

All three paintings were included in two exhibitions: the first, *Pietro Bembo e l'invenzione del Rinascimento* was held at Palazzo del Monte di Pièta in Padua in 2013, whilst the second, *In the Age of Giorgione*, dedicated to Giorgione and his followers, was held at the Royal Academy of Arts, 2016.

The first painting representing a young man holding a green book was discovered in the 1860s by Giovanni Battista Cavalcaselle in the Onigo collection in Treviso. He sent a drawing of it to his partner Joseph Archer Crowe with the comment: 'Giorgione and Onigo, Treviso' and we know that Giovanni Onigo, a physician from Treviso, was a friend of Giorgione. In 1907 at the Winter Exhibition of the Burlington Fine Art Club in London, Herbert Cook wrote: 'we have a beautiful portrait of the young man Giovanni Onigo attributed to none other than Giorgione' (Beltramini, Gasparotto and Tura, 2013: 147).

In the 2016 catalogue identification of the sitter as a member of the Onigo family starts by referencing Cavalcaselle who saw it 'in the house of Count

Rinaldi in Treviso' in the 1860s, suggesting that it came from the Onigo family. Yet these comments were not published in Crowe and Cavalcaselle's *A History of Painting in North Italy* (1871).

Herbert Cook's attribution to Giorgione made in 1907 is confirmed with the additional comment that there is no documentary evidence regarding the identity of the sitter as a member of the Onigo family.

It was renowned Giorgione scholar Alessandro Ballarin, who undertook to analyse the portrait in conjunction with Giorgione's double portrait in Rome and the portrait of a young man in Budapest, and on that basis he dated it around 1502. But he rejected Giorgione's authorship, whilst identification of the sitter as a member of the Onigo family is omitted. Instead the name of Giovanni Cariani is suggested with a date of execution between 1510 and 1515 (Facchinetti and Galansino, 2016: 67).

Attribution of the double portrait starts with the disagreement of some of the most famous scholars. including Roberto Longhi who attributed it to Giorgione, Giuseppe Fiocco and Bernard Berenson who attributed it to Domenico Mancini, and Terisio Pignatti who considered it to be by an anonymous painter (Beltramini, Gasparotto and Tura, 2013). But a radical hypothesis is put forward by Alessandro Ballarin, proposing 'una stagione intermedia' in Giorgione's career which antedates the bizarre painting titled *Concert* (in the collection of Milanese Gianni Mattioli, on loan to the Galleria dell'Accademia di Venezia); the *Impassioned Singer* (in the Borghese Gallery) and *Portrait of a Young Woman* (Laura) (in the Kunsthistorisches Museum, Vienna) all dated around 1506. They provide the *terminus ante quem* for the seminal *Pala de Castelfranco*, dated 1503–4.

This putative intermediary period between 1500 and 1503 would add a new chapter in the history of the painter's career, characterized by the emergence of a courtly style of portraiture: central to this period is *Portrait of a Young Man and His Servant* dated 1502.

This date is important because the subject matter, which appears to deal with two lovelorn young men, reflects the culture expressed by Pietro Bembo's *Gli Asolani*.

The second proof is Carlo Dionisotti's *Leggi della compania degli amici*, a text published in 1966 and found in the Ambrosian library. One of its members was Pietro Bembo, whose *Gli Asolani* was linked to the company.

The two young men in the double portrait are represented bust-length, the one in front with his right hand holds his temple, whilst in his left hand he holds a *melangolo* (a Seville orange) which refers to *pomum o malum auerum,* an allegory of the bittersweet nature of love, and his melancholic gaze tells of the courtly love rituals described in *Gli Asolani.*

In the 2016 catalogue the double portrait is listed as 'attributed to Giorgione', quoting its earliest description dated 1624, found in the inventory of the collection of Cardinal Carlo Emanuele Pio de Savoia: 'Two portraits in one frame by Giorgione medium size, one of them holds his hand to the temple and holds a Seville Orange in his other hand black frame touches of gold' (Facchinetti and Galansino, 2016: 434). The painting was attributed to 'Dosso Dossi of Ferrara' until 1919, but in 1922, Emilio Ravaglia attributed it to the Venetian period of Sebastiano del Piombo, placing it within 'the close circle around Giorgione'. Several years later, Roberto Longhi firmly attributed it to Giorgione, 'considering the painting to be a late work, along with the Munich *Daphnis* and the Budapest *The Portrait of a Young Man*', but Longhi's attribution passed unnoticed (Facchinetti and Galansino, 2016: 434). Whilst there is no general consensus regarding its authorship, the 2016 catalogue references Alessandro Ballarin's recent (1979) attribution to Giorgione, linking it to Pietro Bembo and *Gli Asolani,* relevant to this debate:

> A fresh outlook was offered by Alessandro Ballarin who interpreted the double portrait as an early work by Giorgione painted in about 1502 and crucial to the explanation of the birth of a 'courtly neo-Platonist new style of portraiture'. The painting was thus analysed in the light of the culture promulgated in Pietro Bembo's *Gli Asolani* written in 1502 but not published until 1505. (Facchinetti and Galansino, 2016: 434)

The third painting, in the Fine Arts Museum in Budapest, generally accepted to be by Giorgione, is a bust-length portrait of a sad-looking young man dressed in a black damask coat with gold embroidery, holding his right hand on his chest whilst his elbow is resting on a wide parapet. On its sill is a 'three headed device representing the virtue of Prudence'. The device is surrounded by a garland, tied with a ribbon whose contents allude to the four seasons; flowers for spring, corn for summer, grapes for autumn and walnuts for winter (Facchinetti and Galansino, 2016: 59). Flanking this image are two plaques: to

the left a plaque of a hat with the letter 'V' embroidered on it, and to the right, a plaque with two handles with an inscription which identifies the sitter as 'Antonius Bro(kar)dus Mari', with the word 'Mari' referencing Antonio's father, the well-known physician Marino Brocardo (Facchinetti and Galansino, 2016: 59). Problems of attribution notwithstanding, as Pignatti pointed out: 'The attraction of this painting derives largely from the mystery which surrounds the character represented and it is not matched in our opinion by the actual appearance of the painting' (Pignatti, 1971: 118).

But the identification of the sitter remains a mystery; thus in the 2016 catalogue it has been suggested that the name incised on the parapet is that of the tragic Antonio Brocardo, son of physician Marino, involved in 'una dura polemica con Pietro Bembo' in 1531 (Beltramini, Gasparotto and Tura, 2014: 154). But there are problems with this identification because if the portrait is dated 'at the beginning of the first decade of the sixteenth century', Antonio Brocardo would have been still a child (Beltramini, Gasparotto and Tura, 2014: 154).

Ballarin identified firmly its author as Giorgione and the sitter as Antonio Brocardo, linking the painting (as in the case of the *Double Portrait* in Rome) to Pietro Bembo and *Gli Asolani*.

Perhaps the conclusion proposed in the 2016 catalogue should be (at least for the time being) accepted. It starts with the identification of the sitter following its restoration, which, as conservator Gyürgy Kákay-Szabó explained, has caused 'paint to remain only in the tiniest cracks in this area'. Consequently 'Giorgione could not have painted a portrait of Antonio Brocardo (the poet would have been too young at Giorgione's death in 1510), therefore the main supporters of this attribution consider the inscription to be apocryphal' (Facchinetti and Galansino, 2016: 59). But many scholars, including Roberto Longhi, Giuseppe Fiocco, Rodolfo Pallucchini, Carlo Volpe, John Pope-Hennessy, Alessandro Ballarin, Mauro Lucco, Jaynie Anderson, Enrico Maria Dal Pozzolo and Sarah Ferrari accept Giorgione's authorship. One question, however, remains unanswered: 'why a later hand might have wished to ennoble a personality as controversial as Brocardo by falsifying the inscription' (Facchinetti and Galansino, 2016: 59). An explanation is on offer.

Even more radical than *Gli Asolani* was Pietro Bembo's *Prose della volgar lingua* first published in 1525, which attracted its fair share of hostility, one example being the same Antonio Brocardo – allegedly painted by Giorgione – who 'ridiculed the rules laid down by the "dictator of letters". Inexplicably he died one year later, in 1531' (Facchinetti and Galansino, 2016: 59).

The controversy Brocardo attracted by criticizing Bembo did not stop even after his death due to one of the most influential presences in Venice, Pietro Aretino, who claimed that his sonnets in which he mocked Brocardo's poetry and his Jewish origins 'caused him to die of a broken heart'. Aretino continued to write merciless letters about him, but whether Pietro Bembo was affected by this tragic affair is debatable. One thing is certain: reluctant to antagonize Aretino, Bembo kept quiet.

This vast panorama of personalities and events provide the historical and cultural context of Venice during the first decades of the sixteenth century, which shaped Giorgione's career, but conclusive evidence regarding Giorgione's relationship with Pietro Bembo and *Gli Asolani* has yet to surface.

Therefore a *paragone* between Venice with Florence might suggest some answers.

Florence was home of the Platonic Academy led by Marsilio Ficino, which although short-lived (after the death of Lorenzo il Magnifico in 1492 it was dissolved), it impacted not only on the cultural life of Florence but also went far beyond, reaching Venice and Europe. Among its activities devised by Ficino were improvised conversations with friends and visitors; banquets and celebrations, such as the celebrations on Plato's birthday, whose dialogues were translated into Italian by Ficino himself; as well as public lectures on Plato, Plotinus and St. Paul held in the church of S. Maria degli Angeli (Kristeller, 1965). Central to Ficino's philosophy was the theory of platonic love, which provided the foundation of a vast literature, including Pietro Bembo's *Gli Asolani*:

Ficino was the first to use the terms 'Platonic' or 'Socratic' love, and in doing so, he merely thought of the love theory found in Plato's *Symposium* and Phaedrus as he understood it. More frequently Ficino speaks of divine love, which he tends to identify with Christian *charitas* and with friendship. For

him, this divine love is not a sublimated form of sexual love (although he is very far from condemning sexual love as such). It is rather a spiritual bond between two persons who both participate in the contemplative life. (Kristeller, 1965: 96)

The Medici Academy fostered a new interest in the visual arts, starting with a much needed theoretical foundation which altered the status of the triad of painting, sculpture and architecture – Lorenzo Valla's triad of the Fine Arts – from crafts to liberal arts. That foundation was provided by Leon Battista Alberti's trilogy dedicated to painting, sculpture and architecture. In the first, published in 1435, *On Painting*, Alberti established its theoretical basis for placing *istoria* centre stage and providing the tools for its optimum achievement, starting with perspective, light and shade, and use of colour, but above all *la più grassa Minerva*, the curious name he gave to dealing with the visible reality (Alberti, 1970: 43).

When Bernardo Bembo arrived in Florence in 1478, bringing his son Pietro to learn Tuscan, he was introduced to Marsilio Ficino and Lorenzo Medici. But this was a troubled period in Florentine history, marked by the Pazzi Conspiracy on Easter Sunday 26 April 1478, which took place in the Duomo when Giuliano Medici was killed, but Lorenzo escaped with some of his friends including Angelo Poliziano. In 1492 – as Pietro Bembo was leaving Florence for Sicily to learn Greek – Lorenzo died; two years later, Charles VIII occupied Florence and the Medici family was expelled.

The Florentine painter who came closest to the teachings of the Platonic Academy was Sandro Botticelli, whose *Birth of Venus* and *Primavera* are every bit as mysterious as Giorgione's *The Tempest*. For that reason an analogy can be proposed between Botticelli and his links with the Medici Academy and Giorgione and his links with Caterina Cornaro's court at Asolo. A case can also be made about the way Neoplatonism informed their work: in the case of Botticelli the link is more palpable, but with Giorgione it is more a sentiment to do with the *noumenal* which imbued his work.

It is not known whether Botticelli or any of the Florentine painters, sculptors and architects were members of the Neoplatonic Academy, and it was not until

the nineteenth century that Botticelli's mythological paintings were linked to Plato's philosophy and Botticelli himself rediscovered:

> It was tempting, with this context and following his rediscovery, for some pioneering nineteenth-century art historians to address Botticelli's artistic persona through the lens of fifteenth-century Florence's cultural milieu. Viewed in this way, Botticelli's mythological paintings appeared to them to have been informed by Neoplatonist interpretations of classical Gods. This concept found its starting point from the correspondence between Ficino and the young patron of Botticelli, Lorenzo di Pierfrancesco de'Medici, which coincided (during the late 1400s) with the creation of *Primavera* and the *Birth of Venus*. (Debenedetti in Evans and Wepplemann, 2016: 310)

But Botticelli's attenuated pagan goddesses and sad Madonnas were far from being considered the embodiment of Neoplatonic beauty! Walter Pater, in an essay dated 1870 – reprinted in his seminal book *The Renaissance*, first published in 1873 – introduced Botticelli to the English readership commenting that in the *Birth of Venus* 'what is unmistakable is the sadness with which he has conceived the goddess of pleasure, as the depositary of a great power over the lives of men', to which he added: 'He paints the story of the goddess of pleasure in other episodes besides that of her birth from the sea, but never without some shadow of death in the grey flesh and wan flowers' (Pater, 1971: 76). Bernard Berenson is equally merciless regarding Botticelli's representations of feminine beauty:

> Never pretty, scarcely even charming or even attractive; rarely correct in drawing, and seldom satisfactory in colour; in types ill favoured; in feeling acutely intense and even dolorous – what is it then that makes Sandro Botticelli so irresistible that nowadays we may have no alternative but to worship or abhor him? (Berenson, 1968: 33)

We can continue to stay with Walter Pater because in 1877 he wrote an article titled 'The School of Giorgione' published in the *Fortnightly Review* and again in the third edition of *The Renaissance* (1888). And it is in this essay that we find Pater's much quoted aphorism: 'All art constantly aspires towards the condition of music' (Pater, 1971: 129), but read in its rightful context it makes

proper sense so that the concept of *Giorgionesque* – Pater invented it to explain the aesthetic experience Giorgione's landscapes with figures evoked in the viewer – becomes more akin to music than poetry, because it cannot be put into words.

Giorgione is introduced by Pater as the inventor of genre and Pater's own writing can, too, be described as poetic, like Giorgione's landscapes. Pater starts with a short biography of Giorgione and although he mentions that 'not far from his home lives Caterina Cornara, formerly Queen of Cyprus' (Pater, 1971: 138), there is no intimation of any relationship between them. The concept of *Giorgionesque* is introduced at this point:

> For the aesthetic philosopher, therefore, over and above the real Giorgione and his authentic extant works, there remains the *Giorgionesque* also – an influence, a spirit or type in art, active in men so different as those to whom many of his supposed works are really assignable. (Pater, 1971: 139)

Pater's example which embodies the Giorgionesque is the *Concert* in the Pitti Palace – one of the few works Pater accepts to be by Giorgione – and he returns to music 'as the condition to which every form of art is perpetually aspiring', including painting which uses colour and design to obtain it and that depends on

> the dexterous choice of that subject, or phase of subject; and such choice is one of the secrets of Giorgione's School. It is the school of *genre* and employs itself mainly with 'painted Idylls' but, in the production of this pictorial poetry, exercises a wonderful tact in the selecting of such matter as lends itself most readily and entirely to pictorial form, to complete expression by drawing and colour. (Pater, 1971: 14)

Here Pater makes good use of *ekphrasis*, the ancient Greek rhetorical tool which required the 'translation' of a visual work of art into a literary text, so that Giorgione's *Concert* can translate into a literary work of art. In fact it was Pater who reintroduced *ekphrasis* in modern art criticism, with his equivalent of Leonardo da Vinci's *Mona Lisa*: 'She is older than the rocks among which she sits; like the vampire, she has been dead many times and learnt the secrets of the grave' (Pater, 1971: 123).

Pater listed a multitude of ingredients used by Giorgione to create the Giorgionesque effect starting with music and from music they moved to the theatre,

> which is like music; to those masques in which men avowedly do but play at real life, like children 'dressing up' disguised in the strange old Italian dresses parti-coloured, or fantastic with embroidery and furs, of which the master was so curious a designer, and which, above all the spotless white linen at wrist and throat, he painted so dexterously. (Pater, 1971: 142)

Pater was also the first to notice Giorgione's interest in fashion, noticeable in the outfit worn by the fashionable male figure in *The Tempest*, and there is no doubt that he must have had first-hand acquaintance with the Venetian beau monde who would have paraded their finery at Asolo.

Walter Pater's Giorgionesque dimension with which Giorgione imbued his paintings can no more be expressed in language than Ludwig van Beethoven's *Pastoral* symphony can, and therefore we can conclude that at the *intrinsic meaning* or *content* level, we revert to what Panofsky calls *synthetic intuition* (familiarity with the essential tendencies of the human mind) conditioned by personal psychology and *Weltanschauung* (Panofsky, 1970: 66) and experience *The Tempest* in this way.

David LaChapelle's photograph of Alexander McQueen and his 'muse', stylist Isabella Blow, at Hedingham Castle in Essex was first published in the March 1997 'Swinging London' edition of *Vanity Fair*, under the title *The Provocateurs*. And so they are!

What we see at the *primary* or *natural* subject matter level is a young man 'in drag' wearing a strapless mustard-coloured evening gown, consisting of a black bodice and a black choker around his neck complemented by long, red (very likely leather) gloves, leaning precariously backwards, mouth wide open as if in shock or screaming and brandishing a torch. By contrast, the demure young woman to his left is dressed in a pink sleeveless sheath dress with a wide shawl collar which stands up to cover most of her face so that only her nose and quizzical eyes are visible. Her red hat with a disproportionately tall crown is precariously balancing on top of her head, and it is a true miracle that it still stands in place. She is tiptoeing on her

Figure 1.2 *Alexander McQueen and Isabella Blow. Photo by David LaChapelle/ Contour by Getty Images,* Vanity Fair, *1 March 1997.*

right foot, whilst her left foot is bent at the knee and raised backwards, and with her right hand she is holding the long train of her companion's skirt. To their right a caparisoned horse evocative of a child's hobbyhorse stands on its hind legs, and under its belly we spy a *chevalier* in full medieval armour lying flat on his back. But in spite of so much movement there is something frozen about their posture: a *tableau vivant* against the backdrop of a medieval castle engulfed by flames.

Attempting to unravel its meaning is more problematic than it appears, but we could start by revisiting its dramatis personae: the torch-brandishing young man dressed as a woman is fashion designer Alexander McQueen, whilst his companion is stylist and fashion 'icon', Isabella Blow.

What unites the two protagonists – apart from their tragic deaths by suicide – is their notoriety: McQueen was a brilliant but idiosyncratic fashion designer, who designed both outfits, and so was Isabella Blow regarded as a 'celebrity' on the fashionable London art and fashion circuit.

Moreover, Hedingham Castle, chosen by LaChapelle as the backdrop, is no less distinguished than its protagonists, whose history can be traced back to the Domesday Book. Hedingham Castle was built during the eleventh century by a Norman nobleman, Aubrey de Vere I, remaining in the family until the seventeenth century. In 1713 it was bought by Sir William Ashhurst whose descendants, Jason Lindsay and wife Demetra, are the present owners.

The photographer is David LaChapelle, and we need only turn to Google to find out all about him, and we learn that he started his career as a successful commercial and fashion photographer. He is also a fine art photographer, and a music video and film director. We learn also something about the man: he was diagnosed as bi-polar and in the 1980s he lost his boyfriend to AIDS. After a short stay in London, he returned to Los Angeles and made the radical decision to move 'away from it all' to Hawaii, where he became a farmer. But then a colleague asked him to shoot for an art gallery and for him the invitation was a 'home coming', because it enabled him to leave the commercial world behind and return to art.

The bibliographical list about him is impressive and recently we found his work included in an exhibition titled *Botticelli Re-imagined* (V&A Museum, 2016) with two photographs on display: *Rebirth of Venus* and *Rape of Africa* (both dated 2009), and in the exhibition catalogue we find an explanatory text (p. 143) providing information from the aforesaid Google:

> The American photographer, film maker and video artist David LaChapelle is best known for his large format C print editions. His images often conceived as series, play with photographic genres like documentary or fashion photography. LaChapelle's works often contain references to Old Master paintings and Renaissance sculpture, above all of Michelangelo. (Natali in Evans and Wepplemann, 2016: 143)

The text proceeds to analyse his two Botticelli-inspired photographs, providing us with the perfect example of the still-predominant descriptive approach limited to Panofsky's *primary* or *natural* subject matter level. At the *secondary* or *conventional* level Botticelli's titles provide, at least prima facie, the meaning, but the explanation on offer in the text is unsatisfactory to say the least. Thus,

we are told that in the case of the *Rebirth of Venus* 'he uses the shell ironically as the *locus* of the physical connection between men and women' (Natali in Evans and Wepplemann, 2016: 143).

But what is on offer is an oversimplification because if we move to the *intrinsic meaning* or *content* level, the photograph abounds with references to the ravages of consumerism with all its ills, and a good starting point would have been to provide an equivalent of something like a *Botticelli moralisée*, whose ethical dimension is the key to understanding the narrative.

For the second image, a quote from LaChapelle seems to be used at the *intrinsic meaning* or *content* level in order to contextualize the *Rape of Africa* based on Botticelli's *Venus and Mars* in the National Gallery. But in this instance it makes good sense, because LaChapelle's use of Naomi Campbell as Venus – apart from its glamorous dimension (again an oversimplification if understood only in this way) – takes us to Africa, exploitation of natural resources and so on, in other words, the domain of *iconology*:

> The use of Africa in my photographs is about it being the cradle of civilization, the idea of Mother Earth and Mother Africa. The production of gold in Africa is destroying both the society and the country itself. (Natali in Evans and Wepplemann, 2016: 143)

If we embark on a compare/contrast exercise between Giorgione's and David LaChapelle's images, in the former, in spite of the extensive level of historical documentation, the conclusion regarding its *secondary* or *conventional* subject matter level remains in the domain of speculation, but recent research contributed to elucidating its *intrinsic meaning* or *content* level, which points to Giorgione's connection with the circle of Caterina Cornaro and the philosophy of Pietro Bembo.

In LaChapelle's photograph, at the *secondary* or *conventional* subject matter level, unlike in Giorgione's painting, LaChapelle's protagonists would have been easily identified by visitors to the National Portrait Gallery as Alexander McQueen and Isabella Blow. But what can we learn about them and about the author of the photograph?

Alexander McQueen started his career as apprentice at Saville Row, where he learnt the craft of tailoring and then went on to St. Martin's School of Art

and Design to study for an MA, graduating in 1994. At the graduation show his entire collection was bought by Isabella Blow who became one of his most dedicated supporters.

In 1996 he was nominated – following in the footsteps of John Galliano – as director of the *maison de couture* at Givenchy, and one year later he presented his first collection to the Parisian public.

Isabella Blow is described as a stylist, a journalist and an entrepreneur – among other things – and her chequered career included not only collaborations with fashion designers but also forays into publishing working for *Vogue* and later as fashion director for *The Sunday Times*. American-born David LaChapelle started his career as a fashion and society photographer, but his talent led him to artistic photography, and consequently his photographs were exhibited in museums around the world. It is to this artistic 'mode' that his photograph of McQueen and Blow belongs.

What connects Giorgione's painting *The Tempest* (1506) with David LaChapelle's photograph displayed at the National Portrait Gallery under the title *Burning Down the House* (1997) is that they speak to each other across the centuries, which is evident at the *intrinsic meaning* or *content* level.

Thus, both consist of two figures in a landscape: in the first instance we see to the right in the composition a naked young woman, save her shoulder covered by a white scarf, seated on her chemise spread on the grass quietly suckling her baby. To the left, the young man is wearing a white shirt topped by a short red doublet, matching slashed breeches and two-colour hose for which dress historian Stella Mary Newton provides an analysis in the context of what was fashionable in Venice at that time:

Already it was no longer necessary to hold up the long hose by a circle of ties laced to the waist, whilst Giorgione's young man still wears hose which rigidly encase his thighs, his torso has been freed from the traditional corseting. The shirt, never previously exposed in even semi-respectable circumstances is now unashamedly visible, although this young man would not, of course, have been regarded by his contemporaries as the apotheosis of fashionable youth. He is, nevertheless, elegant by the standards of the station to which he belonged. Page, household man-at-arms, junior

member of a city guard, the young man wears the new shorter hair cut and jacket (still presumably called by the old-fashioned name *zupon* or *zipon*) of good quality cloth of scarlet; his hose alone must have cost more than his pay-packet could have afforded. A nagging doubt remains: is he a Venetian? (Newton, 1988: 37)

He is represented in a classical *contrapposto* position leaning on a stave. His gaze is turned to the right in the direction of the naked woman, whilst she is looking out at us, the viewer.

But X-rays revealed that Giorgione initially painted another naked woman bathing, which he then replaced with the fashionable young man, and as Frederick Hartt observed: 'A change in the dramatis personae, from nude woman to clothed soldier spells disaster for any story one can possibly imagine' (Hartt, 1970: 531). Hartt has more uncomfortable things to say about the image he finds menacing:

> The woman is trapped in the unkempt, weedy natural world that has grown up around her. The trees are unpruned (Piero di Cosimo would have loved them), the bushes shaggy, the columns ruined, the bridge precarious, the village dishevelled. And the whole scene is threatened by an immense, low storm cloud, which fills the sky and emits a bolt of lightning, casting the shadow of the bridge upon the little river and illuminating the scene with a sudden glare. (Hartt, 1970: 531)

All is still, nothing happens, but a stillness foreshadowing disaster, whether in the form of a natural (storm) or man-made (the impending war of the League of Cambrai, which started in 1508, two years after Giorgione painted *The Tempest*) disaster. This 'mood' of impending disaster, encapsulating Sigmund Freud's concept of the *uncanny*, he turned into an aesthetic category, whereby the German word for 'uncanny', *unheimlich*, the opposite of *heimlich* (homely), is defined as 'the class of the frightening which leads back to what is known of old and long familiar', and he then explains the circumstances in which 'the familiar can become uncanny and frightening' (Freud, 1990: 340).

In Giorgione's painting we see a naked young woman seated on the ground, breastfeeding her child whilst a mighty storm is brewing in the

background. In David LaChapelle's photograph we see a young man with his mouth wide open as if screaming attired in a woman's evening gown, brandishing a torch whilst the castle in the background is burning. Did he torch it? Is this also the reason why he is precariously leaning backwards about to fall to the ground?

Both images lack an *istoria* and that constitutes to my mind a bond between the Giorgione painting and the David LaChapelle photograph across the centuries. Although they are the result of different historical and cultural contexts, both arrived at something which aspires to the condition of music.

2

Renaissance books of clothes

How did it all begin? Villard de Honnecourt's 'Sketchbook'

History tells us that people were always fascinated by manners and mores, and by what people wore and why they wore what they wore. This fascination can be traced back as far as the Renaissance and even before this if we consider (and we ought to) Villard de Honnecourt who left us a sketchbook in the collection of the Bibliothèque nationale, Paris (Focillon, 1969: 110). His familiarity with contemporary attire and its beauty and elegance makes the sketchbook a worthy antecedent of the Renaissance costume and tailor books.

Dated around 1225–35, the 'Sketchbook' consists of 33 parchment sheets and 250 drawings accompanied by captions arranged on the page in a seemingly haphazard manner. The subject matter varies from architectural plans, elevations and ornamentation to human and animal figures, sculptures, religious objects, and mechanical devices, which makes it difficult to figure what their purpose was in the first place. But Villard's real contribution was to alter the way the human figure was represented by altering its stocky Romanesque proportions and replacing them with the elongated silhouette associated with the Gothic style:

> It was only about the middle of the thirteenth century, if we can trust the album of Villard de Honnecourt, that they began to acquire the elongated

46 *Images on the Page*

stature, the slightly fragile elegance, and the combination of the slender waist, with breath of shoulder that we see in his triangulated figures. (Focillon, 1969: 80–1)

One of the first, if not the first, dress historians to pay attention to the 'Sketchbook' was François Boucher. In *A History of Costume in the West* (published in 1965), Boucher reproduced a drawing whose title specifies 'Drawing by Villard de Honnecourt' (fig. 332, p. 184), with a second example representing a military man wearing a coat of arms about to mount his horse, but in this instance the title references an item of clothing, 'Draped hose'. The image may be a humorous attempt to show a young man in free fall from the back of his bad-tempered horse, whose flowing short mantle reveals the hose underneath (fig. 350, p. 194).

Boucher identifies several styles of hose: the 'round hose', the longer hose known as *chausses à queue* and the full-bottomed hose (*chausse à plain fond*). Yet the 'draped hose' in the drawing is nowhere to be found. But this should not come as a surprise because Boucher himself commented that the relationship between items of clothing during the twelfth century and their nomenclature is fluid. He attributed this lack of clarity to the emergence of *langue d'oil* (old French), which emerged in Northern France during the ninth century replacing Latin. Consequently old terms like *tunique* were replaced by the *bliaud*, and new terms were invented: '*doublet, peliçon, gippon, guimpe, amigaut*' (Boucher, 1997: 180).

The *bliaud* is variously described as 'a robe which fitted close about the body', or 'the long train of ladies robes' (Shaw, 1843: 5), whilst Boucher describes it as 'a gown sometimes short with long, flaring sleeves known sometimes as a *bliaud*; embroidery and braid often decorate the foot of the gown and sleeves and the inset panel over the shoulders' (1997: 168).

We find the *bliaud* listed as an item of dress worn in England during the Anglo-Norman period in the popular *Romance of Tristan,* describing Queen Iseult's luxurious attire:

The queen had clothes of silk, they were brought from *Baldak,* they were furred with white ermine. The mantle, the *bliaud* all train after her. Her

locks on her shoulders are banded in line of fine gold. She had a circle of gold on her head. ('Romance de Tristan' in Shaw, 1843: Introduction)

The *bliaud* was worn also by men: 'Men always wear a short *bliaud*, full skirted with the girdle usually hidden by the pouching upper part; a medium-length cloak is fastened on the shoulder or chest' (Barnes, 2009: 90).

Dorothy Hartley, in *Medieval Costume and Life: A Review of Their Social Aspects Arranged Under Various Classes and Workers – With Instructions for Making Numerous Types of Dress*, argued that the hose (derived from the French *chausse* and Latin *calcet*) are stockings covering the legs, whilst the breeches or *braies* (from Latin *bracca*) were 'coverings for the loins' (Hartley, 1931: 32).

Villard de Honnecourt must have known a lot about clothes, and this is reflected in the accuracy with which they are depicted. One of his most endearing images has to be the two wrestlers stripped to the waist engaged in combat. The right figure wears *braies* or drawers tied up to the waist, whilst the left figure wears long stockings (*bas de chausses*) 'into which the *braies* are stuffed' (Barnes, 2009: 91).

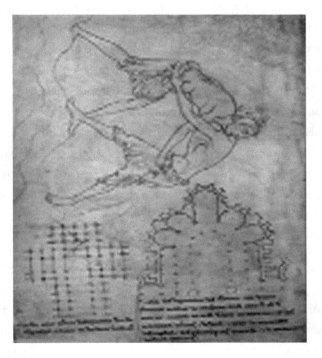

Figure 2.1 *Villard de Honnecourt,* Wrestlers. *Graphite and light sepia ink (Folio 14V).*

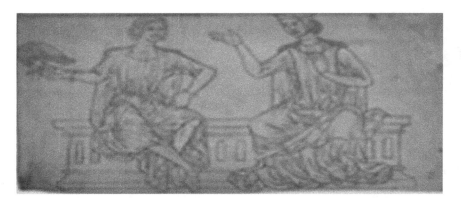

Figure 2.2 *Villard de Honnecourt,* Lord and Lady. *Inked drawing (Folio 14).*

We have accurate depictions of the *bliaud* in a drawing representing a seated couple variously known as the 'Lord and Lady' or 'Lovers' or 'Youth', clearly representing the upper level of society.

> Their fancy costuming assures that the couple represents an upper level of society. The man wears a sleeved tunic (bliaud) cinched at the waist with a narrow belt. Both also wear cloaks tipped at the top with fur held by thin (metal?) connections. The woman wears a sleeveless unbelted surcoat (cotte). Their headgear is that of the upper classes: the man wears an *orfroi*, a skullcap of gold embroidery; the woman wears a headpiece that holds her hair in place and a scarf ties under her chin. That her hair is hidden is an indication of modesty and social status. The woman's feet are partially visible . . . He holds a falcon in his right hand, which is gloved as a protection against the bird's talons. The couple are in conversation, the man paying attention to the woman who gestures towards him. This is a 'carefully executed costume piece'. (Barnes, 2009: 90)

This lengthy description of the costume worn by the princely couple provides us with the *primary* or *natural* subject matter level, but at the *secondary* or *conventional* subject matter level there are some problems and that is reflected by the variety of titles: 'Lord and Lady', 'Lovers' or 'Youth', suggesting uncertainty. But it is the *intrinsic meaning* or *content* level which provides the key, revealed by a very special attribute: a falcon perched on the young man's hand.

Although classifiable as 'entertainment', hunting played a special part in the collective psyche of the medieval man, not only because of its connotations of bravery, chivalry and visual beauty but also because it provided a splendid occasion for displaying the courage needed in battle, but without its life-threatening dimension. The three distinct branches of hunting were *venery*, defined as 'the science of snaring, taking or killing the particular animal from amongst a heard'; *hawking*, which 'was not only the act of hunting with the falcon but that of training birds of prey to hung feathered game'; and *fowling* which 'had originally no other object than that of protecting the crops and fruit from birds and other animals whose nature was to feed on them' (Lacroix, 1874: 178). The *hawk* was the most desirable attribute of the noblemen, regarded as 'a mark of dignity' and 'even bishops and abbots entered the churches with their hunting birds, which they placed on the steps of the altar itself during the service' (Lacroix, 1874: 198).

We can find an example in the calendar months of a psalter dated 1250 from Flanders (J. Paul Getty Museum) in which the month of May is represented by a riding man wearing a crown, 'A Man Hawking', (Scott, 2011: 58), confirming that only the highest echelons of medieval society could practice the noble sport of 'hawking'.

At the other end of the social spectrum, the two wrestlers stripped to the waist, wearing only their drawers tied to their waists with strings, belong to the peasant classes (who belonged to the land-owning lords) and whose low status is reflected in their way of dress: 'In contrast to the lavish materials and furs of the upper classes, the clothing of these peasants at work is an accurate reflection of their vastly inferior social status and means' (Scott, 2011: 15).

We see the peasants toiling in the fields in the calendar months of a psalter dated *c.* 1250 from Flanders (J. Paul Getty Museum) representing the month of August in which 'the harvester has stripped down to his linen underpants, though his companion still wears his woollen stockings and tunic' (Scott, 2011: 15).

The *intrinsic meaning* or *content* level of the two extremes of the medieval social spectrum was perfectly summed up by J. Huizinga in his seminal book *The Waning of the Middle Ages*. On the one hand the luxury and splendour of the new order of Gothic society divided both by rank and worldly possessions, expressed by ostentatious display:

Every order and estate, every rank and profession, was distinguished by costume. The great lords never moved about without a glorious display of arms and liveries, exciting fear and envy. Executions and other public acts of justice, hawking, marriages and funerals, were all announced by cries and processions, songs and music. The lover wore the colours of his lady; companions the emblem of their confraternity; parties and servants the badges or blazon of their lords. (Huizinga, 1979: 9)

On the other hand, the generators of the ostentatious display lived in abject poverty:

Calamities and indigence were more afflicting than at present; it was more difficult to guard against them, and to find solace. Illness and health presented a more striking contrast; the cold and darkness of winter were more real evils. Honours and riches were relished with greater avidity and contrasted more vividly with surrounding misery . . . Then again, all things in life were of a proud or cruel publicity. Lepers sounded their rattles and went about in processions, beggars exhibited their deformity and their misery in churches. (Huizinga, 1979: 9)

Renaissance books of costume: A neglected subject of study

Fashion illustration has hitherto been a neglected area of research and this fact has not passed unnoticed:

Fashion illustrations wordlessly carry within them so much information, both historical and cultural. For far too long, they have been overlooked by art and history academics, but even a cursory inspection of a fashion print can bring to life a particular period in ways no amount of text can manage – a fashion drawing can give a glimpse of manners and customs at play and it can show us which aesthetic ideals were aspired to and by whom. They often give clues to the wider events of the day and the consequent feelings of the people involved. The study of fashion illustration through the ages now has a place as an important source, these days called material

culture, for historians, ethnographers and scientists, as it always has for fashion designers, costume designers, filmmakers, artists, connoisseurs and collectors. (Robinson with Calvey, 2015: Preface).

Elsewhere we find 'costume books, that is, books consisting of a series of woodcuts or etchings representing persons in native dress from all over the world, have so far received very limited attention in modern scholarship' (Ilg in Richardson, 1988: 29).

When we do have examples, the approach is limited to descriptions of what people from different countries, cultures, social classes, and of different gender and age are wearing or – with the emergence of fashion – the latest 'must haves' for a young person *de bon ton*.

The Renaissance, which is the subject of this chapter, is no exception, and the starting point are two pivotal Renaissance books of costume chosen for analysis:

(1) *The Clothing of the Renaissance World: Europe, Asia, Africa, the Americas*; *Cesare Vecellio's Habiti Antichi et Moderni* by Cesare Vecellio.

(2) *The First Book of Fashion* (*The Book of Clothes of Matthäus and Veit Schwarz of Augsburg*).

But before we proceed, what follows is an overview of a number of lesser known books – although referenced in specialized literature – that have been given short shrift.

Fritz Saxl's 'discovery' of *Il Libro del Sarto*

We start with *Il Libro del Sarto* (*della Fondazione Querini Stampalia di Venezia*) published in facsimile edition by Edizioni Panini in 1987, which includes six essays contributed by Fritz Saxl, Alessandra Mottola Molfrino, Paolo Getrevi, Doretta Davanzo Poli and Alessandra Schiavoni. Its publication, however, passed almost unnoticed with a few exceptions, including Margaret F. Rosenthal and Ann Rosalind Jones who reference it in the introduction

52 *Images on the Page*

of *Cesare Vecellio's Habiti Antichi et Moderni* as a 'tailor's sample book' for practical instruction:

> One such book, assembled by two tailors and entitled *Il Libro del Sarto* by later scholars, included court dress and costumes for masques from the 1540s to the 1570s. One of the tailors, Gian Giacomo, was employed at the court of Prince Renato Borromeo of Milan in the 1570s and annotated many watercolours with the names, colours and quantities of fabrics he had used for these garments. Such books recorded ceremonial and festive costume and presented courtly attire in sufficient detail to allow followers of court fashion to order similar garments to be made for themselves. (Rosenthal and Jones, 2008: 15)

Eugenia Paulicelli also commented in *Writing Fashion in Early Modern History: From Sprezzatura to Satire* that *Il Libro del Sarto*, 'first studied by Saxl in the mid-1930s', was 'a rich pattern-book produced by a tailor's shop that operated in Milan in the second half of the sixteenth century. In the book, the tailor reproduced a series of drawings, each one illustrating a variety of models, patterns, fabrics, festive and celebratory clothing, and ceremonial dress for those belonging to everyday professions'. It is attributed to Gian Giacomo del Conte, a tailor who worked for Renato Borromeo. (Paulicelli, 2014: 19)

Fritz Saxl started with the analysis of the grandest image in the book – Emperor Charles V – suggesting that it was based on a xylography by Lucas Cranach the Younger, but conceded that they do not wear identical costumes. The reason behind the similarity of style between an image by a German painter and a Milanese tailor, Saxl argued, was their common source: the Spanish imperial style of dress which tells us a great deal about Spain during the reign of Charles V.

What the eyes see at the *primary* or *natural* subject matter level is a man dressed in sombre burgundy red and black from head to toe, although the sumptuous materials more than compensated for their lack of ostentation. Over the matching burgundy doublet with upright collar and detachable sleeves fastened on the shoulders complemented by puffed trunk hose, he

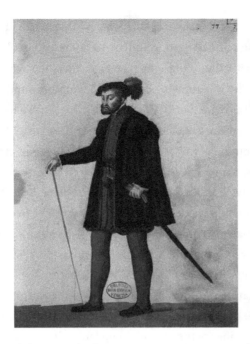

Figure 2.3 Il Libro del Sarto, Charles V, c. 1560–1600. Watercolour. Original manuscript. Biblioteca Querini Stampalia, Venice. Foundation Querini Stampalia, Onlus, Venice.

wears a flaring black hip-length *saio* (habit) of cloth lined with velvet and decorated with white fur reaching to above the knees and opening in front. In his left hand he clasps the sword, symbol of nobility, whilst in his right hand he holds a thin, elegant walking stick or perhaps a ceremonial baton. The elegant ensemble is complemented by a black flat cap decorated with burgundy plumage.

The image is labelled 'A Gentleman's Attire', but by identifying him as Charles V, Saxl moved to the *secondary* or *conventional* subject matter level: this was the emperor of Spain. But it is at the third *intrinsic meaning* or *content* that we learn the whole story: In 1519 Emperor Maximilian I died and his grandson Charles V was elected emperor; at that point he was already king of Spain and ruler of Portugal, and now he inherited also control of the Netherlands, which made him the most powerful ruler in Europe. His first task was to transform the medieval fortress of the Royal Alcazar into a palace fit to be a royal residence.

Venetian diplomat Mario Cavalli, who visited Madrid in 1551, left a description of the stiffness and grandeur of court protocol which created a pitiful contrast with the ailing emperor aged fifty-one who was riddled by gout, asthma and 'he was showing even slight symptoms of the French disease (syphilis)'. Cavalli provided also a portrait of Charles V when he was young, healthy and enjoyed dressing up: 'He does not dress ostentatiously, nor has he ever done so, but he is wont to wear now a doublet and cloak, now a short garment reaching to his knees; and he is as well groomed and trim as it is possible to be' (Cavalli in Ross and McLaughlin, 1976: 300–1).

The emperor might have been small and gouty, but he had the good fortune of employing Titian to paint his portrait, and he performed a miraculous transformation by turning the emperor into a fashion 'icon'. It was during Titian's visit at Augsburg – as Charles V was defeating the 'Protestant League' at Mülhberg – that he immortalized him in two portraits: one in full armour on horseback; the other seated, fully dressed in black which could have been interpreted as a signifier of the prevailing melancholic mood which dominated the Spanish court. But black was nothing of the sort; in fact the opposite was the case because black was the latest fashion trend not only in Spain but the whole of Europe.

The rigidity of Spanish etiquette was the direct result of the political and economic situation of Europe in the aftermath of the Reformation, and it was left to Charles V to become the main supporter of the Counter-Reformation and dominate the whole of Western Europe.

Saxl's second example was the portrait of Alfonso d'Avalos, Marques of Vasto, represented in three very similar images (nos. 22r, 23r and 28r) in the book. At the *primary* or *natural* subject matter level in one of the images (nr. 22r) the marquis, who is represented on horseback holding his commander's baton in the right hand, is wearing over a shiny metal coat of arms a *saio* (habit), whose decorative motif matches that of the horse's caparison. Underneath he is wearing a belted doublet with gold and red trimmed with green detachable hanging sleeves, and he is holding the reins of the horse with his left hand and turning to the right so that his torso is seen frontally. The outfit is completed by a flat felt cap similar to the Polish or Caucasian *colbaccho* – in some instances replaced by a fur *ushanka*, a Russian type of fur cap with flaps – in this instance

Renaissance Books of Clothes

decorated with feathers in hues of red matched by those fastened on the top of the horse's head.

The caption reveals the identity of the rider as Alfonso d'Avalos, Marques de Vasto, which provides the *secondary* or *conventional* subject matter level. But at the *intrinsic meaning* or content level we learn a great deal about this military man: he was the nephew of Major d'Avalos, and the Marques of Pescara (husband of Vittoria Colonna) and one of Charles V's most ardent champions. He too was repeatedly painted by Titian, one example being *The Allocution of Alfonso d'Avalos, Marquis de Vasto to His Troops* in which he is represented in full armour addressing his soldiers. And this is what the marquis was: a solider, whose career started with the battle of Pavia, then the Sack of Rome and in 1532 he was in Hungary fighting the Turks. In his final years he became viceroy of Milan and died at the age of forty-four in 1544.

Saxl suggests that this image was copied by the tailor from a xylography by Dutch painter Cornelius Anthonisz representing Philippe de Lalaing, Stadholder of Geldern, and he compares the two images, concluding that the Marques of Vasto was more important as 'a social personality', whilst Lalaing was more important 'as an individual', which explains why the latter was portrayed by 'one of the best painters in Europe'. Both images followed the same typology for representing a high-ranking official of the imperial army, which would have fitted equally well everywhere in Europe.

Where Saxl differs from Panofsky is that he is less rigorously structured in approach, by starting – as both examples prove – with the *intrinsic meaning* or *content* level in order to justify why the anonymous Milanese tailors who created the garments made them look the way they looked. And the explanation he provided was the influence of the Hapsburg Court and the cosmopolitan Spanish nobility on the ruling classes the Milanese tailors wanted to capture.

Saxl then returns to the *primary* or *natural* subject matter level by describing the typical male outfit and arguing that in sixteenth-century pattern books it was possible to differentiate the outfits according to their town of origin, as will be demonstrated in Cesare Vecellio's book published several decades after *Il Libro del Sarto*. But unlike Vecellio, the Milanese tailors illustrated only the dominant fashion of their time, worn 'by Don Carlos son of Charles V, Henry

II of France and the German nobility, all paying tribute to Charles V' (Saxl, 1987: 37).

Moving to women's garments, Saxl argued that although their clothes were similar in style throughout Europe, it was possible to differentiate between countries, as for instance French and Spanish fashions differed from those in Milan. In the case of the former, clothes were used to 'protect their wearer from the male gaze' and therefore when women appeared in public their garments made their movements difficult. Passing through a gate, sitting down or descending a staircase proved a challenge, attracting – as Saxl put it – 'the sarcastic comments of some "dude" who would not miss such a spectacle'. But the key feature which linked them was the 'graceful curve signalling the end of the corsage from which emerged a blouse adorned with pearls and precious embroidery', and Saxl considered the finest example to be Alonso Sanchez Coello's *Portrait of Elisabeth of Valois, Queen of Spain*, 1560:

> Milanese dresses were similar to the Queen of Spain's ensemble but with one subtle difference: whilst a curved line to border the corsage was preferred in Spain and France, the Milanese used a straight line and this difference of detail revealed the fact that the Milanese costume was even more unnatural, with important consequences, because 'such a characteristic which tends to deviate attention from the natural line of the body contributes to making women forget about their true nature, which was to be 'amante e costante'.' (Saxl, 1987: 38)

The cluster of examples found in *Il Libro del Sarto* depict the characteristic 'look' of the Milanese lady's way of dress, generally consisting of a stiffened bodice – which looked more like an armour – finished in a point over the stomach, an upright collar, square *décolletage* and 'straps' from which hang the long decorative flaps of the short, bouffant over sleeves. The narrow sleeves underneath them could be made of the same material as the *soprana* (overdress), but in some cases it accorded with the *sottana* (underdress), revealed by the triangular aperture formed by the wedges of the gown, filled by a golden chain, usually finishing with a large tassel.

The shoulders and breast were covered by an embroidered *bavara* (shoulder cape with hanging ends) and its collar finished in a soft *ruche* framing the face.

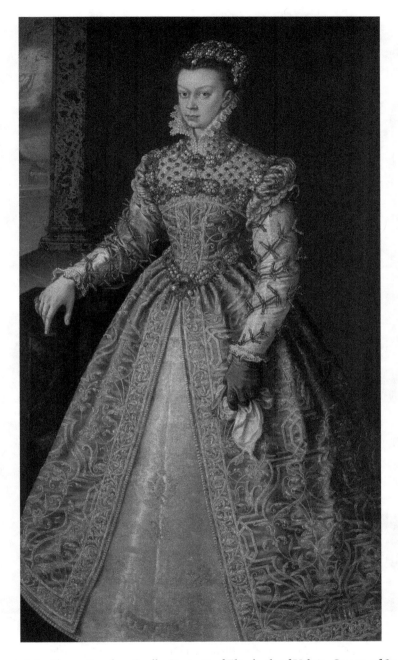

Figure 2.4 *Alonso Sanchez Coello,* Portrait of Elizabeth of Valois, Queen of Spain, *c. 1560. Oil on canvas, 163 × 91.5 cm. Picture credit: KHM-Museumsverband. Kunsthistorisches Museum, Vienna.*

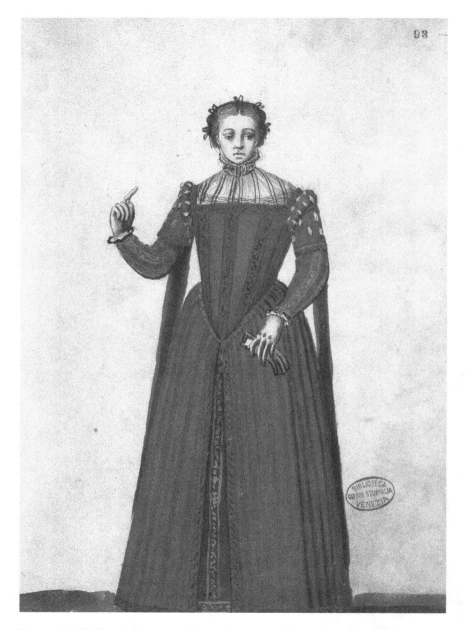

Figure 2.5 Il Libro del Sarto, Milanese lady in red dress, c. *1560–1600. Watercolour. Original manuscript, Biblioteca Querini Stampalia, Venice. Foundation Querini Stampalia Onlus, Venice.*

The only difference which separates the garments were found in the detail, such as, for instance, different patterns and materials were used for their sumptuous dresses.

Thus, in one example (Figure 2.5) what we see at the *primary* or *natural* subject matter level is a fashionably plump Milanese lady dressed in a dark red *soprana* with short sleeves finishing at the elbow and flaps reaching the ground, opened in front to reveal the dark green *sottana* whose long sleeves are showing from under the short ones. Its square *décolletage* is demurely covered by the fine embroidered lace of her *bavara*, which converges round her neck to create a small ruff. She holds a pair of gloves in her left hand with the index finger of her right hand pointing towards herself.

A special detail is the jewelled belt outlining the 'V'-shaped form of the waistline in contrast, Saxl argued, with the stiffness of the outfit, introducing an element of sensuality. At this point Saxl embarks on a journey of discovery, which takes us beyond the *secondary* or *conventional* subject matter level indicated by the impersonal title to its fascinating *intrinsic meaning* or *content* level. And what inspired Saxl was the fact that 'we know very little especially regarding the clothes of a woman if we have no idea about how the outfit presents itself when she wears it, crossing a room, seated or climbing a staircase' (Saxl, 1987: 38).

How then would the wives of important dignitaries such as the Marques of Vasto or Muzio Sforza look like when they moved? Saxl finds the most wonderful example to give us an idea of how movement affected the 'look' of a garment: a mechanical doll in the collection of the Kunsthistorisches Museum in Vienna. It was made by the celebrated clockmaker Giovanni Toriano from Cremona who moved to Toledo – calling himself now Juanelo Turriano – and working as a clockmaker, astronomer and engineer in the employment of both Charles V and Philip II. Among other wondrous things he made a mechanical doll who played the lute.

By observing the movements of the mechanical doll attired in a costume that was similar but lighter than those represented in the manuscript, Saxl concluded that her movements were characterized by a combination of grace and solemnity: its feet are moving slowly and the figure seems to hover. The shape of the body is completely hidden by the robe. By contrast the hands and the head are moving with ease and elegance. At the sound of music modulated

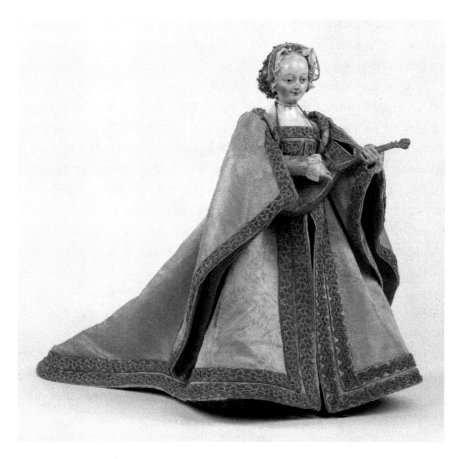

Figure 2.6 *Gianekki Turiano (c. 1500–85), mechanical doll playing the lute, dated 1550s. Picture credit: KHM-Museumsverband. Kunsthistorisches Museum, Vienna.*

with her sensitive and graceful hands, the head is describing in its motion a graceful bow. In this way a mechanical device reproduces the style of a society lady of the time with its own limits – emphasizing in the manner of a caricature – its characteristics (Saxl, 1987: 39).

Consequently, the women in the tailor's book can be brought to life so that 'the square shape of the costume can be understood in a visual correlation with the harmonious curves of the body in movement, a characteristic of Italian women which endures to this day' (Saxl, 1987: 39).

The second phase referenced in the book switches from the reign of Charles V to that of Philip II, and in Milan, from Alfonso de Avalos, Marquis de Vasto

and Muzio Sforza to S. Carlo Borromeo and his fun loving brother, Renato. The example chosen from this period (Figure 2.7) represents a woman holding the hand of a boy (her son? a page?).

This image is absolutely different from all the others; dated very likely during the last quarter of the Cinquecento because her hair is backcombed in the Spanish style and her dress differs radically from that of the earlier outfits such as 'The Woman in Red'. Thus, the *décolletage* is eliminated and her blue *sottana* finishes around her neck with a proper white ruff, whilst the customary short sleeves of the *soprana* are replaced by huge (almost certainly detachable) bouffant slashed sleeves. The little boy is wearing hose 'a zucca' (pumpkin style) over his shirt which finishes in a white ruff, and he is wearing a blue-padded arming doublet, whose colour matches that of his hose.

What to conclude? The explanation provided by Saxl – coextensive with Erwin Panofsky's third *intrinsic meaning* or *content* level – informs us that rigid outfits worn by the Milanese women were inspired by those worn at the Spanish court of Charles V and Philip II. Most importantly, Saxl argues that they were sharing not only the work of their courtier husbands but also their lifestyle. But the ultimate explanation was the influence of the Counter-Reformation – not even the Catholic Church fully succeeded to repress – on fashion: 'The real conflict of this society between the pleasures of life and the total subordination of any mundane tendency to the supreme values affirmed by the church did not find in the new style of dress a pacific solution because if anything this style was far too realistic' (Saxl, 1987: 44).

Saxl concludes by choosing Giuseppe Moroni's splendid 'gentleman' tailor:

> *The Tailor* by Moroni in the National Gallery, London is more or less contemporary with our book. And I chose it for two reasons: firstly, it was a characteristic of that period that a tailor could become the subject worthy of the hand of a grand master. Secondly, it is pleasant to imagine that the author and possessor of our book was watching the turbulent world of his clients with an expression of esteem, critical participation as well as the intelligent melancholy just like the tailor in Moroni's painting. (Saxl, 1987: 44)

Saxl's analysis, as Alessandra Mottola Molfino argues, demonstrated that by starting from a visual image, which prima facie 'is pleasant and mundane', it is

Figure 2.7 Il Libro del Sarto, Woman and Child, c. *1560–1600*. *Original manuscript, Biblioteca Querini Stampalia, Venice. Foundation Querini Stampalia Onlus, Venice.*

still possible, given the sparse documentation, to build a portrait of courtly life in Milan during the Cinquecento:

> He made use of other sources (both from public and private archives) and painted a lively portrait of Prince Renato Borromeo, brother of Cardinal Federico and his 'nobili et allegri' friends, Antonio della Somaglia, Annibale Rombello, Matteo Taerna, Pompeo Spiciano who liked to enjoy themselves with 'mascherate and tournaments'. (Molfino in Saxl, 1987: 10)

Moving from the attire the Milanese tailor, author of *Il Libro del Sarto*, created for this colourful crowd of courtiers, Molfino provides a lively *iconographical/ iconological* interpretation:

> But this was part of the scene because in all Europe the best poets, architects, painters, scholars and musicians were employed to create these spectacles from Leonardo to Holbein and Arcimbolodo to Giulio Romano and Vasari to Tintoretto, Veronese and Palladio to Rubens, from Ben Johnson to Torquato Taso to Gilardo di Lasso to Monteverdi. (Molfino in Saxl, 1987: 11)

Another essay in the book, 'La Moda del Libro del Sarto' (pp. 57–63) by Doretta Davanzo Poli, starts with Tomaso Garzoni's wonderfully ironic definition of a tailor from his 'Piazza universale di tutte le professioni del mondo' published in Venice in 1585:

> If such a thing as a decent guy (huomo di bene) is to be found in the world, he has got to be a tailor, one reason being at least that he does not drink the blood of others, because when he pricks his fingers sewing, he drinks his own blood. (Poli, 1987: 57)

This is followed by a timeline of the profession of tailoring, dating from the first-known charter of the artisanal corporation of tailors created in Germany in 1152, but it appears that a corporation of weavers, dyers and tailors already existed in Milan in 1102. She also provides a list of antecedents of *Il Libro del Sarto*, among them a fifteenth-century manuscript titled *Memorie della illustre famiglia dei Freschi Cittadini Originari Veneti* (Biblioteca Marciana, Venice) which contains thirty images in tempera of these families richly

attired in Venetian fashions. The second is the *Libro dei capovalori* written by a tailor from Innsbruck, Jörg Praun, dated 1561 in the collection of the Museum Ferdinandeum in Innsbruck, very likely created from a desire to know how the Counter-Reformation affected fashion. Another reason was an ever-growing interest in manners, mores and dress around the world, and Poli provided a useful chronological list of the most important sixteenth-century books of costumes and the way different peoples of Europe and the world were dressing, published in Venice and Padua.

She starts with Enea Vico's *Diversarum Gentium Aetatis* (Venice, 1558), followed in Paris by the better known *La diversié des habits di François Desprez*. Back to Venice, Ferdinando Bertelli's *Omnium fere gentium nostrae aetatis habitus nunquam ante hoc aediti* was published in 1563, whilst in Nuremberg Jost Amman published in 1575 *Habitus praecipuorum populorum*.

Back in Padua, Pietro Bertelli's *Diversarum Nationem Haubitus* was published in two volumes, in 1591 and 1596, respectively, at the same time as Cesare Vecellio's *Degli habiti antichi et moderni di diverse parti del mondo,* first published in 1590, which concludes the list (Poli, 1987: 28).

The question is what motivated this new interest in understanding 'otherness'.

Ulinka Rublack introduces by way of explanation the notion of 'moral geography' defined as a new ethical dimension incorporated in the way spaces and their inhabitants are understood. Her example is Albrecht Dürer, who was a 'second-generation immigrant' given that his father was a 'Hungarian of rural descent': 'Dürer therefore was not straightforwardly "of the German nation" and his father's cultural heritage and adaptations would have been integral to life at home' (Rublack, 2010: 125). She proves her point by mentioning Dürer's drawing, already referenced, representing a Venetian *gentildonna* and a Nuremberg *hausfrau* side by side in which he captures their differences:

> Everything wide and loose in the Italian dress is narrow and tight in the German one, the bodies as well as the sleeves and shoes. The Venetian skirt is cut on what may be called architectural lines; the figure seems to rise from a solid horizontal base, and the simple parallel folds give an effect not unlike that of a fluted column. The German skirt is arranged so as to create a picturesque contrast between crumpled and flattened areas and the figure

seems to taper from the waist downward. The very idea of this juxtaposition might have been suggested by Heinrich Wölfflin. Dürer contrasts the two figures as a modern art historian would contrast a Renaissance palazzo with a late Gothic town house. In sum the costumes are interpreted not only as curiosities but also as documents of style. (Rublack, 2010: 126)

This notion that clothes belong to a *gesamtkunstwerk* by replicating the dominant style of the period finds support in the visual arts; we need only look at Gothic architecture to see how the vertical tension dominated by pointed arches, ribbed vaults and the soaring cathedral spires whose silhouettes are reaching for the sky, find expression in Gothic attire in the pointed shoes, headgear and elongated silhouette which dominated fashionable dress.

Rublack argues that the first books of clothing were created to reflect the 'moral geography' of the land and starts her account with the *Trachtenbuch* of Hans Weigel from Nuremberg titled *Habitus praecipuorum populorum tam virorum quam foeminarum Singulari arte depicti. Trachtenbuch etc.*, dated 1577.

Hans Weigel's *Trachtenbuch*, 1577

First published in modern facsimile in 1969, the *Trachtenbuch* contains 219 images engraved in wood by Hans Weigel after Jost Amman, starting with Emperor Maximilian II with the last representing an aristocratic black woman from Fess.

Each plate consists of the title in Latin above the coloured image, as for instance in our example, 'Ornatus Romanorum Imperator' above the image of the emperor, and underneath the German title written in Gothic script, 'Also gehet die Romische Kaiserliche Maiestet' in our example, completed by four verses, displayed two to the left and two to the right.

In between the emperor and the black woman from Fess, the book offers a magical range of images which reflect the geographical location of the various styles of the clothes, mostly worn by women starting with Germany and followed by England, France and Spain and then on to non-European countries and peoples: Ethiopia, Mauretania, Persia, Turkey, Russia, reaching as far as the Tupinamba Indians from Brazil. Among the three images of

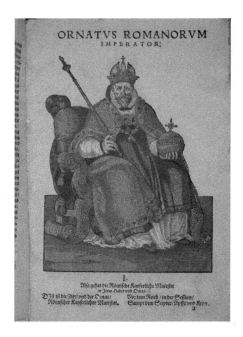

Figure 2.8 *Hans Weigel, The Emperor Maximilian II. Habitus praecipuorum populorum.* Trachtenbuch *(Costume Book). Nuremberg, 1577. Original manuscript in the collection of Trinity College, Cambridge. Reference I.II.33.*

Brazilian women on offer, one of them representing a woman carrying a baby in a knotted sling was clearly appropriated from François Desprez's *Recueil de la diversité des habits* (Paris, 1562).

We start with the portrait of Maximilian II. At the *primary* or *natural* subject matter level what is seen is a middle-aged man weighted down by his attributes of power: a huge crown, heavy brocaded mantle, sceptre and orb in hands, all of which constitute the *secondary* or *conventional* subject matter level, indicated in the title of the image. At the *intrinsic meaning* or *content* level we learn a great deal more about him. Maximilian II became emperor in 1562 and died the year before Weigel's book was published, and therefore the rigid frontal view and formal attire may have been intended as an *ex-voto* image. He married Maria, daughter of Charles V and Isabella of Portugal, and fathered nine sons and six daughters. Politically, his reign was marked by conflict with the Ottoman Turks and the formidable

Suleiman the Magnificent, and during his reign, Turkey not only became a major European power, but it experienced a golden age of cultural and artistic development. In 1566, during one of his campaigns in present day Romania, Suleiman died, and two years later, when *Trachtenbuch* was published, the new Turkish sultan was Murad III, and the image of the Turkish sultan represented by Weigel in the book is every bit as grandiose as that of Maximilian II.

What is seen at the *primary* or *natural* subject matter level is the dignified image of the Turkish sultan dressed formally and seen standing on bare ground strewn with small plants.

François Boucher provides an example of a miniature of Suleiman by his court painter in which the sultan is wearing a flaring caftan with short sleeves lined with ermine, revealing the long sleeves of the *zupan* of printed brocade, buttoned up to the neck, worn underneath (Boucher, 1997: 247).

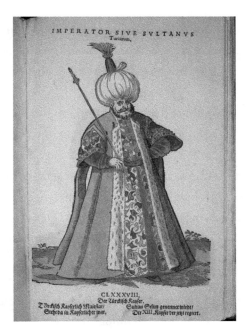

Figure 2.9 *Hans Weigel,* The Turkish Sultan. Habitus praecipuorum populorum. Trachtenbuch *(Costume Book). Nuremberg, 1577. Original manuscript in the collection of Trinity College, Cambridge. Reference I.II.33.*

The same layering is noticed in the Weigel image complemented by a magnificent pumpkin-shaped turban consisting of a tall headgear, the *külah* topped by a decorative tuft, made of fine white linen fabric (*tülbent*) wrapped around it to create the pumpkin shape. As in the case of Maximilian II, the *secondary* or *conventional* subject matter level is provided by the title: this is the Turkish sultan.

At the *intrinsic meaning* or *content* level we learn his identity: this is Sultan Murad III. Examples of European representations of Turkish costume were already well known, starting with Gentile Bellini who was commissioned by the Venetian government in 1479 to go to Istanbul to paint a portrait of Mehmet II. Albrecht Dürer too made drawings of Turkish costumes he might have seen during his stay in Venice.

But we understand also that in representing not only the Turkish sultan but also a whole array of Turkish dignitaries, Weigel was motivated by political developments in Europe, although it is possible that some of his inspiration came from François Desprez's *Recueil de la diversité des habits*, dated 1562.

Weigel was not only interested in the ruling classes; he turned his attention to the everyday, representing images of ordinary people going about their business, which kept good company with a new category of painting focusing on the quotidian: genre.

In one such image we see at the *primary* or *natural* subject matter level the full-length figure of a French peasant woman represented from a three-quarter angle as she is striding to the right. On her right shoulder she carries a yoke, balancing at each end a wicker basket filled with vegetables and fish. Her outfit consists of a blouse with long sleeves and over it a sleeveless bodice and an ankle-long skirt and apron, flat walking shoes and a straw hat with a very wide brim. The Latin title 'Rustica mulier Gallica' is translated to German as 'Eine Beuerin in Franchreich'.

Where would Weigel have seen a French peasant woman? It seems logical though that she would be represented by the Frenchman Desprez, who would have drawn her 'from nature'; in fact comparison between Weigel's image and Desprez's counterpart reveal similarities such as the positioning of the full-length images of the peasant women seen from a three-quarter angle striding purposefully towards the right on a bare ground strewn with plants and

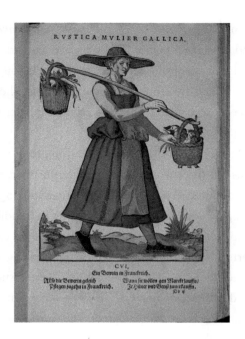

Figure 2.10 *Hans Weigel,* French Peasant Woman. Habitus praecipuorum populorum. Trachtenbuch *(Costume Book). Nuremberg, 1577. Original manuscript in the collection of Trinity College, Cambridge. Reference I.II.33.*

flowers. Both women carry rustic wicker baskets filled with food and although their outfits differ, the detailing of the main items is similar.

In both instances, the *secondary* or *conventional* subject matter level is provided by the titles: they are both French peasant women. But what is interesting is that at the *intrinsic meaning* or *content* level we reveal a communal source of inspiration both for Weigel and Desprez found in sixteenth-century northern European genre painting which became popular with a lesser known generation of Flemish and Dutch artists. They pioneered a new approach to the established iconographical norms in representations of religious paintings by reversing the order, so that the secular subject takes precedence over the religious one.

Both Pieter Aertsen and his nephew Joachim Beuckelaer were among the first painters to work in this new genre by abandoning the Italianate style dominating Netherlandish mannerism and casting off its pretensions to Italian grandeur.

In Pieter Aertsen's *Market with Christ and the Woman Taken in Adultery* at the *primary* or *natural* subject matter level we see in the foreground a market scene, whilst the religious subject is relegated to the background, where we see the biblical figures of the adulterous woman and Christ to her left, crouching to pick up a stone in accordance with the iconographical requirements of the story.

The male and female peasant figures in the foreground are divided into three groups: to the left three women; to the right one man and two women; whilst the centre is dominated by a crouching woman looking pensively at the wealth of good things spread at her feet – vegetables in bundles strewn on the ground or gathered in wicker baskets, attractively displayed to lure customers. If we compare Aertsen's peasant woman on the left wearing a large straw hat with Weigel's image, the similarities – including details such as the rustic wicker baskets filled with vegetables, eggs or fish – are remarkable.

At the *conventional* or *secondary* subject matter level, Pieter Aertsen's title leaves us in no doubt about its meaning which is also, albeit in a simplified

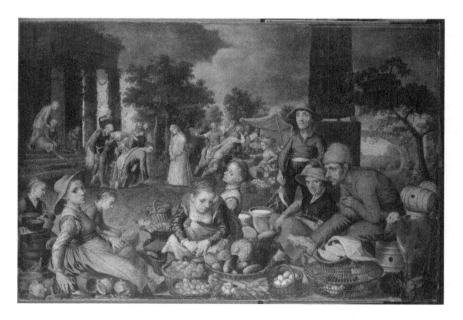

Figure 2.11 *Pieter Aertsen,* Market with Christ and the Woman Taken in Adultery, *1559. Oil on canvas, 88.8 × 180.7 cm. Image ID: 19895. Staedel Museum, Amsterdam.*

way, the case with Weigel's peasant woman. But what needs to be established is the source of their common interest in the everyday and the answer is revealed at the *intrinsic meaning* or *content* level.

Two important religious events dominated the sixteenth century: the first was Martin Luther's Reformation, triggered by his '95 Theses or Disputation on the Power of Indulgences'. On 31 October 1517, 'All Saints Eve', Martin Luther, a bad-tempered German professor of theology, nailed his 95 theses to the door of All Saints' Church of Wittenberg, thundering against the practice of the Catholic Church raising money by selling indulgences, and his actions led to the irreversible split between the Catholic and Protestant faiths. But the main reason for the success of the Lutheran revolt was that 'it appealed to the deepest devotional traditions of the Middle Ages, and it rode on a wave of religious revival which affected not just the scholars but the masses' (Davies, 1997: 482). One of its consequences was the Peasants' War (1522–3) against the land-owning aristocracy who suppressed the revolt by executing more than a hundred thousand peasants. But instead of support, Luther denounced them in a pamphlet titled 'Against the Murderous and Thieving Hordes of Peasants' (Davies, 1997: 485).

The second event was the Sack of Rome on 6 May 1527, when the army of the Holy Roman emperor, Charles V, marched on Rome and Pope Clement VII had to seek refuge in the fortress of Castel Sant'Angelo. As with the Peasants' War, the Sack of Rome was started from 'below' by the unpaid and hungry soldiers of the emperor – including the Swiss mercenaries, the 'Landsnecht' – who marched on Rome pillaging, looting and killing.

A 'populist' social order started to emerge which found expression in the *Picaresque* (the word is derived from the Spanish *picaro* meaning tramp) literary *genre*:

Vagabondage and beggars filled a large special space between the medieval forest outlaws and the regimented urban poor of the nineteenth century. It was spawned by the disintegration of hierarchical rural society, and encouraged by social policing that combined ferocious punishments with highly incompetent enforcement. Men and women took to the road in droves because they were unemployed, because they were fugitives

from justice, above all because they longed to escape the oppressive, dependent status of serfs and servants. The *picaro* was wild but free. (Davies, 1997: 535)

The visual artists too responded to the new zeitgeist and this is where genre belongs; in fact there is not much difference between 'the written text' of the picaresque novel and 'the illustrated or painted image' of the world of the disenfranchised who populated them and this explains why during the sixteenth century the artists and illustrators of costume books turned to the quotidian for inspiration.

Christoph Weiditz's 'Book of Costumes': *Trachtenbuch* 1560–80

A magnificent costume book seldom mentioned in specialized literature – Ulinka Rublack being the exception – that predates François Desprez's book as well as *Il Libro del Sarto* is the *Trachtenbuch* of Christoph Weiditz.

Weiditz was a trained form cutter and sculptor in Augsburg, where he settled in 1526 and met Narziss Renner (who was working for Matthäus Schwarz), but in 1529 he set off from Augsburg to meet the Holy Roman emperor. Weiditz produced 'no less than 154 water coloured pen drawings of ordinary people he saw, executed on heavy cardboard-like paper. They were put into sequence as well as cropped and bound together by a later owner. This manuscript is known as the Weiditz Book of Costumes, his *Trachtenbuch*' (Rublack, 2010: 13).

In connection with Weiditz, Rublack mentions another album in the Berlin Costume Library of the Freiherr zu Lipperheide which 'presents the largest compilation of clothing anyone had put together anywhere in the world until then', assembled between 1560 and 1580 by 'a Nuremberg official called Sigmund Heldt' (Rublack, 2010: 199).

Heldt's large quarto volume became a vast undertaking: a full 867 watercolour depictions were bound together on 506 sheets in expensive and artfully stamped leather. Larger than Vecellio's final edition, yet never printed, Heldt incorporated earlier depictions of Africans, Indians, Americans, Christianized

Muslims and Turks. The project culminated in an extensive depiction of Nuremberg dress and customs (Rublack, 2010: 199).

According to Rublack, Heldt's book, which has not been discussed in scholarly literature and only rarely used, provides an example of transculturation, that is, experiencing how another culture changes the way you think of your own. 'The manuscript evinced a conservative view, which affirmed that local customs should be preserved but nonetheless was informed by a sense of Nuremberg's cultural peculiarity. This perspective resulted from ethnographic knowledge' (Rublack, 2010: 200).

The list of subjects illustrated by Heldt starts from 'secular dignitaries', tournaments, carnival, dances at Nuremberg Town Hall, after which it moves to an extensive section (132 sheets) dealing with German female costume, with only 6 sheets representing Venetian costume. This is followed by 87 sheets representing images of Turkish, Polish, Russian, Greek, Moorish, African and Spanish dress, with the final hundred sheets (nos. 388 to 499) returning to Nuremberg dress and the last 43 focusing on peasant costume.

In its prologue, Heldt justified his undertaking as a wish to inform his readers with an added moral dimension, in keeping with sober tenets of Protestantism, whereby he wanted to display simple clothes to discourage lavish spending on expensive ones.

And there was good reason for Heldt's moralizing tone, as historian John Hale observed:

> Male attacks on female vanity – the use of cosmetics, tweezers and hair bleaches – were almost as old as Jezebel herself. But Leonardo da Vinci had both narcissistic men and women in mind when he wrote that 'among the simple-minded one single hair out of place presages to the wearer high disgrace . . . and such as these keep only a mirror and comb for their counsel and the wind in their principal enemy . . . Human folly ever increases'. His own interest in hair and head-dress styles and costumes was acute, as was that of his contemporary Dürer, who annotated his costume drawings as to where and when he had drawn them. (Hale, 1991: 481)

Hale's comments are of special interest for another reason, namely it is very unusual for an historian of his reputation to turn his attention to costume

books, but as we know, he had a precedent in another distinguished scholar, Fritz Saxl, who turned his attention to *Il Libro del Sarto*.

Books of costume like Weiditz's *Trachtenbuch* could be classified as ethnographical or anthropological, rather than historical, and in this respect John Hale's interest in books of costume makes it even more unusual. We find him introducing another costume book by Jost Amman, his *Theatrum Mulierum*, dated 1580, in a charming way:

> there was something of the choreographer's interest in local customs here, but increased travel and travel literature, and the circulation of tailors' guides to the making of foreign styles, all fostered an interest in fashion for its own sake. It was not just an abstract anthropological fascination that led to the adoption in court entertainments of exotic costumes or to translations of such works as Jost Amman's *Theatrum Mulierum* of 1580. (Hale, 1991: 480–1)

Thus Hale provided us with the *intrinsic meaning* or *content* level for Weiditz's costume book, arguing that it acted as a political, social and economic barometer of its time, through the representation of various peoples, their manners and mores but especially clothes, as an important 'signifier' of their social identity.

> Everywhere in courts and cities fashion drew attention to changing aspirations and enhanced an awareness of social distinctions. Even when an adopted style was sober, as in the case of the rich gravity of Spanish noble attire, the gap was emphasized by the wardrobes of the well-off and the standardized work clothes of the poor whose single holiday outfits, however lovingly and carefully made, retained almost unfaltering regional tradition. In times of reasonable prosperity, distinctions of rank, even when more complexly orchestrated through cut and colour, aroused moral outrage rather than social resentment. (Hale, 1991: 482)

The first modern edition of *Das Trachtenbuch des Christoph Weiditz* (with an introduction by Dr Theodor Hampe, translated also into English) was published in 1927, and it began with an overview of the earliest costume books such as 'the dancing bridal couples of Aldegrever or Hans Leohard Schaeufelein and others', and Matthäus and Veit Konrad Schwarz, he called

'the Augsburg dandies', who 'had always had their picture taken every time a new fashion came up and many more' (p. 57).

Next, François Desprez's *Recueil de la divertisé des habits: qui sont de present en usage, tant en pays d'Europe, Asie, Affrique & Isles sauvages, le tout fait après le naturel*, published in 1562, is introduced as 'the oldest real costume book', followed by Ferdinando Bertelli's *Omnium feregentium nostrae aetatis habitus, nunqueam ante hac aediti* published in Venice in 1563.

> Then Hampe tells us how he discovered Christoph Weiditz's *Trachtenbuch*, here introduced for the first time to the literature of the elder costume works, which can be designated as the earliest of these. It is a modest quarto volume which was presented by Dr Johann N. Egger – district physician in Freyun near Passau on the Bavarian Austrian border – on April 14, 1868 to the library of the German National Museum of Nuremberg. (Hale, 1991: 482)

The book consists of 154 pages of heavy cardboard-like paper with a width of about 150 cm and a length of 198–200 cm, whose sheets might have been bound in their current format at a later date, as well as a variety of costumes 'of the better and lower classes, folk types and scenes from the public and home life especially of Spain, but also Netherlands, Italy and France, and furthermore by way of example or comparison of Germany, England, Ireland and Portugal. The pictures are pen drawings boldly executed water-coloured and in part with raised gold and silver lines' (Hale, 1991: 482).

Until this remarkable discovery in 1925, the book attracted no attention until Georg Habich identified it as being the work of prominent goldsmith Christoph Weiditz. Theodor Hampe also provides a speculative explanation as to how this pioneering book came into being:

> In my opinion the costume book came into existence in the following manner: From his Spanish trip in 1529, and also at the end of 1530 and beginning of 1531, after he had, as we must assume from the medallions made at that time followed the Kaiser to the Netherlands, Christoph Weiditz brought well filled sketchbooks back to Augsburg. On the different sheets he wrote hasty inscriptions or explanations readable by other persons with difficulty and he may possibly also have indicated at first by brief notes the colours he used. (Hampe, 1927: 61–2)

76 *Images on the Page*

Sigmund Heldt's book may not have been hitherto discussed in scholarly literature, but we cannot ignore the fact that Theodor Hampe gives it extensive coverage in connection with his argument that Weiditz was drawing from nature and with few exceptions 'all of the representations have no counter part either in older or later literature and art. Hence they must be all Christoph Weiditz's creation' (Hampe, 1927: 72). Heldt then used Weiditz's drawings from nature – argued Hampe – and he was in fact able to identify such examples in the 'so called Heldt costume book', such as 'a codex which Sigmund Hagelsheimer known by the name of Heldt, had caused to be collected in Nuremberg about the middle of sixteenth century and which is today in the Costume Library of Baron von Lipperheide in the State Art Library in Berlin' (Hampe, 1927: 72).

In the second part of his introduction (pp. 76–162) Hampe provided a page-for-page comparison between Weiditz's and Heldt's costume books giving examples, such as the former 's representations of Indians (plates XI–XXIII), which, with the exception of the first picture showing Indians at a game of throwing and catching (XI, XII) and the last sheet of the series (XXIII), have their counterpart in the Heldt book. Hampe's comparisons are made by using texts, as he had no images available. But in a note (nr. 11, p. 72) he informs us that an entry of the Heldt costume book, first published in Berlin between 1896 and 1901, exists in the catalogue of the Lipperheide Costume Library, and on pages 5ff. the dates 1548, 1550, 1560, 1564, 1565, up to 1580 are listed, suggesting that the catalogue was published between 1560 and 1580.

The first image in Christoph Weiditz's *Trachtenbuch* represents Ferdinand Cortez who brought the Indians to His Imperial Majesty 'from India' and therefore, Hampe argued, Weiditz himself would have observed 'these wild people and their activities and games at the court of the Emperor' he pictured and they became the model for Heldt's representations:

> For it goes without saying that Heldt, when he made the plans for his comprehensive costume book reached out feelers in all directions. This is shown, among other things by the close relationship of Heldt to the great Frankfurt publisher Sigmund Feyerabend. Unfortunately we know nothing whatsoever about the earlier history of the Weiditz costume book. It is possible that his precise work was very well received in interested circles

and it is very probable that the sheets were sold shortly after his death in 1559. (Hampe, 1927: 73)

Weiditz's decision to incorporate in 1528 the 'wild' Americans brought to Spain by Cortez in his *Trachtenbuch* complied with the European appetite for things exotic and that did not only include human beings; we need only think of the wonderful paintings of Giovanni Mansueti and Gentile Bellini filled with exotic animals. But what is unusual is that Weiditz's images have nothing to do with clothes and would have fitted better in an ethnographic book.

Andrea McKenzie Satterfield, in her MA thesis (2007) titled 'The Assimilation of the Marvelous Other: Reading Christoph Weiditz's Trachtenbuch (1529) as an Ethnographic Document', proposes just that: we should consider the images 'as a visual ethnographic collection' and by choosing to present the American natives as court performers and by not dressing them in European attire in order to assimilate them, the emperor aimed to 'neutralize' them (Satterfield, 2007: VIII).

But I argue that the opposite is the case, because by leaving them as they are, their 'otherness' becomes even more apparent; had they been dressed like court servants, that would have been the attempt to 'neutralize' them, although their Aztec features and demeanour could not be altered.

My argument is supported by Hampe himself who stated that Weiditz had first-hand experience of the indigenous Americans brought to Spain by Cortez and was able to observe 'these wild people and their activities and games at the court of the Emperor, whose lively interest and care for the Indians was often apparent', and Weiditz then pictured them, 'pointing out their consideration and "care" for them' (Hampe, 1927: 73).

A special category of outsiders in Spain were the Moriscos – whose status approximate that of the immigrants of our times – repeatedly depicted by Weiditz (found in Heldt as well), given that when he was working on his book, Granada was the only town where the Moriscos were allowed to preserve their old way of life and dress,

but even here women had long since been compelled to abandon the traditional face covering worn on the streets and had substituted for it a broad mantle with which it was possible for them to cover their faces

almost entirely. This left numerous traces in the costume pictures of sixteenth century and later. As early as the time of Ferdinand and Isabella the Moriscos who refused to be converted to Christianity had been treated with severe repressive measures, and around the year 1530 it was only in Granada that such a deep insight could be gained into the life of these last remnants of the old Moorish population such as is documented both in the Weiditz and the Heldt costume books. (Hampe, 1927: 73)

Weiditz's description reads: 'The Morisco women look like this in the streets of Granada'. At the *primary* or *natural* subject matter level we see the Morisco woman wearing a silver-embossed white mantle with grey fringes, revealing the gold-embossed half-yellow and half-blue undergarment with golden buttons, complemented by silver-embossed red stockings. But as they were forbidden to wear face veils (*niqab*), they resorted to using their mantles to cover their faces

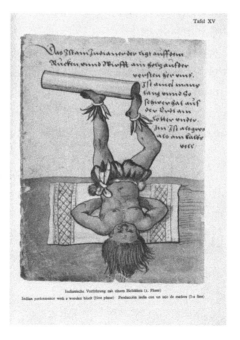

Figure 2.12 *Christoph Weiditz, (a)* Performance with a wooden block, *(b)* Indian and his defense. Trachtenbuch, *1529. Theodor Hampe (ed.), Das Trachtenbuch des Christoph Weiditz und seinen reisen nach Spanien (1529) und den Niederlanden (1531–2). Berlin und Leipzig, 1927, Verlag von Walter de Gruyter & Co.*

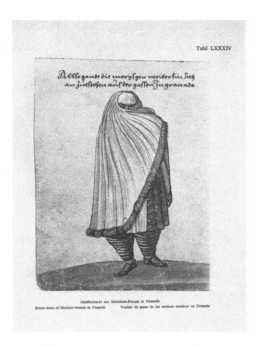

Figure 2.13 *Christoph Weiditz*, Morisco women. Trachtenbuch, *1529. Theodor Hampe (ed.), Das* Trachtenbuch des Christoph Weiditz und seinen reisen nach Spanien *(1529)* und den Niederlanden *(1531–2). Berlin und Leipzig, 1927, Verlag von Walter de Gruyter & Co.*

and this identified them on the streets of Granada as Moriscos. It was this simple act of covering their faces, which provides the *secondary* or *conventional* subject matter level: 'Morisco women in Granada'. But the full explanation is provided at the *intrinsic meaning* or *content* level, and so we turn to history.

In 1469 the rival kingdoms of Castilla and Aragon were united through the marriage of the 'Catholic Monarchs' Ferdinand II of Aragon and Isabella I of Castilla, and in 1476 she set up the Holy Brotherhood, followed in 1483 by the Holy Inquisition, under the presidency of the Queen's Confessor, the formidable Thomas Torquemada. 'Henceforth, treason and heresy were virtually indistinguishable. Non-conformers, Jews, and dissidents were rigorously persecuted. The further existence of the emirate of Granada could not be tolerated' (Davies, 1997: 453).

After the conquest of Granada in 1492, the Jews and the Muslims were given the choice of converting to Christianity or exile. Those who remained

became 'conversos' or 'moriscos' but they paid the price: their synagogues and mosques were either destroyed or converted into churches, and their way of life including their way of dress had to change.

In 1526 Carlos I issued a degree forbidding the use of the Arabic language and the wearing of Muslim dress. And what Christoph Weiditz captured when he represented the Morisco women on the streets of Granada was their resourcefulness in trying to preserve their ethnic identity.

Weiditz did not only represent Morisco women at play but also at work as in the example (Figure 2.14) of a Morisco woman with the subtitle 'In this manner the Morisco women spin in their houses in Granada'. She is wearing a green-and-white head cloth under a blue-and-white band, a brownish vest, white silver-embossed jacket and matching trousers, and the distinct blue stockings, and she is barefooted. In her left hand she holds the distaff, and a spindle in her right hand.

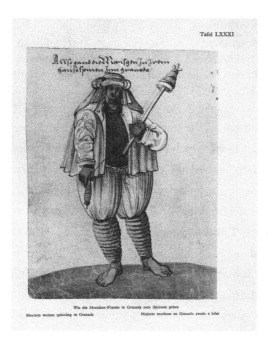

Figure 2.14 *Christoph Weiditz*, Morisco woman spinning. Trachtenbuch, *1529. Theodor Hampe (ed.)*, Das Trachtenbuch des Christoph Weiditz und seinen reisen nach Spanien *(1529)* und den Niederlanden *(1531–2). Berlin und Leipzig, 1927, Verlag von Walter de Gruyter & Co.*

The Morisco woman appears also in Heldt except that her body is naked under the vest and Hampe argues that Weiditz's Morisco women were the source of inspiration for Heldt's representations. But in this instance Weiditz did not draw them 'from nature' either because – Hampe argued – it is doubtful that he visited Granada, although 'in the costuming of his Morisco woman with an undergarment resembling a vest' 'he comes closer to reality than Heldt' (Hampe, 1927: 74).

How then were Weiditz and Heldt able to represent their Moriscos? At this point, Hampe makes an ingenious suggestion:

> I am inclined to assume that both men, Weiditz and Heldt independent of each other drew their material from the same source, which is concealed from us today but perhaps was easily available in those days or in any event if Heldt was also dependent on Weiditz the latter's representations were not based upon studies of the subject but upon an older and possibly Spanish pattern. (Hampe, 1927: 74)

Be that as it may, the story does not stop here for we encounter Morisco women in other publications which provide evidence about the way images 'travelled' from author to author, or to put it bluntly, how authors purloined images from each other. And so, we find our Morisco woman spinning in Cesare Vecellio's 1589 edition of his *Habiti Antichi et Moderni* under the title 'Donzella di Granata', who provides the *primary* or *natural* subject matter level, describing what the young woman from Granada, who was nude from waist up, was wearing:

> As a headdress they wear a circle of wood or copper padded all around with cotton, holding in place a piece of wool or linen which they wear on their heads and which falls down to their shoulders. Under this piece of wool or linen they wear a short, thigh-length cape, open in front and trimmed along the hem with embroidered hands of another type and colour of cloth. Then they wear a pair of white *braghesse* or trousers of linen or wool, very snug, which they tie to their belts. They wrap their legs with bands, as we do with children. And because they are poor, they go about in this fashion spinning. (Rosenthal and Jones, 2008: 292)

Another link can also be established not only between Sigmund Heldt and the Frankfurt publisher Sigmund Feyerabend but also between Feyerabend with Jost Amman and Hans Weigel (Hampe, 1927: 73).

Two plates from Weigel are of special interest: the first (Figure 2.15) with the title 'Mauritana in Betica sive Granatensi regno', where the young woman wears a pleated pink mantle reaching to her knees covering part of her face, and underneath a green dress complemented by the characteristic ethnic stockings, which is closely linked to Weiditz's own representation of a Morisco woman hiding her face, although the colours of their garments differ.

Another representation, titled 'Mauretana in domestico vestita betica sive Granatensis', depicts the young woman – accompanied by a little girl, perhaps her daughter – spinning. She wears the same special stockings and separate breeches, whilst her *mantelet* opens in front to reveal her bare breasts. In this

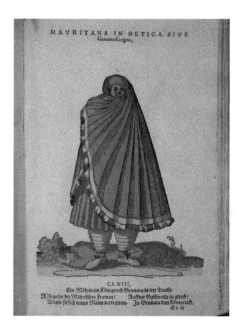

Figure 2.15 *Hans Weigel*, Morisco woman. Habitus praecipuorum populorum. Trachtenbuch *(Costume Book). Nuremberg, 1577. Original manuscript in the collection of Trinity College, Cambridge, Reference I.II.33.*

respect she resembles Heldt's representation of a spinning Morisco woman with bare breasts, which differs from Weiditz who represents her fully dressed.

The Morisco woman turns up again in Jost Amman's *Gynaeceum* (1586), whose awesome full title is *The Theatre of Women wherein may be seen the female costumes of all the principal nations, tribes, and peoples of Europe, of whatsoever rank, order, estate, condition, profession or age with new and most exquisite figures unequalled hitherto for beauty. Designed by Jobst Ammon, published in Frankfurt by Sigismund Feyerbend in 1586.*

Its first facsimile edition was published in 1872 by the Holbein Society's Facsimile Reprints as *The Theatre of Women designed by Jobst Ammon*; edited by Alfred Aspland, published for the Holbein Society by A. Brothers, Manchester, and Trübner & Co., London.

The book consists of 122 illustrations starting at the top of the hierarchical pyramid with an empress, followed by queens, women of high rank, among them (nr. 8) 'A maiden of the illustrious family of the Fuggers', who is represented with long tresses falling on her back, a low-cut *décolletage* holding in her hand the distinct Venetian fan.

Curiously, we find an identical representation of our lady again in the same book, this time introduced as 'Veneta Sposa Patricia' (nr. 62). How can this be explained? On the one hand, a member of a distinguished German family, the Fuggers, on the other a married Venetian lady. We have no explanation, but the latter version is more credible because of her typical Venetian fan.

The images progress from Western Europe towards the East, and after having visited Prague, Bohemia and Russia, Amman takes us to Turkey where we find an image representing Camilla, the daughter of the Turkish sultan introduced as 'Camilla Turcici impetratoris filia' (nr. 112) subsequently painted by Titian.

Cesare Vecellio's *Degli habiti antichi e moderni*

The two best known Renaissance books of costume are Cesare Vecellio's *Degli habiti antichi e moderni* and Matthäus Schwarz's *Klaidungsbuchlein* or the *Trachtenbuch* (hereinafter referred to as *The First Book of Fashion* following its first translation and publication with this title). But the important difference

between them, reflected also by their titles, is that the former belongs to the category of Renaissance tailors and costume books, whilst the latter is unique and may be best described as a visual diary.

Cesare Vecellio was a trained painter and printer, but the 428 woodcuts used in the first edition published 1590 and 503 woodcuts used in the second edition dated 1598, were executed after Vecellio's drawings by the Nuremberg woodcutter Christoph Chrieger (Rosenthal and Jones, 2008: 14).

What was radical about Vecellio's book was his coverage of costume investigated both diachronically going back to the Old Testament and synchronically, by covering the whole of Europe and beyond, as far as, in the second edition, the Americas.

Vecellio offers more information about nearby and faraway costume and custom than any of the dozen costume books published before his. He promises that the labour and art he has devoted to collecting the images will delight readers curious about the diversity of dress and culture, from Italy to the farthest reaches of the known world (Rosenthal and Jones, 2008: 20).

Although the general consensus is that François Desprez's *Recueil*, first published in 1562, is 'the oldest real costume book', it can be argued that Vecellio's book is the first modern history of costume, and in this respect we find a parallel in Giorgio Vasari's first modern history of art published in 1550. First, both relied on similar methodologies based on personal observation for the present, and visual and written primary and secondary sources for the past.

Secondly, both Vecellio and Vasari worked closely with painters and both had special relationships with Titian: the former as his cousin, the latter as his close friend, as the following example proves. Titian was commissioned by Suleiman the Magnificent to paint his wife (hurrem) Roxolana (Sultana Rossa) and their daughter Mihrimah (Cameria), and in the 'Life of Titian' Vasari writes about it:

By the same hand are M. Niccolo Zono, la Rossa, wife of the grand Turk, aged sixteen, and Cameria her daughter with beautiful dresses and hair (in the original: con abiti et acconciature bellissime). (Gaunt, 1963: 210)

Cameria also makes an appearance in Vecellio's book under the title 'Favorita del turco', but there is no mention of her identity.

As for the clothing of the sultan's favourite, we must imagine that the gold and purple she wears pale by comparison to the pearls and jewels that adorn such a lady. Her *cidari* is very high, with very beautiful trim and a thin veil that falls from its peak to the ground. In her apparel she wears whatever colours she fancies. (Rosenthal and Jones, 2008: 444)

In another image, titled 'Donna turca in casa', Vecellio makes the specific comment that Turkish women 'usually dress like men':

Their overgowns are long, open down the front and buttoned down to the belt with gold or crystal buttons. There is no set colour for their garments, they wear every colour except black. They wear *braghesse* or trousers of *ormesino* or *sessa*. They sit barefoot, keeping their little *pianelle* near them. (Rosenthal and Jones, 2008: 389)

In both examples Vecellio's description provides the *primary* or *natural* subject matter level, whilst the titles provide the *secondary* or *conventional* subject matter. But it is the *intrinsic meaning* or *content* which explains Vecellio's special interest in Turkish dress.

The Ottoman way of dressing was not well known in Western Europe and even less in the case of women, given that the sultan's harem was inaccessible even to distinguished visitors such as Nicolas de Nicolay who accompanied the French ambassador in 1551 to the Court of Suleiman the Magnificent.

The similarity of dress between men and women did not apply only to trousers (*shalwars*), described by Vecellio as 'very rich, especially around the bottom, which some of them have trimmed with jewels' (Rosenthal and Jones, 2008: 389), but to other items of clothing, seen in the sketches published by Nicolas de Nicolay in his four-volume tome *Travels in Turkey* (1551).

But the justification regarding the similarity of dress between sexes was determined by the historical and cultural context of the Ottoman Empire, as we learn at the *intrinsic meaning* or *content* level.

During the tenth century, the Central Asian Turkic tribes were 'nomadic horsemen who had evolved on the grassland steppes and whose way of life was based on animal husbandry, rudimentary trade and the sacking of cities' (Rieff-Anawalt, 2007: 55). They embarked on conquering new lands and by 1453 one of its tribes, the Ottomans, conquered Constantinople, bringing

with them their own way of dress – which replaced the typical Eastern Mediterranean, ankle-length, body-encasing *dalmatic* – with 'loose-fitting, baggy pants together with a separate top that wrapped around the upper torso with the right side over the left' (Rieff-Anawalt, 2007: 55).

The reason why both men and women wore trousers was therefore grounded in the nomadic way of life of the Turkic tribes:

> In the Eastern Mediterranean, baggy pants were and are worn by both men and women. Varying greatly in size and cut, some extend clear to the ankle, others only to the knee; some have close-fitting legs, others are shaped into wide, voluminous pantaloons. All types of baggy pants are gathered into folds at the waist by a drawstring. (Rieff-Anawalt, 2007: 55)

Information regarding sixteenth-century Turkish women's costume is sparse, although it is possible to form an idea about an Ottoman 'look' from surviving visual and written records, and an important example of *primary* or *natural* subject matter level is found in the following description:

> Records for Ottoman women's costume are not complete for this period; however a general sense can be gained through the remaining visual and material records. Ottoman women's dress was based around layers of garments worn one on top of another, typically cut in such a way that the individual layers were partially revealed. It included a foundation garment made from filmy material, typically with a round neck, loose trousers gathered at the ankle, and one or more over-garments, commonly made of colourful patterned silks, velvets or brocades. A headdress usually shown as a tall pointed hat or a pillbox hat with an attached veil, covered the head. Veils draped over the headdress concealed the face when going out of doors. (Madar, 2011: 14)

As painter of the European elite, Titian was reported by Vasari to have been commissioned by Suleiman the Magnificent to paint his wife and their daughter (both known only from copies).

Titian never visited Istanbul and therefore his portraits were either fictitious or, more likely (as this was common practice during the Renaissance), the sultan sent Titian miniatures of his two ladies. The extant copies of Titian's

original portraits of Cameria and Roxolana (in the collection of the Courtauld Gallery and the collection of the John and Mable Ringling Museum of Art, State Museum of Florida, respectively) in turn, provided the model for Vecellio's woodcuts.

Titian's portraits featured richly dressed women and Vasari's comment underlines the special role of their attire. Both women wear tall, pointed cloth hats with long veils attached, and in the example of Mihrimah, complemented by an elaborate aigrette placed frontally on her hat. Both women wear layered clothing: in the case of Sultana Rossa the underdress is clearly visible, over which she is wearing a heavier overdress. The pink flower on her chest, possibly a rose, may have been intended as a play on her name and the marten perched on her arm suggests her status (Madar, 2011).

Vecellio's interest in 'things Turkish' was not restricted to attire, for he provided an informed overview of their history going back to 'a certain Osman, a ferocious man' who led the Ottomans (one of the four tribes Vecellio calls 'families') from the Middle East. The Ottomans settled in Asia Minor and Osman's son Orcan (Sultan Orhan Gazi) became the founder of the Turkish Empire, but almost a century separates him from the Ottoman conquest of Constantinople. Vecellio is vague regarding the period of the Turkish costume plates he reproduced, but judging by the image of Sultan Murat III, they would belong to his time:

It is impressive to say or imagine how very rich and more than beautiful the clothing of this Great Lord is. As far as colour is concerned, he appears now in one, now in another. Still I will say what he usually wears: a *dulimano* (loose formal overgown) of gold and a *sottana* of velvet, in whatever colour he prefers. He wears many *broccatelli* and other kinds of silk, such as *zendado* and very often white satin woven with silver. The sleeves of all his gowns are made of the same fabric as the body of the gown. On his head he always wears a turban of very beautiful *sessa* and when he goes out, he wears two feathers in it, one of each side, laden with pearls and jewels. He wears buttons of heavy gold and adamant. He wears short boots and always rides a horse equipped with a rein and bridle, as suits a man of his stature. (Rosenthal and Jones, 2008: 177)

Vecellio's oral sources would have come from travellers' accounts and costume books – as the Morisco woman he called *Donzella di Granata* (An unmarried Girl of Spanish Granada) was very likely purloined from Christoph Weiditz – as well as written sources, but above all from visual artists.

In a remarkable book published in 1581 titled *Venetia città nobilissima et singolare,* its author Francesco Sansovino undertook to write a compendium of Venetian history covering everything considered 'worthy of committing to memory': the lives of dignitaries and writers, descriptions of its churches, buildings, public and private palaces, rules and regulations as well as attire, old and new 'gli habiti antichi et moderni'.

Indeed, by the time Sansovino was writing the book, Venice had become a noble, but above all, a singular city, as a paradigm of multiculturalism, and the most unmediated way of representing 'otherness' at a visual level was attire. We find the exotic wearers depicted in the Quattrocento narrative paintings of Gentile Bellini, Giovanni Mansueti and Vittore Carpaccio, who would have witnessed events such as the siege of Venice by Ottoman Turks led by Sultan Bayezid in 1499, recorded by the humanist and philosopher Pietro Bembo in his *History of Venice:*

> He (Bayezid) was incensed at the Republic for a number of reasons, but chiefly because Niccolò Pesaro, the *provveditore* (superintendent) of the Venetian fleet, had at the end of the previous summer sunk in the Aegean a merchant ship of the sultan's commanders – known to them as 'pashas'. (Bembo in Blake de Maria, 2010: 18–19)

Giorgio Vasari noticed this Venetian particularity in his 'Lives', and dedicated two chapters to Venetian Quattrocento painting: 'Vita di Jacopo, Giovanni e Gentile Bellini' and 'Vita di Vittore Scarpaccia et altri pittori' (Vasari, 1550, 1997: 456–61 and 538–42).

In the former Vasari mentions Gentile Bellini's monumental *St. Mark Preaching in Alexandria* (he mistakenly attributed it to Giovanni Mansueti) describing the motley audience gathered to listen to St. Mark as 'the multitude of men and women who were listening to him: Turks, Greeks and other people of diverse nations dressed in extravagant attire' (*la moltitudine degli uomini é dell done che l'ascoltano, turchi, greci é altri'uomini di diverse nationi con abiti*

stravaganti) (Vasari 1550, 1997: 543). And it was through such 'extravagant attire' that Gentile represented cosmopolitan Alexandria, which he never visited but got his inspiration from Bernhard von Breydenbach's *Peregrinatio in terram sanctam* (illustrated with woodcuts by Erhard Reuwick and published in Mainz in 1486), from which he took the architectural elements, identified as being from Istanbul, not Alexandria:

> the obelisk with pseudo-hieroglyphs and the Column of Diocletian also known as the Pillar of Pompey. The church is composite: St. Mark's Basilica in Venice, Church of Holy Apostles in Constantinople alluding also to the Boucolis church in Alexandria funded by St. Mark. Gentile also made reference to Islamic architecture such as the minarets of the Ibn Tilun Mosque in Cairo with an exterior staircase and the tower of Bab Zuwayla. There are also other minarets and houses with small windows typical of Syro-Egyptian buildings. Finally: the symbol of Alexandria, the Pharos lighthouse was incorporated. (Schmidt Arcangeli in Stefano Carboni, 2007: 129)

Vecellio's book can also be linked to the new interest in non-European dress, which emerged during the middle of the sixteenth century, although representations of exotic costume in painting preceded costume books by at least one century. Thus we know that Vecellio would have been familiar with the Quattrocento Venetian narrative paintings of Gentile and Giovanni Bellini, Giovanni Mansueti and Vittore Carpaccio as he mentions Luigi Vivarino, Vittore Scarpa (Carpaccio) and Giovanni Bellini as examples (Rosenthal and Jones, 2008: 23).

François Desprez too capitalized on this new interest and, in collaboration with Richard Breton, published in Paris in 1562 his *Recueil de la diversité des Habits qui sont des present en usage tant en Pays d'Europe, Asie, Afrique, et isles sauvages.*

His book consisting of 121 woodcuts accompanied by quatrains, represented the foremost personalities of his time as well as the ordinary citizens of Paris, e.g. 'the old citizen' or 'the knight of the order of the gentleman'. Foreigners were also included: 'the Englishwoman' or 'the Italian Woman', to which Desprez added a colourful category of 'strangeness and exoticism' such as monkeys and Cyclops. The images were very likely based on stereotyped descriptions

from travellers' tales such as the Englishwoman's hat: 'See how her square cap is lined with furs/She is still easy to recognize/Though we can hardly see into it/so great is her size' (Roche, 1994: 13).

But unlike Desprez, Vecellio's approach was that of the historian, and his descriptions included not only attire but also a wealth of information about the social position, occupation, profession and lifestyle of the wearer. A special example is Vecellio's thorough knowledge regarding the position of women in Venetian society, starting with the way they dressed. For example, an aristocratic young woman was not allowed to leave the house, even when going to church without being veiled. But as times were changing, a new practice allowed chaperoned visits between future spouses, although their faces were still veiled. After signing the marriage contract the bride could reveal her face and Vecellio makes a humorous remark about her hair, blonde either through nature or 'through the exquisite diligence of art', 'spread loose over her shoulders, interlaced with golden filaments, and adorned with a circlet of jewelled gold or toward the end of the century, a tiara' (Deborah L. Krohn in Andrea Bayer, 2008: 146).

Nor was Vecellio's research confined to his native Venice, for he made it his business to write about the whole of Italy reporting from the princely courts of Mantua, Milan and Ferrara and their fashionable way of life and attire. Vecellio's work continues to provide a unique visual and written source for our understanding of costume and the role it played during the Renaissance.

Matthäus Schwarz's *Klaidungsbüchlein* or the *Trachtenbuch* (1520–60)

A unique book came into being during the first half of the sixteenth century: Matthäus Schwarz's *Klaidungsbüchlein* or *Trachtenbuch*, translated and published (in 2015) as *The First Book of Fashion*. It was started by Schwarz in 1520 when he was twenty-three years old and had just secured the job of head accountant working for the Fugger merchant bank in Augsburg, and it ended by commemorating the death of his beloved patron Herr Annthoni Fugger on 14 September 1560. But this was by no means the end because Schwarz

convinced his son to continue the project, and so *The Book of Clothes of Veit Konrad Schwarz* was started in 1561 and in its prologue we find: 'Date, Augsburg, the other day of January in the year 1561 at two o'clock in the afternoon' (Rublack and Hayward, 2015: 352). But Veit Konrad soon lost interest and the last image in the book, in which we see him with two friends learning the art of sword fighting, is dated 13 March 1561 (Rublack and Hayward, 2015: 371).

What prompted Matthäus Schwarz to start so unusual a project? His childhood ambition had been to write an autobiography and fifteen years later when he became chief accountant with the Fugger bank he started it: *The Way of the World*. The project, which has not survived, was complemented by watercolours of himself in various outfits:

> A more narcissistic project can hardly be imagined. This brilliant mind, this confidant of one of the most powerful men of his time, led a full life yet deliberately chose to indulge himself by concentrating his attention on appearances and frivolities. Having achieved success, the adult cast an eye back on his childhood. His sentimental and mordant commentary suggests what feelings the men of the Renaissance, after generations of self-absorbed literature, harboured towards their youth. (Braunstein in Ariès and Duby, 1988: 556)

But Matthäus Schwarz was not in the least concerned with the public; his concern was only with himself and his clothes,

> commissioned by him for various occasions: birthdays, marriages, holidays. Schwarz compares contemporary fashions with those of earlier generations; he was probably the first historian of clothing, with a keen eye for both change and cyclic repetition. He turns a simple catalogue of clothing into a veritable chronicle of private life, tracing his own history back to his earliest memories – 'as in a fog' – at age four and even beyond, back to his swaddling clothes, his 'first clothing' in this world, and his mother's womb ('in which I lay hidden'). (Bernstein in Ariès and Duby, 1988: 580)

And this is what makes the book unique because unlike every Renaissance costume and tailors' book, it was never meant for public consumption and it remained in the possession of the Schwarz family.

After Matthäus' death in 1574, the book was inherited by his daughter Barbara, who continued to live in the family house with her mother Magdalena

and brother Veit Konrad, until the death of her mother in 1581/2 and that of Veit Konrad in 1587/8. Her descendants sold it in 1658 to Duke August the Younger of Brunswick, who acquired it for his library. In 1704, Sophie Electress of Hanover requested the Schwarz manuscript and asked her scribe J. B. Knoche to make two copies. She kept one and the other was sent to Versailles to her niece Elizabeth Charlotte of Orleans. The two copies are now preserved in the Bibliothèque Nationale in Paris and the Gottfried Wilhelm Leibniz Bibliothek in Hanover, respectively, whilst the original survives in the possession of the Herzog Anton Ulrich Museum in Brunswick. 'The manuscript is so fragile that it is very rarely shown to scholars, and if it is shown, it is only by two trained curators, who carefully and slowly turn each page' (Rublack and Hayward, 2015: 22).

The wondrous project was the result of the collaboration between Matthäus Schwarz and illuminator Narziss Renner, who had probably been trained locally by his father, and, as we have seen, began to work for Schwarz in 1521 but 'he died after the plague hit Augsburg, in 1536, when Schwarz was thirty-nine' (Rublack and Hayward, 2015: 20). Between 1538 and 1546 Schwarz inaugurated a new collaboration with fashionable portrait painter Christoph Amberger. The final result cannot be classified as a costume book; instead we have an intimate account of the lives of a father and son, who lived during the sixteenth century in Augsburg and chose to tell their story through clothes.

The First Book of Fashion was little known until recently and for that reason there is no mention of it in François Boucher's *A History of Costume in the West* when it was first published in 1965, but we find it mentioned by James Laver in *A Concise History of Costume*, which was first published in 1969. The image selected represents Matthäus Schwarz seated at his desk in his office, whilst his boss, Jacob Fugger 'the Rich', stands opposite him. The caption reads: 'Jacob Fugger "the Rich" the Emperor's banker, with Matthäus Schwarz, his chief accountant, 1519' (Laver, 1969: 76, fig. 73).

He calls the watercolour 'a miniature' and gives its correct location: 'Brunswick, Herzog Anton Ulrich-Museum', but there is no mention of the book to which it belongs and the reason could be that even in 1969 *The First Book of Fashion* was only known in specialized circles.

The Herzog Anton Ulrich Museum in Brunswick – the Art Museum of the State of Lower Saxony – is one of the oldest museums in the world and among

its treasures, *The First Book of Fashion* of Matthäus and Veit Schwarz is kept in the Prints and Drawings Cabinet. But it was only as recently as 2015, when Ulinka Rublack's and Maria Hayward's excellent book was published, that this veritable treasure trove was made public. In fact, Rublack had already introduced *The First Book of Fashion* in her earlier book, already referenced, *Dressing Up: Cultural Identity in Renaissance Europe* (2010) in which Chapter 2 'Looking at the Self' is dedicated to it. In its prologue, Rublack explains that what makes this book unique is its adoption of a new perspective of looking at Renaissance attire, 'by considering people's appearance: what they wore, how this made them move, what images they created of their looks, and how all this shaped men and women's identities. It rediscovers appearances as part of a rich symbolic world capable of transmitting compact information that people responded to, misunderstood, had fun with, or fought over' (Rublack, 2010: Prologue).

And this is indeed the perspective from which the book should be understood and what better way to begin than with the most startling image on offer:

> In 1526, the head accountant of the mighty Fugger merchant company in Augsburg was a man called Matthäus Schwarz. Schwarz was a successful 29 years old. He had trained in Venice, written about double entry book keeping and had worked with Jakob Fugger, one of the most wealthy and influential people of his time. On the first of July, Matthäus Schwarz took off his jewellery, weapons and clothes. His doublet was unlaced, which held up his hose. He took off his shirt and his under-drawers and posed for two small water-colour paintings. A 19 year old aspiring miniaturist called Narziss Renner dipped his brushes into water and paint to depict Schwarz first from the back, then from the front, on precious parchment paper. (Rublack, 2010: 32)

The fact that we see two images of a male nude represented from front and back is not that startling in itself; after all the Renaissance is full of sculptures of male nude figures, none more awesome than Michelangelo's *David* commissioned barely two decades earlier, in 1504, to be placed in the most important public space in Florence: the Piazza della Signoria. In both instances the figures are represented in a contrapposto position, but here all similarities end because

unlike Michelangelo's heroic athlete, Renner presented us a plump young man with an expanding waist, his left arm outstretched, whilst with his right hand he is gingerly holding his penis.

As Rublack commented: 'no one had ever done this before', but this unique double image may perhaps be regarded as symptomatic of an equally unique book consisting of 135 watercolours, with the first one dated 1520, charting Schwarz's life from infancy until the age of 63, when he decided to stop in the year 1560.

The First Book of Fashion presents also a panorama of life in Augsburg during the sixteenth century, because the images do not focus only on clothes; they provide also a wealth of information about the historical and cultural context which produced them, and we can make them tell us their stories.

One of the seminal images in the book, chosen also by James Laver, represents Matthäus Schwarz in his office and at the *primary* or *natural* subject matter level we see the young accountant seated on a high stool at his work table, with a voluminous tome opened in front of him and pen in hand ready to write. The sheets of paper strewn under the table, create a relaxed yet sober atmosphere dominated by work ethics. But his elegant attire is not that of an office employee but a man of privilege: he is wearing an expensive doublet with fashionable slashing, a brown sleeveless overcoat, white breeches, hose, black garters and flat shoes whilst his boss, Jakob Fugger, standing in front of him on the opposite side of the table, is clad completely in black. The caption which reads 'First October, 1516, when I came to master Jakob Fugger, but was only contracted on the 9th (October) Tenth, 1516', provides the *secondary* or *conventional* subject matter level for this is what the image represents. But it is at the *intrinsic meaning* or *content* level that the image reveals the whole story.

The Fugger headquarters were located in a splendid complex of buildings known as the Goldene Schreibstube, which since 1488 was the seat of the Fugger banking empire, and the dominant element in Matthäus Schwarz's office located at this exclusive address was the imposing filing cabinet seen behind him with its multiple drawers labelled with the names of the locations where the Fuggers were trading, each fulfilling a specific role as purveyor of different wares. Thus, **Innsbruck** in the Tyrolean Alps was the mining district, **Ofen** (the old German name for Budapest) was the centre of the Hungarian Trading Company, **Antorff**

(Antwerp) and **Venedig** (Venice) were the Fuggers' premier copper markets, **Rome** was the hub of finance, and **Kurie** (Curia) and Lisbon were the distributing centres of the Portuguese overseas trade. But among them **Nuremberg**, conveniently located near Augsburg and Milan, was the most important South German city (Häberlin in Minning, Rottan and Richter, 2019: 22).

The year 1520, when Matthäus Schwarz embarked on his mission, was an important year in European history, triggered by Martin Luther's Reformation, whose roots can be traced to his rebellion against Catholicism with all that implied, for example, 'the cult of the saints, pilgrimages and relics, the world of the *Golden Legend*' (Dickens, 1977: 42). It led during the fourteenth century to a new approach to religion: that of *devotio moderna,* based on the writings of mystics such as Meister Eckhart, and finding a practical application in a new way of life exemplified by 'The Brethren of the Common Life'. They were

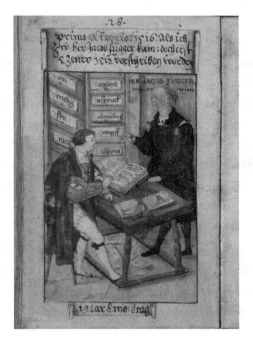

Figure 2.16 *Matthäus Schwarz working as a clerk in the banking house of Jakob Fugger, Augsburg.* The First Book of Fashion: The Books of Clothes of Matthäus and Veit Konrad Schwarz of Augsburg, *edited by Ulinka Rublack and Maria Hayward, Bloomsbury, 2015. Original manuscript in the Herzog Anton Ulrich Museum in Braunschweig, Lower Saxony.*

laymen from the Netherlands and Lower Rhineland who lived in communities and 'laid stress on practical piety and character rather than upon ritualism or theological analysis' (Dickens, 1977: 42), and German canon Thomas à Kempis, whose book *Imitation of Christ,* written as a practical guide to devotion and obtained cult status, was educated in just such a community.

But there was another reason for the popularity of these new cults that had to do with the domination of a 'host of irrational forces', which were far from pleasant: 'a preoccupation with diabolic agencies, witchcraft and sortilege, a curious blend of eschatological expectancy with a dread of universal dissolution. Disease, insecurity and the shortness of life not only urged men to thoughts of salvation but made them listen eagerly to apocalyptic teachings and yearn for sudden changes which would usher in an age of gold' (Dickens, 1977: 48).

They found their expression in the 'diableries' of Hieronymus Bosch and the eschatological vision of Albrecht Dürer's celebrated woodcut 'Four Horses of the Apocalypse' from the *Apocalypse* series of images published in 1498. In it he deals with an old theme represented in the unsettling vision of 'Death, War, Pestilence and Destruction', which 'is bringing back a spirit that has not been felt in art for a long time' (Myers, 1967: 256).

Against this troubled background, Luther's attacks against the Catholic Church were successful and they spread to other European countries. In 1520 he published his manifesto, *To the Christian Nobility of the German Nation,* attacking the Catholic Church and its interpretation of the scriptures. This resulted in a papal ban, and Luther replied by publishing in Latin the *Babylonian Captivity of the Church,* reducing the seven sacraments of the Catholic Church to two: Baptism and Eucharist (Dickens, 1977).

But the Reformation was also a positive force which enabled the emergence of the new age of international business, commerce and technology, led by the northern European power centres of business such as Augsburg, the seat of the mighty Fugger dynasty of bankers:

> The dominant elements of the new Europe were the lawyers, merchants, bankers, industrialists, bureaucrats, ambassadors, publicists, printers designers and skilled craftsmen, men of courts and cities with increasing educational attainments and broadening horizons. (Dickens, 1977: 44)

The fashion conscious Matthäus Schwarz was starting his apprenticeship with the Fuggers at this moment of change, whilst the political and religious dramas unfolding across Europe had little effect on the well-ordered world of the Fuggers.

But a full understanding of the image is provided at the *intrinsic meaning* or *content* level, and that is provided by Jakob Fugger's black attire, which had nothing to do with religious piety for he was dressed at the height of fashion because the colour black dominated European court protocol. Thus, by dressing in black, the banker implicitly aligned himself with the Counter-Reformation and the rigidity of the etiquette observed at the Spanish court of Charles I who became its main champion.

After his abdication in 1555, his successor, the melancholic Philip II, became the ideal on whom the Spanish aristocrats modelled themselves and that meant not only sartorial fashion but also moral fortitude and stoicism, which meant complete self-control:

> The courtier had to know to control himself because it was considered neither serious nor dignified to show emotions in public, one had to appear haughty and detached, in order to convey nobility. The great painters of the sixteenth century captured these ambitions in their portraits; rigid personalities, haughty and distant, indifferent to emotions, configured in controlled postures, which rendered them inaccessible, closed with their own solitude like in an ivory tower. Spanish society turned to the past, to its hierarchic order and to medieval feudalism and a bigoted etiquette and morality, in total contrast to the liberality of appearance, thought and colours found in the Italian fashion of the Cinquecento. (Mafai, 2011: 254–5)

When the fashion for wearing black reached Augsburg, Jakob Fugger's choice to follow it indicated that, unlike his fashionable apprentice, Fugger's choice of black was a political gesture.

Nuremberg is the oldest medieval city in Germany and home to Albrecht Dürer, and around 1500 'Nuremberg was in its heyday. There were successful merchants, there were great Renaissance humanists: for example, Dürer's friend the lawyer/scholar Willibald Pirckheimer; there was a lot of wealth within the city, which had trading connections with the entire world – to Venice, to

Brussels and Antwerp, to Krakow, to Oslo – all the important trading cities in Europe' (McGregor, 2014: 308).

No wonder that one of the drawers of the filing cabinet in Matthäus Schwarz's office has the label Nuremberg, revealing it as a city the Fuggers traded with, equal in importance to Milan and Paris.

Nuremberg was also the town of the Imperial Diets going back to the thirteenth century and Schwarz's visit to it was sandwiched between two Diets held in 1522 and 1524, respectively, both related to the conflict between Martin Luther and the newly elected Dutch-born pope, Adrian VI.

In an image dated 1523, we see Schwarz on the streets of Nuremberg. He is now quite the mature businessman and in order to convey this new *gravitas* he sports a moustache and goatee, but his love of clothes is undiminished. What the eyes see at the *primary* or *natural* subject matter level is Schwarz, wearing a brown mantle with split sleeves and a golden pendant hanging from a black

Figure 2.17 *Matthäus Schwarz in Nuremberg.* The First Book of Fashion: The Books of Clothes of Matthäus and Veit Konrad Schwarz of Augsburg, *edited by Ulinka Rublack and Maria Hayward, Bloomsbury, 2015. Original manuscript in the Herzog Anton Ulrich Museum in Braunschweig, Lower Saxony.*

ribbon round his neck. Underneath his overcoat he is wearing a silver outfit with slashings, consisting of a doublet trimmed with a small black collar and cuffs, whilst more ribbons are tied above his waist and around his sleeves. The nether part consisting of breeches and hose all silvery and black are completed by duckbilled shoes tied with a ribbon around his ankles. He is represented full length against a charming cityscape with houses with gabled roofs and behind him to the right, a piazza with a fountain in the middle. But to his left we spy a tiny black dog unceremoniously lifting his hind paw to urinate on the wall of one of the houses, and it is this humorous detail which deflates Schwartz's stance, telling us that this young man is not yet allowed as much *gravitas* as he would wish for.

But that *gravitas* can be found in the last image in the book where we see him as a 63-year-old man in mourning on a sad occasion:

So he (Schwarz) decided to end his project in September 1560. This time to commemorate deep sadness. Two days ago he wrote: 'my gracious old Herr Anthoni Fugger, in holy memory died the 14th at eight o' clock in the morning'. Underneath the picture he noted with his customary precision his age: 'I was 63½ years old and 25 days old'. But this time he added laconically: 'this 137th image is unlike the 86th image'. The 86th image had depicted him more than 30 years earlier dressed in the most splendid red silks and velvets for Anton Fugger's wedding in 1527 in his prime. (Rublack, 2010: 73)

This change from youth and lover of beautiful clothes to the black (but fashionably black) 'look' mirrored, apart from the fashion trends established by Spanish protocol, the complex political situation resulting from the conflict between the Lutheran Schmalkaldic League and Charles V, culminating in 1545 with the Council of Trent and the onset of the Counter-Reformation.

Charles V outlawed the Schmalkaldic League and we witness Schwarz defending Augsburg against him, but then, he 'commemorated the Imperial Diet in 1547 the abolition of the guild regiment and the final emperor's presence at the Imperial Diet in 1550 as well as Charles' departure in 1551' (Rublack, 2010: 68).

The wars against the Schmalkaldic League concluded with the Peace of Augsburg in 1555, at which point Charles V abdicated in favour of his son, Philip II. Consequently, it was stipulated that every German prince was free 'to regulate whether his territory should follow Lutheran or Catholic beliefs. Augsburg became a city of mixed confessions' (Rublack, 2010: 70).

We also notice a gap in *The Book of Clothes* but 'anyone looking at the book would have considered it a failure if it closed with a picture of him triumphing over Protestantism, celebrating Moritz of Saxony's death' (Rublack, 2010: 71). Instead Matthäus Schwarz finished his book in September 1560 in order to mark a personal event: the death of his beloved employer Anton Fugger, and in the final image we see him dressed in black – but in mourning rather than fashionable black – attending the funeral.

Between 1545 when the Council of Trent met for the first time and its last meeting in 1563, it succeeded in re-establishing the supremacy of the Catholic Church, albeit a diminished version.

Yet 'the Papacy recovered that commanding position within the Church which it had never since relinquished' (Dickens, 1977: 135).

The seventeenth century is ushered in with the devastating Thirty Years War (1618–48), which decimated Germany as well as the Holy Roman Empire, and one of its consequences was the division of Europe between a Catholic-influenced propagandistic art dictated by the Council of Trent and a Protestant art that was secular, exemplified by Holland which emerged in 1609 as an independent country. This division will impact all aspects of culture and art as well as people's way of dress.

The seventeenth century also sees a radical volte face in the way images are represented on the page. Thus, the main function of sixteenth-century representations of costume was to 'collect curiosity, now the production of the printed image was aiming to communicate fashion' (Ginsburg in Morini, 2006: 28).

3

The seventeenth century

A new profession – the gentleman journalist writing for Le Mercure galant

The Counter-Reformation and its consequences: Catholicism versus Protestantism

The need for a general council to negotiate the complex political configuration of Europe in the aftermath of the Reformation was initially championed by the Farnese Pope, Paul III. But it was not until 1545 that the first session of the Council of Trent opened on 13 December, operating until 1548 when it was suspended. Two more sessions followed, between 1551 and 1552 and between January 1562 and December 1563; after this date the Council ceased its activities because of its unpopularity and not a minute too soon.

During its last session, attention was focused on the visual arts and the normative criteria imposed by the Council acquired the label 'counter-Maniera', defined as 'an expression in a style of art of a temper we identify with the cultural and religious movements of the Counter-Reformation':

In such a milieu, the decrees issued specifically in regard to art by the Council of Trent (only in its last session, 3–4 December, 1563) were, rather than a new force to reshape the style of art in Rome, a codifying and official

sanction of a temper that had come to be conspicuous in Roman culture. Counter-Maniera and the Counter-Reformation came to be reciprocal to one another, and a similarity of terms for them is thus informative, but the style of art must not be thought of as more than a function of the movement in religion. (Freedberg, 1975: 429)

Irrespective of the impact of its tenets, the Council stipulated that the job of the painter was to provide an *ekphrasis* of the scriptures: 'Angels must have wings; saints must have haloes and their particular attributes, or if they are really obscure, it may even be necessary to write their names below them to avoid any confusion' (Carlo Borromeo in Blunt, 1973: 111).

The length to which these self-styled adjudicators of religious painting went to impose the dogmas of the Council on art make for comical reading, and a notorious example is Gilio da Fabriano, one of the bureaucrats appointed to dictate the rules of good painting, commenting on Michelangelo's *Last Judgement* in the Sistine Chapel:

Michelangelo, he says, has represented the angels without wings. Certain of the figures have draperies blown about by the wind, in spite of the fact that at the Day of Judgement wind and storm will have eased. The trumpeting angels are shown all standing together, whereas it is written that they shall be sent into the four corners of the earth. Among the dead rising from the earth some are still bare skeletons, while others are already clothes with flesh, though according to the Biblical version the general Resurrection will take place instantaneously. (Gilio da Fabriano in Blunt, 1973: 116)

The consequences of the Counter-Reformation reverberated throughout Europe, and its impact on the entire fabric of society, especially in Italy, Spain and parts of the Netherlands still under Spanish occupation, cannot be overemphasized. But above all it affected France where it culminated with the 'darkest deed of the Catholics': the massacre of the Huguenots. On St. Bartholomew's Eve on 23 August 1572, two thousand Huguenots were butchered in Paris, and when the gruesome deed was completed, the pope celebrated a *Te Deum* and the king of Spain 'began to laugh' (Davies, 1997: 502).

The reign of Louis XIV and the Court of Versailles

Like Italy, France was Catholic, but its contribution to seventeenth-century culture differed from the sentimental style associated with Italian baroque, due to its adoption of a rigorous style influenced by classical antiquity: this was 'The Age of Reason'. To this a second label can be added: 'The Age of Absolutism', which defined the totalitarian regime of Louis XIV.

When Louis XIV became king in 1643, he appointed a new minister of finance, Jean-Baptiste Colbert, who embarked on a series of reformations, starting with the founding in 1648 of the Académie Royale de Peinture et de Sculpure, followed by a cluster of other Royal Academies: music, architecture, inscriptions, etc. Colbert even considered opening a Royal Academy of Spectacles, to improve the standard of 'carousels, games, fights, combats, parades, hunting and fire works' (Wilenski, 1973: 80).

In fact, the entertainment favoured by the Court of Versailles was spectacle and Louis XIV himself contributed to staging grandiose ballets and performances, often with himself as the main protagonist and several of them, such as the *Ballet de la Nuit* produced in 1653 at the Salle du Petit-Bourbon, became legendary. But for such grandiose pageantry a grandiose stage was needed and this is how Versailles evolved from a hunting lodge built by Louis XIII into the grandest palace in Europe.

Splendid clothes were called for to match the splendour of the setting, testifying to their importance as part of the visual displays, which established for Versailles its international reputation.

A new institution: the fashion magazine

A primary source to record and visually preserve the splendour of the Court of Versailles, its gossip, scandals and elegance, but above all the latest fashions, was the magazine. Although the specialized fashion magazine was the creation of the Enlightenment, we have an antecedent in *Le Mercure galant*, first published between 1672 and 1674 by Jean Donneau de Visé, only to re-emerge

in 1677 as *Le Nouveau Mercure galant*. It was modelled on existing practices of authors of the 'gallant satirical and literary press', whose function was to publish information about goings-on at the court and town festivities (Roche, 1994: 478), establishing 'gallant journalism' as a new *genre* which required that a 'well-bred tone' be adopted in order to create a sympathetic link between readers and writer. The latter 'made confidences and observations, repeated salon gossip and used various means to make his fictions sound like facts, so as to win the readers' confidence and give an air of authenticity to his information' (Roche, 1994: 479).

To that effect the wording on the cover of the first edition of *Le Mercure galant* informed the readers that the magazine offered 'veritable stories' and everything that was happening after the departure of the king from Paris to fight in the Franco–Dutch War. Started by Louis XIV, its purpose was to punish Holland for its interference in the War of Devolution against the Spanish Netherlands: 'The Congress of Nijmegen (1678–9) saw Louis' diplomats holding the ring – appeasing the Dutch with commercial advantages, forcing the Spaniards to cede territory, imposing a settlement on the lesser powers' (Davies, 1997: 624).

This new breed of journalists paid little attention to fashion, only referring to it 'by reason of an external and wholly social legitimation since it had not yet achieved recognition and totally autonomous expression' (Roche, 1994: 479). This explains why so few fashion illustrations were published, and when they were, they fulfilled an altogether different function: they informed the reader about the latest developments in sartorial fashion, which constituted an early form of advertising and that involved 'using procedures which would later ensure the success of advertising'. In this sense, these images can be regarded as the first form of modern publicity. 'But the experiment was short lived lasting only one year and was not used again until 1724 in the *Mercure de France*' (Morini, 2006: 29). *Le Mercure galant* established the template for fashion advertising, starting with the Encyclopédistes who borrowed its strategy of combining text with images:

> With a title that evoked the mythological messenger of the gods, as well as the sensibility of pleasure and amusement that characterized the court of Louis XIV, the magazine provocatively promised in its inaugural editorial to report on a mélange of 'all the things that other magazines won't cover'. It

held to its word: while it followed the *Gazette de France* by printing political news, and imitated the *Journal de Savants* by publishing erudite literature, the *Mercure galant* went beyond the scope of either of these publications by also offering a mix of society gossip, news of marriages and deaths, notices of curiosities (Siamese twins, bearded ladies, and the like), and reviews of plays, operas and new books. (Davis, 2006: 2–3)

The magazine also provided the template for 'the style press' practised to date, which consisted in establishing the primacy of fashion in the pursuit of the lifestyle cherished at court, whilst also breaking new ground in fashion reporting by introducing the fashion plate:

Borrowing the idea for visual representations of fashion from the costume books and almanacs which flourished from the fifteenth century onward, the *Mercure's* editor Jean Donneau de Visé began to use illustrations captioned with descriptive texts to convey the latest looks in his journal in 1678, after he was granted a royal privilege allowing him to include engraved plates in the publication. (Davis, 2006: 4)

Thus the March 1678 issue of the *Nouveau Mercure galant* reproduced a fashion shop belonging to a *marchande des modes,* accompanied by a description of the contents on sale, informing prospective buyers not only about the latest fashions and their retail prices but where they could be bought (Morini, 2006). They were accompanied by illustrations demonstrating how these items should be put together to construct a fashionable 'look'.

One example reproduced in *Mercure galant* is a plate illustrated by Jean Bérain and engraved by Jean Le Pautre (Davis, 2006: 4) representing a *Habit d'Hyver* for a gentleman. He is wearing a close-cropped beaver hat decorated with an embroidered silk ribbon, a *just-au-corps* made of *drap de Hollande* (Holland cloth), and given that the images were reproduced in black and white, the colour was described by word: hazelnut. The knee-length coat was complemented by an embroidered sling and a tassel decorating the hilt of the sword, the colour of 'de Prince' as were the breeches. Finally, the shoes described as *de point d'espagne* reveal their source of inspiration.

The practice endured and if we open any contemporary fashion magazine or search on Google for the most glamorous fashion designers of our times,

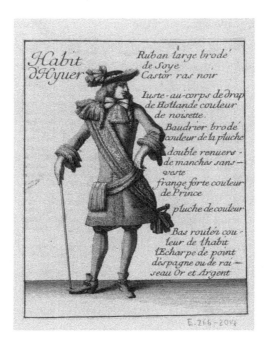

Figure 3.1 *Man in winter clothes,* Nouveau Mercure galant *(1677–8),* Victoria and Albert Museum, London.

the same process is followed, the difference being modern technology, so that using words in a black-and-white image to indicate colours was dispensed with, yet some instances specify them all the same. If we Google 'Hussein Chalayan', under the title 'Transforming dress' we find: 'Chalayan Draped Stretch-jersey Gown Woman Red (£274.00)'. Another example is: 'Hussein Chalayan layered organza striped dress – Brown £473.00'. And there seems to be little difference, although they are separated by six centuries, between a *just-au-corps* made of 'drap de Hollande' and a 'Stretch-jersey Gown Woman Red' with one exception: in the first instance specifying the colour 'hazelnut' was a necessity, but not so in the second, where the red garment in the image is tautologically complemented by the word 'red'.

Louis XIV's legacy

During the last year of his life, Louis XIV came under the influence of the governess of his children, Madame de Maintenon, and after the death of his

wife, Queen Maria Theresa of Austria, in 1683, he secretly married his morose governess whose influence brought to an end the frivolous atmosphere of Versailles. But this royal marriage also attracted the sarcasm of satirists, such as Jean de la Bruyère:

> Formerly a courtier had his own hair, wore doublet and breeches and wide cannons and was a libertine. This is no longer in favour: now he has a wig, a tight suit and plain stockings and he is fervently religious. Gone were light colours, masses of ribbons, plumes and points; now long, severe, buttoned just-au-corps, tight breeches and dark stockings were worn; gone was lace, except on the cravat and sleeves; gone were plumes, except of hats and rarely, as edgings; at the end of the century the cravat itself had given place to a simple neck ribbon, the *chaconne*. (de la Bruyère in Boucher, 1997: 258)

Louis XIV fulfilled his desire to transform Versailles into the grandest palace in Europe, but after an unusually long reign, his legacy was less clear-cut than it appears. He certainly succeeded in creating an 'institutionalized uniformity' with the founding of the academies, but regarding matters of government, his legacy was less impressive: as a consequence, the gap between the nobility and the working people kept growing and it culminated with the gruesome 1789 French Revolution.

Capturing elegance in the printed image at the French Court

Louis XIV's greatest legacy was his love of luxury and fashion, preserved for posterity not only by the visual arts but also by the numerous costume and fashion books published during his reign. One such is a wonderful collection of 190 hand-coloured fashion prints bound in a volume titled *Recueil de modes de la cour de France* (acquired in 2002 by the Los Angeles County Museum of Art, LACMA).

Between 1672 (when Jean Donneau de Visé founded the *Mercure galant*) and the beginning of the eighteenth century, fashion prints proliferated, facilitated by the introduction of a new technique: etching, which replaced engraving and it 'revolutionized image making and transformed the manufacture of

reproducible images' (Norberg and Rosenbaum, 2014: Introduction). The resulting fashion images became a collaborative endeavour aimed at creating 'a fashion image, a publisher, an artist, an engraver, press men and finally a merchant were all needed' (Norberg and Rosenbaum, 2014: Introduction).

Jean Donneau de Visé had the inspiration to introduce 'fashion (les modes) reportage' in his magazine, 'making the *Mercure* the first example of fashion journalism' (Norberg and Rosenbaum, 2014: Introduction) and he provided at the same time an insight into the way images were created and used by printmakers. Thus, in 1679 we find him praising four fashion prints published by Jean Dieu de Saint Jean: 'One can see that (these prints) came from a **gallant man** who understands several languages and knows everything that the most accomplished gentleman (cavalier) should know' (Donneau de Visé in Norberg and Rosenbaum, 2014: Introduction). And these gallant creators of fashion images found them in the most fashionable venues of Paris and reported them to the printmakers,

> who had no trouble creating the clothing detailed in these reports. The printers were above all else illustrators and they were used to providing images for books on distant lands ancient times, and fiction. In other words they were experts at creating images of people and things they had never seen. Consequently, the fashion prints are probably not images of 'real' clothing nor are they snapshots from the balls of Versailles or the Gardens of Tuileries. (Norberg and Rosenbaum, 2014: Introduction)

It has been argued that during the seventeenth century, fashion prints did not provide a realistic representation of dress, and that would explain why fashion historians considered them as 'a document – an illustration of a dress or suit – that require no explanation and receives no analysis of the images, function or utilization' (Tétart-Vittu in Norberg and Rosenbaum, 2014: 3).

But this assumption is contradicted by surviving fashion plates representing clothes 'in the round', which give us a clear idea about the way they were meant to look on their wearer, as well as their 'cut and construction'. Louis XIV himself held such fashion plates in high esteem, considering them,

> equally the products of the imagination, 'for ornament, for pleasure and for collections'. The high quality of the fashion plates ensured that they were

The Seventeenth Century

regarded as minor works of art, future collectors' items, not only do they provide a visual narrative of elite fashion, but they often depict clothes in the round – back and side as well as front views – (necessarily so as they were used by tailors and dressmakers), thus furthering knowledge of the cut and construction of clothing in this period, very little of which survives. (Ribeiro, 2017: 145–6)

To that effect the king passed an act in 1660 providing printmakers with the freedom enjoyed by visual artists, although he conceded that prints cannot be compared to paintings and their emotional content, because 'they depict movement and gesture, and a range of clothing from informal to formal – from *robes de chambre* to *robes de cour* – and also preoccupations, such as the toilette, or leisure pursuits such as playing music – all usually outside the remit of portraiture' (Ribeiro, 2017: 146).

But this does not mean that our knowledge of seventeenth-century fashion plates is problem-free, because a number of other issues, such as dating, or how often they were published, or where, given that with the exception of Jean Donneau de Visé's *Mercure galant*, no other publications seem to have survived and even in his magazine, publication of fashion plates only lasted one year (Ribeiro, 2017: 146).

The *Recueil des modes de la cour de France* consists of 190 hand-coloured engravings dated between 1670 and 1692/3, coextensive with the middle period in Louis XIV's reign, but what makes this collection special is that its images cover all social classes, representing them at work and play.

The way the images are presented on the page belongs to an existing seventeenth-century template created by Jacques Callot and Abraham Bosse, which consisted of an engraved (in this case also hand-coloured) image, accompanied by text (couplets or quatrains), and the LACMA album follows this template. The plates are organized according to the social categories represented, starting with 'social status from high (men and women of quality), through to low (actors, peasants and working men and women)' and introducing towards the end traditional stereotypes from 'Cries' and 'Books of Trade'. Several special 'rubrics' have also been identified, which included 'national ethnic portraits, occupations, military, clerical and official positions, musicians, theatrical roles, dancers, characters from *commedia dell'arte*,

followed by costumes of 'shepherds, peasants, lower class positions' (Reid in Norberg and Rosenbaum, 2014: 77). Their presentation on the page is 'simple elegant' rather than heroic and they are drawn 'from worlds of court, theatre, trades and occupations with figures constructed from their tools of trade and emblematic types' (Reid in Norberg and Rosenbaum, 2014: 77).

Whilst it is generally accepted that the prints are not faithful reproductions of specific garments, they provide information about the way garments were combined to provide the complete 'look':

> For fashion and art historians, curators, and conservators working with the few garments from the period that have survived, the prints demonstrate how to put an outfit together, and how accessories such as the period ribbon, lace and feathers that survive in museum collections were used. (Rosenbaum in Norberg and Rosenbaum, 2014: 188)

But their most important message can be unravelled at the *intrinsic meaning* or *content* level because these images are a treasure trove of information about life during the reign of Louis XIV. Moreover, the information contained in them transcends the French context to provide a hint, often encoded in the most unassuming accessory, about the way other countries and continents interacted with France.

Two similar prints in the LACMA *Recueil* represent images coloured differently by Nicolas Bonnart with the generic title *Homme en robe de chambre* and the first two lines include an accompanying quatrain which reads 'cette robe d'Armenien/Est en desabillé commode'.

The subtext emphasizes the garment's use as *déshabillé* and, rather than employing the term *banyan*, it describes the garment as *robe d'Armenian*. This is indicative of an association with distant commerce given that Armenians, sometimes called Greeks, were important traders in and between Islamic and European centres, especially in Poland and Russia where in the early eighteenth century they introduced the *patka* weaving (Schoeser in Norberg and Rosenbaum, 2014: 178).

One of the two images represents the young man in a contrapposto posture standing in a loggia with a red curtain to his left drawn open to reveal a garden with lovely trees. In the second image the architectural context is removed

and focus is on the standing figure of the young man, and this is what we see at the *primary* or *natural* subject matter level where focus is exclusively on the elegantly attired young man in a contrapposto position. He is represented wearing a *montrero* (a Russian-style fur-lined cap) and a loosely fitted red silky gown, depicting a cloth with narrow gold stripes set amid two-toned cloth with narrow gold stripes amid two-toned red bands, rendered in colours suggestive of Adrianopole red or Turkey red, a much sought after, especially fast madder-based red dye formulated specifically for cotton yarns and cloth (Schoeser in Norberg and Rosenbaum, 2014: 178).

The outfit is complemented by *pantouffles* (backless mules) with red heels. At the *secondary* or *conventional* subject matter level its title gives us the meaning: a man wearing an informal robe but there is a subtext here because the term 'robe de chambre' emphasizes its function as a *déshabillé*, meant to be interpreted as 'oriental' or 'exotic' (Schoeser in Norberg and Rosenbaum, 2014: 178) and that is confirmed by the first line of the quatrain 'cette robe d'Armenien/Est en desabillé commode'.

At the *intrinsic meaning* or *content* level a wider picture emerges, to do with the importance of Oriental textiles, clothes and accessories which had already reached Europe and were in great demand at the Court of Versailles. One of the reasons was the importance accorded to materials imported from countries outside Europe such as Mughal, Persia and the Ottoman Empire, because the Oriental way of dressing was influencing European styles: 'Banyan, Persian vest, mantua, each can be seen in the hand coloured engravings in *Recueil des modes de la cour de France*' (Schoeser in Norberg and Rosenbaum, 2014: 167).

Another image, illustrated by Henri Bonnard representing a guard lieutenant, is described at the *primary* or *natural* subject matter level as wearing just such a Persian vest:

> He is wearing a long, close fitting Persian vest sometimes called a *surtout* or *justaucourps* – but details are costly: embroidery, silk ribbons, galloons (a narrow ornamental strip of fabric, typically a silk braid or a piece of lace, used to trim clothing or finish upholstery) laces, and buttons and the cloth woven with gold and silver. (Schoeser in Norberg and Rosenbaum, 2014: 174)

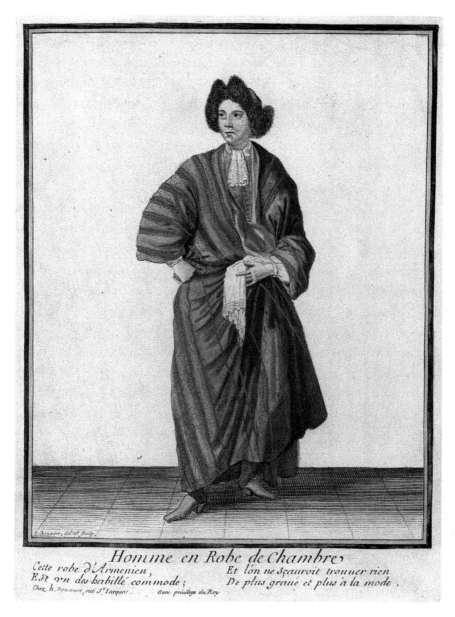

Figure 3.2 *Nicolas Bonnart,* Homme en robe de chambre in Recueil, *France (1670–c. 1693). In* Recueil des modes de la cour de France.

The Seventeenth Century

But we find that the Persian vest had already arrived at the court of Charles II and is mentioned by both Samuel Pepys and John Evelyn in their respective diaries. Thus, in an entry dated 8 October 1666, Samuel Pepys writes:

> The King had yesterday in Council declared his resolution of setting a fashion for clothes, which will never alter, it will be a vest, I know not well how, but it is to teach the nobility thrift and will do good.

Meanwhile in an entry of the same date, John Evelyn writes:

> To Court. It being the first time his Majesty put himself solemnly into the Eastern fashion of vest, changing doublet, stiff collar, bands and cloak into a comely dress after the Persian mode, with girdle or stripes, and shoe strings and garters into buckles, of which some were set with precious stones, resolving never to alter it, and to leave the French mode, which had hitherto obtained to our great expense and reproach.

Evelyn himself succumbed to the new 'look' and in an entry dated 30 October he writes:

> To London to our office, and now had I on the vest and surcoat and tunic as 'twas called, after his Majesty had brought the whole Court to it. It was a comely and manly habit, too good to hold, it being impossible for us in good earnest to leave the Monsierus. (Pepys and Evelyn quoted in Tortora and Eubank, 2010: 249)

But the Persian vest was not new at the English court and we see Sir Robert Shirley, who was a regular traveller to Persia and became familiar with their mode of dress, wearing such a vest in a splendid portrait by Anthony van Dyck dated 1622:

> Shirley, who had travelled much in Persia in the early years of the seventeenth century, occupied the strange position, for an Englishman, of Persian ambassador at the Court of St. James's. English relations with Persia, were, indeed, very close throughout the century a new fillip to English interest in the East was given when Charles II received the island of Bombay as part of the dowry of Catherine of Braganza. (Laver, 1969: 115)

Women too benefited from the new diplomatic and commercial links between East and West, and in one example by Jean Dieu de Saint Jean we see a young lady attired in a *negligée* with the caption 'Femme de qualité en désabillé détoffe Siamoise'.

At the *primary* or *natural* subject matter level the young lady is seen to be wearing a costly dress which follows the canons of French seventeenth-century fashion: a tight bodice and a loose long skirt. But an unusual detail is the use of the word 'Siamoise' in the title, in order to designate clothes made in France, 'in imitation of the sumptuous fabrics worn by ambassadors of the King of Siam who were presented at the court of Louis IV on two occasions in the 1680s' (Schoeser in Norberg and Rosenbaum, 2014: 175).

The title of the image identifies the *secondary* or *conventional* subject matter level, but the explanation of the word 'Siamoise' can be found at the *intrinsic meaning* or *content* level and is to do with the new diplomatic relationship between Louis XIV and the king of Siam, who sent to Versailles three missions. The first dated in 1680 was lost at sea, with a second dated 1685, followed by a third in June 1685. What characterized these diplomatic events was the exchange of gifts and the third mission was led by a Siamese nobleman, Kosa Pan, who was granted an audience with Louis XIV at Versailles – to whom he brought marvellous gifts:

> This is one of the best documented diplomatic receptions in East-West relations. The Siamese kept meticulous diaries – a fragment of Kosa Pan's still survives – and the French court recorded the Sun King's pleasure in engravings, medallions and paintings. The Siamese gifts included many gilded textiles along with other fineries, and the dispersal of these gifts to courtiers and others generated a vogue in late seventeenth-century France for *les siamoiseries*. (Guy in Jackson and Jaffer, 2004: 88)

Thus, the Siamese *negligée* worn by the aristocratic lady is telling a story about the diplomatic and trade relationship which developed between France and Siam.

If we leave the well-bred (and heeled) courtiers and aristocrats behind and turn to the disenfranchised men and women who worked for a living amply represented in the album, another picture emerges, not that different from examples such as Abraham Bosse's 'Cries of Paris'.

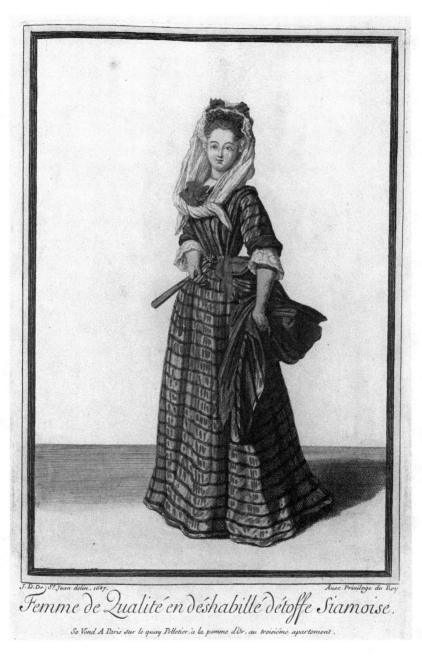

Figure 3.3 *Jean Dieu de Saint Jean,* Femme de qualité en déshabillé d'étoffe Siamoise, *France (1670–c. 1697). In Recueil des modes de la cour de France.*

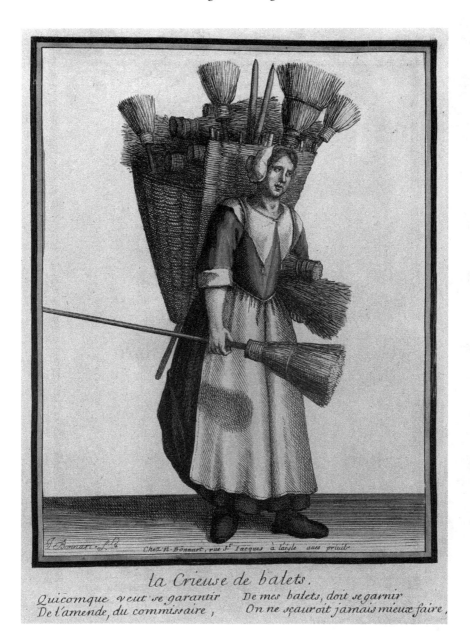

Figure 3.4 *Jean-Baptiste and Nicholas Bonnart,* La crieuse de balets, *France (1670–c. 1697). In* Recueil des modes de la cour de France.

And this is what we see at the *primary* or *natural* subject matter level in an example such as *La crieuse de balets* (vendor of brooms), which represents a woman dressed in a modest outfit carrying on her back a huge basket filled with brooms, whilst holding one in her right hand and another under her left arm.

Capturing the everyday in the printed image

We are fortunate to be well informed about seventeenth-century dress from an unexpected source – artists' engravings – and we have two outstanding examples: Abraham Bosse and Jacques Callot, whose war images constitute a severe indictment of the devastating Thirty Years' War (1618–48).

In 1633 Jacques Callot produced two series of prints titled *Miseries and Misfortunes of War*: the first incomplete edition known as *Les Petites Misères* and the second, consisting of eighteen prints, known as *Les Grandes Misères de la guerre*.

Both Abraham Bosse and Francisco Goya owned Callot's prints and the latter was influenced by Callot in his own *Los Desastres de la Guerra*.

But Bosse chose a different visual language to depict the horrors of the Thirty Years' War rendered famous by Bertolt Brecht in his masterpiece *Mother Courage and Her Children*, which tells the epic adventures of a picaresque character taken from seventeenth-century German literature nicknamed 'Mother Courage', a canteen woman with the Swedish army. In Brecht's play she becomes as much part of the street culture of the disenfranchised victims of the war as the characters represented in Bosse's prints. But there was nothing new about Bosse's choice of subject matter given that 'images of criers, hawkers and beggars were ubiquitous around Europe during the seventeenth and eighteenth century' (Goldstein, 2014: 44). Drawing on this tradition, he produced in 1639 a series of prints titled *The Cries of Paris* dedicated to the flotsam and jetsam who filled the streets of Paris coping the best they could with the devastation brought by war. But Bosse's dramatis personae were neither beggars nor vagabonds; they were decent, hard-working folk such as craftsmen who became victims of the war, and in Bosse's images their métier is easy to identify by their attributes: 'a well cleaner, water carrier, a rat catcher, a

chimney sweep as well as vendors of firewood, stomach remedies, pastry and oysters, a street singer and beggar' (Goldstein, 2014: 44).

Bosse complied with the standard layout of representing a single image accompanied by explanatory quatrains and a particularly poignant example is *The Ratcatcher*:

> A Quixotesque Spanish knight who at one time caused the earth to tremble now strikes fear only into the hearts of rats. The inscription under the image reads: 'A Spanish knight who in combat/Made the earthquake/Through a reverse of fortune in war's wake/Goes about crying death to the rats'. (Goldstein, 2014: 45)

At the *primary* or *natural* subject matter level, we see a man standing in a barren landscape projected monumentally against a low horizon; he is wearing an imposing ruff which contrasts with the rest of his threadbare outfit that was once as elegant as the ruff but is now falling apart, as is the man himself with his right leg amputated at knee level, replaced by a wooden stump. On his left shoulder he carries a flag with several dead rats dangling from its handle as well as from a stick he balances on his right arm. Rats, as we know, are signifiers of war calamities such as epidemics and plagues. Its title provides the *secondary* or *conventional* subject matter level, and in this sense Bosse's *Ratcatcher* could be interpreted as a visual equivalent of Brecht's play *Mother Courage*: they are both victims of circumstances beyond their control and have to adapt to their fate, but they do so with dignity.

But it is the Thirty Years' War which provides the *intrinsic meaning* or *content* level. We find equivalents of Bosse's *Ratcatcher* and Brecht's *Mother Courage* in paintings: one celebrated example being Jusepe de Ribera's *The Clubfoot* dated 1642.

At the *primary* or *natural* subject matter level we see a crippled beggar boy with a deformed foot, his crutch slung over his left shoulder. Like *The Ratcatcher*, the beggar boy is monumentally projected against the blue sky, which contrasts with his dull brown rags. In his left hand he holds a piece of paper with a Latin text translating as 'Give me alms, for the love of God', revealing that he is dumb. But this Neapolitan urchin is also an emblem of the transcending of the miserable realities of everyday life to become a vehicle for the transmission

The Seventeenth Century 119

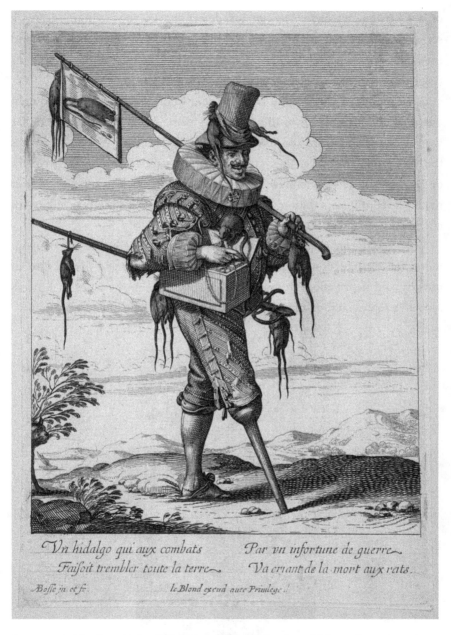

Figure 3.5 *Abraham Bosse,* The Ratcatcher. *In* The Cries of Paris *(1602/4–76)*. *Alamy Stock Photographers.*

of a Christian message. Despite his deformity, the boy communicates a serenity and joy that are enhanced by the immense Mediterranean sky and the landscape that fades into the distance in the pale blue of the mountains (Pagano in Péréz Sánchez and Nicola Spinoza, 1992: 146).

A Neapolitan street urchin, crippled and dumb, yet he is staring straight out at us, and his smile, revealing his rotten teeth, is a smile of defiance rather than self-pity, much like *The Ratcatcher*'s dignified posture. A world separates the two protagonists, yet they are surprisingly similar at both the *primary* or *natural* subject matter level and the *secondary* or *conventional* subject matter level of interpretation, given that their titles reveal them as victims of circumstances and of their cruel fates.

But it is at the *intrinsic meaning* or *content level* that we find the link between them: the Counter-Reformation. In the former as the main contributor to poverty and deprivation brought about by war, and in the latter in Ribera's symbolic representation of the tenet that good deeds help attain salvation:

Figure 3.6 *Jusepe de Ribera,* The Clubfoot, *1642. Oil on canvas, 164 × 92 cm. Louvre, Paris.*

Thus the boy embodies the theme of mercy toward the poor which St. Ignatius Loyola wrote about in his Introduction to pious life in which Saint Francis for whom poverty and charity were the highest virtues illustrates various ways to achieve holiness. The painting is an invitation both to the rich to give to the poor (the hat in hand must be a gift received by the small beggar and to the poor to rejoice in their state). (Pagano in Péréz Sánchez and Nicola Spinoza, 1992: 149)

Capturing elegance in England: A Bohemian printmaker, Wenceslaus Hollar

In England the equivalent of Versailles was the Palace of Whitehall, initially the residence of Cardinal Wolsey, but after his fall from favour in 1530, Henry VIII seized the property which became his royal residence, described as a 'vast and sprawling collection of buildings on the river Thames', 'estimated to consist of around 2,000 rooms . . . The monarch's apartments were at Whitehall when at court in London (a peripatetic lifestyle meant much time was also spent at other royal residences outside the capital)' (Reynolds, 2013: 16).

As with their French counterparts, English courtiers were obliged to dress elegantly and expected to offer gifts of clothing to their monarch on New Year's Day. In return, the monarch had to repay them with his generosity: thus during the reign of Charles II, the 'Grooms of the Bedchamber' could keep the king's linen, which had to be renewed every three months (Reynolds, 2013: 17).

Few items of clothing have survived and for that reason information about fashion is based on paintings, fashion plates and written sources. The Renaissance practice of creating fashion plates with engravings referring to peculiarities of manners and mores including dress continued in England with the arrival in 1637 at the invitation of Thomas Howard, 2nd Earl of Arundel, of Wenceslaus Hollar, a Bohemian printmaker.

Although his etchings have been described as not having the 'brilliant and piquant qualities of his French contemporary Jacques Callot', his images of costumes are considered as 'among the most exquisite of their kind' (Hind, 1922: 10). His earliest set of twenty-six plates with the title *Ornatus Muliebris*

Anglicanus or *The Severall Habits of English Women from the Nobilitie to the Country Women as they are in these times*, completed in 1640, was dedicated to English women, and it is noticeable that Hollar was influenced by Anthony van Dyck, although the royal painter did not approve of Hollar.

This early set was followed in 1643 by the better known *Aula Veneris*, probably started by Hollar before he arrived in England in 1636 and was an ongoing project: '*Aula Veneris* was not a single coherent published set but a project that was continually augmented, and a number of plates bear English titles in their first state and German ones later as Hollar adapted to a continental audience' (Godfrey, 1994: 78).

Unlike in the preceding set, *Aula Veneris* provided examples not only from the courts and cities of England but also from Europe 'to the wilderness of Virginia', and for these Hollar had to find inspiration from other books of costume (Godfrey, 1994: 78). But Hollar's best known etchings are *The Four Seasons* dated between 1643 and 1644, of which two sets were produced: one consisting of three-quarter length figures with the second set consisting of full-length female figures standing on platforms against the low horizon line of landscapes or townscapes. They are allegorical representations of the four seasons accompanied by corresponding attributes and explanatory quatrains: Thus the young woman representing winter is wearing a full-length, expensive coat justified by the accompanying quatrain: 'The cold, not cruelty makes her weare/in Winter furs and wild beasts haire/For a smoother skinn at night/ Embraceth her with more delight'. She is wearing a mask (*vizard*) and masks had a multitude of connotations: during the sixteenth century they were mostly associated with prostitution, but during Hollar's time *vizards* were worn by fashionable women, such as the one representing winter (Reynolds, 2013: 68–70).

At the *primary* or *natural* subject matter level we see the young woman wearing a hooded cape to protect her from the cold, complemented by a fur collar and in her left hand she is holding a muff. Her skirt consists of three distinct layers: an embroidered *secrete* (inner petticoat), topped by a spotted caught-up *friponne* with a third, the *modeste* carried over the arm (Boucher, 1997: 272).

She is projected monumentally against a cityscape filled with people mingling in the city square: we see them on foot, riding horses or sitting in

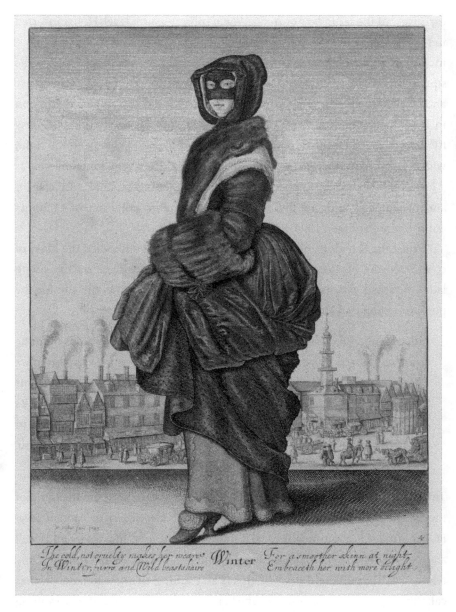

Figure 3.7 *Wenceslaus Hollar,* Winter, *1643. Etching. In* The Four Seasons. *British Museum, London.*

124 *Images on the Page*

carriages. At the *secondary* or *conventional* subject matter level, Hollar inserted in the cityscape plenty of signifiers – telling us that his image is about winter – including smoke coming out from the chimneys of the buildings framing the square, whose architectural styles are a mixture of contemporary architecture and pointed medieval gables, captured the picturesque atmosphere of London in 1666, just before the Great Fire. The buildings in the background are easy to identify as the Cornhill, with the tower of the Royal Exchange to the right, whilst to the extreme right is the 'Tun' built in 1283, whose function was 'as a lockup for drunks and other miscreants'. The plumes of smoke are elegant and ornamental and give little idea of the extreme pollution of London's atmosphere (Godfrey, 1994: 81).

Whilst the Cornhill and the Royal Exchange, which embodied the heart of commerce and business in London, are signifiers of wealth as are the young lady's furs and expensive clothes, not so the Tun which was the site for the poor, revealing that Hollar's London had nothing to do with reality:

> Indeed Hollar's London was more the fetid city of Charles Dickens than the clean, contoured place that he depicts. Hollar's intention as a topographer was to clear the air, to show us what should be, and to provide the armchair traveller with pleasure and edification. He scours its surfaces, cleans its gutters, and clips clear the edges of the buildings until we half believe in this idyllic metropolis in which well-clad figures stroll and take their ease. (Godfrey, 1994: 14)

Thus, if at the *secondary* or *conventional* subject matter level the meaning of the image is an allegory of winter, at the *intrinsic meaning* or *content* level Hollar's image is about wealth, social status and the good life, where all is well and people of all social classes mingle happily on the streets of London. Only reality was very different because this is an example of what Roland Barthes calls 'the myth' in his image of a young black man in a French uniform, saluting the French tricolour, he spied whilst at his barber's on the cover of *Paris-Match*. Barthes argued that at the *primary* level of signification, the black man in French military uniform is 'one of us', but at the *secondary level* of signification or *meta-language*, the distortion occurring in the 'myth' was to hide French racism (Barthes, 1972: 109). In Hollar's image, the attractive cityscape with

its well-to-do passers-by also distorts reality to hide what Godfrey called 'the fetid city of Dickens'.

Hollar arrived in England during the reign of Charles I, who reigned with his French-born queen Henrietta Maria between 1625 and 1649. Both loved luxury and ostentation, and the king was also an assiduous collector of art, a passion he shared with Hollar's patron, the Earl of Arundel. One of the crowning glories of Charles I was to commission, in 1629, Peter Paul Rubens to decorate the ceiling of the Banqueting House, and the result was three allegorical canvases representing 'The Union of the Crowns', 'The Apotheosis of James I' and 'The Peaceful Reign of James I'. Rubens' masterpiece was installed in situ in 1636, and when Hollar arrived in England he would have admired it and even been inspired in his choice of allegorical subjects.

The English Civil War lasted between 1642 and 1651, and during that span Oliver Cromwell ordered the execution of Charles I, which took place on 30 January 1649 in front of Whitehall Palace, 'thereby initiating the Commonwealth':

> Unable to control the Long Parliament, Cromwell purged it. Unable to win over the Irish and the Scots by persuasion, he invaded first Ireland then Scotland. His victory over the Scots at Worcester (1651) left him totally triumphant in the field. (Davies, 1997: 553)

The king's son, the future Charles II, fled to Europe where he spent the following nine years as a wandering fugitive living at a number of courts, including Versailles. When Cromwell died in 1658, he was invited to return to England as its monarch. On 29 May 1660, Charles II, aged thirty, became its king, and during his long reign he left his indelible mark on life, culture and, not least, dress.

Capturing the everyday on the printed page during the Restoration

The Restoration brought prosperity and wealth, noticeable in the fashion trade through which the fashion industry and commerce blossomed, with the East

India Company introducing *chintz* to England, whilst the silk industry brought by the Huguenots established its centre in Spitalfields.

Charles II was interested in town planning and embarked on a programme of construction, starting with St. James's Park, which had been vandalized during the Civil War, where he built a new avenue he named Catherine Street in honour of his wife, but it retained its popular name of Pall Mall: 'By 1716 when John Gay wrote *Trivia* or *The Art of Walking the Streets of London*, Pall Mall had become synonymous with luxury' (Ashelford, 1996: 111).

Two dramatic events dominated the first decade of Charles II's reign: the Great Plague and the Fire of London in 1665 and 1666, respectively, both recorded in the diaries of Samuel Pepys. But there was more to Pepys than his talent to chronicle his times, for he was a passionate lover of fashion.

Samuel Pepys was the son of a tailor and enjoyed buying clothes for his attractive wife, Elizabeth St. Michel. There are frequent references in his diary to their pleasurable trips to buy silk, lace, gloves and jewellery. But there were heated arguments too, when Pepys felt his wife had spent too much money or bought something without his approval. In fact most of the women Pepys had affairs with were involved in the fashion business, as it was standard practice to choose the most attractive girls to work in the seamstresses' stalls at the Exchange and for shopkeepers to use their wives to lure customers into their shops (Ashelford, 1996).

Pepys enjoyed shopping and often purchased 'gloves, stockings, lace and garters at the Exchange', shopped for linen inside Westminster Hall, especially from Betty Lane and her sister Doll, 'and both ladies granted him sexual favours over a long period of time' and enjoyed buying accessories from street sellers, such as 'hats, pins and bone lace' (Ashelford, 1996: 113).

We know what these street sellers looked like because their appearance was captured by Dutch-born painter and engraver Marcellus Laroon in *Marcellus Laroon's Cries of the city of London after the life*, indicating that they were drawn 'from nature'. The first forty images, which subsequently increased to seventy-four, were engraved by John Savage and published by Pierce Tempest in 1689. They provide a wonderful visual source of how Londoners (and at times visitors to London) from all social classes and with varied professions looked like and dressed thanks to Laroon, who presents us with a picturesque

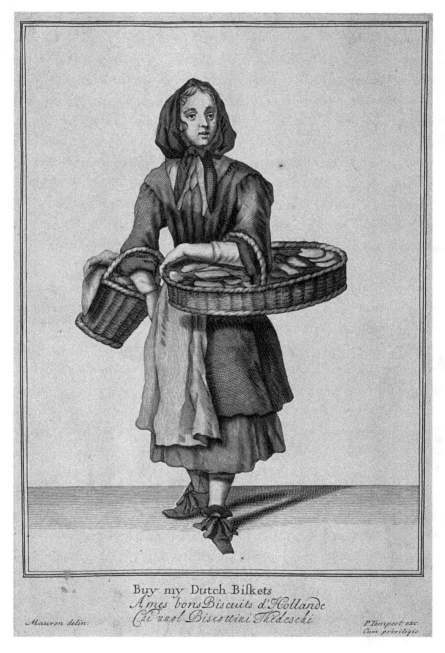

Figure 3.8 *Marcellus Laroon*, Buy my Dutch biskets. *In* Cries of London, *1689*.

gallery of people: water carriers, courtesans, a gentleman from Alsace and a clergyman, among others. In his choice of organizing the image on the page, Laroon was following the established template by representing a single image covering the entire page, complemented by a title and a few lines.

But there are exceptions, such as the charming example of a young man driving a donkey whose back is laden with wares, accompanied by the inscription: 'Lilly white vinegar – 3 pence a quart', telling us not only what was on offer but also the price. Two outstanding images, related to street entertainment, are titled *The Famous Dutch Woman*. In the first, a maiden dressed like a pageboy is mounting a tightrope and an ugly *Pulcinella* seen half-length in the left-hand corner is pointing up towards her, whilst in the second, she is fearlessly walking the tightrope by keeping her balance with a long rod.

Another example, titled *Buy my Dutch biskets* (Figure 3.8), represents a seller, not of any biscuits, but (patriotically?) Dutch biscuits and we wonder what separated them from English biscuits.

What we see at the *primary* or *natural* subject matter level is a young woman who carries a large basket on her left arm and holding a smaller one with her right, both filled with 'Dutch biskets'. She is wearing a three-quarter length man's jacket and striped apron over her dress and on her head a hood. Another image is *The Chair Mender* in which at the *primary* or *natural* subject matter level we see an old man carrying a heavy bundle of cane on his shoulder, dressed in a shabby belted overcoat with his breeches just visible on his right foot, complemented by stockings and square-toed shoes fastened with ribbons. The ensemble is completed by a hat with a low crown with the wide brim covering his face. In both instances the *secondary* or *conventional* subject matter level is revealed by the titles: a seller of biscuits and mender of chairs, but the key is found at the *intrinsic meaning* or *content* level.

Seventeenth-century images of *Cries*, representing the poor earning their living on the streets, have been interpreted as belonging to 'an iconography gradually becoming linked to constructions of national identity' (Radisich in Norberg and Rosenbaum, 2014: 56). An important antecedent was Annibale Carracci who drew such a series of street sellers from his native Bologna in the 1580s, adapted by printer Giuseppe Maria Mitelli and published in

1669 as *Di Bologna, l'arti per via d'Anibal Carracci* (Radisich in Norberg and Rosenbaum, 2014: 56).

But we notice that in the LACMA *Crieur d'oranges*, engraved by Jean-Baptiste Bonnart, Parisian street vendors were portrayed very differently; this particular street seller is dressed like a *gentilhomme*, comparable with Henri Bonnart's image of a French nobleman titled *Gentilhomme*. 'The orange seller wears a bi-corne hat smart black leather shoes with red tongues and a gentleman's coat, although lacking in intricate fringe, lace ruffles and embroidery applied on the surface of a gentleman's coat' (Radisich in Norberg and Rosenbaum, 2014: 57). If we compare him with Laroon's image of an oyster vendor, captioned *Twelve Pence a Peck oysters*, gone is the gentleman's attire and nonchalant swagger; instead, a scruffily dressed young man with a kerchief around his neck is hard at work pushing a wooden barrel which requires all his strength. And there is no question that this is a more credible image of a street vendor than Bonnart's balletic orange seller, and for this reason it has been suggested that the street vendors represented in the LACMA album are, unlike Laroon's realistic images, fictitious: 'The iron monger, the oyster vendor, the orange seller and the gentleman are representations – with the possible exception of Laroon's oyster vendor – all are fictions' (Radisich in Norberg and Rosenbaum, 2014: 58).

At the *intrinsic meaning* or *content* level, both the *Cris de Paris* and the *Cries of London* reveal that, in spite of these differences, they belong to a new category of painting which emerged in Holland during the seventeenth century: genre, invented as a consequence of a pioneering system of patronage created by the political circumstances that contributed to the creation of Holland as an independent state.

The United Provinces, better known as Holland, after the name of one of its seven northern provinces, won independence from Spanish occupation in 1609, becoming a confederation – the Dutch Republic of the United Provinces of the Netherlands – and the wonder of Europe, because of its wise political rule and support of a middle-class ideology, adhered to by all its citizens:

> Its sturdy burgher society widely practised the virtues of prudent management, democracy, and toleration. Its engineers, bankers, and sailors

130 *Images on the Page*

were justly famed. Its constitution (1584) ensured that the governments of the seven provinces remained separate from a federal council of state at The Hague. (Davies, 1997: 538)

Holland's tolerant attitude towards religion, philosophy, science and the arts engendered new categories of painting meant to reflect the new order: landscape, portraiture, still-life and especially *genre,* whose naturalistic accounts of everyday life allowed the painter to record 'the look, the manners, the character of those quotidian events, which comprise day-to-day existence', turning the painter into a 'Peeping Tom':

> Through them we enter the immaculate middle-class homes that were the pride and preserve of every Dutch *huisvrouw*, or venture into the fetid recesses of cafés patronized by boors, and peasants. Dutch genre painters depicted everything from the leisured refinements of the upper classes and the licit entertainments of simple burghers and tradesmen – a wedding feast, a game of cards or trictrac, or one of the rhetoricians' uproarious performances – to the romping free-for-all the village kermis, as well as the more iniquitous pleasures of Amsterdam's brothels and dancehalls. Here we meet the tailor and tattered ratcatcher, the soldier on bivuac and the itinerant gypsy, the neglectful maidservant and the nurturing mother, as well as all manner of mendicant and dandy. (Sutton in Arkins, 1984: 13)

The origins of Dutch *genre* can be traced to sixteenth-century Netherlandish painting initiated by Pieter Aertsen and Joachim Beukelaer, as I argued in Chapter 2, and the low-life images created by Christoph Weiditz and Hans Weigel, among others, can be incorporated within this category. A similar link can be established with representations of low life by the outstanding seventeenth-century *genre* painter Adriaen van Ostade:

> He is listed as a peasant painter. One asks oneself whether these thick-set, unwieldy men, good-natured, dullards and sharpers at once, can possibly be peasants. At any rate one never catches them doing any land-work. So far as they have a recognizable profession they are village musicians, beggars, cobblers, tinkers. Generally they are hunched up in the pub smoking,

drinking, gaming, and sitting peaceably with wife and child in the house or in front of the house. (Friedländer, 1963: 183)

Thus, the dramatis personae which populate Dutch genre paintings can be found in Laroon's images, in Abraham Bosse's *Ratcatcher* and the artists who worked for the LACMA *Recuel*: they belong together.

Another important but hitherto ignored link which can be established between genre painting and the images found in the *Cris de Paris* and the *Cries of London* is the system of patronage. They were all created for a wealthy clientele who could afford to buy and enjoy them in the privacy of their well-appointed homes. They found pleasure not only in looking at these *drolleries* but also in learning something about 'how the other half lives', very much as we do now, and this is what makes the images in the series of *Cris de Paris* and *Cries of London* relevant today: they speak to us across the centuries in the same language as 'Brueghel's, Brouwer's and van Ostade's *genre* – pictures' (Friedländer, 1963: 166), affecting us directly.

Charles II's Restoration period was brought to an end with his death in 1688, and what followed was the rule of a new dynasty, the Hanoverians, who between them ruled for 123 years. During this period England became a constitutional monarchy presiding 'over the acquisition and the loss of an empire, over the world's first Industrial Revolution, and over the rise of unprecedented naval power which rendered Britain uniquely immune from the Continent's affairs' (Davies, 1997: 637).

When the first George arrived in England, his name was Georg Ludwig, Duke of Brunswick-Lüneburg, Elector of Hanover, member of the ancient Guelph dynasty; he landed at Greenwich on 18 September 1714 and became George I, ushering in the Georgian period.

4

The eighteenth century
From the fashion doll to the fashion plate

Reconfiguring the paradox of the Enlightenment and its revolutions

'Dare to know' – this is what Immanuel Kant commanded in his essay 'What Is Enlightenment?' published in 1784, because daring to know required the investigative courage to dispel the accumulation of myths which clouded knowledge, and for Kant, 'Dare to know' had to be the motto of the Enlightenment. However, the more prosaic dictionary definition of *Enlightenment* is 'an eighteenth century philosophical movement stressing the importance of reason and the critical reappraisal of existing ideas and social institution' (*Collins English Dictionary*, 2005: 545).

The intellectual basis of the Enlightenment can be traced to the philosophical movements of the seventeenth century, especially René Descartes' Rationalism, and the British Empiricists: John Locke, George (Bishop) Berkeley and David Hume.

But if the intellectual roots of the Enlightenment can be traced to seventeenth-century philosophy, what were its links with the three revolutions: the French, the English (Industrial) and the American? Nor were they isolated phenomena; in fact any number of the revolutions – not necessarily political

or economic – such as the scientific revolution, the military revolution and recently even the sexual revolution, were all postulated as signifiers of progress (Honour and Fleming, 1992: 459).

The iconic event which marked the end of the Ancien Régime was the storming of Bastille on 14 July 1789. In its aftermath, the French Revolution unfolded in three phases: the first, which took place between 1789 and 1794, saw the transition from monarchy to the Jacobin regime and among its gruesome deeds was the deposing of the king and the massacre of his Swiss guards and the declaration of the Republic. The second phase, which lasted between 1794 and 1804, instituted the rule of 'a five men executive Directory', with the last phase dominated by Napoleon Bonaparte, who crowned himself emperor in 1804, ruling until 1815 (Davies, 1997: 694–701).

The 'revolution' in sartorial fashion

The direct expression of this period of historical transition was reflected in a radical change in attire from the excesses of the rococo to the streamlined classicism of the 'Directory' style inspired by the simplicity of the ancient Greek chiton.

The discovery of Herculaneum in 1709 and Pompeii in 1748 yielded spectacular results, and Johann Joachim Winckelmann placed these discoveries centre stage in his seminal book, *Reflections on the Imitation of Greek Works in Painting and Sculpture*, published in 1755.

Until the middle of the eighteenth century, the focus of classical scholarship had been Rome. But Winckelmann's short text was both a symptom of and a stimulus to change, and Rome – for so long pre-eminent as the centre of Western culture – was now regarded as having inherited the mantle from Athens. Greece was beginning to be perceived as the true original whose achievements were captured in Winckelmann's famous description of its *edle Einfalt und stille Grösse* (noble simplicity and quiet grandeur) (Harrison, Wood and Gaiger, 2000: 450).

Winckelmann's aesthetics contributed to an 'artistic revelation and conversion', and the two artists who embodied these neoclassical ideals were

a sculptor, Antonio Canova, and a painter, Jacques-Louis David. The latter discovered Winckelmann in Rome – where he lived between 1755 and 1768 – and his classicizing masterpiece, *The Oath of the Horatii*, based on a story by Livy and dramatized by Pierre Corneille, belongs to this period.

Antonio Canova too worked for Napoleon, but his best known work was dedicated to Napoleon's sister, Pauline: *Pauline Borghese as Venus Victorious*, 1805–8. Carved in luxurious marble, she is seen reclining on a classical couch, her hips encircled by drapery and in her left hand she is holding an apple, possibly a reference to the biblical Eve. But whilst Canova used allegory to turn the princess into a mythological being, David dispensed with academic norms and became a painter of his time, choosing to paint a society beauty instead: *Mme Récamier*. She is represented bare footed and attired in a fashionable, white dress inspired by the Greek chiton, with not a single jewel in sight: the perfect embodiment of Winckelmann's *noble simplicity*.

But it was not only the visual aspect of classicism which impacted on the Enlightenment but also its ethical and moral dimensions inspired by Athenian democracy and the philosophy of Socrates, Plato and Aristotle, whose *Nicomachean Ethics* provided a practical guide to achieving human happiness *(eudaimonia)*, for Aristotle, the highest good in life. The ethical tenets of Greek philosophy were adopted as the foundation of French post-revolutionary society and their most unmediated way of expression was dress: a democratic 'look' was meant to eradicate the distinction between the wealthy and poor, and what could be more appropriate than the model of Athenian democratic city states *(poloi)* ruled by the people *(demos)* created during the fifth century BC. David was quick to capitalize on these new ideals and employed them in his portrait of Mme Récamier (1800).

Visual representations of sartorial dress during the Directory period

In painting

Even before the French Revolution and even before Greek- and Roman-inspired fashion spilt into the streets of Paris, we find it in David's masterpiece,

136 *Images on the Page*

The Oath of the Horatii, which tells the brutal story of the fight between the Horatii and Curiatii brothers. In 1782 the *Comedie Française* staged Corneille's tragedy *Horace*, and David was profoundly impressed by its end, especially with the aged Horace's speech in defence of his sons who killed the Curatii, and decided to paint his own version. He travelled to Rome for that purpose and when the painting was finished, it was considered to be "'the most beautiful picture of the century," a *merveille*; one talked of "David's revolution'" (Friedlaender, 1974: 15).

Walter Friedlaender's description found in his book *David to Delacroix*, published in 1930, constitutes a thorough *primary* or *natural* subject matter level:

> One sees a yellow-brown canvas, the quiet colours flatly applied, set off only here and there (as in the cloak of the father) by a powerful local red; a composition in part pathetic and declamatory, in part empty: the three Horatii, arrayed one behind the other in profile, step forward, their arms raised in oath towards the three swords which their father, the ancient Horace, holds out toward them. In contrast to this altogether manly, strongly expressed, and plastically executed group, the two women, broken by their conflicting emotions, are pushed to one side as a quiet, prettily stylized foil. These few figures, plus the small background group of the children and their nurse, are placed on a wide stage, closed at the back by arches of the heavy, baseless, Doric columns. (Friedlaender, 1974: 16)

We notice the usual concerns of the art historian for composition, colour, balance, symmetry and the manner in which the narrative is conveyed through movement and gestures, but apart from a cursory reference to Doric columns (by definition baseless) as part of the architectural setting, nothing tells us about the one element that would have timed the narrative: costume.

Another analysis provided by Michael Levey belongs more to literary fiction than art history:

> David tells a simple story in a simple way; illuminated with hallucinatory clarity, and shot through with frightening, dramatic intensity. The picture shrieks of the sword; nowhere does the light glitter more threateningly than on the cluster of blades – unless on those sword like arms thrust

The Eighteenth Century 137

out so greedily toward them. Though there is poignancy in the group of
grieving women, it is subordinated to stern patriotism. Men toe the line
at the moment of exultation and self-sacrifice. In this republican world
there is no place for anything else: nothing to break the unrelenting
claustrophobic courtyard of bare brick which completely fill the
background. (Levey, 1966: 190)

Here, the *primary* or *natural* subject matter level has been dispersed with
altogether; instead focus is on the *secondary* or *conventional* subject matter
level, whilst the *intrinsic meaning* or *content* level reveals that David intended
not so much to depict a historical event from the seventh century BC but to
convey a universal message of heroism, self-sacrifice and stoicism: 'The whole
Horatii story is one of exaggerated *pietas,* involving a series of deaths through
duty which culminate in the high Roman virtue of a brother killing his sister
for loving the Republic's enemy' (Levey, 1966: 191). Notwithstanding that
David was happy to serve Emperor Napoleon by becoming his court painter, he
started his career as a republican who justified Maximilien Robespierre's Reign
of Terror as a bloody means towards a noble end by replacing the absolute
monarchy of Louis XVI with an equalitarian republic. Thus an *iconological*
interpretation of *The Oath of the Horatii* reveals that David conflated Roman
republican virtues with those of the French Republic.

A third example by Thomas E. Crow provides yet another analysis of
David's painting:

The Horatii, of course is not only dissonant, unnuanced and disjointed;
the control David renounces – that of conventional academic practice
– he reasserts on another level. First of all there is in the picture's visibly
mathematical rationality, the rigorous geometrical structure which
underlies the composition: the spacing of the figure groups, the perspective
construction, the heights of the columns, even the angles of limbs, swords
and spear are inter-related in a precisely adhered to geometry based on the
golden section. (Crow, 1985: 237)

In this description geometrical structure is emphasized to the detriment of other,
equally important features, but what all of the preceding descriptions share is a

glaring omission of even mentioning costume, given that David valued his Roman costumes as much as all the other visual elements he used at the *secondary* or *conventional* subject matter level to tell a story which took place a long time ago.

If we turn to histories of dress, the method of analysis tends to be focused on the material object, resulting in a one-dimensional analysis which tells all about each item of clothing and how it was put together, but nothing about the painting as the context they belong to, rendering any attempt at an *iconographical/iconological* interpretation futile. David paid special attention to costume and I would like to provide my own *iconographical/iconological* interpretation of *The Oath of the Horatii*, which incorporates his formidable knowledge of Roman attire.

At the *primary* or *natural* subject matter level what the eyes see are the three Horatii aligned in a staggered row: the young warrior seen in the foreground wears a *subcutula* (a short tunic) topped by the *tunica exteriorum* (the outer tunic) and over these, the *toga gabiana* (military style) wrapped around the waist and fastened by a wide belt. All three brothers wear splendid Roman helmets consisting of 'a smooth crown, a neck-guard, and in some cases a fixed or movable visor and cheek-guards' (Boucher, 1997: 119–28). The two mournful women seated in the right hand corner are wearing ankle length *stolas* (tunics) of different colours on top of their woollen *subcutulas* (under tunics) fastened on the hip with a flat belt: *succinta* and the *cingulum* fastened below the breast (Boucher, 1997: 119–28). The woman wearing a white *stola* has removed her red *palla* (mantle) seen draped on a chair. She is barefoot and her hair is decorated with a blue band – the *vitta* – tied in a bun at the back of her neck.

Such attention to detail indicates not only a desire for historical accuracy but also a special interest in dress, and little wonder because when David lived in Rome, he came under the influence of Joachim Winckelmann. And after visiting Pompeii in 1779, he filled twelve sketchbooks – of which five survived – with drawings of the 'Eternal City' (Johnson, 2006), proving that Rome was instrumental in transforming David into an apostle of neoclassicism.

On stage

The theatre became a popular form of entertainment ever since the *Comédie Française* was founded by Royal Decree in 1688 to popularize the tragedies

of Corneille and Racine and the comedies of Molière. Before the French Revolution the company performed in the *Salle des Machines* at the Tuileries Palace, subsequently acquiring its own building designed by Peyre and Wailly, at present the *Odéon*. After the death of Corneille in 1673, the *Comédie Française* faced competition from the *Comédie Italienne* – deeply rooted in the tradition of the *commedia dell'arte* – which became more popular than its French counterpart (Hartnoll, 1989). The *Comédie Française* enjoyed, however, a last flourishing with Voltaire, who not only wrote plays and acted in them but also built several playhouses including one in his town of birth, Ferney. Voltaire's earliest tragedies were 'classical in form', even showing the influence of William Shakespeare, 'whom Voltaire was the first Frenchman to admire, though with reservations.' But all that was about to change:

> His later plays are unashamedly *drames bourgeois*, worse still, *comedies larmoyantes*. In them he mingled tragedy with comedy, and employed crowd scenes and spectacular effects in a way which completed the divorce of French tragedy from its seventeenth century roots with the result was that Voltaire completed the divorce of French tragedy from its seventeenth-century roots. (Hartnoll, 1989: 154)

In 1789, François Joseph Talma – Napoleon's favourite actor – was offered a small part in Voltaire's tragedy *Brutus* performed at the *Comédie Française* and he shocked his audience by appearing attired in an authentic Roman toga designed by his friend David.

The theatre was a prime mover in reviving the 'values and the culture of the Roman Republic' through the tragedies of Corneille and Racine and Talma's revolution in costume, and because of their accessibility, theatre costumes were replicated through the 'grandiose scenography' of street spectacles (Morini, 2006: 45).

But this process was gradual and although the historical sources of inspiration available were accurate, the way they were adopted was less so:

> The look of the noble draped beauty of gods and heroes was revealed again to newly appreciative European eyes. These same eyes soon observed the glaring discrepancy between the garments actually worn in antiquity and

those worn by theatrical performers purporting to represent the ancients. Reform was inevitable. (Hollander, 1993: 275)

It became imperative to alter the baroque tradition of representing classical heroes on stage, so that 'the uncluttered lines and clear colours worn by people in the lately unearthed Pompeian frescoes', looking 'wholesomely simple' could be presented on stage and the actors representing classical heroes on stage were expected to wear 'simple robes of authentic virtue and honesty, and not parade the plumes, embroidered silks, and curled wigs that had adorned the persons of dissolute, pleasure-loving kings and their self-congratulatory theatricals' (Hollander, 1993: 285–6).

This transition from baroque to historical costume on stage was performed by a new crop of costume designers who replaced Louis-René Boquet, 'a decorative artist greatly skilled in creating delicate Rococo confections that were firmly based on the stiff and standardized costume shape' (Hollander, 1993: 185). Among this new generation were two painters trained in Rome, Jean Simon Berthélémy and François Guillaume Ménageot, very much in touch with popular trends.

Consequently, 'Bérthélemy and Ménageot plunged into a sea of togas and sandals and broadswords, tunics, fillets – the whole "Davidian" property shop'. Even more radical than the accuracy of their costume designs was their novel approach to stage design. Whilst Boquet – who had an academic training – produced sketches summed up as 'stock figures, mannequins wearing fancy dress', Berthélémy and Ménageot created 'dramatic compositions, showing several characters at once in various postures and groupings appropriate to the drama. The clothes themselves are not very inventive (the same old snakes and bat wings, suitably updated, appear on the "Fury") but the mode of composition, as if the stage were visualized as a painting (by David, of course), is a real innovation' (Hollander, 1993: 285–6).

In fashion magazines

An analogous relationship to that between painting and theatrical costume and stage design can be found in fashion magazines and the way they used paintings to alter fashion images. The first specialized fashion magazine, *Le*

Cabinet des Modes, was published between 1785 and 1786 by Jean Antoine Brun (aka Le Brun Tossa), but subsequently its title changed, becoming between 1786 and 1789 *Le Magazine des Modes nouvelles françaises et anglaises* and finally, between 1790 and 1793, to *Le Journal de la mode et du goût* (Miller in Bartlett, Cole and Rocamora, 2014: 13–24). Their main subject matter was fashion and we find on the front page of *Le Cabinet des Modes* a text explaining that its aims and objectives were to describe fashion 'in a clear and precise manner and represented by engraved and illuminated plates', which required 'an exact and prompt knowledge of all clothing and finery worn by persons of the one and the other sex, as well as new furniture of all kinds, home decoration, the latest carriages, jewellery, as well as the goldsmith's art and in general all that fashion offers as singular, agreeable or interesting in all its genres'.

In a lovely plate printed in the November 1785 issue of *Le Cabinet des Modes* we see a young woman wearing a green dress, with the caption 'Femme en fourreau vert à la Levite' and the description underneath the image starts with the line 'Elle répresente une Femme en fourreau vert à la Levite' and against the word 'Levite' a footnote from which we learn that in all descriptions the use of italics refers to technical terms. But there is no additional information about the way the word 'Levite' should be understood.

At the *primary* or *natural* subject matter level we start with the young lady's straw hat with a high crown decorated with a violet ribbon and a cockade and the two ends of the ribbon hanging down her back. Her hairstyle is *demi-hériffon* finished by two floating loops, whilst the rest of the hair hanging behind is styled *à la Conseillése*. Then we move downwards to the decorated linen scarf, black spotted satin *mantelet*, the linen apron and a violet satin petticoat; the elegant outfit is complemented by white shoes decorated with violet rosettes. The last line is interesting because it specifies that dresses and scabbards 'à l'Anglaise, à la Turque, à la Janséniste, à la Circassienne' were also fashionable.

The exoticism of these names reveal exotic sources of inspiration: the Orient, history and religion (Jansenists), but the key influence was the theatre and the term *à la Lévite* comes from the theatre, specifically from Jean Racine's play *Athalie* – performed at the *Théâtre Français* – in which a Jewish priestly costume was worn:

This straight gown, with its shawl collar and back pleats, was held at the waist by a loose scarf Marie-Antoinette contributed to its popularization by wearing it during her first pregnancy in 1778.

There were other 'Oriental' gowns: the circassiene had an under gown with long, very tight sleeves with an over gown tucked up all round and short sleeves cut straight across; the levantine consisted of a sort of pelisse edged with ermine, opening over an under gown and petticoat; the sultana gown, which was short-sleeved and completely opening front, stood out mainly because of the sense of contrasting colours for the different parts of the gown, as was the case for the circassienne. (Boucher, 1997: 300–3)

At the *secondary* or *conventional* subject matter level the specification *à la Lévite* comes from Jean Racine's tragedy *Athalie* written in 1691 based on the Old Testament, but it is at the *intrinsic meaning* or *content* level when it starts being interesting. Jean Racine was an *ancien*, in other words a traditionalist, actively involved in the *Querrelle des anciens et des modernes*, the controversy which split the French Academy in 1687. It was sparked by a debate regarding the merits of antiquity versus those of modernity, when Charles Perrault read his poem *The Century of Louis the Great* comparing the reign of Louis XIV with the Age of Augustus:

Beautiful Antiquity has always been an object of veneration/but I do not believe that it has ever been worthy of adoration./ I look upon the Ancients without bending the knee/they were great it is true, but they were men like us/without fear of being unjust we may compare/the century of Louis with the century of Augustus. (Perrault quoted in Harrison, Wood and Gaiger, 2000: 15)

In the audience was Nicolas Boileau, who published in 1674 *L'art poétique* and became one of the key proponents of the superiority of Greek and Roman literature to Modern literature, declaring Jean Racine to be its canon of excellence. The *modernes* on the other hand wanted to be rid of classical canons and write about their own times. Consequently, the entire literary and artistic establishment of the eighteenth century was influenced by the *Querrelle*:

Writers were searching for new forms of expression. They were no longer trying to create – like the Ancients – timeless works – but works which

Figure 4.1 *Woman in green dress.* Cabinet des modes. *November 1785.*

144 *Images on the Page*

concerned their times. And we know only too well the role played by the French intellectuals and writers in the hatching of the French Revolution. (Deshusses and Karlson, 1994: 285)

At the *intrinsic meaning* or *content* level, the woman dressed *à la Lévite* should be interpreted as a creation of Jean Racine and that aligns her to the Ancien Régime, which justifies her conservative attire even beyond its links with Racine's play, *Athalie*.

Not so with *Le magazine des modes nouvelles françaises et anglaises* whose title confirms an important new influence on French fashion: English fashion. Nor was this the first time: when philosopher Jean Jacques Rousseau arrived in England in 1762, he received a pension from George III whilst he was busy befriending the finest English philosophers, among them Edmund Burke and David Hume. During the same year his *Social Contract*, in which he outlined his political theory, was published. It opens with the splendid lines: 'Man is born free, and everywhere he is in chains' (Rousseau in Russell, 1982: 669). Its key tenet – reflecting the influence of Thomas Hobbes – was to reject man's 'state of nature' which would be 'solitary, poore, nasty, brutish and short' (Hobbes, 1985: 186) in favour of a societal existence based on a social contract:

The *Social Contract* became the Bible of most of the leaders in the French Revolution, but no doubt as is the fate of Bibles, it was not carefully read and was still less understood by many of its disciples. (Russell, 1982: 674)

Le magazine des modes nouvelles françaises et anglaises testifies to the success not only of English attire in France but the English way of life, perceived to be closer to nature than culture and reflecting thus the influence of Jean Jacques Rousseau.

In the December 1787 issue, one fashion plate represents a splendid aristocratic trio and what the eyes see at the *primary* or *natural* subject matter level is a young man wearing stripes, flanked by two ladies: the young woman to the left wears a yellow and white skirt with a matching *caraco* and a red waistcoat underneath, whilst the woman to the right wears a blue and white dress bordered by a double flounce. The young man wears an elegant three-piece outfit: a long overcoat with yellow and green stripes, a contrasting red

Figure 4.2 *Three fashionable people.* Magazine des modes nouvelles françaises et anglaises. *December 1787.*

justaucorps and underneath a waistcoat. Whilst the simplicity of their 'look' reflects 'Anglomania', their rococo accessories – such as the *gargantuan* hats worn by the ladies and even more so the accessory the young man holds in his left hand which is the most enormous brown furry muff imaginable, decorated with a red cockade – create a comical contrast. The ladies too sport muffs: the lady to the right is wearing hers decorated with a red ribbon, whilst the one to the left holds in her right hand what looks more like a shaggy dog hanging in mid-air.

Even after the French Revolution, among the aristocracy men continued to wear their colourful attire and in the June 1790 issue of *Le journal de la mode et du goût*, an image titled 'Young man of fashion' represents an elegant man who is not that different from the elegant trio in the December 1787 issue of the *Magazine des Modes nouvelles françaises et anglaises*.

At the *primary* or *natural* subject matter level he is seen wearing a vividly coloured three-piece suit, consisting of a tight-fitting red overcoat and under it a pale yellow waistcoat cut straight across the waist. The breeches finishing below the knee in a panel are decorated with a ribbon and completed by white stockings and tight leather boots. He wears a bouffant powdered wig and in his right hand he holds his tricorne decorated with the cockade of the French

146 *Images on the Page*

Revolution. At the *secondary* or *conventional* subject matter we see that this is indeed a fashionable man, but is he dressed in the 'latest' fashions? His attire could be described as a combination of old and new: the tricorne is of the revolution but not so the powdered wig which is a remnant from the Ancien Régime.

At the *intrinsic meaning* or *content* level the message which emerges loud and clear is the fast political and social changes captured by it, summed up perfectly in an image published in the 1790 issue of the magazine representing a young woman dressed in an outfit reflecting the values of the French Revolution, which becomes at the *secondary* or *conventional* level interpretation, a signifier of how the revolution started, with the formation of the National Assembly, the *Constituante* (which was given full power to abolish the old system of the Ancien Régime) followed by the 'introduction of a consolidated Constitution' (September 1791) calling for new elections (Davies, 1997: 695).

The simple, white dress then was about the new and that was expressed by a 'look' that rejected the arcane structuring of rococo attire and replacing it with *Liberté, Fraternité* and above all, *Egalité*. The message of this dress is clear and simple, and this is what the eyes see at the *primary* or *natural* level: the young lady is dressed in a light white dress, possibly cotton or muslin with two rows of flounces decorating the skirt three quarters towards the ground with a third decorating the hem, complemented by a blue caraco fastened tightly on her tiny waist and opened widely in front to reveal the white skirt. Her curly black hair is fastened at the back by a discreet, but special ribbon with the *tricolore* of the revolution: red, white and blue.

And this is what the *intrinsic meaning* or *content* level reveals, namely that fashion magazines constituted one of the most important sources of information regarding the historical and cultural changes brought about by the French Revolution expressed through fashion.

The disappearance of court attire protocol signalled a new code of dress for the three estates (clergy, nobility and the bourgeoisie) created by the French Revolution, but whilst the first two preserved the established code of dress, the Third Estate, consisting not only of the bourgeoisie but also of the workers and the peasants, brought changes. The 'bourgeoisie and the people of Paris discovered the communicative power of dress, a power no longer restricted

Figure 4.3 *Constitution style dress, 1790.* Journal de la mode et du goût. *1790.*

to the old hierarchical connotations, but which was flexible and could accommodate multiple meanings' (Morini, 2006: 34), and they communicated their mission through sartorial fashion.

Society life in France was superseded by political assemblies and the Third Estate wore black attire, which became the sombre uniform worn by French officials and we find one example in the May 1790 issue of *Journal de la mode et du goût* in an image titled 'Uniform of official'. It represents a young man wearing a long and narrow redingote covering his breeches so that only the stockings are visible, complemented by the obligatory tricolour sash draped on the right shoulder. Under his right arm he carries a red book whose title is visible: it is the *Report of the National Assembly Sessions.*

The genesis of the Directory style

The genesis of the Directory style continues to be disputed, but the general consensus is that it may have originated from the *robe à la créole* or the *chemise* dress from the French West Indies, regarded in Europe as 'revolutionary in its simplicity' for in its early form it was merely a tube of white muslin with a drawstring at the neck and a sash at the waist (Ashleford, 1996: 175). An interesting theory suggesting that visual sources made a crucial contribution to fashion was proposed by Anne Hollander who argued that fashion was based on visual sources: painting, sculpture and, later, photography and cinematography, because, the primary function of Western garments was to

> contribute to the making of a self-conscious individual image, an image linked to all other imaginative and idealized visualizations of the human body. Any such garment has more connection with the history of pictures than with any household objects or vehicles of its own moment – it is more like a Rubens than like a chair. Western clothing derives its visual authenticity, its claim to importance, its meaning and its appeal to the imagination, through its link with figurative art, which continually both interprets and creates the way it looks. (Hollander, 1993: Introduction)

A different influence from that of the lofty fine arts on the 'new look' came from the streets: a 'street style' which may have stemmed from the *marchandes de modes* and the ingenuity of the fashionable young men and women who felt free to become the *jeunesse doré* and whose excessive manner of dress attracted them the labels of *Incroyables* and *Merveilleuses*.

In 1795, at the start of the Directory period, the *Incroyables* 'wore what was essentially the costume of an English country gentleman, but with all the details of colour, cut and ornament carried to an extreme to create a calculatedly sloppy and careless appearance'; meanwhile the *Merveilleuses* 'wore clinging muslin dresses that fully revealed the female figure. Their exaggerated version of classical dress gave rise to the apocryphal story that the ultra-fashionable dampened their gowns with water to achieve the desired result' (Ashleford, 1996: 176).

The magazine which best responded to the relaxed mood of the Directory period was *le Journal des dames et des modes* started by Jean Baptiste Sellèque in 1797, until 1801 when it was taken over by Pierre Antoine Leboux de la Mésagère. Sellèque, who began his career as an abbé teaching philosophy at the distinguished College de la Flèche, ran the magazine until his death in 1831 when it changed owners, but by 1836 it ceased publication. The magazine provided a vivid portrait of the Directory period, at the point when it was possible to return to the brutality of the French Revolution with a degree of benign nostalgia; thus a fascinating plate titled *Coiffure en porc-épic et a la Titus* specified that the plate was 'designed after nature' on the Boulevard des Capucines.

The 'porcupine' hairstyle was created in solidarity with the victims whose hair was cut short before they were to be guillotined. But a different reality emerges if we compare this witty image of the lady dressed *all'antica*, wearing an expensive scarf and fashionable *cothurni*, with a drawing of Marie-Antoinette by David before she was executed on 16 October 1793, true to the grim practice of cutting the hair of the condemned before they were guillotined.

Another, equally lugubrious example is linked with *le bals des Victimes*, organized after '9 Thermidor' (27 July 1794), the date which commemorated the arrest and execution of Robespierre, on '10 Thermidor' (28 July 1794), and its participants had to wear black

in chilling mockery of the Terror (or did they mock themselves for having succumbed to such horror?). Some of the dancers had their hair cut *à la victime* and wore red shawls in recollection of those thrown over murderers when executed. Some women wore a red ribbon round the neck in imitation of the cut made by the blade of the guillotine and this somewhat sinister theme continued into the late 1790s, when there was a fashion for scarlet ribbons crossed over the bodies of women's dress, such *croisures à la victime* indicating that their wearers would sacrifice everything for their lovers. (Ribeiro, 1988: 124)

The 'revolution' of the fashion plate

The proliferation of fashion plates after 1750 testifies to the growing interest in people's way of dress and one such was *La Gallerie des modes et des costumes français* started in 1787, still in need of proper academic research (Roche, 1994: 14), whose full heroic title was *Gallerie des modes et des costumes français dessinés d'après nature. Gravés par le plus Célèbres Artistes en ce genre, et colorés avec le plus gran soin par Madame Le Beau. Ouvrage commence en l'année 1778. A Paris chez le S.rs. Esnauts et Rapilly, rue St. Jacques, à la Ville de coutances. Avec Priv. Du Roi* (Morini, 2006: 29).

An important characteristic was their focus on variety such as social class and ethnicity, with titles like *The Governess*; high-class exoticism: *gowns à la circassiene* and *à la australiene*; but above all their political endorsement of the royal family, whose modernity constituted 'a milestone in the perception of the evolution of habits' (Roche, 1996: 15). Their most radical innovation, however, which seems to have passed unnoticed, was that the outfits were 'drawn after nature' by painters who pioneered a new approach to fashion images different from the established practices of the anonymous illustrators of the marionette-like bearers of elegance seen in fashion magazines. The streets and places of entertainment where the Parisians enjoyed themselves provided an accessible source for the study of the clothes worn by the wooden-like mannequins, illustrated with loving accuracy on the printed page.

But what seems to have also passed unnoticed is the source of inspiration for illustrating the wearers of the lovely clothes represented in these images:

The Eighteenth Century

it is possible that the reason why they appeared so wooden, is because they were wooden! They were in fact the popular fashion dolls which disseminated the latest fashions from Versailles to the courts of Europe, before the fashion magazine came into being. For where would these illustrators (given that there was no antecedent to inspire them) turn for inspiration? They turned to fashion dolls:

> The dolls were eagerly discussed at the Italian, English and French courts, offered as wedding presents and adorned the collections of curiosities made by the European nobilities. In France, the Hotel de Ambouillet and les Précieuses devoted exhibitions to these fragile mannequins, made of wax, wood or porcelain, their clothes changing with the season. The shops of the rue Saint-Honoré were quick to organize the manufacture and adornment of these emissaries of French fashion, which in the eighteenth century were despatched monthly to the four corners of Europe and the world. (Roche, 1994: 474–5)

After the French Revolution, all that changed and so did the fashion image. The anonymous illustrators who turned – as I argue – to fashion dolls for inspiration, were replaced by professional painters employed as illustrators who worked 'àpres nature', finding inspiration in real life. We know at least four names: Claude-Louis Desrais, Pierre Thomas Leclére, François-Louis-Joseph Watteau (the great nephew of Antoine Watteau) and Augustin de Saint-Aubin (Morini, 2006: 32).

Whilst the First and Second Estates still provided the main inspiration for these images, it was the bourgeoisie, the merchants, workers and peasants of the Third Estate who were becoming increasingly visible on the streets and promenades of Paris, who attracted the interest of the illustrators.

Thus in the example titled *Promenade*, at the *primary* or *natural* subject matter level what the eyes see is an enchanting image of a young lady with a huge wig, dressed in an opulent open overgown and matching undergown, walking her miniature poodle, whilst a young man dressed in black – perhaps a member of the exclusive First Estate – is bowing in front of her. Both of them seem to delight in their casual encounter during their promenade; and both the young lady dressed in rococo style and the young man attired in black

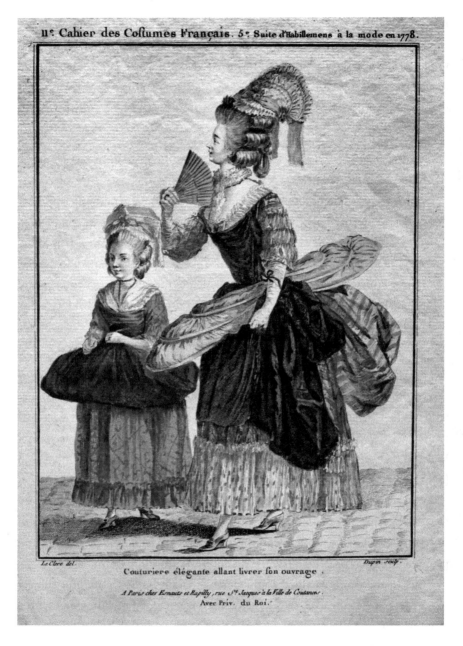

Figure 4.4 Couturiere élégante *delivering panniers to her client*. La Gallerie des modes, et des costumes françaises *(started in 1788).*

The Eighteenth Century 153

certainly belong either to the First or Second Estate and are therefore part of the old social order and this is confirmed by the date, 1778, when the album was first started and it provides us with the *secondary* or *conventional* subject matter level.

The fashion magazines and fashion plates published in France during one of the most turbulent periods of its history are an accurate mirror of their times and whilst the fashionable pair represented in *Promenade* belong to the Ancien Régime, not so the way they are represented on the page, as comparison with the wooden mannequins (or dolls?) used in *Cabinet des modes* and its subsequent versions reveals.

What we learn, therefore, at the *intrinsic meaning* or *content* level is that these images were replaced by realistic representations drawn 'after nature'. This wind of change extended also to the choice of characters, specifically those selected from the Third Estate, and one such is the example of a dressmaker accompanied by a young girl, perhaps an apprentice or her daughter, carrying a set of panniers, whose title *Couturiere élégante* confers a certain dignity upon her lowly métier.

As the century was drawing to a close, the early signs of new styles in art and dress inspired by romantic heroes and heroines, heralded the dominance of emotions over reason and its most immediate expression can be found not in paintings or literature, but in what people were wearing in the streets of Paris. Romanticism had arrived!

5

Capturing modernity in nineteenth-century France and England

Paris and *La Parisienne*

In the much quoted salon review published in 1863 dedicated to illustrator Constantin Guys (referred to therein as 'the painter of modern life'), poet and art critic of the *Salons*, Charles Baudelaire, defined modernity as 'the transient, the fleeting, the contingent; it is one half of art, the other being the eternal and the immovable' (Baudelaire, 1972: 403). In the same essay, Baudelaire introduced his much quoted aphorism about fashion: 'All fashions are charming', but then altered it to 'all were legitimately charming in their day' (Baudelaire, 1972: 426–7). By switching from the universal 'all' to the particular 'in their day', Baudelaire established the transitory nature of fashion, aligning it at the same time to art. And it was this elusive dimension of 'transitoriness' which seduced artists such as Edouard Manet and the impressionists, because it embodied the essence of modernity, and what better signifier than its most transitory manifestation: fashion, embodied by *la Parisienne*.

But who was this *la Parisienne*? Arsene Houssaye, editor of the weekly literary and artistic magazine *L'Artiste*, summed up *la Parisienne* in the August 1867 issue as follows:

The Parisienne is not in fashion, she is fashion – whatever she does – whatever barbaric outfit she decided to wear. When a provincial walks down the boulevard, one recognizes that her dress is brand new, the dress of the Parisienne could well date from that very instant, from Worth or from any ordinary seamstress, and it will appear as if she's been wearing it for a certain time. The Provincial is dressed by the dress, the Parisienne wears the dress. And how much this dress is hers and not another's. The dress is supple, the dress caresses her like a woman caresses a dress. Then she takes on a romantic sentimental mood, her train languishing. (Houssaye in Groom, 2012: 256)

The painter who embodied Houssaye's *Parisienne* was Claude Monet in the portrait of his nineteen-year-old mistress Camille Doncieux titled *Camille (The Woman in a Green Dress)*, painted in 1866.

At the *primary* or *natural* subject matter level what the eyes see is a full-length representation of a pretty young woman, wearing a silk dress (*robe de promenade*) with green and black stripes and a fur-trimmed fitted coat (*paletot*). What renders her outfit special is that Monet departed from established norms used by fashion portraitists, the so-called *peintres couturiers*, who used fashion plates and photographs for accuracy purposes, and created his own fashionable ensemble not for accuracy purposes but as a means of capturing modernity, oblivious to the fact that 'the dress appears slightly too large for her, and the train is too long for a walking dress' (Ribeiro, 2017: 358).

In his review of the 1879 *Salon*, Joris-Karl Huysmans – author of the notorious *À Rebours*, regarded by Oscar Wilde as the manifesto of decadence – commented that some artists are only 'excellent couturiers' who dress their sitters like mannequins 'under the pretext of modernity'. But he considered the impressionists superior in the way they interpreted rather than reproduced fashionable attire (Huysmans in Groom, 2012: 96). Monet did just that: he captured Camille's 'look' by eliminating the cage crinoline (the crinoline did not disappear until 1868 and was still used in fashion illustration) and altering the bouffant silhouette to an attenuated line, emphasized by its long train.

At the *secondary* or *conventional* level, the subject matter is revealed to be a nineteen-year-old woman whose name is Camille. At the *intrinsic meaning*

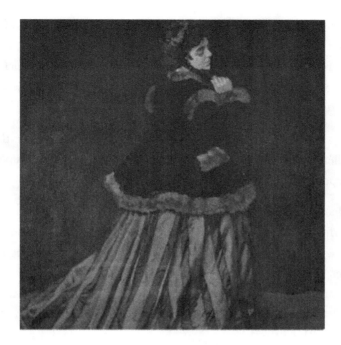

Figure 5.1 *Claude Monet,* Camille (The Woman in a Green Dress), *1866. Oil on canvas, 81.2 × 55.2 cm. Muzeul Naational de Arta al Romaniei, Bucharest.*

or *content* level we learn that she was also Monet's mistress, but what links the image to Baudelaire's definition of modernity is that Camille is the embodiment of Houssaye's *la Parisienne*.

The concept of *la Parisienne* originated in the literature of the second quarter of the nineteenth century, specifically the writings of Honoré de Balzac, and was subsequently purloined by visual artists.

Countless manuals of etiquette and courtesy describe *la Parisienne* 'as having no need to be pretty (although it helped), but to be charming and witty and to have good taste in dress and appearance' (Ribeiro, 2017: 398). Examples of her representation in the visual arts abound, and apart from Monet, we find her in Renoir's and Manet's own versions: Renoir's *La Parisienne*, exhibited at the First Impressionist exhibition held at Nadar's studio in 1874, is a portrait of vaudeville actress Henriette Henriot wearing 'a *toilette de ville*, the city costume painters preferred to depict as most representative of modern Paris' for it was worn by women on foot and not in a carriage, consisting of

a matching bodice, skirt and *tablier* (a draped up overskirt); even the band of velvet round her neck, the small hat (*capote*) and the leather gloves are of the same 'heavenly blue', as one critic described the colour, which Renoir created by loose strokes of paint and fine glazes to create the different shades of blue. (Ribeiro, 2017: 400)

Manet's *La Parisienne*, painted one year later, represents another thespian, actress Ellen Andrée, wearing a heavy black silk dress, criticized as not being fit for purpose, because it was

intended as walking dress (she carries a collapsible umbrella), it looks too formal for a *toilette de ville*, and has an air of the fancy dress about it. The upper half of the figure looks rather like a young gallant with a high necked doublet, small ruffled white collar, a jewelled chain and a rakish, slightly tilted hat; this might possibly be the result of a visit made by Manet with his Dutch wife, Suzanne, in 1872, to the Frans Hals Museum in Haarlem. (Ribeiro, 2017: 401–2)

It transpires therefore that both renderings of *La Parisienne* were found wanting. Thus the costume worn by Renoir's lady was deemed 'to overwhelm the figure, to create a rather doll-like, stilted fashion-plate effect, and lacks the overall harmony which Baudelaire wished to see in women's appearance' (Ribeiro, 2017: 400). Manet did not fare better, for his painting was regarded as 'neither a portrait nor the chic Parisienne who could step out of a fashion plate or an advertisement' (Ribeiro, 2017: 402).

But there is good reason why neither Renoir nor Manet, anymore than Monet, would not have attempted to aim at capturing the 'real' *la Parisienne* as she promenaded the boulevards of Paris. As painters, their concern was with making art which submitted to aesthetic rather than realistic criteria of representation and therefore had little interest in the minutiae of the garments worn by their sitters; that was left to fashion magazines.

At the *intrinsic meaning* or *content* level, Renoir's, Manet's and Monet's portraits are revealed as symptomatic of the political and social changes introduced by Napoleon III, which altered forever the fabric of French society. The starting point was the programme of modernizing Paris that Napoleon

Capturing Modernity in Nineteenth-Century France and England

embarked on with his architect Georges Eugène Haussmann, which consisted of the brutal demolition of large quarters of medieval Paris and replacement by *grands boulevards*, splendid *hôtels particuliers* built for the new elite bourgeoisie and flagship *grands magasins* – advertised in the ever-increasing number of fashion magazines – whilst photographers, painters and writers alike strived to capture its vitality:

> With the rise of the department store, the advent of ready-made clothing and the proliferation of fashion magazines, those at the forefront of the avant-garde, from artists such as Edouard Manet, Claude Monet, Berthe Morisot and Pierre-Auguste Renoir, to writers such as Charles Baudelaire, Stéphane Mallarmé and Émile Zola looked with a fresh eye to contemporary dress, embracing fashion as the quintessential symbol of Modernity. The novelty, vibrancy, and fleeting allure of the latest trends proved seductive for a generation of artists and writers who sought to give expression to the pulse of modern life in all its nuanced richness. (Groom, 2012: Foreword 22)

But who were, in reality, these *Parisiennes?* We are informed about their 'fashionability' but told nothing about their social status in Napoleon III's empire; thus we are informed that Monet's sitter, Camille, was his nineteen-year-old mistress but do not know where she belonged. We know also that in the case of Renoir and Manet, the models for their respective *La Parisienne*, Henriette Henriot and Ellen Andrée, were actresses, which usually meant that they were *demi-mondaines*, famously embodied by Proust's courtesan Odette de Crécy whose character was inspired by Manet's model and lover Méry Laurent. They were also the dramatis personae who populated the world of Edouard Manet, who portrayed one such *demi-mondaine*: the courtesan Victorine Meurent he famously painted naked in *Le Déjeuner sur l'herbe* and *Olympia*.

But this was not the whole story: there was another class of women who never made it to the enviable social status of the *demi-mondaines*; they were the prostitutes and one such is the pitiful creature in Edgar Degas' painting *The Café* (*The Absinthe Drinker*) dated 1875–6, which captures their human degradation far removed from the fashionable world of *la Parisienne*.

Two important factors which became instrumental in ushering in modernity during the nineteenth century, contributing thus to the emancipation of fashion, were the invention of photography and the emergence of haute couture.

The invention of photography: Nadar and Disdéri

The official 'birth' of photography is considered to be in 1839 when the brand-new technique of the *daguerreotype* was revealed to the world, and the birth of photography was proclaimed in *The Literary Gazette* on 6 January 1939 in Paris, under the title 'Fine Arts: the Daguerrotype', reporting:

> This discovery seems like a prodigy. M. Daguerre has discovered a method to fix the images which are represented at the back of a camera so that these images are not the temporary reflection of objects, but their fixed and durable impress, which may be removed from the presence of those objects like a picture or an engraving. (Beumont Newhall in Weaver, 1989: 12)

Photography soon became a booming industry and a new institution rivalling the painter's atelier emerged: the photographer's atelier.

> During the 1850s, a complete new place where fashionable people congregated seemed to appear out of nowhere. This was the photographer's studio. It combined the attractions of a stroll along the boulevard with a visit to the theatre. At the same time, the price, quality, and standard of a personal portrait were changing constantly. This meant that the narcissistic pleasures of possessing an image of oneself could be enjoyed by an ever wider public, just at a time when kings and princes were busy making sure everyone had pictures of them in an attempt to convey a sense of both authority and social stability. (Sagne in Frizot, 1998: 103)

One such atelier belonged to Gaspar-Félix Tournachon, better known as Nadar, who opened it in 1854 at 35 Boulevard des Capucines, and soon became the photographer of the great and the good counting among his sitters politicians (Georges Clemenceau), writers (George Sand), musicians (Franz Liszt), actors (Sarah Bernhardt), painters (Georges Courbet) and above all his special friend, Charles Baudelaire.

Capturing Modernity in Nineteenth-Century France and England 161

Equally successful was photographer André-Adolphe-Eugène Disdéri, who opened his atelier during the same year as Nadar and patented his wonderful invention, the *carte de visite*, which consisted of eight photographs mounted on a card, and his commercial success became assured when he was commissioned in 1858–9 to photograph Napoleon III.

Unlike Nadar, who was a bohemian, the bourgeois Disdéri aimed at conveying status and wealth by bringing into focus the splendour of his sitters' attire and by 1861 he was in such demand that he was reputed to earn the princely sum of £48,000 per year (Scharf, 1974: 46).

If photography was able to capture the fickleness of fashion, was 'the painter of modern life' able to do the same, as Baudelaire had prescribed? He was the only critic to evidence fashion as the ultimate signifier of modernity, but fashion was one thing and the fine arts another, as art critic Théophile Thoré observed. In his review of the 1861 *Salon*, he condemned fashion for 'infiltrating' painting because, 'it distorts personal originality and effaces all particularities and eccentricities reducing the individuality of the sitters to a common denominator' (Thoré in Renouard, quoted by McCauley, 2012: 256).

Painters were quick to enlist the support of photography, and Jean Auguste Dominique Ingres was among the first to use the daguerreotype in his collaboration with Nadar. Writer and journalist Eugène de Mirecourt commented that by 1855, Ingres was sending Nadar his prospective sitters to be photographed for his portraits (Scharf, 1974: 46). But it worked in the opposite direction as well, with paintings being used by photographers, one example being Ingres' portrait of baroness James de Rothschild painted in 1848. In it she is wearing a splendid crimson crinoline with a low décolletage, and her hair decorated with two marabou feathers is fastened on the crown of her head with a brooch. And there is little doubt that Ingres' attention to detail, such as the fine lace trimming, the short sleeves and the appliqué decoration on the skirt, testifies to his fascination with fashion.

In fact there is a story attached to the baroness' dress, reported in the press by critic Louis Geoffroy, who revealed that Ingres altered its colour for aesthetic purposes.

> There is a whole story about the dress: it was originally blue, having been selected according to the preference of the model; but once the painting was

162 *Images on the Page*

finished, the artist, unhappy with the effect, suddenly decided to change it without saying a word or asking anyone. Going back to his painting with coats of lacquer, he submitted it to a total transformation in two days. Great disappointment at the news and repeated entreaties brought the artist to the brink of reverting to the preferred colour.

Ingres refused to budge and in the end Geoffroy agreed with him:

M. Ingres, for all that was right. The light red that he adopted warmed the general tone of the picture, and harmonized better with the pomegranate velvet and dark green damask wall hanging in the background, a background which, parenthetically, is too high. The blue under-painting did not disappear in the places covered by gauze or by the lace of the corsage. It results in a bluish tint and, in certain passages of fabric, violet, which perhaps intentionally, give the silk a rich effect. (Geoffroy in Tinterow and Conisbee, 1999: 351–494).

A recently discovered account of the baroness' attendance at a musical *fête* given by the duc de Nemours in March 1847, reported in the *Journal des dames et des modes*, suggests that the dress she wore may have been the one painted by Ingres:

The pretty Mme. de R . . . was wearing a dress of rose taffeta, the full length (of the skirt) ornamented with shirred puffs forming four bands; a flat corsage, low cut, the front ornamented with a puff forming a point strewn with small sequins; short sleeves with clumps of satin ribbons on the shoulder falling over the sleeve; a soft cap in green velvet, decorated with a panache of sequined marabou feathers. (Anonymous, 13 March 1847, in Tinterow and Conisbee, 1999: 424)

The baroness herself commissioned Disdéri in 1859 to photograph her portrait by Ingres so she could turn it into a *carte de visite* (Tinterow and Conisbee, 1999: 423, fig. 262).

The link between Ingres, fashion magazines and photography, provides an example of the confluence between painting, fashion magazines and photography: together they created *la Parisienne*. But it was not a harmonious collaboration, given that whilst painters were happy to emulate the 'realist'

effects of photography, they strove to avoid its reductionist effect, caused by the process of mechanical reproduction, criticized by Théophile Thoré who considered photography to be detrimental to painting.

The 'invention' of haute couture

The Second Empire spanned the reign of Napoleon III from 1852 to 1870, during which he married a Spanish countess, Eugénie de Montijo, whose interest in fashion ushered in a new phase in its history, dominated by the personality of English-born couturier Charles Frederick Worth.

Worth is credited with a number of inventions regarding the system of production and distribution of clothes, the first being the inauguration of the first *maison de couture*, opened in 1857 in partnership with Swedish businessman Otto Gustaf Boberg at 7 rue de la Paix, and the second being his decision to employ young girls to wear his models for customers. 'It has

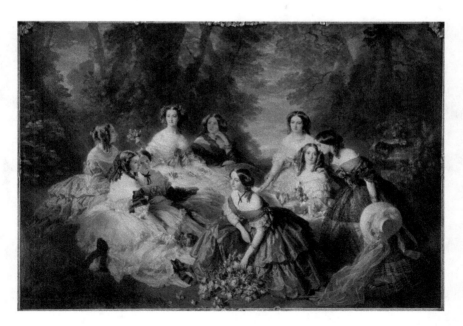

Figure 5.2 *Franz Xaver Winterhalter,* Empress Eugénie Surrounded by Her Ladies in Waiting, *1855. Oil on canvas, 300 × 420 cm. Musée du Second Empire, Compiègne, France.*

164 *Images on the Page*

been said that these "doubles" who were later to be called "mannequins" were chosen for their resemblance to his principal customers' (Boucher, 1997: 385). But Worth did not change the way women dressed; that was left to his successor, Paul Poiret, who alone introduced modernity into fashion.

The relationship between painting, fashion illustration, literature and haute couture

A crucial factor in the process of emancipating fashion was the confluence between painting, fashion illustration and haute couture. Whilst the mutual influence between painting and fashion illustration was well established, a new addition was literature with 'celebrities' such as Émile Zola, Stéphane Mallarmé and Marcel Proust taking a keen interest in fashions and *la Parisiennes* who wore them.

On his own admission Edouard Manet loved fashion and found great pleasure in doing his 'home work', exemplified in his painting titled *Autumn* (Portrait of Méry Laurent) commissioned in 1881 by his friend Antonin Proust.

Mme Laurent, a celebrated courtesan who served as inspiration for Marcel Proust's Odette de Crécy in *À la recherché du temps perdu*, purchased the outfit from Worth, and in the three-quarter length portrait, Manet accurately reproduced her fashionable *pellise* trimmed with fur and her black muff:

> Despite the pose's suggestion of Italian quattrocento profile portraits or Japanese *ukio-é* prints, the undeniably contemporary costume that Laurent wears in this modern representation of a timeless, allegorical subject aligns Manet's work with similar treatments by Morisot and Alfred Stevens, and with Baudelaire's aesthetic for the new art, which proclaimed the superiority of modern dress over classical or historical costume. (Stevens in Stevens and Lehmbeck, 2013: 199)

Stéphane Mallarmé too immortalized Méry Laurent's flair for fashion in the magazine he created, dedicated to fashion: *La Dèrniere Mode*. The word 'create' is apposite, because Mallarmé was responsible for bringing it into being, from writing to designing and printing, and the result was a short-lived but

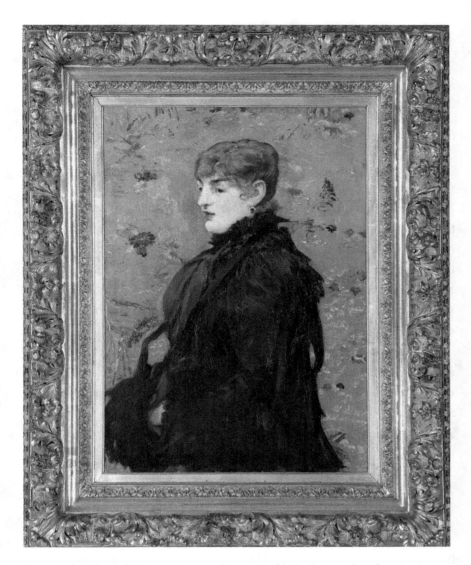

Figure 5.3 *Edouard Manet,* Autumn *(Portrait of Méry Laurent). Oil on canvas, 73 × 52 cm. Musée des Beaux-Arts de Nancy, Nancy, France.*

influential magazine dedicated to fashion. Only eight issues were published between 1874 and 1875, after which it ceased publication. Taking his cue from Charles Baudelaire's definition of modernity, Mallarmé placed 'transitoriness' centre stage in his own definition of fashion. But Mallarmé's uniqueness consisted in his awareness of the commercial dimension of fashion:

Yet his relationship with fashion appears also as the most straightforward among the artists and poets examined in this book because it was rendered as a commercial enterprise. As we know from the writings of Balzac, Barbey d'Aurevilly, Gautier, and others, throughout the nineteenth century many writers contributed to fashion magazines but Mallarmé is the first to regard fashion as an area imbued with all characteristics necessary to discuss *la mode* as the stylistic nucleus of the wider implications of cultural (as well as social, economic, and political) *modernité*. (Lehmann, 2000: 54)

Mallarmé's definition of transitoriness found expression in a series of quatrains titled *Photographies*, celebrating the fashion flair and elegance of his muse and mistress, Méry Laurent. Comparison between Manet's portrait, in which she is wearing the brown *pelisse* made by Worth specially for the occasion, with Mallarmé's poetic description of her blue dress provides an interesting case study about the way the visual image and the written text convey to express the one and only 'technological object'.

In 1967, Roland Barthes published *The Fashion System* in which he provided a *paragone* (already referenced) between the way the visual image and the written text reproduce differently the 'technological object', and Mallarmé adhering to the latter finds particular pleasure in providing a 'written text' about the colour of Méry Laurent's dress,

which constantly changes its look: from turquoise-blue fabric reminiscent of the sky, via silken folds that glisten and gleam to evoke mythic creatures, to a silvery, blue, subtle but strong like the mutual admiration and love affair that binds her to the poet. (Lehmann, 2000: 62)

Barthes' visual-based 'image-clothing' and the text-based 'written-clothing' – both predicated of the 'technological' garment – provide the theoretical framework for the way words – Mallarmé's quatrains describing Méry Laurent's blue dress – and visual images – Manet's painting – convey the same message: a description of the 'technological object' (not always available to us).

La dernière mode had several antecedents which may have been sources of inspiration, among them *La Vie Parisienne*, founded in 1863 by Émile-Victor Harvard Marcelin, whose initial brief was to cover 'new stories, sports, theatre

and music and the arts' and this hugely popular *hebdo* (weekly) was published without interruption until 1970.

In 1905, under the new editorship of Charles Saglio, the magazine acquired its playfully erotic profile and in the 4 January 1913 issue – celebrating fifty years since its inception – Saglio published an article praising its success and arguing that in spite of its appearance of frivolity, the magazine was truthful regarding '*la vie mondaine*' of Paris. Saglio also provided a lovable portrait of Marcelin, describing him as: 'the pensive and melancholic spectator of the eternal Parisian comedy'. Among its contributors were such luminaries as Charles Baudelaire (*La Vie Parisienne*, Samedy 4 Janvier 1913: 4).

But whilst *La Vie Parisienne* was a popular and cheaply produced weekly, Mallarmé's magazine was exclusive and expensive, which may explain why it was so short-lived. The former was published during the reign of Napoleon III and the latter in the aftermath of the Franco-Prussian War (1870–1) that put an end to the Second Empire, ushering in the Third Republic, but in their own ways both mirrored a society in transition:

> This combination of the old regime and new democratic tendencies became mirrored in the French bourgeoisie. In a given *hotel particulier* one might find the pretensions of old families, and old customs; in a *palais* next to them, the nouveaux riches who gained and lost their reputations on the stock market. This uneasy co-existence of tradition and contemporariness, epitomized in Proust's *Recherche* by the relationship between the Guermantes and Verdurins, also characterized the readership of Mallarmé's journal. (Lehmann, 2000: 67)

In fact, Marcel Proust had a lot to say about fashion and his comments regarding Odette de Crécy's decision to abandon such horrors as the bustle, reveals his extensive knowledge of it:

> The pads, the preposterous 'bustle' had disappeared, as well as those tailed bodices which, overlapping the skirt and stiffened by rods of whalebone, had so long amplified Odette with an artificial stomach and had given her the appearance of being composed of several disparate pieces which there was no individuality to bind together. (Proust, 1981: 665)

168 *Images on the Page*

Instead, Odette de Crécy adopted a less formal way of dress to wear at her fashionable tea parties:

> I would find her (Mme. Swann) dressed in one or other of her beautiful dresses, some of which were of taffeta, others of grosgrain, or of velvet, or of *crêpe-de-chine*, or satin or silk, dresses which, not being loose like the gowns she generally wore in the house but pulled together as though she were just going out in them, gave to her stay-at-home laziness on those afternoons something alert and energetic. And no doubt the bold simplicity of their cut was singularly appropriate in her figure and to her movements, which her sleeves appeared to be symbolising in colours that varied from day to day. (Proust, 1981: 665)

At the *intrinsic meaning* or *content* level, the relationship between painting, photography, fashion illustration, literature and haute couture indicates that the novelty dimension regarding the presentation of the image on the page was the direct result of their interaction. Paintings were still paintings, and although painters such Ingres collaborated with photographers, Monet, Manet or Renoir made it their business to familiarize themselves with the world of haute couture, as did writers such as Marcel Proust, whilst Stéphane Mallarmé went a step further by publishing a fashion magazine.

Whilst the eighteenth century witnessed the emergence of the specialized fashion magazine and the proliferation of the fashion plate, the nineteenth century was witnessing the proliferation of a different kind of fashion magazine, with important contributions regarding the way images on the page were presented, which were influenced by factors such as the development of better printing techniques and the invention of photography. But their interest in what their sitters wore stopped at the *primary* or *natural* subject matter level with what the eyes saw. This was about to change at the beginning of the twentieth century when fashion photography emerged as an independent branch of photography, as the result of the inspired collaboration between a painter-turned-photographer, Edward Steichen, and couturier Paul Poiret. He commissioned Steichen to photograph his latest collection, published in the April 1911 issue of *Art et Décoration*. It was at this point that fashion photography not only challenged the printed image but also took over as the main mode of presenting the image on the page.

Commercialism and the fashion magazine

We can sum up in one word the 'style' of the fashion images published in European mainstream fashion magazines – commercial – and this is why they were regarded as bastions of tradition, noticeable in the way they reported the latest fashion trends which were becoming increasingly ornate and silly.

It has also been argued (Julian Robinson and Gracie Calvey, 2015: 129–31) that with the introduction of new printing techniques and increased demands leading to an increase in their circulation, the high quality of the fashion image established during the eighteenth century declined. Meanwhile public demand for information regarding the latest 'must haves' in fashion, led 'many of the illustrators to continuously invent designs and details, adding more and more to the existing silhouette and affecting in turn the way people dressed' (Julian Robinson and Gracie Calvey, 2015: 129–31).

A cursory look at an example, such as the *Journal des Dames*, reveals the changes introduced in the way these imaginary fashions were represented on the page, with the consequence that 'women's dresses became ridiculously extravagant and intricately detailed, often rivalling the fashions of the fallen court of Versailles' (Julian Robinson and Gracie Calvey, 2015: 129–31). No wonder that rebellion was in the air, and the way it manifested itself was by introducing a new type of publication exemplified by Stéphane Mallarmé's *La Dernière Mode*.

Last but not least, was the invention of new media, such as photography and 'moving images', for example, the cinema, which made it possible for the first time to show the embodied dress in movement, fulfilling the old Renaissance dream of capturing movement, to show how a lady of fashion looked when she walked the streets of Milan.

Romanticism, historicism and the return to historic costume: Auguste Racinet's *Le Costume Historique*

Fortunately the commercial magazine was not the true heir of the Renaissance tailors or the erudite fashion magazines published during

the Enlightenment; their legacy can be found elsewhere. This brings us to Auguste Racinet.

A new interest in historic costume was emerging during the nineteenth century under the influence of two separate but related developments in French literature and German philosophy, respectively, romanticism and historicism, expounded by Charles Baudelaire and Georg Friedrich Wilhelm Hegel.

In his review of the *Salon of 1846*, Charles Baudelaire offered an explanation of romanticism:

> Properly speaking romanticism lies neither in the subject an artist chooses nor in his exact copying of truth, but in the way he feels. Where artists were outward-looking, they should have looked inward, as the only way to find it. For me, Romanticism is the most recent, the most up-to-date expression of beauty. (Baudelaire, 1972: 52)

What he proposed was a shift from the primacy of the intellect dominant during the Enlightenment, to that of the emotions with all their ramifications into the realms of 'the picturesque, the macabre, the gothic' (Myers, 1967: 340).

But even if a logical definition (in the sense of the necessary and sufficient conditions which define a word) of romanticism does not appear to exist, it is possible to offer an explanation about the way attempts to provide a definition have emerged:

> The many definitions of romanticism published between the 1790s and the 1830s are symptomatic of an obsessive urge to explore, to describe and account for, the qualities in works of art and literature which had suddenly come to be most highly valued. They reflect a desire to discover why some works of art made a strong emotional appeal and others did not, even though they seemed to observe all the rules which had been derived from the masterpieces then accepted as the greatest products of the human mind and hand. (Honour, 1981: 24)

One romantic giant epitomizes what romanticism is about: Ludwig von Beethoven, summed up by E. T. A. Hoffmann, writing in 1810, as 'ein rein romantischer . . . Komponist', because his music 'set in motion the lever of fear,

of awe, of horror, of suffering, and awakens that infinite longing which is the essence of Romanticism' (Honour, 1981: 24).

The term 'historicism', coined by Karl Wilhelm Friedrich Schlegel, was adopted by Georg Friedrich Wilhelm Hegel in his new definition of philosophy, hitherto regarded as 'a timeless *a priori* reflection upon eternal values and beliefs' to something radically different: 'One of the most striking features of Hegel's thought is that it *historicizes* philosophy, explaining its purpose, principles, and problems in historical terms' (Beiser in Beiser, 1993: 270). Thus, Hegel turned history on its head by transforming it into a category of thought, and used it as a research methodology. The result was that, apart from his 'history of philosophy' which constituted the starting point, a whole array of 'histories' were subsequently created, including the history of art and this is how Hegel became the first historian of art.

But what prompted Hegel to propose a historical conception of philosophy according to which philosophy too is historically and culturally determined?

> One basic premise of Hegel's historicism is his doctrine that each society is a unique whole, all of whose parts are inseparable from one another. The art, religion, constitution, traditions, manners, and language of a people form a systematic unity. We cannot separate one of these factors from the whole without changing its nature and that of the whole. This organic whole, is what Hegel, following Montesquieu, calls 'the spirit' of a nation, its characteristic manner of thinking and acting. (Beiser in Beiser, 1993: 374)

Between 1818 and 1829, Hegel gave a series of lectures at the universities of Heidelberg in 1818 and then Berlin, published posthumously in 1835 under the title *Lectures on Aesthetics,* in which he introduced his theories of aesthetics and history of art as historically determined disciplines.

Hegel proposed a tripartite division of the history of art starting with the 'symbolic' period, then progressing to the 'classical' period, during which the transition from the Egyptian 'symbolic' to the Greek 'classical' art was affected, followed by a transition from the 'classical' to the 'romantic' phase: 'a phase where artistic expression tried to reach deeper and deeper into the interior of human subjectivity'. This last transition 'marked the culmination or "end" of ideal artistic expression' (Beiser in Beiser, 1993: 354).

At the practical level this new interest in history had another source of inspiration: the development of science and technology placed centre stage during the Second Empire, with the aid of an important invention, the universal exhibition, inaugurated in Paris with two exhibitions held in 1855 and 1867. They provided a practical demonstration regarding the affinities between science and technology with the fine arts, celebrated in the 1867 exhibition with a *Palais de l'industrie* and a *Palais des Beaux-Arts*, whose aims were 'to demonstrate the diversity and vitality of art at mid-century: the Romantics, the Realists, the painters of Barbizon and genre' (Mainardi, 1989: 460).

The 1867 exhibition also became a celebration of Napoleon III's achievements, especially his modernization of Paris. The event was publicized in the weekly newspaper *L'Illustration*, and thus the Parisians were becoming accustomed to seeing what far away countries, for instance, Japan, had on offer, and it was this fascination with other lands and countries beyond the confines of Europe that contributed to printing an ever-increasing number of publications in which they were reported.

Figure 5.4 *Royal and ducal costume, court, city and war costume. In* The Costume History *(first published in 1888, Paris). (Plate 310 in Racinet, p. 334.)*

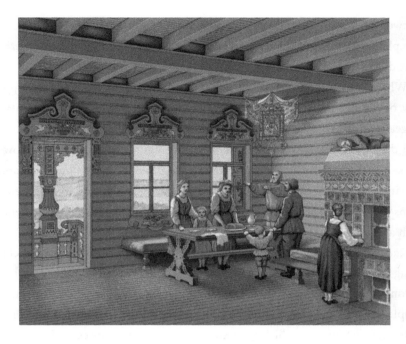

Figure 5.5 Izba, *Dwelling of the* Muzhik. *In* The Costume History *(first published in 1888, Paris). (Plate 443 in Racinet, p. 664.)*

There is nothing new regarding the publication of historical and ethnographic albums, but there is no doubt that the nineteenth-century heir to this tradition was Auguste Racinet and his monumental *Le Costume Historique* (in six volumes), published between 1876 and 1888, was the result of this new interest in history, which inspired Racinet to adopt Hegel's revolutionary methodology – *historicism* – and apply it to costume.

Racinet's book *Le Costume Historique* is divided into four chapters: 'The Ancient World', 'The 19th Century Beyond the Borders of Europe', 'Europe 400–1800' and 'Traditional Costume till the Late 19th Century'. It explores folk and ethnographic costume, and Racinet's use of chromolithography enabled him to obtain images of great beauty, with which he takes his reader on a wondrous voyage of discovery through history and culture.

And it is on the pages of Racinet's book where art, miniature and fashion illustration blend harmoniously, as the two images selected for analysis demonstrate. The first, belonging to the European Middle Ages, consists

174 *Images on the Page*

of two superimposed rows of standing royal and aristocratic male figures, complete with the attributes which identify their status and respective *metiers* introduced by an accompanying text.

What the eyes see at the *primary* or *natural* subject matter level is an upper row of figures, and reading from left to right the first image represents 'a sergeant at arms', followed by seven figures representing royalty, aristocracy and the clergy. The lower row consists of five figures representing the lower classes, including musicians and musical instruments (a lute and a *dicorde*, a string instrument looking like a narrow, rectangular contrabass) as well as items of clothing (the *chaperon*, the *dalmatic*, often with added specific details such as *bombarde* sleeves).

Racinet also provides the *secondary* or *conventional* subject matter level by using the attributes which identify the figures; thus, a crown tells us something beyond what the eyes see by identifying its wearer as a king. The use of such a simple template enabled Racinet to concentrate on what interested him most: historical costume, for which he used the only primary source available – the visual arts – and some of the images reveal the direct influence of famous painters such as Jan van Eyck, Rogier van der Weyden and Hans Memling. A particularly lovely example is plate 469 (Racinet, 2016: p. 707) which takes us to Spain. The short entry reads: 'Late 18th century. Scenes of upper class life and popular entertainment. The game of the spoon, stilts race, *clarines, esadas*' (Racinet, 2016: 704).

This beautiful illustration in shades of brown was literally lifted from Francisco Goya's *La gallina ciega* (The Blind Chicken) dated 1788, in the Museo Nacional del Prado in Madrid, which opened to the public in 1819, so Racinet would have known it.

Even more fascinating are his images from lesser known countries, and one such is a dwelling (*izba*) of a Russian *muzhik* (peasant). The short entry reads:

> Izba. Dwelling of the muzhik. First floor room *svetlitza*. Stove bed, benches, table, images of the Virgin, of a saint (Icon), portraits of the tsar and tsarina, plain walls. Additional rooms, dressing room, *seny*, tool and utensil room. (Racinet, 2016: 664)

At the *primary* or *natural* subject matter level Racinet's description tells us in simple terms what the eyes see: four characters and a small child standing

around a dining table. One of them, positioned at the top of the table with arms outstretched, appears either to bless the food brought to table by a woman or is saying a prayer. A young woman, possibly a servant, stands in front of the stove, whilst a young *muzhik* laying on top of it not only provides a humorous touch but refers to a well-known practice in Russian villages. They may all be peasants, but they were sufficiently affluent to be living in such a large wooden *izba*. At the *secondary* or *conventional* subject matter level Racinet presents us with a strong narrative about the way of life in rural Russia, but it is at the *intrinsic meaning* or *content* level that we learn more from all these examples. Thus, it is in the case of the first image, the rows of figures from the Middle Ages with attendant attributes which identify their social status, that tells us who they are and what they do, whilst the second image captures a moment in the life of a Russian peasant family.

Ultimately it is the beautiful coloured chromolithographs imbued with the spirit of romanticism which reveal Racinet as a writer of his times, but above all Racinet's interest in historic costume prompted him to write his learned tome rendering him the true heir of the costume and fashion books of the Renaissance and the sophisticated fashion magazines of the Enlightenment.

The conclusion which emerges at the *intrinsic meaning* or *content* level is that what enabled Auguste Racinet to fulfil his task was that he employed Hegelian *historicism*, proving him to be a writer and illustrator of his own time.

Rebellion and reform against the tyranny of fashion in England: Death to the crinoline!

Nineteenth-century England was a capitalist society with a divided class system, consisting of the bourgeoisie and the workers, the former enriched at the appalling cost of the human suffering of the latter, famously indicted by Alexis de Tocqueville who visited Manchester in 1835: 'From the filthy sewer pure gold flows. Here humanity attains its most complete development and its most brutish, here civilization works its miracles and civilized man is turned almost into a savage' (Tocqueville in Honour and Fleming, 1992: 481).

176 *Images on the Page*

A young German arrived in Manchester in 1842 sent by his parents to oversee work at the family mills: his name was Friedrich Engels. On his way he stopped in Cologne to meet Karl Marx, one of the collaborators of the influential newspaper *Rheinische Zeitung*.

In 1848 the most famous pamphlet in the world co-authored by Marx and Engels, *The Communist Manifesto*, was published, calling for 'the forcible overthrow of all existing social conditions' which acquired the status of 'holy text, nowadays accepted by half the human race' (Tocqueville in Honour and Fleming, 1992: 481).

A more benign account of Victorian England and its radical reforms is provided by Nikolaus Pevsner in his iconic book, *The Englishness of English Art*, first published in 1956:

> The reform acted from the apex of society downwards: a royal couple, genuinely fond of one another and leading an impeccably respectable married life, a prince consort intelligent, highly educated, industrious, and conscientious, a new ideal of decency, fair play, high-mindedness, and gentlemanliness grafted on to the old often all but moribund, public schools and established in the many new ones, and – in our field – a new ideal of morality in art preached powerfully and verbosely by Ruskin. (Pevsner, 1976: 204)

These reforms reverberated in the art and fashion world and even a link has been suggested between William Paxton's use of cast iron to build the Crystal Palace and the invention of the cage crinoline:

> Crinoline cloth was only a makeshift, and it was replaced by hooped petticoats as early as 1850. The hooped cages which replaced these again took the name *crinoline* and though they did not relieve the body of the weight of petticoats, they enjoyed an unprecedented vogue from 1856 on. Could it be that the immense network of iron struts Paxton devised for the Crystal Palace inspired the invention in 1856 of this cage of flexible metal strips, patented by Tavernier? (Boucher, 1997: 381)

If the cage crinoline so fashionable in France was indeed the result of English technology, it is even more remarkable that it was in England where it acquired

its most vociferous enemies, triggering the emergence of the first 'anti-fashion' movement in the history of dress, the Rational Dress Movement.

It started in 1851, when the formidable Mrs. Amelia Bloomer voyaged to London to suggest an alternative to corsets and crinolines, regarded as health hazards, consisting of 'a simplified version of the bodice in vogue, and a fairly ample skirt which reached well below the knee. Underneath it, however, were to be seen baggy trousers reaching to the ankle, unusually with a large frill at the bottom. This very modest attempt to reform female dress provoked an almost unbelievable outburst of excitement, ridicule and vituperation' (Laver, 1969: 180–1).

Amelia Bloomer's reform can be aligned to a dissident streak in the history of fashion, which under the generic name of 'anti-fashion' designated all rebellious styles of the nineteenth century, including 'rational' and 'aesthetic' dress as Anne Hollander explained:

Anti-fashion, a recurrent theme in the history of dress was probably first taken up as a sign of status by the nobility, perhaps originally out of necessity. Impoverished, threadbare noblemen could take pride in their lack of style while middle-class upstarts were deeply considering the cut of their coats. This strain of aristocratic style persists. The essential presumptuousness of fashion – its constant pushiness, its middle-class mobility – is one of the things that make people hate and fear it, especially very radical and very conservative people. Some variety of anti-fashion is one natural response. The constant dress-reform movements of the nineteenth century in England and America were attempts, in different modes, to resist and even to abolish fashion, which had become a more and more virulent and noticeable public phenomenon than ever in the uneven but booming expansion of Victorian times. These attempts were also linked to social reform. If elaborate fashion was the outward sign of bourgeois prosperity, anti-fashion had to be invented as a necessary means of indicating objections to existing social, economic and sexual standards. (Hollander, 1993: 303–4)

The undisputed champion of 'anti-fashion' was Oscar Wilde who, like his hero Charles Baudelaire, was a brilliant writer, poet, playwright and pioneering

fashion critic. In 1887, Wilde became editor of the society magazine *The Lady's World*, whose title he promptly altered to *The Woman's World*, enabling him to raise its intellectual profile to a different level, as a comparison between the contents of *The Lady's World* and *The Woman's World* reveals. Thus, the list of contents of the November 1887 of the former reads as follows: 'Notes of the Month'; 'Fashionable Marriages'; 'Pastimes for Ladies' (in this instance hunting); with the final article 'Fashions for November' reporting from Paris, Vienna and Berlin. In it, the anonymous fashion reviewer commented on the 'artistic' status of Parisian *couturiers*, whilst prescribing what ladies of fashion returning to the capital at the end of the summer holiday should purchase. And the first move of the 'lady of fashion' was the visit to the 'great artists in dress', one such being *Maison Cavally* singled out for 'its originality and refinement of taste', the reviewer considered 'among the first in Paris' so that the 'lady of fashion' would be in a position to assess what was on offer. One example was 'the most charming toilette, which, for its exquisite simplicity and elegance, will be especially acceptable to young married ladies. It is suitable for dinner and other parties at which the demi-gala or very *robe montante* may be worn.'

The article is accompanied by an illustration of the outfit with the caption 'Dinner dress. Designed by Mme. Cavally *boulevard des Capucines*' as well as a technical explanation of the craft of dress-making, which provided a lot of details such as a 'jabot of lace *D'Argentan*', the upper side 'festooned en *ourlet*' caught up at the waist on the right side, forming a *basque* finishing on the bodice cut *en coeur*, and buttoned crosswise'. At the end, the reviewer recommended that if 'a bouquet either of marguerites or tea-roses be worn on the side of the collar and ivory coloured kid shoes', that would be 'in good taste' (*The Lady's World*, 1887:12–14).

But all this was about to change with Wilde's editorship, and although it lasted only two years, between 1887 and 1889, he changed it radically by addressing a number of sensitive issues regarding not only the duties but also the rights of women in Victorian society.

Thus, in the February 1888 issue we find an article signed by M. F. Donaldson titled 'A Day at Girton College'. In it she describes her visit to the first Cambridge University residential college for women, established in 1869. But the idea of allowing women to study at university had its limitations, and

Capturing Modernity in Nineteenth-Century France and England 179

in the closing paragraph we find the following – for our modern sensibilities – patronizing statement:

> The great aim of the college is not to exalt the ideas of the students or raise them above the proper sphere as women, by thus competing with men, which would only make them unwomanly; but it is rather, while keeping them in all the delicacy and refinement of that womanhood, so to widen the field of their labours as to give them more exalted objects and thus not only to fit them for life's duties but to enable them the better to fulfil them. (Donaldson, 1888: 9–10)

What appears to be less well known is that one of Oscar Wilde's main interests was fashion, to the extent that he is credited with the infamous remark which acquired the status of aphorism: 'Fashion is a form of ugliness so intolerable that we have to alter it every six months.' And if he is indeed its author, he took it upon himself to offer an alternative: 'rational' dress.

Thus, in the February 1888 issue, an article titled 'The Rational Dress Movement' announced the founding of the Rational Dress Society initiated in 1881 and championed by Lady Haberton, Mary Eliza Haweis and Oscar Wilde's wife, Constance. Their intention was to protest against the dominant 'fashionable absurdities' which seemed to have 'perhaps aroused more opposition and excited more ridicule than any movement of modern times' and this they did by proposing new objectives:

> To promote the adoption according to individual taste and convenience of a style of dress based upon considerations of health, comfort and beauty and to deprecate constant changes of fashion which cannot be recommended on any of these grounds.
>
> To protest against the attempt to introduce any fashion in dress which either deforms the figure, impedes movement of the body or injures the health.
>
> To protest against corsets or tight-fitting bodices of any kind, and high and narrow-heeled boots and shoes as injurious to health; against heavily-weighted skirts, as rendering healthy exercise almost impossible; and all 'tie-down' cloaks or other garments which impede the movements of the

arms. Also crinolinettes and crinolines of any kind or shape, as deforming, indecent, and vulgar.

To recommend that the maximum weight of underclothing (without shoes) should not exceed 7 lbs. (Anonymous, 1888: 128)

A practical recommendation for a viable alternative to the 'horrors' imposed by sartorial fashion was children's attire, and illustrated in *The Woman's World* was a drawing of a child's kindergarten dress – pronounced 'hygienically perfect' by a medical gentleman who has given much attention to the subject of female attire.

The upper garment of this dress is a straight loose robe, confined at the waist by a broad band or a sash of contrasting colour. It is artistically 'smoked' across the chest and shoulders; the sleeves are loose and smocked at the wrist. There is nothing in the costume which can interfere with perfect freedom of movement. Yet in addition to all this it is thoroughly pretty and unique. (Anonymous, 1888: 128)

Figure 5.6 *Drawing with children's clothes. In* Peterson's Magazine, *Children's Fashions. (Alamy ID: W5833H.)*

Capturing Modernity in Nineteenth-Century France and England 181

Wilde himself contributed a number of articles on fashion for *The Woman's World* in which he reiterated, with characteristic humour and mischief, the key points made in the article on the Rational Dress Movement to which he added a few of his own, and in the article titled 'Slaves of Fashion' we find him defending himself against criticism for reproducing a hat covered 'with the bodies of dead birds':

> Talking of Fashion, a critic in the Pall Mall Gazette expresses his surprise that I should have allowed an illustration of a hat, covered with 'the bodies of dead birds' to appear in the first number of the Woman's World . . . Fashion is such an essential part of the mundus muliebris of our day, that it seems to me absolutely necessary that its growth, development and phases should be duly chronicled, and the historical and practical value of such a record depends entirely upon its perfect fidelity to fact.

In another article, titled 'Woman's Dress', Wilde argued against the 'most uncomfortable articles of dress fashion has ever in her folly prescribed, not the tight corset merely, but the *farthingale,* the *vertugadin*, the *hoop*, the *crinoline* and that modern monstrosity the so-called "dress improver"' that shared the same error: 'the error of not seeing that it is from the shoulders, and from the shoulders only, that all garments should be hung'.

He objected also to high heels. He wanted them to be replaced with clogs, but Wilde being Wilde makes it difficult to ascertain whether this was a serious suggestion or he made it in jest: 'Why should clogs be despised? Much art has been expended on clogs. They have been made of lovely woods, and delicately inlaid with ivory, and with mother-of-pearl. A clog might be a dream of beauty, and, if not too high or too heavy, most comfortable also.'

Wilde turned his attention to men as well. In an article titled 'More Radical Ideas Upon Dress Reform', he argued that men's attire should be driven by comfort and utilitarian principles:

> This rationally dressed young man can turn his hat brim down if it rains, and his loose trousers and boots down if he is tired – that is, he can adapt his costume to circumstances; then he enjoys perfect freedom, the arms and legs are not made awkward or uncomfortable by excessive tightness of narrow sleeves and knee-breeches, and the hips are left quite untrammelled,

always an important point, and as regards comfort, his jacket is not too loose for warmth, nor too close for respiration, his neck is well protected without being strangled, and even his ostrich feathers, if any Philistine should object to them, are not merely dandyism, but fan him very pleasantly, I am sure, in summer, and when the weather is bad they are no doubt left at home, and his cloak taken out.

The tenets of the Rational Dress Movement reverberated in the art world, producing any number of variations on the theme of practicality versus excess and visual appeal versus what was perceived to be the vulgar excesses of the 'look' promoted by the middle classes. In their quest for historical truth, the Pre-Raphaelites studied medieval and Renaissance dress, whose visual appeal and lack of visible constrictions created a new 'anti-fashion' trend, the Aesthetic Dress Movement. The Movement's founding members included Dante Gabriel Rossetti, William Holman Hunt and John Everett Millais, joined later by Edward Burne-Jones and William Morris; William Powell Frith's painting *Private View at the Royal Academy 1881* can indeed be called its manifesto.

Frith depicts a vast panorama of visitors to the private view of the Royal Academy's Summer Show. This was a world of wealth and privilege and its guests were attired at the height of fashion. Moreover, a lot of the dramatis personae can be identified, starting with Oscar Wilde, acknowledged as the apostle of aestheticism and decadence. Frith's intention was not only to record an event but also to record for posterity what he, as a conservative painter, considered 'the aesthetic craze as regards dress'.

But the rebellious world of Oscar Wilde – 'anti-fashion', 'rational' and 'aesthetic' dress – was barely represented in mainstream fashion magazines. Queen Victoria's death in 1901 marked the end of an era, although the aftermath of her legacy still reverberates till today, and one example is the way 'Victorian' is used as an adjective predicated of manners and mores. But the irony is that it has acquired pejorative connotations in the process. As the nineteenth century was drawing to a close, we could sum it up as an era of ostentation bordering on vulgarity known in France as *la belle époque* and in England the Edwardian period, although strictly speaking, the reign of

Capturing Modernity in Nineteenth-Century France and England 183

Edward VII belonged to the twentieth century. But as James Laver observed, France and England were united through their frivolous pursuits:

> In both countries the atmosphere was very similar. It was an age of great ostentation and extravagance. In England society and the Court, which had of course always overlapped now began to coincide and the King himself set the example. As Virginia Cowles remarks, 'The fact that the King liked City and millionaires, Jewish jokes and American heiresses and pretty women (regardless of their origin), meant that the doors were open to anyone who succeeded in titillating the Monarch's fancy.' (Laver, 1969: 213)

But even if the end of the nineteenth century is described as decadent, this is a century which ought to be analysed as the sum of all its parts, aptly summed up as a 'Dynamo', because between 1815 and 1914 Europe had become 'the powerhouse of the world':

> There is a dynamism about nineteenth-century Europe that far exceeds anything previously known. Europe vibrated with power as never before, with technical power, economic power, cultural power, intercontinental power. Its prime symbols were its engines – the locomotives, the gasworks, the electric dynamos. Raw power appeared to be made a virtue in itself, whether in popular views of evolution, which preached 'the survival of the fittest', in philosophy of historical materialism, which preached the triumph of the strongest class, in the cult of the Superman, or in the theory and practice of imperialism. (Davies, 1997: 757)

6

Modernism

Part One

Fashion and art; is fashion art?

Pioneering 'modernism' on the fashion plate: Paul Poiret

The Universal Exhibition of 1900 ushered in the twentieth century, and between that date and 1937, the date of the last Universal Exhibition, Paris became the cultural capital of Europe. Even more impressive in scale than its predecessors, the 1900 exhibition left us the **Grand Palais,** the **Petit Palais** and **Pont Alexandre III** as testimonies of its imperial grandeur.

Paradoxically, the exhibition chose to convey a different message by presenting a republican vision of Paris as an ancient yet modern metropolitan centre of a diverse country, the capital of a nation to be counted in the 'concert of nations' (Green, 2000: 2). Its aims, as defined by Commissioner General Alfred Picard, were 'education and instruction, the fine and decorative arts, technology, labour and state welfare and hygiene' (Stevens in Rosenblum et al., 2000: 55).

Painting and sculpture which were given pride of place, filling the 'Grand' and 'Petit' palaces focusing primarily on French art; painting could be admired in the 'Centennial Exhibition of French Art 1800–1900' (the *Centennale*), whilst the Petit palace was filled with French sculpture prior to 1800.

But a new feature was added to the *Centennale*, **the decorative arts,** and even braver was the *apologia* offered by the organizers, summed up by Emile

Molinier (curator of the Louvre) in his preface to a collection of reproductions of the works on display:

> We have wished for the most intimate possible mixture of painting, sculpture and interior decoration . . . It will show once again how false is the concept of two arts, the great and the industrial, the unity of art is a principle it should be a veritable dogma. (Molinier in Green, 2000: 5–6)

Although the inclusion of haute couture at the exhibition was not the direct consequence of this process of democratization, it certainly paved the way and *The Pavillon de l'Élégance* provided the locus for displaying the best in Parisian fashion, headed by Charles Frederick Worth's two sons: Gaston and Jean-Philippe. Interestingly, the selection of the participants was relegated to a woman, Jeanne Paquin, who opened her own *maison de couture* in 1891 on rue de la Paix. She did not introduce new styles of dress, but in an astute exercise of public relations, she placed a wax model of herself centre stage, 'dressed up in the finest lace and silk, and this clever presentation deflected attention from the absence of innovation. The only shockingly new thing was that a woman had been given the chairmanship of the fashion fair, for the world of couture was and still is dominated by men' (Seeling, 2000: 16).

The third couturier was Jacques Doucet, and whilst his garments were indeed exquisite to behold, he was even less of a *prime mover* for change, as he still favoured the 'S' silhouette of *la belle époque*.

What is less well known is that he regarded himself primarily as an artist and collector, not only of fine art but also furniture and rare books, and his correspondence with artists and writers, especially the Dadaists and surrealists, reveal him as an enlightened patron of avant-garde art.

It was also Jacques Doucet who purchased from Picasso *Les Demoiselles d'Avignon*, very likely directly from under Picasso's bed where he hid it, shocked by the reactions of his friends Georges Braque and Daniel-Henry Kahnweiler, who feared for Picasso's sanity:

> There was also that large painting Uhde had told me about, which was later called *Les Demoiselles d'Avignon* and which constitutes the beginning of cubism. I wish I could convey to you the incredible heroism of a man like

Picasso, whose spiritual solitude at this time was truly terrifying for not one of his painter friends followed him. The picture he had painted seemed to everyone something mad or monstrous. Braque, who had met Picasso through Apollinaire, had declared that it made him feel as if someone were drinking gasoline and spitting fire, and Derain told me that one day Picasso would be found hanging behind his big picture, so desperate did this enterprise appear. (Kahnweiler, 1971: 38–9)

After its 'disappearance', books on the history of art informed us that *Les Demoiselles d'Avignon* did not re-emerge until 1925 when it was published under its real title in *La Révolution Surrealiste*. But this is not true, because we have an exception, hitherto unpublished in art historical bibliographies: the painting was exhibited in 1916 by another couturier, Paul Poiret, in his own *galerie Barbazanges*.

The aftermath of the 1900 Universal Exhibition marked the starting point of one of the most radical artistic periods in the visual arts: the avant-garde movements, inaugurated in 1905 at the Salon d'Automne, with its first movement, Fauvism.

At about the same time an unknown couturier, Paul Poiret, inaugurated his career in 1908 with his first collection 'Directory' under the influence of the French eighteenth-century style of that name, followed in 1909 by the 'Orientalist' phase influenced by the *Ballets ruses*. It was this ability to incorporate inspiration from hitherto unexplored sources such as art and performance, rather than just fashion illustration, which brought Poiret the accolade of being the first *couturier* to bring art into fashion.

One of his collaborators was Fauve painter Raoul Dufy whose range of sparkling textile designs were used by Poiret to great effect. But at the structural level he was inspired by cubism, which led him to flatten the 'S' silhouette by reducing it to a tubular shape with privileged front and back and side facades, which inspired him to turn to the 'Directory' silhouette because it coincided with his needs to create his first collection, illustrated by Paul Iribe.

The 'Orientalist' phase which followed in 1909 revealed the influence of the splendid costumes designed by Leon Bakst for the *Ballets russes* whose arrival in Paris created a sensation. Poiret is credited with the introduction, under

their influence, of the *jupe pantalon* or 'harem trousers' to sartorial fashion, although he merely capitalized on an existing trend. He complemented the harem trousers with tunics mounted on wire frames which made them resemble lampshades, hence the 'lamp-shade look' we find illustrated by Georges Lepape.

Equally unprecedented was Paul Poiret's collaboration with the artists of the first avant-garde movements, the fauves and the Cubists, which led to a revolution in fashion: modernism had arrived!

The relationship between fashion and the first avant-garde movements: Fauvism and cubism

Fauvism was inaugurated in 1905 when critic Louis Vauxcelles used the word 'fauves' (wild beasts) to describe the painters who exhibited in 1905 at the Salon d'Automne, 'unwittingly baptizing the first modern movement of the twentieth century' (Barr in Hamilton, 1967: 158). Its core painters were Henri Matisse, André Derain and Maurice de Vlaminck, later joined by the 'provincials from Le Havre', Émile-Othon Friesz and Raoul Dufy. Dufy's collaboration with Paul Poiret resulted in the 'fauve' palette of the textiles he used for his garments, attracting him admiration and derision in equal measure. It was Dufy's joie de vivre and love of the simple pleasures of quotidian life at the French seaside – the regatta, the charming cafes and places of entertainment, the promenade – which attracted Paul Poiret because he realized that Dufy's vision of a comfortable provincial bourgeois lifestyle would appeal to his bourgeois clientele, captured for Poiret by Paul Iribe, Georges Lepape and the circle of illustrators who gravitated around him. They were inspired not only by Dufy's love of colours, 'which were bright but never garish and which he applied to canvas or paper, for he was equally a water colourist in broad patches', but also by his 'stenographic' technique, whereby 'his objects, dissociated from their local colours were drawn in stenographic outlines unequalled for their wit and affectionate irony' (Hamilton, 1967: 168).

In 1909, Poiret commissioned Dufy to create vignettes for the stationery of his new couture house and later Dufy designed the invitations for 'one of

Poiret's most notorious parties'. So impressed was Poiret with Dufy's woodcuts for *Images d'Épinal* (popular prints) created between 1909 and 1911 for a book of poetry by Guillaume Apollinaire, that he launched Dufy's career as a textile designer. Thus, he commissioned him to make woodcuts for fabrics 'in a similarly powerful graphic style that exploited the stark contrast between black and white, or light and dark colours' (Koda and Bolton, 2007: 18).

One of the loveliest examples of their collaboration is the coat known as *la Perse*, dated 1911, made for his muse and wife, Denise. Dufy used bold beige, woodblock-printed arabesque-like designs on a black background, with a broad fur collar and matching sleeve cuffs completed by a dramatic emerald green lining. The coat was illustrated in the *Women's Wear Daily* (Koda and Bolton, 2007: 66).

Cubism pursued an almost antithetical aesthetic to fauvism: the Cubists were controlled and rational, and their paintings may have appeared unattractive to all but a minority of sticklers for heavy-duty theory, and this was largely due to their monochromatic palette and rigorous geometry. Its point of inception is considered to be a meeting between Pablo Picasso and Georges Braque, who were introduced to each other in 1907 by the poet and critic Guillaume Apollinaire (Golding, 1968: 19).

But what we now call the Cubist 'style' stems from the landscapes painted by Georges Braque during the summers of 1908 and 1909 at L'Estaque and La Roche-Guyon, respectively. It was also in 1908 that two of Braque's paintings were accepted at the Salon d'Automne and the same Louis Vauxcelles who invented the label Fauve, called Braque's landscapes 'à des cubes' and in March 1909, when Braque exhibited two paintings at the Salon des Indépendants in March, he dismissed them as 'bizarreries cubiques' (Hamilton, 1967: 238).

Cubism, more than any avant-garde movement, has a profound influence that is still with us today: 'They can be seen in much of the art of today. In as much as Cubism has conditioned the development of architecture and the applied arts it has become part of our daily life' (Golding, 1968: 17).

Fashion was no exception and in the seminal exhibition titled *Cubism and Fashion* at the Metropolitan Museum of Art in 1998/9, its curator, art historian Richard Martin, outlined its aims as, 'understanding the fundamental changes in fashion that occurred between 1908–25 and to offer the proposition that

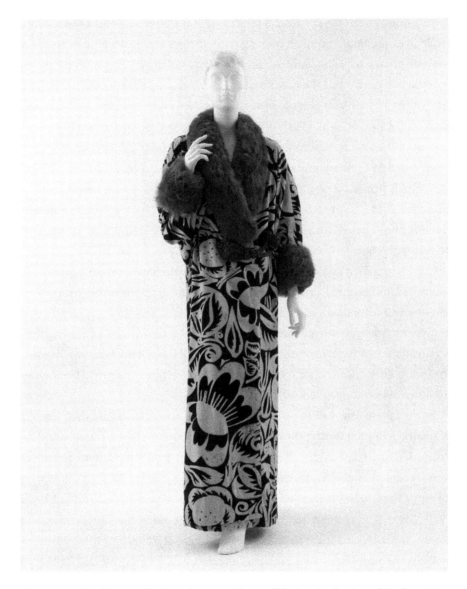

Figure 6.1 *Paul Poiret, 'La Perse' coat with woodblock print by Raoul Dufy, 1911. The Metropolitan Museum of Art. Source: Art Resource, NY.*

perhaps Cubism which transformed art as fundamentally during the epoch, is also a prime cause of fashion's modern forms' (Martin, 1999: Introduction). Through cubism fashion was flattened and we find this effect re-emerging in the work of André Courrèges during the 1960s and more recently with Rei

Figure 6.2 *Raoul Dufy textile designs executed by Bianchini-Ferrér for Paul Poiret. Stapleton Collection, London.*

Kawakubo's 'wrapping and twisting, obviating front and back'. They were all influenced by cubism but its most radical expression is found in Madeleine Vionnet's ability to defy fashion conventions, 'but also letting a little tridimensionality feel its way onto the flat field of dress' (Martin, 1999: 147–9).

It was therefore Paul Poiret who must be credited to have ushered, under the influence of cubism, modernism into the world of fashion:

> In freeing women from corsets and thus dissolving the fortified grandeur of the obdurate, hyperbolic silhouette, Poiret effected a concomitant revolution in dressmaking, one that shifted the emphasis way from the skills of tailoring to those based on the skills of draping. It was a radical departure from the couture traditions of the nineteenth century, which like menswear (to which they were indebted) relied on pattern pieces or more specifically the precision of pattern making for their efficacy. Looking to both antique and regional dress types, most notably to the Greek chiton, the Japanese kimono and the North African and Middle Eastern caftan. (Koda and Bolton, 2007: 13–14)

Fashion purloined, Martin argued, from the aesthetics of cubism's three fundamental criteria: flatness, the cylinder and the plane, as well as the 'indeterminacy of forms' (Martin, 1999: 14).

For that reason, Poiret's modernism manifested itself at a structural rather than formal level, and the technique of draping he reintroduced enabled him to hang the garment from the shoulders and that, in turn, facilitated a multiplicity of possibilities.

Between 1906 and 1911, Poiret produced a series of designs 'that were startling in their simplicity and originality' published in two albums: Paul Iribe's *Les robes de Paul Poiret racontées par Paul Iribe* and Georges Lepape's *Les choses de Paul Poiret*, published in 1908 and 1911, respectively (Koda and Bolton, 2007: 14).

Paul Iribe's 'Directory' album and Georges Lepape's 'Orientalist' album

Paul Iribe changed the time-honoured approach to fashion illustration, starting with his preference for the expensive technique of **pochoir** (stencilling), which enabled him to emulate the Fauve palette.

But his most important contribution was to create a narrative, and at the *primary* or *natural* subject matter level what the eyes see are his elegant

Modernism: Fashion and Art 195

dramatis personae enjoying themselves at the theatre, in the parks and the boulevards or at home in their elegantly appointed drawing rooms:

> He grouped his models in expensive combinations, suggesting action conversation, or introspection, thus promoting Poiret's clothing while defining stylish contexts for its wearers and advocating a more relaxed and natural attitude for the new century. (Davis in Koda and Bolton, 2007: 35)

At the *secondary* or *conventional* subject matter level, we are invited to create our own narrative, and we have the wonderfully humorous example of three young ladies attired in Directory outfits, standing beside a three-legged neo-classical table and on it a porcelain bibelot of a frog is the focus of their fascination. Can this be a reference to the fairy tale in which the frog turned into a prince when kissed by a beautiful princess? One of the three ladies, dressed in a striped high-waist Directory dress, is bending towards the frog with a mischievous smile.

If we turn to the *intrinsic meaning* or *content* level one possible interpretation regarding Poiret's choice of the Directory style was that he liked to present himself as the *couturier* who liberated women from their corsets and crinolines. But Poiret's new style was not that new after all; rather it was a shrewd manoeuvre to accommodate

> a taste for historicizing styles that had characterized French fashion almost from its inception. Most obviously his gowns paid homage to the neoclassical tastes that prevailed in the years after the Revolution, and particularly during the French Directory (1795–9) when dresses inspired by the robes of ancient Greece and Rome were worn by young women known as the 'merveilleuses', a group that included in its ranks the famous *Mme. Récamier* and the future Empress Josephine. (Davis, 2006: 26)

Poiret even paid homage to the Empress Joséphine by calling one of his earliest neo-classical outfits dated 1907 'Josephine'. It consisted of a white satin evening dress covered by a fine black tulle tunic decorated with a stylized border consisting of a circular motif, and a high-waist bodice separated from the skirt by a black border decorated with a golden rose. The 'Josephine' gown was incorporated by Paul Iribe in his album, and what the eyes see at the

Figure 6.3 *Paul Iribe,* Les Robes de Paul Poiret racontées pour Paul Iribe. *Pochoir. Plate nr. 3, 19082. Diktats Bookstore, Lille.*

primary or *natural* subject matter leve is the image of a young lady draped in a finely pleated chiton-like chemise and over it a pleated three-quarter length black *himation*-like tunic whose timeless beauty brings to mind the Caryatid Porch of the Erechtheion on the Athenian Acropolis. The only concession to fashionability was the red rose placed in the décolletage matched by the red bandeau encircling her black hair. The young lady seen frontally is leaning against a chest of drawers, and on it a small bronze statuette representing a female nude, possibly Aphrodite, whilst on the wall we spy a reproduction of George Romney's portrait of Emma, Lady Hamilton. At the *secondary* or *conventional* subject matter level the expensive attributes surrounding the lady

reveal her elevated social standing, but we learn even more at the *intrinsic meaning* or *content* level:

> Poiret's white 'Josephine' gown is shown in front of George Romney's 18th century portrait of Emma Hamilton. It is a meaningful juxtaposition, for the reference both to Empress Josephine, the first wife of Napoleon Bonaparte, and to Hamilton, the spirited artist's model and muse; both ladies were early adopters of the chemise gown in the final years of the 18th century. (Calahan and Zachary, 2015: 20)

The 1908 album was followed in 1911 by a second, *Les choses de Paul Poiret par Georges Lepape*, containing twelve **pochoir** illustrations, revealing Poiret's fascination with all things exotic and oriental. Like Iribe before him, Lepape provided a *gesamtkunstwerk* about the world inhabited by Poiret's exotically attired young models who populate his images:

> Lepape's waifish models – sinuously elongated and wearing masklike makeup – lounge in sumptuous settings, turbaned and bejewelled, they inhabit cushioned salons and chic theater loges and attend to tiny gardens in audacious 'Harem' pants. (Davis in Koda and Bolton, 2007: 35)

Like Iribe, Lepape does not provide titles for his images, and for that reason the *secondary* or *conventional* subject matter level is left for us to work out. Fortunately, Lepape's images tend to be self-explanatory, telling the same story about youth, beauty, wealth and privilege. But there are tantalizing exceptions, as in the example in which we see at the *primary* or *natural* subject matter level a young lady wearing a yellow 'directory' gown encircled by a red girdle under her breast terminating with an imposing tassel. She is seen frontally against a neutral background; a green parrot is balancing on her left-hand fingers, whilst with her right hand she picks a red berry (or cherry) from a plate handed to her by a black child, dressed in blue *shalvar* with red polka dots, his waist encircled by a wide blue shawl and bands on his arms and barefooted ankles. At the *secondary* or *conventional* subject matter level, however, there is something disturbing about the way the young boy is bent at waist level so that we cannot see his face hidden between his outstretched arms. He is holding the plate in a position of abject submission suggesting a slave-like

status, whilst the young woman looks down at him with disdain. Is the young black slave inspired by the *Ballets russes,* perhaps, the ballet *Schéhérazade* awash with slaves? There is no certainty, regarding the subject matter, but at the *intrinsic meaning* or *content* level one thing is certain: Poiret's 'orientalist' phase was inspired by the arrival of the *Ballets russes* in Paris. The date was 19 May 1909 when their maverick impresario Sergei Diaghilev presented his fourth *Saison russe* in Paris. His encounter with Paris started in 1906 when he organized an exhibition of Russian art at the Salon d'Automne, followed in 1907 and 1908 by musical events, including Modest Mussorsky's opera *Boris Godunov* with the awesome Feodor Chaliapin in the title role (Bell, 2010: 25–47). On the same dates two ballet productions also premiered at the Châtelet: *Le Pavilion d'Armide* and *Danses polovtsiennes du Prince Igor,* with costumes designed by Alexander Benois and Nicholas Roerich.

But this was only a taste of things to come: on 14 June 1910, the ballet *Schéhérazade* which presented a gruesome story of love, betrayal and death derived from the *One Thousand and One Nights* became an overnight sensation, not only because of its violent narrative but also the powerful stage and costume designs by Leon Bakst (Bell and Maxell in Bell, 2010: 83–164). When the curtain went up it revealed a seraglio painted by Bakst in brilliant colours, poignantly analysed in *Vogue* as follows:

> Like an exuberant barbarian, Bakst wanted his pigments to live in the paint, the dancers to sing and shout about and dance with joyous abandon. Emerald, indigo and geranium. The leopard's spots and the scales of the serpent, black, rose, vermillion and triumphant orange were all shrieking to be heard and shrieking in strange harmony. The author of *Les Fleurs Du Mal* would have hailed the colourist as a great epic poet . . . The effect of Bakst's scenery was exalted by the voluptuous movements of the dancers and the astonishing music of Rimsky-Korsakov. The result was a bacchanal more splendid than Rubens ever dreamt of; an orgy of sound, colour and movements. *Schéhérazade* was more than that however it was the greatest protest against traditional stage convention seen in Paris in generations ... it became an immediate favourite of Paris . . . Paris was swept off its feet. (*Vogue*, New York, 15 December 1910, in Davis, 2010: 122–3)

Modernism: Fashion and Art 199

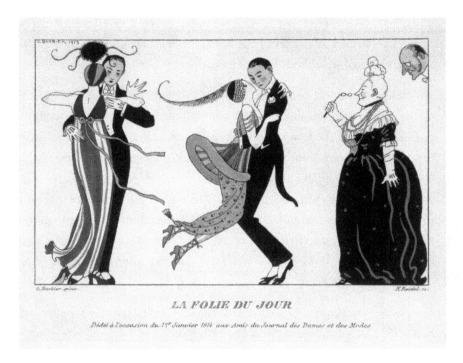

Figure 6.4 *Georges Barbier,* The Madness of the Day, *1913. In* Journal des dames et des modes. *Colour lithograph. The Stapleton Collection, London.*

The impact of this ballet on Poiret was instantaneous and he embarked on his 'Orientalist' phase with a series of magical creations, including his 'harem pantaloons' in 1911 and the 'lampshade' tunics in 1913, combined in one outfit in action in Georges Barbier's witty image.

Indeed when *le style Sultane* was launched it created a sensation not only because putting women in trousers was perceived as a challenge to established social norms, but also because it was perceived as constituting a threat to male political supremacy (Davis, 2006). The audacious new look reverberated as far as Eastern Europe visited by Poiret in 1911 with his retinue, which included his wife Denise, nine mannequins and numerous trunks filled with the latest 'Orientalist' outfits. His itinerary took them through 'Berlin, Warsaw, St. Petersburg, Moscow, Bucharest, Budapest and Munich, ending in November 1911 in Vienna.' (Hess in Koda and Bolton, 2007: 39).

But although there was no mention of Poiret's visit in the Romanian press, something even stranger happened, because his reputation preceded his visit.

Thus, we find on page one of the reputable newspaper *Universul* dated Saturday 12 February 1911 a reportage about the latest fashion trends in Paris, signed by *Veturia*, but without Poiret's name:

> This kind of vestment consists of some sort of wide silk trousers which fall all the way to the ground topped by a tunic – at times left loose – to allow only a glimpse of the lower part of the trousers, which gives it the illusion of an ordinary dress. In other instances the *jupe pantalon* is fastened on the ankle creating a *bouffant* effect and yet in other instances its sides are split open attracting thus indiscreet glances. This type of *jupe pantalon* is meant to be officially launched in the near future, by considering our sense of the ridiculous we will see if it will succeed. What we have seen so far is that at the *Comedie Française* it did not work and the actresses wearing *jupe pantalons* were booed.

Two separate reportages followed on Monday, 21 February and Wednesday, 2 March 1911, respectively, in the same *Universul* about two separate events. The first happened in the provincial town of Craiova, where a prostitute named Vasilichia wearing such a *jupe pantalon* was chased in the street by a mob and the police had to intervene. A second, very similar event took place on the streets of Bucharest. But the most flattering homage to Poiret was that on Saturday, 2 July 1911, we find in *Universul* an advertisement about a comedy in three acts titled *The Jupe Pantalon* by C. Riuletz presented by the artists of the prestigious National Theatre at an open air theatre in the *Blanduzia* Garden.

A new way of presenting images on the page: Fashion photography

Fashion photography was inaugurated by Edward Steichen in 1911 when he photographed thirteen models wearing Paul Poiret's latest collections using soft focus to create his moody images, but they were not meant to inform the viewers how the clothes they modelled should be worn by their owners.

Steichen, who was a trained painter, wanted to create artistic tableaux and this is how fashion photography was invented. But in spite of being a newcomer

to presenting fashion images on the page, photography was able to deliver results that established protocols the old techniques based on the drawn or painted image were not able to, because of their technical limitations.

So impressed was art critic Paul Cornu with Paul Poiret's albums that in the April 1911 issue of *Art et Décoration* he published an article titled 'The Art of Dress'. But his article was not accompanied by Lepape's **pochoirs** but something new: thirteen photographs of Poiret's mannequins modelling the latest fashions, taken by painter/photographer Edward Steichen. His achievement is even more remarkable, considering that no antecedents existed:

> Before then the photography of costume had not conceived anything beyond, let's say, standing two models side by side and having one of them hold the programme of *Schéhérazade*. Steichen created soft-focus *tableaux* involving graceful gestures, the choreographic interplay of figures, an understanding of the clothes and an intriguingly angular presentation of space which translated readily into an orderly geometry on the printed page. (Hammond in Frizot, 1998: 3003–4)

We can see that its 'orderly geometry' was influenced by cubism, not only in context but also in 'the cloth, the cut of the garment and also the photographic composition' (Ducros in Frizot, 1998: 538).

Steichen's new approach, which involves complex spatial relationships, was perfectly captured in the image titled 'Bakou' and 'Shepherdess' for which Steichen used a soft-focus approach which enabled him to create the moody atmosphere characteristic of each of the thirteen photographs he took of Poiret's collection for *Art et Décoration*.

Poiret head-hunted the former editor of *Art et Décoration*, Lucien Vogel, for another enterprise he became involved with: the luxurious magazine *Gazette du bon ton*, whose telling subtitle was 'Modes et frivolités', jointly financed by seven leading Parisian couture houses: Doucet, Cheruit, Doeuillet, Paquin, Poiret, Redern and Worth. Its inaugural issue was published in October 1912 with an introduction by poet Henri Bidou, who provided the first history of fashion illustration, whose starting point was 1786, when Baron Melchior von Grimm published *Le journal de modes*.

Bidou was also the first to make the link between fashion and art, introducing it in a poetic manner: 'Women's garments are a pleasure for the eye which must not be judged as inferior to the other arts' (Bidou, 1912: 3). He then went on to say that the function of magazines is to be the expression of this 'new' art, recommending also a method for achieving it. Thus, each issue would present two sets of illustrations: one commissioned from artists such as Bakst or Iribe, who would produce their own inventions of haute couture garments. The second will be based on the outfits created by the *couturiers* themselves, but even these would be drawn by artists: they will be the 'portraits of these *toilettes* interpreted by the painters' (Bidou, 1912: 3).

Thus Bidou established that fashion illustrations became a 'new' form of art reflecting the way artists produced the images on the page, so that what the eyes saw were their artistic interpretations of what Roland Barthes called the 'technological' garment created by the *couturier*. And there is no doubt that one of the most celebrated examples of how this worked has to be the collaboration between Madeleine Vionnet and Thayaht for *Gazette du bon ton*.

Fashion and art, case study: Madeleine Vionnet and Thayaht

A newcomer to the fashion scene, Madeleine Vionnet opened her first couture house in 1912 at rue de Rivoli, but in 1914 the war forced her to close the establishment. When she reopened it in 1918, a new generation of women – very different from the women of *La Belle Epoque* – emerged, ready for what Vionnet had to offer: the 'flapper' had arrived!

In 1919 the young futurist painter Ernesto Michahelles, who signed with the palindrome Thayaht, arrived in Paris, and his collaboration with Madeleine Vionnet started with his witty logo created for her establishment that she used until closing it in 1939 (Saurat in Golbin, 2009: 293).

Encouraged by Thayaht, Vionnet embarked on what would become her signature 'look' inspired by the new style which originated from the streamlined functionality of *Art Deco*. Its roots can be found in *Purism*, the

art movement founded by Amedée Ozenfant and Charles-Edouard Jeanneret, also joint founders in 1920 of the magazine *L'esprit nouveau*.

Their complicated theoretical principles reverberated at *the Exposition Internationale des Arts Décoratifs et Industriels Modernes* (April–November 1925) for which Charles-Edouard Jeanneret, now calling himself Le Corbusier, created the *Pavillon de l'esprit nouveau*: the ultimate embodiment of Purist aesthetics. But the *Art Déco* label (short for 'décoratif') was in fact derived from an exhibition held at a later date, in 1966: *Art Déco/Bauhaus/Esprit Nouveau* (Benton, Benton and Wood, 2003: 16).

Madeleine Vionnet was the true heir of the fashion revolution inaugurated by Paul Poiret, who used the visual vocabulary of cubism in the sense that 'the cylindrical wardrobe replaced the statuesque, turning three-dimensional representations into two-dimensional abstractions'. For that reason Poiret's 'process of design through draping, is the source of fashion's modern forms' (Koda and Bolton, 2007: 14).

Poiret advocated fashion cut along straight lines and constructed from rectangles, but Vionnet took it a stage further by tilting the rectangles at 45 degrees to obtain the lozenges which complied with her **invention** of the **bias cut**, as she unequivocally declared: 'I was the first to make use of the bias' (Marie Lavie-Compin, 'Vionnet' in *Vogue France*, April 1974, p. 116, in Golbin, 2009: 117).

Like Poiret, she abandoned the fitted system in favour of draping, working with an 80-centimetre wooden mannequin placed on a revolving stool and starting from three basic geometrical shapes: the square, the rectangle, the circle. From these 'archetypal forms', she proceeded to 'cut into, to fold to pleat, to twist' in order to evidence her artistic vocabulary (Golbin, 2009: 23).

When Thayaht arrived in Paris, a special collaboration started between him and Vionnet for the *Gazette du bon ton*, and Thayaht, as a futurist, used its tenets to create the images which illustrated Vionnet's creations.

Inaugurated in 1909 by five maverick Milanese artists, they chose the label 'Futurism' because it captured the concept at the centre of the movement: **velocità**. During the same year, futurism arrived in Paris and 'The First Manifesto of Futurism' was published on the front page of *Le Figaro*. In it the

204 *Images on the Page*

futurists proclaimed the supremacy of the machine over art, thus anticipating *Art Déco*.

> We declare that the splendour of the world has been enriched with a new form of beauty, the beauty of speed. A race-automobile adorned with great pipes like serpents with explosive breath . . . a race automobile which seems to rush over exploding powder is more beautiful than the *Victory of Samothrace*. (Taylor in Chipp, 1973: 286)

A key influence on futurist aesthetics was Henri Bergson's philosophy, and this was particularly obvious in Umberto Boccioni's own theories outlined in the *Technical Manifesto of Futurist Sculpture*, published on 11 April 1912 and reprinted in the catalogue of his sculpture exhibition at Galerie la Böetie (Petrie, 1974). In it Boccioni argued that the artists' intuitive grasp of absolute motion in terms of *force-lines* revealed 'how the object would disintegrate following the tendency of its innate forces' (Taylor in Chipp, 1973: 298).

A decade later Thayaht put to good use Boccioni's *force-lines* in his **pochoirs** for Vionnet for the *Gazette du bon ton*, demonstrated in the illustration of a coat by Vionnet. The young lady's balletic movements are suggested by the position of her feet whilst the adjacent trajectory lines indicate that her right foot will move forward whilst her left, positioned behind the right toes pointing down, will follow a semi-circular direction. Movement is further emphasized by the black circular *force-lines* tinged with blue and yellow touches, which cover her terra-cotta coat like a spider's web, representing the dynamic movement of the body in space. Were it not for its title *Un manteau de Madeleine Vionnet*, we would not guess that the outfit was the main protagonist.

At the *primary* or *natural* subject matter level, what the eyes see is a young skater represented against an abstract background dominated by the spider web of the *force-lines* indicative of its dynamism.

At the *secondary* or *conventional* subject matter level, the title indicates that we are dealing with an advertisement of a garment by Vionnet and nothing else; but this image is also about a rich, young lady wrapped up in an expensive *manteau* by Vionnet enjoying herself on a chilly autumn day.

But it is at the *intrinsic meaning* or *content* level where Thayaht encoded the cultural heritage of the futurists, who introduced themselves as a radical

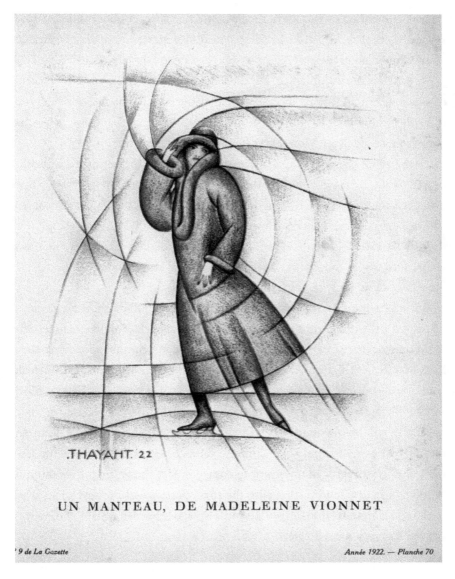

Figure 6.5 *Thayaht,* Un manteau de Madeleine Vionnet, *1922. In* Gazette du bon ton. *Alamy ID WWC3Y9.*

movement that wanted to break away from tradition, even destroying it (of course they did not mean to burn down the Louvre!). Above all, futurism wanted to encapsulate modernism in its visual vocabulary and because no such vocabulary existed, futurists had to invent their own. With hindsight, however,

their proclamation of 'the age of the machine' had sinister undertones because several years later, in 1914, the First World War started and what separated Paul Poiret from Madeleine Vionnet was this tragic event.

By the time the war finished, *la belle époque* was over and a brave new world of speed, technology, jazz and the arrival of the Americans in Paris replaced it. With it came the new woman of the 1920s, the 'flapper', and it was for the flapper that Madeleine Vionnet created her daring garments.

As the 1930s were drawing to a close and with them the optimistic interwar period of the Roaring Twenties, the 'flapper' and 'art deco', a last flourishing event was the Universal Exhibition of 1937. The fine arts were again reinstated centre stage, alongside technology and the crafts whose dominant theme was the Pavillon de l'électricité et de la lumière designed by architects Georges-Henri Pingusson and Robert Mallet-Stevens and decorated with the heroic murals of Raoul Dufy (Green, 2000: Introduction).

But its Pavillon de l'Élégance was a very different affair from the pavilion presented at the 1925 Exposition internationale des Arts Décoratifs et industriels modernes de Paris, dedicated to conspicuous consumption glorifying thus Karl Marx's 'fetishism of the commodities'. The 1937 pavilion was surreal, poetic and moody: it consisted of a landscape of Arcadian elegance filled with artificial trees and Ionic columns designed by Émile Aillaud and strange dysfunctional mannequins. According to their creator Robert Couturier, they were meant to appear like 'fantastic giants of terracotta' with 'featureless faces and tiny breasts' in order not to compete with the garments (Mahon in Wood, 2007: 134), contrasting with the shrill presence of the surrealists who purloined commercial mannequins and displayed them in a state of disarray, as Man Ray recalled with glee:

> In 1937 nineteen nude young women were kidnapped from the windows of the large stores and subjected to the frenzy of the Surrealists who immediately deemed it their duty to violate them, each in his own original and inimitable manner but without any consideration whatsoever for the feelings of the victims who nevertheless submitted with charming goodwill to the homage and outrage that were inflicted on them, with the result that they aroused the excitement of a certain Man Ray who undid and took out his equipment and recorded the orgy. (Mahon in Wood, 2007: 134–5)

One of the strangest displays was Elsa Schiaparelli's installation, consisting of a faceless nude mannequin by Robert Couturier, seated under a tree with both arms stretched outwards as if feeling its surroundings like a blind person, whilst to the right, the dress created by Schiaparelli separated from the body was suspended in the air, limp and lifeless.

But this display of angst merely reflected the political situation in which Europe found itself at that time and this was reflected by a curious detail: the exhibition was dominated by the two most powerful dictatorships in Europe: Nazi Germany and Soviet Russia and it was perhaps an ironic gesture that their aggressive pavilions were positioned facing each other at the entrance to the exhibition. These were troubled times poignantly captured by the Pavilion of Elegance, whose atmosphere was immortalized by Surrealist German artist WOLS (Alfred Otto Wolfgang Schultze) in his black-and-white photographs commissioned by *Harper's Bazaar*. But the press coverage seemed less preoccupied with the shenanigans of the art and fashion world and more interested in the propagandistic aspect of the event. Thus *L'Officiel de la couture, de la mode de Paris* (openly calling itself *Organ de propaganda et d'expression de l'art français*) published a series of reportages by their critic S.R.

Figure 6.6 *Elsa Schiaparelli,* The Pavilion of Elegance *at the Universal Exhibition of 1937. Diktats Bookstore, Lille.*

Nalys, focusing on the triumph of France over Nazi Germany and the Soviet Union. But the celebratory mood tinged with melancholy which permeated the atmosphere, was the result of a sentiment of unrest and with good reason: two years later on 1 September 1939 Germany invaded Poland, plunging Europe into the catastrophic Second World War.

The aftermath of the Second World War and the ideological division of Europe

The Second World War ended in 1945 with the offensive on Berlin by the Red Army, followed by the conference of the 'Big Three': Stalin, Churchill and Roosevelt at Yalta, where they plotted the unconditional surrender of Germany, finalized on 8 May 1945.

Another decision, with important repercussions for the future of Europe, was its division into two blocs dominated in the West by capitalism and the vagaries of the free market, whilst Eastern Europe became the political vassal of the Soviet Union, submitting to the dogma of socialism in its most extreme version: Marxism–Leninism–Stalinism. The two blocs were divided by a metaphorical 'Iron Curtain' which cut across Germany with Berlin becoming the *locus* where the ideological battle between capitalism and communism was enacted. It also marked the beginning of a new kind of war, an ideological and cultural war seeking the domination of 'hearts and minds': the 'Cold War'.

It was in Europe that the battle for hearts and minds was at its bitterest. There the internal political situation was more complex than in the two superpowers; both right and left were powerful forces and no simplistic Cold War patriotism could unite her (Lindey, 1990: 10).

Its impact was felt not only at a cultural and artistic level but also in the fashion world – which continues to this day to be less well known than the visual arts, cinema or literature – and this was particularly true of the Soviet Union and its Eastern European satellites.

A recent and welcome exception emerged, however, thanks to Djurdja Bartlett's book *Fashion East* (2010), whose subtitle, *The Spectre That Haunted Socialism*, was tellingly borrowed from what must be the most famous quote

in history: the opening lines of Marx and Engels's *Communist Manifesto*, published in 1848: 'A spectre is haunting Europe, the spectre of communism.' The paradox is that the utopian fashions created in the 1920s by the Russian Constructivists, whose two female luminaries Varvara Stepanova and Lyubov Popova were designing *prozodezhda* (production clothing) for the proletariat, were the only original Soviet contribution to fashion. But by 1935 the new socialist 'look', informed by Stalinist aesthetics, was implemented through the opening of Moscow's *Dom Modelei* (House of Prototypes) designing for mass production (Bartlett, 2010: 5). Ironically, 1935 was also the year when Elsa Schiaparelli's capsule collection created for the Soviet working woman was rejected by Stalin for being 'too ordinary' (Bartlett, 2010: 29). Meanwhile the members of France's left-wing intelligentsia flocked to Moscow to attend the 'Congress for the Defence of Culture' and one year later – as Stalin was busy with his 'great purge' – André Gide was idiotically swooning over the atmosphere of 'joyful enthusiasm' he encountered on the streets of Moscow. And he seemed genuinely surprised to find so many 'made-up and manicured women with red nails everywhere, and especially on the Crimean peninsula' (Gide quoted by Bartlett, 2010: 70).

Stalin's aspiration to create an aesthetics that informed the 'look' of the new Soviet woman was to produce clothes for everyday living with no distinction between the prototypes reproduced in fashion magazines and the clothes she would wear. This was exactly what the constructivists were aiming for, but whilst their visionary designs were influenced by genuine utilitarian principles, for which Stalin had no patience, his own vision was designed to match the grandiose ideals of the new Soviet Union.

Thus 'fashion became one of the new Stalinist rituals, carefully recorded from traditional Western patterns' and adopted accordingly. The addition of populist propaganda elements, such as ethnic motifs, were meant to reinforce their autochthonous origins and Stalin's fashion ideal evolved into a pompous vulgarity, very remote from the simplicity that should have informed the life of the Soviet woman.

Whilst the world of fashion was accepting the one-dimensional influence both of the capitalist West and the communist East, it was the art world where the real shenanigans generated by the Cold War were being enacted,

with the secret involvement of the United States' mighty Central Intelligence Agency (CIA).

The ideological *locus* for this political battle was realism versus abstraction, with the former paying lip service to Socialist Realism embodied in Vera Mukhina's monumental bronze sculpture commissioned by the Soviet Pavilion built for the Universal Exhibition of 1937, for which she chose a factory worker and a peasant woman striding in unison and holding high the attributes of their social identity: the hammer and the sickle. By contrast 'Abstract Expressionism', which became the first original American avant-garde movement, was inaugurated by Jackson Pollock's 'action paintings'.

Existentialism, feminism and fashion

An unexpected issue which emerged before the war was the ambiguous political position held by French artists, including such luminaries as Pablo Picasso and Fernand Léger, who became members of the French Communist Party. Their endemic ambiguity was traced, according to 'philosophe nouveau' Bernard-Henri Lévy, to Alfred Dreyfus' case won for him by his friends, including Émile Zola, who raised their banners high, whilst inventing a new personage in the process: 'the intellectual' (Lévy, 1995).

One such was Jean-Paul Sartre whose existentialist philosophy captured the mood of despair dominating Europe in the aftermath of the war. Sartre was a polymath whose reputation rested equally on his philosophical, literary, polemical and journalistic activities. In 1943 he published *Being and Nothingness*, initiating at the same time the journal *Les Temps modernes* whose list of collaborators read like the who's who of French *intelligentia*: Simone de Beauvoir, Maurice Merleau-Ponty, Albert Camus and Raymond Aron (Kearney, 1999: 51–72).

But Sartre owed his popularity to a later work titled *Existentialism and Humanism* published in 1946, based on a lecture delivered on 29 October 1945 at the club Maintenant. In it he proposed a popular definition of his existentialist philosophy, famously summed up in three words: 'Existence precedes essence', amounting to no less than a refutation of Plato's idealism

postulating a preordained essence on which human beings modelled themselves. For Sartre, there was no such essence, only existence: 'men are nothing but what they choose to become, their essence consists in what they choose to do' (Warnock, 1965: 41). When Sartre delivered his lecture, the tension was such that members in the audience fainted (Kearney, 1999: 52–3). But whether they fainted because Sartre declared that left-wing philosophy was spreading its roots fast or because of the overcrowded and very likely overheated club, remains a matter of conjecture. What followed was that existentialism became something you not only discussed but also lived: you became it and with that came a distinct life and a distinct dress style.

One of its manifestations were the existentialist cellars of the 1950s scattered in the expensive quarter of Saint Germain-des-Près, populated by

> girls with long hair in jerseys and men's trousers who danced the night away and listened to Juliette Greco's husky voice . . . Juliette and her friends wore their hair long because they could not afford to go to the hairdresser, they wore men's trousers because they could not afford to buy stockings; they wore black jerseys with rolled-collars because they could not afford to send light coloured woollens to the cleaners; they looked like 'an unknown woman from the Seine because they were hungry and sad'. (Maurois, 1954: 24)

They read Sartre, Camus and Merleau-Ponty; they frequented Café Mefisto, Bar Vert and Tabou in rue Dauphine, which became the meeting place where they could keep warm and talk into the early hours of the morning. Simone de Beauvoir captured something of its electric atmosphere in her memoirs and in a seminal passage we learn about the 'official birth' of *Existentialism*, whose history was intertwined with that of the Tabou.

> Sartre's enemies continued to add fuel to the flames of the ambiguities that had been created around Existentialism. The Existentialist label had been applied to all our books – even our pre-war ones – and those of our friends, Mouludji among others, also to a certain style of painting and a certain sort of music. Anne-Marie Cazalis had the idea of profiting by this vogue. She belonged, like Vian and a few others, both to the literary world of Saint-

Germain-des-Près and to the subterranean world of jazz. While talking to some journalists, she baptized the clique of which she was the centre, and the young people who prowled between the *Tabou* and the *Pergola* as Existentialists (de Beauvoir, 1968: 151–2).

Anne-Marie Cazalis's friend, Juliette Greco, became instrumental – together with the musicians, dancers, writers and poets who frequented Tabou – in inventing the existentialist 'look' summed up in one word: black. No links have been established between the existentialists and the mainstream fashion designers, but Dior, Fath or Balenciaga would certainly have been aware of the existentialists for one important reason: their outlook on life and way of dress can be regarded as symptomatic of a radical change in society regarding the status of women. Compared to their English counterparts who won the right to vote in 1918, French women who won the vote only in 1944 were lagging behind.

But it took two world wars to set this process of emancipation in motion and one of its key consequences was the emergence of feminism, with the publication in 1949 of Simone de Beauvoir's book *The Second Sex*. In the introduction, the author described its content as 'irritating, especially to women' but by no means new:

> Enough ink has been spilled in quarrelling over feminism, and perhaps we should say no more about it. It is still talked about, however, for the voluminous nonsense uttered during the last century seems to have done little to illuminate the problem. After all, is there a problem? And if so, what is it? Are there women really ... But first we must ask: what is a woman? (de Beauvoir, 1968: 13)

This was the fundamental premise Beauvoir set out to prove, by undertaking to analyse women in French society from the moment of their birth, via childhood, youth, sexual initiation complete with the lesbian variety, through to adulthood with its options of marriage, motherhood, prostitution and old age. But she also introduced a new breed of women, like herself, admitting that she was still only a 'femme-alibi'. Yet her debate confirmed her famous conclusion that women are not born but made 'On ne naît pas femme; on le devient' (de Beauvoir, 1968: 293). And it was for this new breed of women that Dior, Fath and Balenciaga wanted to design their clothes.

Part Two

The photographed image on the page

Christian Dior and the 'New Look'

A radical shift away from illustration – which dominated the way costume and fashion images were represented on the page since the Renaissance, or even before if Villard de Honnecourt's drawings come into consideration and as I argued, they ought to – emerged after the Second World War with photography.

Its invention during the nineteenth century did not influence fashion images, and magazines continued to use the tried and established system of illustration. Even when Edward Steichen 'invented' fashion photography by photographing Paul Poiret's 1911 collection and had the photographs reprinted in *Art et Decoration*, his 'revolution' passed completely unnoticed. It was only after the Second World War that photography re-emerged and became the dominant mode of presenting images on the page, and Christian Dior's use of photographers for his collections can be regarded as one of its starting points.

Against the backdrop of feminism, Christian Dior's preoccupation with the past appears old-fashioned, but his interest in things 'retro' was in fact influenced by the prevailing zeitgeist and he knew how to capitalize on it by returning to historic dress for inspiration. Dior is regarded as a giant of modern fashion but his iconic status was due not only to his brilliance but also to his seminal 1947 'Corolle' collection, better known as the 'New Look'

214 *Images on the Page*

– the name formidable fashion critic Carmel Snow gave it in her review of the collection for *Harper's Bazaar*.

When Dior launched the 'Corolle' collection on 12 February 1947, it brought him both admiration and resentment in equal measure because his intention, to reintroduce femininity to a generation deprived of it by the war, was misinterpreted as reactionary: 'I designed clothes for flower-like women, with rounded shoulders, full, feminine busts, and hand-span waists above enormous spreading skirts' (Dior in Ewing, 2005: 155).

What Dior did was to depart from the military-inspired masculine silhouette of the war period and replace it with a feminine 'look' whose sheer visual beauty justified its international success, but at closer analysis what he created was anything but a 'new look':

> Despite its name, however, the look was far from new. It revisited the minuscule waists and spreading skirts of historical dress, especially dress of the mid-nineteenth century, it also somewhat resembled ballet costume; but in its total rejection of wartime styles and its defiant challenge to rationing restrictions, it was eminently newsworthy and therefore desirable. (Seeling, 2000: 264)

Less well known but just as important was Dior's decision to depart from established norms of using illustration, which he replaced with photography, and the photograph taken in 1955 by German photographer Willy Maynald of Dior's model Renée wearing the *tailleur bar ensemble* (in the collection of the V&A Museum seen in this illustration) captured its subversive beauty.

What the eyes see in Maynald's very famous photograph at the *primary* or *natural* subject matter level is Dior's model projected monumentally to cover the entire frame and posing in a balletic stance in a narrow, cobbled street which was empty. Her tiny waist encased in the ivory white jacket is further emphasized by the huge black pleated skirt, and the outfit is completed by black gloves, high-heeled white shoes and a lamp-shade black straw hat.

Journalist Ernestine Carter, reporting from Dior's show, described the models as

> swinging their vast skirts (one had 80 yards of fabric) the soft shoulders, the tight bodices, the wasp-waists. To us in our sharp shouldered . . . skimpy

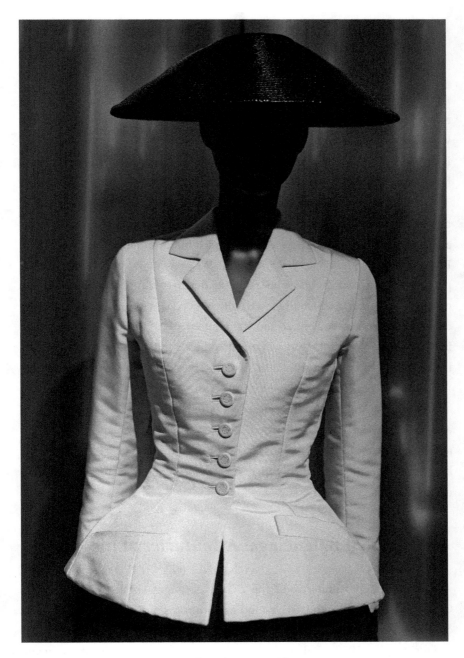

Figure 6.7 *Christian Dior*, the tailleur bar ensemble.

rationed suits, this new softness and roundness was positively voluptuous. All round the salon you could see the English tugging at their skirts trying to inch them over their knees. (Carter in Cullen and Burks, 2019: 7)

At the *secondary* or *conventional* subject matter level we learn more about the ensemble, namely that the ivory white jacket is made of shantung, and the vast pleated black skirt is made of crêpe and lined with silk, but the 'narrative' is revealed at the *intrinsic meaning* or *content* level, because it was this dainty flower-like femininity which was regarded as reactionary.

Little wonder, because Maynald captured an image of a woman disabled by her attire: the suffocating waist, the heavy skirt, her high heels, long gloves and a generously shaped hat are good to pose with but not to lead an active life in. But was this the photographer's intention? We don't know, but if we recall the photograph of a black French soldier saluting the tri-colour photographed for the cover of *Paris-Match*, which Roland Barthes argued was hiding the real message of racism in French society, so too the photograph of an ultra-feminine lady incapacitated by what she was wearing could hide the real message: inequality between men and women still existed in post-Second World War French society.

But it was not Dior who captured the post-war spirit, because he did not address the needs of the new generation of Parisian women who read Sartre and de Beauvoir, dressed in black, smoked, drank and danced the night away in underground night clubs; instead he continued to target the affluent beau monde without realizing that they were threatened to become, like dodos, extinct.

Cristobal Balenciaga: A *couturier* of his time

The couturier who understood the changes brought about by the war was Cristobal Balenciaga, who arrived in Paris from his native Spain in 1937 and opened his couture house at nr. 10 Avenue George V.

During the 1950s Balenciaga produced some of his most enduring collections, expertly summed up by Mme Lucie Noel in an article titled 'Paris Sketchbook Highlights Recent Collections of Balenciaga and Givenchy', published on 1 September 1958 in the *New York Herald Tribune*:

Modernism: The Photographed Image on the Page 217

It has been said of Cristobal Balenciaga that he is 'the di Vinci' [*sic*] of the couture, 'the Molière of dressmakers'. American designers have said that viewing his collection is like 'attending the Sorbonne' and his fellow couturiers refer to him as 'the Master'. All of these expressions are just other ways of describing M. Balenciaga. He is the greatest dress designer in the world today. M. Balenciaga is responsible for better or for worse, for the semi-fitted suit, the sack, the balloon, the bucket hat, the high-waisted suit, the short skirt, the tunic, the cocoon coat, the evening hat, the wide shoulders, the bourgeoning collar, the up-in-front, down-in-back evening dress and the panel back. In short everything that is fashion today. (Noel in Golbin, 2007: 112)

Not much else can be added to such a sycophantic evaluation, but this journalist did her homework because she appeared familiar with the development of Balenciaga's career and the invention of his most iconic 'looks' such as the balloon, tunic, sack and chemise, all of which contradicted everything Dior's lavish crinoline-like 'New Look' stood for.

In the image selected for analysis the model is wearing a Balenciaga coat. What the eyes see at the *primary* or *natural* subject matter level is an attractive young woman wearing a knee-length cocoon coat with a cape-like collar, reminiscent of Sherlock Holmes' iconic outfit, which reveals the hem of a very narrow three-quarter length dress underneath. A tight-fitting hood covering the model's head topped by a capricious little bow completes the outfit. Possibly inspired by Willy Maynald's photograph of Dior's model wearing the *tailleur bar ensemble* taken in a cobbled street, photographer Terry Fincher also chose a street, but a very different kind of street with a wide pavement typical of the expensive *faubourgs* of Paris. Its purpose, as the photograph is a still from a television show, reveals the *secondary* or *conventional* subject matter level, but it is at the *intrinsic meaning* or *content* level that a hitherto unnoticed new trend introduced by photographers revolutionized the way images were presented on the page. And what we see is truly fascinating: they put photography to good use by adding a dimension of everydayness to their photographs, which culminated with one of the most celebrated images in the history of fashion photography: Helmut Newton's moody photograph of

a young woman wearing an Yves St. Laurent' tuxedo, taken in 1975. Newton followed the same template used by Maynald and Fincher to photograph Dior's and Balenciaga's models, respectively, and represented his model standing in a cobbled street but with a mesmerizing difference: Newton's photography was taken during the night. Standing alone but unafraid, smoking a cigarette and sporting a *garcon* hairstyle in keeping with the severity of *le smoking* – Yves St. Laurent's famous creation of 1966 – the new woman of the 1970s is different from her counterparts in high heels wearing Dior and even Balenciaga outfits.

But it is nevertheless Dior who must be credited with having introduced a radical new way of photographing his models by removing them from the 'ivory towers' of the *couture salon* and bringing them out in the open: thus, we see them standing, walking and mingling in the street, probably the most famous location being Moscow, where Dior took his models in 1959. We know little about the fashion shows he presented in Moscow, but what endures are the snapshots taken of his models walking the streets of Moscow, happily mingling with the admiring crowds of Muscovites.

Like Poiret before him, Balenciaga regarded himself as an artist, and his most radical innovation was the use of a new material: *Abraham's gazar*, created for him by the Swiss firm Abraham Ltd., which specialized in silk textiles. Its stiff texture enabled Balenciaga to revolutionize the relationship between dress and the body, and by contradicting the established norms which required the dress to follow the architecture of the body, his dresses acquired a life of their own.

In 1968, Balenciaga closed his *maison de couture* because of his inability to cope with the fact that the 'aristocratic stage of grand couture finished' (Morini, 2006: 323) as prophetically signalled by *Queen* magazine in 1964 in an article 'with fictional obituaries of Balenciaga and Givenchy', including a comment from Brigitte Bardot who considered that their 'couture is for grannies' (Wilcox, 2007: 206).

Bardot understood that she belonged to a changed world and practised what she preached when she chose Jacques Esterel, an outsider from mainstream haute couture and who started his career in 1953 with a boutique rather than a *maison de couture*, to design her wedding dress.

In 1957, a 'nouvelle vague de la mode' (not to be outdone by cinema and literature) was introduced by film director Michel Boisroud with the film *La*

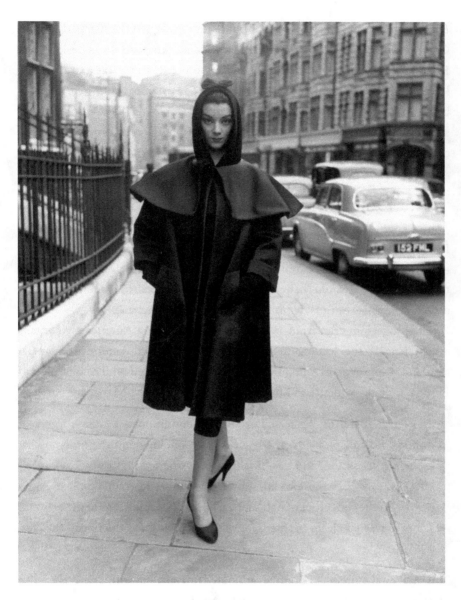

Figure 6.8 *Terry Fincher, photograph of a fashion model wearing a dress and coat by Balenciaga during rehearsals for an appearance on the television show* Fashions for Paris *(22 February 1955).*

Parisienne and that *parisienne* was Brigitte Bardot. When she married Jacques Charnier in 1959, she wore a *toile de Vichy* pink gingham dress designed by Esterel, which became an overnight sensation because this was a dress of the kind a Parisian woman walking the streets of *Le Marais* could wear without being afraid that she would look like a 'dodo', or, worse still like a 'grandmother', and in that sense she was not that different from her antecedent, *le parisienne* of a hundred years ago.

The 1960s: 'Street' fashion in London and Paris

In 1947, US president Truman applied to Congress for a $400 million economic aid for Greece and Turkey, and proposed a new policy whereby the United States would 'help free peoples who are resisting subjugations by armed minorities or outside pressure': the Truman Doctrine.

The programme ran from 1948 to 1951, establishing America's 'voluntary acceptance of the leadership of the free world'. But American financial assistance came at a price amounting to no less than the cultural colonization of Europe, more in evidence in England because there were no language barriers.

> The cultural life of Western Europe was conditioned by the climate of political liberalism, by great advances in technology and the mass media, especially television, and by a tidal wave of American imports. The overall effect was seen in the loosening of conventional restraints and, to some degree, in the reduction of national particularities. Freedom of the arts and sciences was taken for granted. Pluralism of views was the norm. (Davies, 1997: 1076)

This newly acquired freedom reverberated in fashion with the emergence of 'street' culture in England, and on 15 April 1966 *Time* magazine splashed the title 'London, the Swinging City' on its cover and the description stuck (Mendes and de la Haye, 1999: 179).

'Swinging London' was about youth, material culture and the changing of the fabric of society. Young people were able to eschew the social conventions of their parents' generation and parade their freedom on the streets of London.

Carnaby Street became the centre where they congregated to enjoy themselves, but above all to shop at Barbara Hulanicki's boutique, Biba:

> The place to be however was Barbara Hulanicki's crowded and noisy boutique, Biba. The Biba shop was set up in 1964, on the strength of a successful mail-order business established by Hulanicki a year earlier. Biba's retro art nouveau interiors, communal changing rooms, bentwood coat stands (replacing conventional dress rails) and charged atmosphere are legendary. In harmony with the moment, Biba clothes and makeup in sludgy colours were snapped up as soon as stocks arrived and were instant and profitable hits. (Fogg, 2013: 355)

The 'revolution' introduced at Biba's was the 'mini' dress, associated with the name of Mary Quant. She was not trained as a fashion designer; instead she chose to train as a teacher at Goldsmith College where she met her future husband Alexander Plunket Greene and in 1955 they opened their own boutique, Bazaar, in King's Road.

Quant made her dresses in her bedsitting room using paper patterns designed for a young clientele who wanted to look different from their parents by replacing the restrictions of 'torturing' devices such as the corset with freedom of movement.

> The Mary Quant label typified the 'Chelsea look', a silhouette that allowed freedom of movement and was inspired by children's and dancers' clothing: knee-high socks, pinafore dresses, leotards, gingham and flannel, allied to a style of dress worn by art students, with its roots in the Parisian Left Bank and American 'beats'. (Seeling, 2000: 348)

The invention of the mini dress continues to be an issue of debate and perhaps we shall never know the truth, but what separated London from Paris was that in the case of the former, Quant's mini was symptomatic of a 'street style' which emerged in London, providing an example of 'trickle up' theory, as the reverse of the 'trickle down' theory introduced in fashion theory in 1899 by Thorstein Veblen in his book *The Theory of the Leisure Class*. Veblen argued that the fashions worn by the upper classes were purloined by the lower classes who created 'street' replicas, but what we see in London is the reverse: a genuine 'street' style trickling its way up to haute couture.

In Paris, the mini was – if not invented – certainly associated with the name of André Courrèges' 1964 'Space Age' collection inspired by Yuri Gagarin's 1961 voyage to the moon, and for what the eyes see at the *primary* or *natural* subject matter level, I use the humorous analysis provided by François Boucher for it:

> For the now famous collection of 1964 he designed clothes with an extremely refined cut; he gave his dresses, which were structured without darts and hemmed a hand's length above the knee (a length that had not been seen since prehistoric days, an extraordinary form). Short white socks tucked into little square-toed boots, short white gloves, and plastic glasses completed Courrèges' image of the young, active and uncomplicated woman. (Boucher, 1997: 429)

If we follow the iconographical trajectory at the *secondary* or *conventional* subject matter level and then the *intrinsic meaning* or *content* level, their reading proves to be as uncomplicated as the image of the new woman for which André Courrèges designed his 'New Age' space suit, meant to reflect not only her but also the new age, when man reached, literally, to the moon.

'Anti-fashion': Vivienne Westwood, queen of punk

If 'street' fashion dominated the 1960s, the 1970s saw the emergence of 'anti-fashion', but the latter was not something new as Anne Hollander pointed out:

> There are different ways of defining fashion, but what is meant here is the whole spectrum of desirable ways of looking at any given time. The scope of what everyone wants to be seen wearing in a given society is what is in fashion; and this includes the haute couture, all forms of anti-fashion and non-fashion and the garments and accessories of people who claim no interest in fashion – a periodically fashionable attitude in the history of dress. (Hollander, 1993: 350)

Hollander regards 'anti-fashion', of which the 1970s manifestation is just one of many, as a 'recurrent theme in the history of dress', starting with the

'impoverished threadbare noblemen who could take pride in their lack of style', which contrasted with the vulgarity of the bourgeoisie, she ungenerously summed up as 'the middle class upstarts who were deeply considering the cut of their coats' (Hollander, 1993: 363).

The decade of the 1970s was different from the carefree 1960s, bringing with it darker concerns reflected by a specific brand of 'anti-fashion', different from its nineteenth-century version as defined by Hollander and championed by Oscar Wilde. Not so the 1970s, which gained the reputation of the decade of 'bad taste', culminating with the punks.

> The 1970's reputation as the decade of bad taste was well-earned. Platform shoes and hot pants, flared pants and polyester shirts, disco glitter, retro kitsch, and no-future punk, everything was tried, mixed rejected and then served again. It is easy to dismiss it as mere protest, but here was at base, a liberating, creative force which continues to make itself felt today. (Seeling, 2000: 410)

Punk was born in 1976 in London, when a group of unemployed students congregating around a young designer, Vivienne Westwood, who, with her partner Malcolm McLaren, manager of the rock band *The Sex Pistols*, designed the clothes of the notorious band. Once she established herself in her new métier, she opened a succession of boutiques in King's Road starting in 1971: Let It Rock; Too Fast to Live, Too Young to Die; Sex; and finally Seditionaries.

The identity of the punks became well and truly established by the time Sex opened, and its provocative title written in huge pink satin letters on the shop front was a good indication of what could be found inside. But it was not even the obscene T-shirts, such as the explicit image of two homosexuals engaged in a sexual act that were the most shocking but something even more obscene: the symbol of the swastika, which caused, and still does cause, offence.

The last boutique to open in 1976 (until 1980) was Seditionaries, by which time the key ingredients of the punk 'look' were identified as

> black tight trousers striped mohair sweaters with customized leather jackets and heavy duty Doctor Marten boots. Some female punks wore miniskirts, fishnet tights and high stiletto heeled shoes. Fetishistic leather and rubber

were an integral part of the punk look, as were trousers with bondage straps from knee to knee and bondage collars. Clothes were slashed and ripped, embellished with safety pins zips and studs. (de la Haye and Tucker in Laver, 2002: 270–1)

In the image selected for analysis what the eyes see at the *primary* or *natural* subject matter level is a young couple posing for the camera on a derelict site filled sky high with rubble and rubbish, against a background consisting of facades of what looks like a typical 1960s council estate. The image brings somehow to mind Cecil Beaton's immortal 1941 photograph of a model standing in the ruins of a bombed building: elegant and solitary, her face turned away from the viewer, she is defiant and brave. By contrast, the well-dressed and well-fed couple displaying their stylish clothes in the derelict context creates a comical effect, but the overall message is superficiality. At the *secondary* or *conventional* subject matter level this is an improvised fashion shoot modelled by Jordan and Simon. But what the image is trying to convey at the *intrinsic*

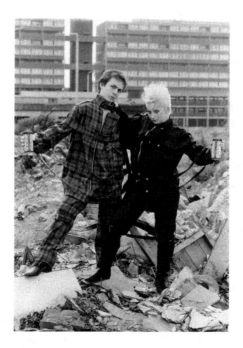

Figure 6.9 *Jordan and Simon modelling punk clothes. Photo Bill Kennedy, 18 May 1977.*

meaning or *content* level is what the punks, who regarded themselves as the direct heirs of Dadaism, were all about. As in the example of Cecil Beaton's photograph, the Dadaists rebelled against the war; meanwhile the punks, who were playing havoc on King's Road by parading their outrageous clothes designed by Vivienne Westwood, were not really the heirs to Dadaism. What matters, however, in this context is that fashion became the punk signifier of their 'rebellion'.

As the 1970s were drawing to a close, so was the dominance of political unrest, artistic rebellion and the appeal of 'anti-fashion', and the outrageous punks started to be replaced by the 'body beautiful' concerns of the new generation of the 1980s. Dance and gym studios replaced King's Road and designer Norma Kamali provided the 'look' of the 1980s: 'sweat shirts, ra-ra skirts, bandeau tops, jumpsuits, leotards and leggings' (de la Haye and Tucker in Laver, 2002: 271–2).

The 1980s: 'Thatcherism', 'Power' dressing and the YUPPIES

Political developments in the UK became a signifier of the 1980s, summed up as the decade of excess, largely due to a change in British government when Margaret Thatcher became, in 1979, the first woman prime minister in the UK and the true measure of her power was the invention of a new term in the British vocabulary: 'Thatcherism'. It was designated to define the new social order which produced a new social class: the **yuppies** (young upwardly mobile urban professionals). But this was only part of the story because the 1980s were also plagued by dramatic events and catastrophes, the most sinister being AIDS, declared an epidemic in 1985 by the World Health Organisation, followed by the collapse of the stock market in 1987 and in 1989 the fall of the Berlin Wall.

With a woman prime minister, women considered this an opportune moment for political and economic emancipation, in the sense of 'power' earning, reflected in a new way of dress: 'power' dressing. But the irony was that the broad padded shoulders, narrow jackets and knee-length skirts, which

defined the 'power' woman, stemmed from the male military uniform of the Second World War.

Meanwhile, the male yuppie choice of dress were Giorgio Armani and Ralph Lauren, who provided not only the right 'look' but sent out the right message and equipped the yuppies to practice the Thatcherite mantra:

> Yuppies lived life on expense accounts, with no sense of responsibility. Three-star restaurants, five-star hotels, flights to any destination became a habit – as long as it was expensive. Shopping replaced rest as a form of relaxation and uninhibited sex replaced long-term relationships. Pop icon Madonna sang the 1980's hymn: 'I am a material girl, and I am living in a material world.' (Seeling, 2000: 490)

The arrival of the Japanese in Europe

During the 1980s, Paris capitalized on its tradition as world capital of fashion, helped by a strong economy boosted by wealthy Americans and the arrival in the French capital of the oil-rich Arabs. Paris had what it takes and it materialized with the arrival of the Japanese. They brought with them a new school of avant-garde fashion design based on their traditions, which, as in the case of the ancient Greeks, did not differentiate between arts and crafts. This explains why the first wave of Japanese culture, which reached Europe during the second half of the nineteenth century, had such a radical impact on the 'Arts and Crafts' movement in England, made possible when Japan opened for trade with Europe in 1854, flooding its markets with Japanese artefacts. Consequently, between the 1880s and the 1920s *Japonisme* emerged as a new stylistic trend in Europe.

In 1895, German impresario Siegfried Bing opened his first shop specializing in Japanese artefacts, Maison de l'art nouveau, and Parisians flocked to buy the beautiful textiles and kimonos he imported, whose minimalist cut and flat construction contributed to the modernist style introduced in fashion by Paul Poiret and Madeleine Vionnet.

The second wave of the Japanese influx into Europe materialized in the 1980s, although some Japanese designers, starting with Kenzo Takada, made

Modernism: The Photographed Image on the Page

their presence felt in Paris in the 1970s. But the three Japanese designers whose impact continues to be felt in the world of fashion are Rei Kawakubo, Issey Miyake and Yohji Yamamoto. They took Paris by storm with their radical approach not only regarding the relationship between the body and clothes, but also with their fashion shows.

Thus, on the occasion of an exhibition titled *Yohji Yamamoto: Juste des Vêtements* held at the Musée de la mode et du textile in Paris in 2005, journalist Susannah Frankel wrote in *The Independent* about the shock of the Parisian fashion world, about the way Yamamoto presented his collections:

> It's been almost a quarter of a century since Yohji Yamamoto's Paris debut. That was in 1981 and the army of grim-faced models that marched down the runway – hair shorn, faces painted white – was to change the face of fashion forever. In place of the requisite uplifting show soundtrack came an amplified, electronic loud speaker. Instead of the standard hourglass silhouette the designer produced asymmetric shaped dresses in distressed fabrics and peppered with holes. And where rainbow colour was at that point *de rigeur*, Yamamoto's clothes were resolutely dark, mainly black. Finally, models' shoes were flat ... By dressing women in low heels, he said much later, 'I give them a different way of walking, feeling and presenting themselves'. (Frankel, 2005: 48–9)

One year later, Ingrid Sischy, editor of *Artforum*, placed on the cover of its February 1982 issue an outfit by Issey Miyake, consisting of a nylon polyester skirt complemented by a rattan body made by artist Koshige Shockihudo. She justified her unprecedented gesture as an attempt to expand existing definitions of art into the wider context of visual culture which incorporates fashion. Sischy's gesture also signalled the beginning of a new relationship between the fine arts and fashion.

Nor did Sischy's gesture pass unnoticed in the art world and we find Peter Wollen, curator of the seminal exhibition titled *Addressing the Century* (100 Years of Art and Fashion) held at the Hayward Gallery in 1998–9, making the following observation:

> The *rapprochement* between art and couture reached a decisive point in March [*sic*] 1982 when the New York magazine *Artforum* featured on its

cover a collaborative work by the Japanese designer, Issey Miyake and the bamboo artist, Koshige Shockihudo a fusion of fashion, craft-work and sculpture. The *Artforum* feature on Miyake signalled the beginning of a new relationship between art and couture. (Wollen, 1998: 15)

One such example is Issey Miyake and his collaboration with sculptor Isamu Noguchi. Noguchi learnt the technique of 'direct carving' in stone as the sole apprentice of Constantin Brancusi in Paris in 1927 and 'later he wrote an article about his apprentice years in Brancusi's *atelier*, recounting how he insisted about the importance of using "each tool according to its precise destination, with respect and patience", and above all respect for materials

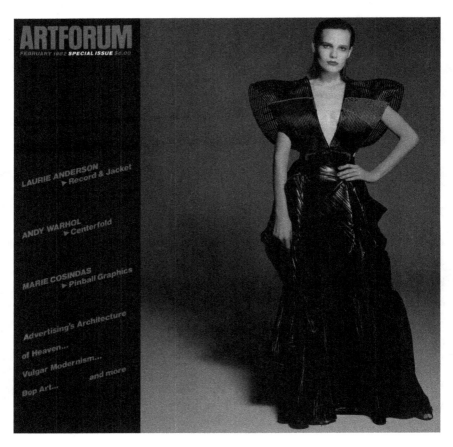

Figure 6.10 *Cover of New York art magazine* Artforum, *February 1982.*
© Artforum.

"manifested in the work methods which became evident in the final result'" (Hulten, Dumitresco and Istrati, 1998: 38).

Noguchi was not only a sculptor but also turned to design inaugurating this new phase in his career with the Akari lamps. He wanted to play the dual role of art (sculpture) and craft (industrial design).

Noguchi learnt from Brancusi a seminal lesson: how to use reductionist techniques to reach what is essential in the form and Brancusi's obsession with essences corresponded to Japanese aesthetics which informed Miyake's development as a clothing designer and artist. Above all it was the childlike innocence – one of Brancusi's aphorisms was 'When we are no longer children we are dead' – of Brancusi inherited by Noguchi, which also permeates the collaboration between Irving Penn and Issey Miyake. It started with their first collaboration in 1986 for the 198-755 collection of poster shots, followed in 1988 with Miyake's exhibition at the *Musée des Arts Decoratifs* in Paris titled *A – UN*, and the first book of photographs by Irving Penn was also published. But the exhibition also marked the end of an era in Miyake's career, after which he embarked on a quest to develop a new functionalism and it led to his iconic 'Pleats Please', the new brand whose technique was inaugurated by Miyake in the 1990 collection dated 1988. 'Pleats Please' came to be regarded as 'the most practical clothing he has yet conceived, and like Noguchi's lamps, they were to become ubiquitous' (Penn, Holborn and Miyake, 1999: unpaginated).

Penn capitalized on Miyake's reductionist techniques, which he captured perfectly in the simple format photographs of Miyake's designs by arranging them against a stark white background that he then filled with playful shapes and colours 'somewhere between Arica and Rothko' (Penn, Holborn and Miyake, 1999: unpaginated). But beyond shapes and colours another dimension to do with Miyake's vision of childhood innocence and deep humanity is also captured; and that is the result of a collaboration which is as much about Issey Miyake as it is about Irving Penn.

Irving Penn's career as fashion photographer started in 1943 when he was appointed to work for *Vogue*, following in the footsteps of such luminaries as Baron de Meyer and Martin Munkácsi. Recognition came fast: in 1975 there was his exhibition titled *Irving Penn: Recent Work, Photographs of Cigarettes* and 2017 he opened at the Museum of Modern Art, and in 2017 the posthumous

230 *Images on the Page*

exhibition *Irving Penn: Centennial* was presented at the Metropolitan Museum, New York, and the Grand Palais, Paris.

Penn's appointment at *Vogue* was significant because, alongside *Harper's Bazaar* and *Vanity Fair*, *Vogue* became instrumental in pioneering a new category of photographs meant to capture *le beau monde* and their enviable way of life, inaugurating fashion reporting. Thus, in 1913, Baron Adolf de Meyer was appointed by *Vogue* and he became the first photographer to photograph events in the calendar of the wealthy New York socialites for *Vogue*, and his photographs have been compared with the work of society painter John Singer Sargent: 'De Meyer's courtier-like articulation of a world of leisure revives the tradition of aristocratic portraits which itself was surviving in pastiche form at the hands of Anglo-American Edwardian painters such as John Singer Sargent' (Mellor in Weaver, 1989: 416).

In the aftermath of the First World War a different kind of photographer started to be employed by fashion magazines and one such is Hungarian born Martin Munkácsi, discovered by Carmel Snow, who employed him in 1933 to work for *Harper's Bazaar*. His main interest was to capture the body in motion inspired by his preoccupation with the body beautiful, sports, health and beauty which dominated the decades between the wars.

Irving Penn's approach to fashion photography was regarded as unthinkable outside the network of meanings encircling the "New Look" in Parisian dress design towards the end of the 1940s, yet unlike Dior's joyous celebration of glamour, Penn's style was described as austere:

An austere formalism, a new Romantic return to the past, a melancholy sense of closure – these elements characterised his photographs as he emerges as a portraitist and fashion photographer. Penn belongs to this tragic, even pessimistic moment in the Western visual imagination and the fine promises of Modernist utopias and politics have collapsed. Apart from his highly contrasted oppositions of black and white, his bleached-out graphic designs of 1950s such as *Black and White Vogue Cover* Penn represents a grave, subdued vision. (Mellor in Weaver, 1989: 417)

This emphasis on Irving Penn's pessimism, however, is one-sided because it presents him as a one-dimensional photographer and that is not true, because

his oeuvre testifies to the breadth of his creativity, and his collaboration with Issey Miyake reveal Penn at his best: playful, humorous, mysterious too!

Rei Kawakubo also pushed the boundaries between the way the body and garments have been related to each other in Western Europe to an unacceptable extreme with her 1997 collection of dresses with bumps, beautifully summed up by Valerie Steele:

> Kawakubo not only challenges the social construction of woman as the beautiful sex, she also interrogates the entire idea of fashion. No longer is fashion a false surface that seeks to create the impression of a naturally beautiful female doll. Instead it exemplifies a new kind of embodiment. In her apparent pursuit of an alternative ideal of beauty, she denaturalizes all our assumptions. The volume of dress may be compressed or stretched or otherwise distorted, as mutable form imply impossible bodies. Comme des Garçons' famous *Dress becomes Body becomes Dress* collection of 1997, for example was harshly criticized in the mainstream fashion press for 'deforming' the wearers. (Steele in Steele and Park, 2008: 69–73)

It was however Yohji Yamamoto, introduced to the London public as one of the most 'influential and enigmatic' fashion designers of the last forty years when his first exhibition organized by the V&A Museum opened in 2011, who succeeded in surprising Londoners with his unfinished 'deconstructed' garments. The clothes were fashionably linked to heavy-handed theories, such as Jacques Derrida's 'deconstruction'.

'Post-structuralism' and 'post-modernism' theories notwithstanding, central to Yamamoto's approach to creating clothes is his concern with the concept of *wabi-sabi*, from Japanese aesthetics, which locates beauty in imperfection, transience and ultimately death.

It is a world view, Yamamoto applied to the suitably transitory discipline of haute couture. 'I think perfection is ugly' he declared: 'Somewhere in the things humans make I want to see scars, failure, disorder, distortion' (Miller, 2011: 111).

In 1987 the stock market collapsed and Black Monday entered in history as the day which marked the largest market crash on record, whose repercussions impacted upon the fashion industry in general but perhaps less on haute couture.

The 1990s

By the beginning of the 1990s a new generation reflecting the new decade emerged led by Martin Margiela, and it was left to them to take fashion to the brink of the new millennium.

In 1930 Sigmund Freud published his seminal book *Civilization and Its Discontents*, in which he introduced the famous 'binary oppositions' between 'the pleasure principle' dominant at the personal level and the 'reality principle' dominant at the societal level, revisited in the definition of 'globalization'.

The dictionary definition (*Collins English Dictionary*, 2005: 1129) of 'globalization' is, on the one hand, 'the process enabling financial and investment markets to operate internationally, largely as a result of deregulation and improved communication', and 'the emergence since the 1980s of a single world market dominated by multinational companies' and on the other this process resulted in the 'diminishing capacity for national government to control their economies'. By analogy with Freud's 'binary oppositions' between 'the pleasure principle' and 'the reality principle', 'globalization' presents its own 'binary oppositions' between the 'global levels' dominated by the free market and deregulation and the 'national governments', powerless to confront these forces.

Globalization emerged at the end of the 1980s during events which led in 1989 to the collapse of the Berlin Wall, the end of the Cold War and the unification of Germany, with three important consequences for the fashion world:

First, the appearance of non-Western clothing traditions based on national characteristics with the Japanese designers among the first to capitalize on their national heritage.

Secondly, the ostentatious 'bling' which dominated the 1980s, became not only 'unfashionable' but also morally reprehensible. There was an awareness of the environment, ecology and global warming with all its incumbent issues, brought into focus by the Kyoto Protocol adopted in 1997, which came into force in 2005. Other concerns related to rootlessness, ethnicity and multiculturalism also emerged.

Modernism: The Photographed Image on the Page

Thirdly, 'branding' – the invention of the New York designers Calvin Klein, Ralph Lauren and Donna Karan, whose leisure and sportswear for Adidas, Reebok and Nike were aggressively marketed reaching global proportions – became a dominant force in the commercial world of fashion.

The response of the fashion industry to these concerns was 'minimalism', a term purloined from 'Minimal Art' invented by art critic Barbara Rose when she published in the 1965 issue of *Art in America* an article titled 'More is Less'. In it she defined the new style emerging in the visual arts as 'the empty, repetitious, uninflected art of many young painters, sculptors, dancers and composers' (Rose in Battcock, 1968: 277).

Several decades later Barbara Rose's slogan 'More is Less' found its way into the world of fashion, whose new ethical and ecological concerns provided the platform, and the designer associated with 'minimalism' is Belgian fashion designer Martin Margiela. He rebelled against the wasteful approach of the fashion industry, proposing to replace it with 'deconstruction', a term he borrowed from philosopher Jacques Derrida's methodology specifically created to be employed in literary criticism.

How did this come about? In the 1990s it became fashionable to provide a theoretical justification for the rapid expansion of fashion studies so as to render it a worthy academic subject, and the more complicated the theories, the better, and what can be more difficult than choosing Jacques Derrida, but he fitted the bill. Derrida proposed a new methodology for literary criticism he called 'deconstruction' purloined by the fashion world, and the notion of 'deconstructed' garments found its way into fashion magazines. Thus in 1998 an article by Alison Gill titled 'Deconstruction Fashion: The Making of Unfinished Decomposing and Re-assembled Clothes' was published in *Fashion Theory*. In it she associates 'deconstruction' with the work of Rei Kawakubo for Comme des Garçons, Karl Lagerfeld, Martin Margiela, Ann Demeulmeester and Dries Van Noten, among others, specifying that it is loosely used to describe garments on a runway that are 'unfinished', 'coming apart', 'recycled', 'transparent' or 'grunge' (Gill in Barnard, 2007: 489). The French even came up with *le destroy*, conceivably a free Gailic interpretation of the heavier

German *destruktion* employed by Martin Heidegger, which Derrida altered to 'deconstruction'. But *le destroy* acquires an additional dimension – apart from Margiela's reductionism – to do with punk sensibilities, grunge, piercing, slashing and other destructive aspects identifiable both in the sub-cultural and mainstream fashion context. The question is, what is the use of 'deconstruction' in fashion in aid of? For Derrida 'deconstruction' is a tool for critical analysis, but why 'deconstruction' in fashion?

There is an ironic twist involved here pointing to Karl Marx's 'fetishism of the commodities', and fashion perceived as a frivolous luxury commodity fits the bill. But in the end the punters will not buy a 'falling apart' (deconstructed) garment unless it carries on its back the mysterious black-and-white label which is no longer that mysterious, for everybody knows that it is the 'deconstructed' signature of Martin Margiela, who never appears in public or allows himself to be photographed but whose name alone brings in business (McNeil and Miller, 2014: 116–21).

Another 'deconstructed' example listed by Alison Gill is 'grunge', which emerged in the 1990s as the result of the amalgamation of two subcultures: punk and Hippie.

> Grunge was a colourful dishevelled style in which clothes that were homemade, customized or second-hand were worn in layers and accessorized (for both sexes) with heavy ex-army boots. It had its roots in the Seattle pop groups Nirvana and Pearl Jam and it was in many respects a reaction against the 'go-getting' society of the 1980s. (Seeling, 2000: 556)

Thus 'Grunge' which became the new 'anti-fashion' of the 1990s was inspired by the same anarchic antecedents, going back to Dadaism and the nihilistic performances of Cabaret 'Voltaire' founded in Zürich in 1916, inherited by the punks and the 'Sex Pistols' in the 1970s and, like the punks before, 'Grunge' adopted music as a source of inspiration.

> The simplicity, nihilism and rawness of the music was reflected in grunge fashion: adherents wore thrift-store finds, vintage smock dresses with boyfriend cardigans, baby-doll nightgowns, ripped and faded jeans, plaid flannel shirts layered over T-shirts, beanies and cargo pants. (Mendes and de la Haye, 1999: 252)

'Grunge' also became a source of inspiration for a new generation of American fashion designers including Marc Jacobs, Anna Sui and Donna Karan; even a 'classicist' such as Ralph Lauren found inspiration in the 'youthful, nonchalance of grunge' (Fogg, 2013: 482).

Related to 'Grunge', another movement which came to be known by the sinister label 'heroin chic' emerged in 1997. But instead of being defined by a particular 'look', 'heroin chic' was media-related and manifested itself mostly in photography and advertising. German photographer Jürgen Teller was credited with its invention when he decided to use a very unusual photographic model: Kristen McMenamy, whose physical appearance complied with his intentions:

> Her naked, mottled torso had a lipstick heart crudely drawn on it containing the word 'Versace', and she had a cigarette stuck to her lower lip. Commissioned by the magazine supplement to the German newspaper *Süddeutsche Zeitung* to illustrate the theme of fashion and morality, Teller felt that his pictures revealed a truth about the model in a world in which the construction of the fashionable woman was always a liar. But again, suggestions of abuse were implied. Controversy was sparked in particular by the 'scar' or mark on her abdomen, the suggestion of abuse and violence, as opposed to the simpler alternative explanation that she had caught her flesh in a slip in one of the rapid backstage costume changes of a fashion show. (Evans, 2003: 202–3)

At the *primary* or *natural* subject matter level what the eyes see is the three-quarter length photograph of the naked androgynous body of the model, hands provocatively on hips, cigarette hanging between her lips, she is wearing a necklace and on her right hand a bracelet. On her belly we notice a scar and between her breasts a heart drawn in lipstick with the word 'Versace' scrawled across.

But what are we to make at the *secondary* or *conventional* subject matter level of this image? Indeed, the subject matter is a photograph of naked model Kristen McMenamy posing to the camera, but we risk falling into the trap of the 'fallacy of intention' if we attempt to deduce from the image the intention of the photographer. The scar, as Evans argued, may suggest abuse but this model

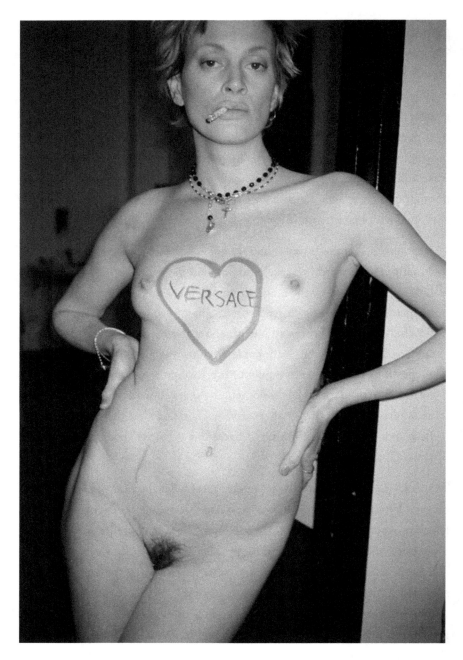

Figure 6.11 *Kristen McMenamy No. 3, London 1996* © Juergen Teller, All rights reserved.

is in no way a victim; on the contrary, self-assured and defiant she displays her adolescent body with pride and the attributes – such as her jewellery, the cigarette and the heart drawn with lipstick on her chest – add to her quite splendid attitude. The interpretation of the subject matter however is found at the *intrinsic meaning* or *content* level, and there is no doubt in my mind that this image has nothing to do with abuse and violence. Rather, the intimations of death stemming from the very label 'heroin chic' come from a different source, Gothic, splendidly displayed in an exhibition titled *Gothic: Dark Glamour* curated by Valerie Steele, held at the Museum at FIT in 2008/9, dedicated to the Gothic in fashion:

> 'Gothic' is an epithet with a strange history, evoking images of death, destruction, and decay. It is not just a word that describes something (such as a Gothic cathedral), it is almost inevitably a term of abuse, implying that something is barbarous, gloomy, and macabre. Ironically its negative connotations have made it, in some respects, ideal as a symbol of rebellion. (Steele and Park, 2008: 3)

It was at the time when 'heroin chic' emerged that Gothic fashion – initiated in the 1980s and promoted by publications such as *Dazed and Confused*, *i-D* and *The Face* – re-emerged in the work of photographers such as Sean Ellis, working with stylist Isabella Blow (Steele and Park, 2008: 77–8), and the *iconographic-iconological* content of Jürgen Teller's haunting photograph belongs to this context.

Part Three

The fashion show: Fashion as 'spectacle'

Another newcomer during the 1990s, which followed in the footsteps of photography, was the fashion show, which had acquired a 'spectacular' dimension bordering on ostentation. But why align a spatio-temporal event to visual forms of representation such as the printed image, be that an illustration or photograph, in the first place? There is good reason for this: firstly, fashion shows also have stories to tell and, secondly, I would like to argue that the fashion show can and does transcend its putatively dominant commercial dimension by aligning itself to a distinguished pedigree whose roots go back to the Renaissance.

We need only consider the costumes designed by Leonardo da Vinci when he was living at the court of Francis I at Fontainebleau, among them his enchanting studies for the series of masquerade costumes, or the costumes designed by Italian-influenced Inigo Jones for the masque staged at Whitehall during the reign of Charles I. When Henrietta Maria moved from her native France to England to become its queen, she brought with her the tradition of the *ballets de cour* Fontainebleau was famous for, which reached a peak during the seventeenth century with the spectacles organized for Louis XIV at Versailles. He loved spectacles and staged ballets and performances, often with himself as the main protagonist. Among them the most fabulous had to be the *Ballet de la Nuit*: a thirteen-hour-long extravaganza staged on 23 February 1653 at the *Sale du Petit-Bourbon*, with Louis XIV among the participants costumed

as a splendid Apollo. But the only records we seem to have of these events are drawings, engravings and paintings of costumes or selected scenes from the performance, which can be interpreted as equivalents of the photographs taken during fashion shows: in both instances, one moment (a still) is selected to be preserved for posterity, with the difference that it is generally accepted that whilst the photograph is a faithful reproduction of reality, an artist's drawing is a subjective rendering.

Modern technological developments such as video made it possible to capture the fashion show in real time, and we do have an equivalent for it: the written text, which gives us an idea about the way plays, masques or ballets unravelled, as famously exemplified in a letter written by Baldassare Castiglione to Ludovico Canossa describing the staging of the comedy *Calandria* written by cardinal Bernardo Dovizi da Bibbiena staged at the court of Urbino. Castiglione was most impressed by the three *intermezzi* (spectacular performances with music, dance and singing between acts), and took great pleasure in describing them: the first was a *moresca*, with the second and third as *tableaux vivants* representing the chariots of Venus and Neptune, respectively. This is how the *moresca* unravelled:

> First a *moresca* by Jason, who appeared on one side of the stage, dancing in antique armour, looking very fine, with a splendid sword and shield. On the other came two bulls, so lifelike that several of the spectators took them for real animals, breathing fire through their nostrils. The good Jason yoked them to the plough and made them draw it, and then sowed dragon's teeth in the furrows. Presently ancient warriors sprang upon the stage in a way that was, I think excellently managed, and danced a fiery *moresca* trying to kill Jason all the while. As they were leaving the stage, they fell upon each other and were slain, without being actually seen to die. Then Jason appeared again, dancing exquisitely with the gold fleece on his shoulders. (Castiglione in Ross and McLaughlin, 1978: 461)

What matters is that Castiglione's letter is the sole testimony of an historical event, whilst the video recordings of the present day show benefit from plenty of additional documentation, including the garments and the props created for the occasion.

If we return to the commercial aspect of the fashion show, its point of inception was Worth's practice of using *mannequins* to present the latest designs to his clients, and this simple template was subsequently adopted by all *couturiers*. But, by the 1990s, the fashion show changed beyond recognition to become an extravagant public spectacle, interpreted as a manifestation of French philosopher Guy Debord's 'Society of Spectacle'. In his book of the same title published in 1967, Debord argued that we live in a society where spectacle is used to hide the domination of consumerism, and Caroline Evans in her book *Fashion at the Edge: Spectacle, Modernity and Deathliness* argued that, during the 1990s, the fashion show amounted to nothing more than a manifestation of Debord's 'society of spectacle'.

> In *The Society of Spectacle*, Debord argued that modern life was dominated by the commodity form and the false desires it engendered. Following Debord's description of the society of the spectacle, the fashion show is a self-absorbed, or narcissistic 'spectacle onto itself', locked into its own world, self-regarding, sealed in the show space of the runway, with its attendant protocols and hierarchies. (Evans, 2003: 67)

The two designers who pioneered the fashion show as 'spectacle' were British: John Galliano and Alexander McQueen. Both were invited to Paris by Bernard Arnault (chairman since 1989 of LVHM group: Möet Hennessy Louis Vuitton) to revive the moribund *haute couture* trade. It was a brave move to appoint John Galliano as creative director of the House of Givenchy and one year later, when he was head-hunted by the House of Dior, Alexander McQueen replaced him.

But what prompted them to present their collections to the public in this 'spectacular' mode? The reasons suggested to explain so unprecedented an approach to the fashion show ranged from a cynical ploy to attract attention, to 'a form of commercial seduction through novelty and innovation, typically in the form of the showpiece designed to attract press coverage on the catwalk' (Evans, 2003: 67).

But could it also be that this was genuinely a new form of art influenced by 'performance art', itself a newcomer to the art world?

The starting point was Galliano's first collection for the House of Dior created in January 1997 when he 'audaciously staged a fake *maison de couture*

242 *Images on the Page*

in the Grand Hotel in Paris' for which he created 'a scaled up facsimile of the original Dior showroom, including the famous staircase on which Cocteau and Dietrich had sat in the 1950s to watch Dior's presentations' (Evans, 2003: 67).

Alexander McQueen started his career in 1993 at the Ritz Hotel in London with a traditional presentation, but this changed with the collection titled *Highland Rape* (Autumn/Winter 1995/6), intended as 'a comment on the Scottish Highland clearances of the eighteenth century' which was close in spirit to grunge and heroin chic, featuring

> ripped bodices and T-bar connecting chains between the front and back of the skirts 'bumster' trousers (cut low at the back to reveal the cleavage of the bottom), dashing frock coats, swaggering military-style coats, lace dresses and body-moulding tailored jackets with crescent moon shoulder peaks are among his many powerful, feminine styles. (Mendes and de la Haye, 1999: 252)

In his spring/summer 1999 collection, McQueen aimed to 'explore the relationship between the nineteenth century Arts and Crafts Movement and what he called "the hard edge of technology of textiles"' (Evans, 2003: 177). The show opened with Aimee Mullins, a model born without shin bones who had her legs amputated below the knee when she was one-year-old, wearing hand-carved prosthetic legs designed for her by McQueen. It closed with model Shalom Harlow, and this is what the eyes see at the *primary* or *natural* subject matter level in a photograph taken at the end of the show.

Shalom Harlow is standing on a turntable in the middle of a white stage, with two white robots flanking her. She is wearing a trapeze-line topless white dress, reminiscent of Balenciaga's Baby Doll dresses, covered by patterns of green and black paint randomly splashed on it. What is going on here? Did the robots have anything to do with what we see? We may well ask, but until we gain access to the narrative of the performance the image makes little sense. Fortunately we have a video of the performance, but we have also something else: an account from a witness of the event – just as Baldassare Castiglione

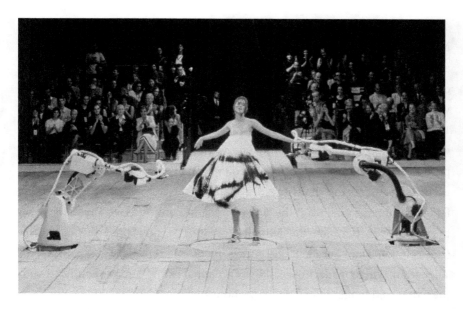

Figure 6.12 *Alexander McQueen, spray paint image, spring/summer collection 1999.*

had done in Urbino in 1513 – and that witness was Caroline Evans who left a description. She starts with Shalom Barlow, who

> revolved like a music-box doll on a turntable as her white dress was sprayed acid green and black by two menacing industrial paint sprayers which suddenly came to life on the catwalk. Juxtaposing the organic with the inorganic (a model that mimicked a doll, paint sprayer that mimicked human motions and an artificial leg that enhanced human performance) the collection skewed the relation of object and subject to evoke Marx's commodity exchange in which 'people and things trade semblances social relations take on the character of object relations and commodities assume the active agency of people'. (Evans, 2003: 177)

If at the *secondary* or *conventional* subject matter level the storyline is about two robots spraying green and black paint on the white dress worn by a famous fashion model who is the main protagonist in the narrative, at the *intrinsic meaning* or *content* level the fashion show was meant, according to Evans, to be the embodiment of Karl Marx's concept of 'alienation'.

First introduced in *The Economic and Philosophical Manuscripts* (1844), Marx defined 'alienation' as a specific historical condition in which man experiences a separation from nature, other beings and especially the products of his labour. At this stage Marx's concept still belonged to philosophy; it was later in his magnum opus, *Das Capital*, whose first volume published in 1867, where the concept of alienation is transposed into the social relations which develop on the shop floor. The worker becomes 'alienated' from the products of his human labour, replaced in capitalism with machines and what is created acquires the 'quasi-mystical' value of the commodity, resulting in its fetishization: Marx calls this the 'fetishism of the commodities'. Breaking down the distinction between the animate (Shalom Harlow) and the inanimate (the robots), Evans argues, becomes a manifestation of Marx's concept of 'alienation', whereby machines take over manual labour and are conflated with the worker no longer in control of his honest manual labour.

But a new and hitherto neglected approach to analysing the fashion show as 'spectacle' can be suggested, which can incorporate not only the visual category of performance art but also other forms of art such as sculpture, and I suggest that in this instance Alexander McQueen was influenced by Swiss sculptor Jean Tinguely.

Part of the *Nouveau Réalisme* movement founded by critic Piere Restany in 1960, Jean Tinguely, alongside Daniel Spoerri, Yves Klein and Arman, 'evolved a junk art aesthetic from an interest in motion and impermanence, accident, and indeterminacy. With an ironic iconoclasm, his "meta-matics" were comically collaged machines that mechanically painted "abstract expressionist" pictures' (Fineberg, 1995: 229–30).

In 1959 Tinguely created his series of *Métamatics* described as 'machines à dessiner'; assembled from obsolete or broken utilitarian implements into sprawling assemblages, activated by a mechanism which made them spring into action in the most anarchic, funny and utterly useless manner or, in some instances, to the more purposeful activity of producing 'abstract writings, analogous to those of contemporary painters' (Abadie in Ceysson et al., 1986: 100). Two iconoclastic creators – one a sculptor who created useless machines assembled from junk activated in order to make drawings or just make noise, the other a fashion designer whose clothes were rendered obsolete by their

purposeless purpose – linked together as both undertook to alter the categorical status of what they created, so that sculpture and fashion, respectively, mutated into something quite else.

Whilst McQueen chose to present emotional alienation, another British fashion designer, Hussein Chalayan, capitalized on his own biography as a Turkish Cypriot living in another country, and he focused on a different kind of alienation which reflected the multiculturalist realities of late twentieth-century society. Chalayan's conceptualism attracted the interest not only of the fashion world but also architects, because his designs are based on the premise that both dress and architecture have been used to 'express collective identity, values and status' (Hodge, 2007: 12).

In his collection titled *Between* (spring/summer 1998) in analysing what the eyes see at the *primary* or *natural* subject matter level, we adopt a dual approach: that of the spatio-temporal event as it unravels in real time and photographs as its tangible witnesses. From existing accounts, incorporating both videos and the written text, we learn that the show started with a naked woman, except for a face mask looking more like a muzzle, wearing flat black sandals, who the audience saw walking from behind a muslin curtain on the stage; she was followed by six other models each progressively wearing more and more black clothing, with the last one (seen in the illustration) covered almost from top to toe in black, but as with Alexander McQueen, a photograph, providing a truncated account, cannot tell the whole story.

At the *secondary* or *conventional* subject matter level, the title of the show, *Between,* leaves us guessing, although we are in no doubt regarding its powerful political message, which is only conveyed at the *intrinsic meaning* or *content* level: the fashion show can be read as an indictment of the religious and social prohibitions introduced with regard to what people walking the streets of towns and cities in Western Europe are allowed, expected or forced to wear.

Equally disturbing, but in a different way, is the fashion show titled *Afterwords* (autumn/winter 2000) presented at the Sadler's Wells Theatre in London, which encapsulates the pain of rootlessness, loneliness and alienation. What the eyes see at the *primary* or *natural* subject matter level is Chalayan's reconstruction on stage of an austere room furnished with four chairs and a round coffee table with a television screen on the wall behind. At this point

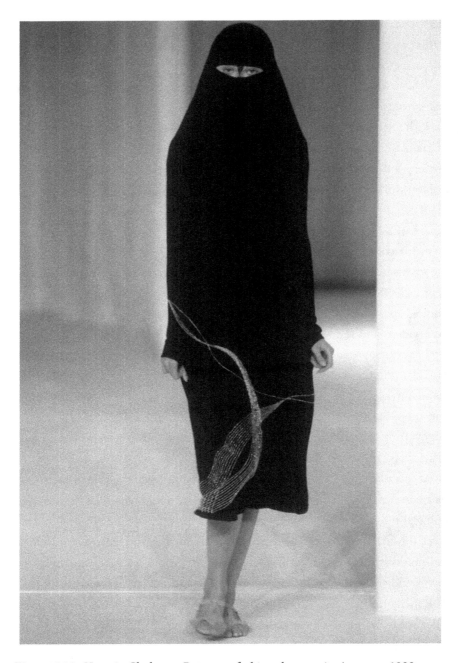

Figure 6.13 *Hussein Chalayan,* Between, *fashion show, spring/summer 1998.*

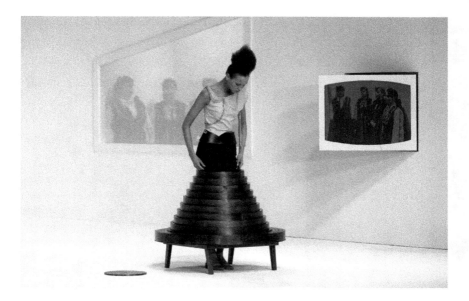

Figure 6.14 *Hussein Chalayan,* Afterwords *(table skirt), autumn/winter 2000. Presented at Sadler's Wells Theatre, London.*

we switch to the spatio-temporal event which contains the storyline: we see four models attired in slips walking into the room picking up the chairs, removing their dust covers and pulling them over their heads so that they become dresses; then the chairs are folded in such a way that they become suitcases. A fifth model walks in (seen in the illustration) and, after removing the circular top of the coffee table in the centre of the room, she steps into the central opening and attaches it to her waist; thus the top formed of increasing concentric circles becomes a skirt. All this is going on against a background which consists of the haunting sound of Bulgarian church music sang by a women's choir. Both at the *secondary* or *conventional* subject matter and the *intrinsic meaning* or *content* levels, the brutal message is about not belonging.

What Chalayan tells us not only in *Afterwords* but throughout his oeuvre as well is to do with the mass phenomenon of immigration, displacement and lack of emotional roots.

With this presentation, Chalayan addressed issues related to his personal identity as a London-based Turkish Cypriot and his identification with

refugees of the 1990s Balkan conflict. The collection suggested the necessity of leaving behind one's home 'with nothing but the clothes on your back' and rebuilding one's life elsewhere. Allusions to identity, the fragility of life, and the importance of creative expression are evident in much of Chalayan's work. (Hodge, 2007: 12)

Conclusion

Where do we stand in the twenty-first century with regard to our choice of representing and interpreting images on the page selected from the world of costume and fashion?

The answer provided by this book takes the form of a veritable voyage of discovery starting with the Renaissance and its tailors' and costume books, through to the twenty-first century and the brave new world of technology which altered beyond recognition the way images are presented on the page. But what unites them across time and space is that all of them have stories to tell, and some of them – this is true especially of the twenty-first century – are far from comfortable.

In fact, at no point was Jean Baudrillard's concept of 'virtual reality' truer, because today we live in a world removed from reality; a world of 'virtual reality'. In his essay 'The Procession of Simulacra' published in 1981 as 'Simulacres et Simulation', Baudrillard argued that 'the dominance of signs, images and representations in the contemporary world is such that the real has been effectively obliterated, and "truth, reference and objective causes have ceased to exist"' (Baudrillard in Payne, 1997: 51).

As our journey of discovery about how images on the page speak to us is coming to an end, what we need to ask – given that our own existence unravels in a world alienated from us – is just what kind of images would reflect our alienated world today.

The answer is simpler than it appears: let's reverse the process and instead of starting from the image on the page to learn about the wider historical and cultural contexts where it belongs, we start with the wider historical and cultural context and move backwards to what the eyes see on the page, and what we are faced with is a veritable *tsunami* of images: illustrations,

advertisements, documentary films, TV programmes, photographs and so on. But we no longer need to ponder what the images tell us at the *primary* or *natural*, at the *secondary* or *conventional* subject matter, and at the *intrinsic meaning* or *content* levels: We know!

In the exhibition organized by the V&A Museum, London, in 2018 titled *Fashioned from Nature*, the foreword for the catalogue was written by actor Emma Watson who mentioned a dress (on display) she wore at the gala in 2016 made for her by Calvin Klein entirely of recycled materials:

> In collaboration with Calvin Klein, every part of the gown was produced with sustainability in mind – from the use of Newlife (a yarn made from post-consumer plastic bottles) to the zippers fashioned from recycled materials. The threads of this dress were woven in a reinvented tale of our consumption. We even designed different layers so that separate components could be worn again in different ways. I am proud of this dress. (Watson in Ehrman, 2018: 6)

We may be forgiven for not knowing what 'Newlife' – which turns out to be a new kind of material – is, but the key message is the world's concern with ecology and how it relates to fashion which, as big business, continues to be one of the worst offenders. This is in a nutshell the *intrinsic meaning* or *content* level.

In a photograph of a fashion show tellingly titled 'Detox Catwalk' organized by Greenpeace in a polluted paddy field in Rancaekek, Java, in 2015, also reproduced in the exhibition catalogue, the models are wearing eco-fashion clothes designed by Indonesian designers Felicia Budi, Indita Karina and Lenny Agustin.

But the categorical status of this image is difficult to fathom: we could call it a fashion photograph because it deals with the world of fashion but on this occasion in a critical rather than sycophantic way; we could call it a documentary photograph of the kind taken by photographers embedded in newsworthy locations; we could call it an investigative photograph meant to uncover illegal or criminal activities, a dimension which can be argued to exist in this instance. But what this photograph most certainly is not is an advertisement.

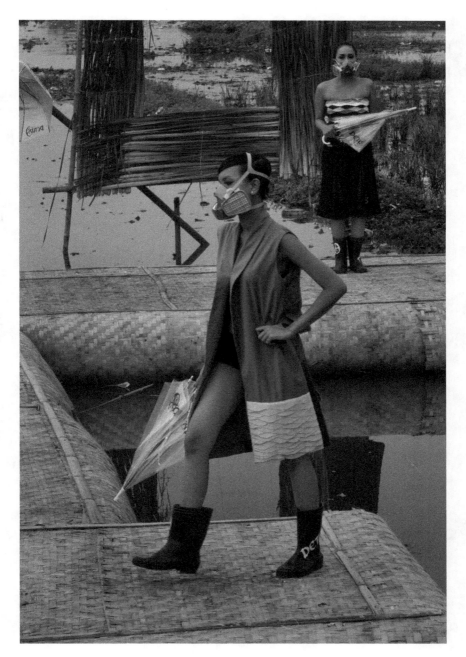

Figure C.1 *Photograph taken on 22 March 2015. Indonesian models with gas masks and dresses designed by Hanna Farhana, during a fashion show in Rancaekek (West Java) as part of a campaign by Greenpeace to address pollution in the Citarum River used by the locals.*

Could we not then call it a **sign** (the word is used in the sense given it by Roland Barthes), as the result of the conflation of the **signifier** (here the polluted town of paddy fields in Rancaekek in Java) and the **signified** (here the *secondary* or *conventional* subject matter the anonymous photographer aimed to narrate)? And it is this composite **sign** which can be regarded as tantamount with Erwin Panofsky's *intrinsic meaning* or *content* level, but we shall call it simply a **sign** of our times.

Bibliography

Adburgham, A. (1990), 'A Punch History of Manners and Modes 1841–1940', London, 1961, in Elizabeth Ann Coleman, *The Opulent Era: Fashions of Worth, Doucet and Pingat*, London: Thames and Hudson.

Alberti, L. B. (1970), *On Painting*, New Haven and London: Yale University Press.

Amman, J. (1879), *The Theatre of Women*, edited by Alfred Aspland, London: Published by Holbein Society by A. Brothers, Manchester and Trübner & Co.

Anonymous (February 1888), 'The Rational Dress Movement', *The Woman's World*.

Anonymous (1999), 'Modes Parisiennes', in *Journal des dames et des modes 98*, March 13, 1847 quoted in Tinterow and Conisbee, New York: The Metropolitan Museum.

Ariès, P. and G. Duby, eds (1988), *A History of Private Life: Volume II: Revelations of the Medieval World*, Cambridge, MA and London: The Belknap Press of Harvard University.

Arkins J. I., ed. (1984), *Masters of Seventeenth-Century Dutch Genre Painting*, Philadelphia: Philadelphia Museum of Art.

Ashelford, J. (1996), *The Art of Dress: Clothes through History 1500–1914*, London: The National Trust.

Barnard, M. (2007), *Fashion Theory: A Reader*, London: Routledge.

Barnes, C. F. (2009), *The Portfolio of Villard de Honnecourt*, London: Ashgate.

Barthes, R. (1983), *The Fashion System*, Berkeley, Los Angeles and London: University of California Press.

Barthes, R. (1972), *Mythologies*, London: Vintage.

Bartlett, D. (2010), *Fashion East: The Spectre that Haunted Socialism*, Cambridge, MA: The MIT Press.

Battcock, G., ed. (1968), *Minimal Art: A Critical Analysis*, New York: E.P. Dutton & Co. Inc.

Baudelaire, C. (1972), *Selected Writings on Art and Artists*, Harmondsworth: Penguin Books.

Bayer, A., ed. (2008), *Art and Love in Renaissance Italy*, New York: The Metropolitan Museum of Art.

Beiser, F. C. (1993), *The Cambridge Companion to Hegel*, Cambridge: Cambridge University Press.

Bell, R. (2010), 'Wild Dreams: Imagining the Ballets Russes', in R. Bell (ed.), *Ballets Russes: The Art of Costume*, Canberra: National Gallery of Australia.

Beltramini, G. D. Gasparotto and A. Tura, eds (2013), *Pietro Bembo é l'invenzione del inascimento* (Exhibition catalogue: (2 February–19 March), Palazzo del Monte di Pietà, Padua), Venezia: Marsilio Editori.

254 *Bibliography*

Benton, C., T. Benton and G. Wood, eds (2003), *Art Deco 1910–1939*, London: V.&A. Publications.

Berenson, B. (1968), *Italian Painters of the Renaissance, vol. 2: Florentine and Central Italian Schools*, London: Phaidon Press.

Bidou, H. (October 1912), 'Introduction', *Gazette du Bon Ton*: 3.

Blackman, C. (2007), *100 Years of Fashion Illustration*, London: Laurence King Publishing.

Blunt, A. (1973), *Artistic Theory In Italy: 1500–1600*, Oxford: Oxford University Press.

Blunt, A. (1982), *Art and Architecture in France 1500–1700*. The Pelican History of Art, London: Penguin Books.

Boucher, F. (1997), *A History of Costume in the West*, London: Thames and Hudson.

Bowie, T., ed. (2005), *The Medieval Sketchbook of Villard de Honnecourt*, New York: Dover Fine Art.

Burckhardt, J. (1860), *The Civilization of the Renaissance in Italy*, New York and Toronto: A Mentor book from New American Library.

Calahan, A. and C. Zachary (2015), *Fashion and the Art of Pochoir: The Golden Age of Illustration in Paris*, London: Thames and Hudson.

Carboni, S., ed. (2007), *Venice and the Islamic World 828–1797*, New York: The Metropolitan Museum of Art.

Ceysson, B. (1986), *Vingt-cinq ans d'art en France, 1960–1985*, Paris: Larousse.

Chipp, H. B., ed. (1973), *Theories of Modern Art: A Source Book by Artists and Critics*, Berkeley and Los Angeles: University of California Press.

Collins English Dictionary, HarperCollins Publishers, 2005.

Cooper, D., ed. (1995), *A Companion to Aesthetics*, Oxford: Blackwell Publishers.

Crow, T. E. (1985), *Painters and Public Life in Eighteenth-Century Paris*, London: Yale University Press.

Cullen, O. and C. K. Burks (2019), *Christian Dior*, London: V.&A. Publishing.

Davies, N. (1997), *Europe: A History*, London: Pimlico.

Davis, M. E. (2006), *Classic Chic: Music, Fashion and Modernism*, Berkeley and Los Angeles: University of California Press.

Davis, M. E. (2010), *Ballets Russes: Diaghilev's Dancers and Paris Fashion*, London: Reaktion Books.

de Beauvoir, S. (1960), *The Prime of Life*, Harmondsworth: Penguin Books.

de Beauvoir, S. (1968), *Force of Circumstance*, Harmondsworth: Penguin Books.

Deshusses, P. and L. Karlson (1994), *La Littérature française au fil des siècles: Du Moyen Âge au XVIIie Siècle*, Paris: Bordas.

Dickens, A. G. (1977), *Reformation and Society in Sixteenth-Century Europe*, London: Thames and Hudson.

Dickens, C. (1998), '"Old Lamps for New Ones", in *Household Words: A Weekly Journal Conducted by Charles Dickens*, vol. 1, nr. 12, London, 15 June, 1850, pp. 265–7', in C. Harrison, P. Wood and J. Gaiger, *Art in Theory 1815–1900: An Anthology of Changing Ideas*, Oxford: Blackwell.

Donaldson, M. F. (February 1888), 'A Day at Girton College', *The Woman's World*, 142–3.

Duthuit, G. (1950), *The Fauvist Painters, The Documents of Modern Art. (Director Robert Motherwell)*, New York: Wittenborn, Schultz Inc.

Ehrman, E. (2018), *Fashioned from Nature*, London: V.&A. Publications.

Bibliography

Evans, C. (2003), *Fashion at the Edge: Spectacle, Modernity and Deathliness*, New Haven and London: Yale University Press.

Evans, M. and S. Weppelmann, eds (2016), *Botticelli Reimagined*, London: V.&A. Publications.

Ewing, E. (revised by Alice Mackrell) (2005), *History of 20th Century Fashion*, London: Batsford.

Facchinetti, S. and A. Galansino (2016), *In the Age of Giorgione*, London: Royal Academy of Arts.

Faini, M. (2016), *Pietro Bembo*: A Life in Laurels and Scarlet, Geneva: Legenda/Modern Humanities Research Association with the Foundation Barbier-Mueller pour l'étude de la poésie italienne de la Renaissance.

Fineberg, J. (1995), *Art Since 1940: Strategies of Being*, London: Laurence King.

Focillon, H. (1969), *The Art of the West: Two Volumes*. Part One: Romanesque; Part Two: Gothic, London: Phaidon Press.

Fogg , M., ed. (2013), *Fashion: The Whole Story*, London: Thames and Hudson.

Frankel, S. (2005), 'Yohji: Back to Front', *The Independent*, Thursday 14 April.

Freedberg, S. J. (1975), *Painting in Italy: 1500–1750*. The Pelican History of Art, Harmondsworth: Penguin Books.

Freud, S. (1990), 'The Uncanny', in *Sigmund Freud* (Volume 14. Art and Literature), 335–76, London: Penguin Books.

Friedlaender, D. (1974), *David to Delacroix*, Cambridge, MA: Harvard University Press.

Friedländer, M. J. (1963), *Landscape, Portrait, Still-Life: Their Origin and Development*, New York: Shocken Books.

Frizot, M., ed. (1998), *The New History of Photography*, Cologne: Könneman.

Gaunt, W., ed. (1963), *Giorgio Vasari: The Lives of the Painters, Sculptors and Architects* (in four volumes), London: Everyman's Library, Dent.

Godfrey, R. T. (1994), *Wenceslaus Hollar: A Bohemian Painter in England*, New Haven and London: Yale Center for British Art, Yale University Press.

Golbin, P., ed. (2007), *Balenciaga Paris*, London: Thames and Hudson.

Golbin, P., ed. (2009), *Madeleine Vionnet: puriste de la mode*, Paris: Rizzoli International Publications.

Golding, J. (1968), *Cubism: A History and Analysis 1907–1914*, London: Faber and Faber.

Goldstein, C. (2014), *Print Culture in Early Modern France: Abraham Bosse and the Purpose of Print*, Cambridge: Cambridge University Press.

Gombrich, E. H. (1966), *Norm and Form: Studies in the Art of the Renaissance*, London: Phaidon.

Gowing, G., ed. (1988), Catalogue of the exhibition *Cézanne: The Early Years 1859–1872*. Royal Academy of Arts, London: Weidenfeld and Nicholson.

Green, C. (2000), *Art in France 1900–1940*, New Haven and London: Yale University Press.

Groom, G., ed. (2012), *Impressionism, Fashion and Modernity*, New Haven and London: Yale University Press.

Habitus praecipuorum populorum, tam virorum quam foeminarum (sic) singulari arte depicti; Trachtenbuch: darin fast allerley und der fürnemnstern Nationem die heutigs tags bekant sein, kleidungen beyde wie es bei Manns unde Weibspersonons gebrenchlich. Nüremberg: Hans Weigel 1577. Unterschneidheim W. Uhl, 1969.

256 *Bibliography*

Hale, J. (1991), *The Civilization of Europe in the Renaissance*, London: Fontana Press.

Hamilton, G. H. (1967), *Painting and Sculpture in Europe 1880–1940*. The Pelican History of Art, Harmondsworth: Penguin Books.

Hampe, T. ed. (1927), *Das Trachtenbuch des Christoph Weiditz*, Berlin: de Gruyter.

Harrison, C., P. Wood and J. Gaiger, eds (2000), *Art in Theory 1648–1815: An Anthology of Changing Ideas*, Oxford: Blackwell.

Hartley, D. (1931), *Medieval Costume and Life: A Review of their Social Aspects Arranged under Various Classes and Workers with Instructions for Making Numerous Types of Dress*, London: E.T. Batsford.

Hartnoll, P. (1989), *The Concise Oxford Companion to the Theatre*, Oxford: Oxford University Press.

Hartt, F. (1970), *A History of Italian Renaissance Art: Painting, Sculpture, Architecture*, London: Thames and Hudson.

Hind, A. M. (1922), *Wenceslaus Hollar and His Views of London and Windsor in the Seventeenth Century*, London: John Lane.

Hobbes, T. (1985), *Leviathan*, London: Penguin Books.

Hodge, B. (2007), *Skin + Bones: Parallel Practices in Fashion and Architecture*. Catalogue for the exhibition of the same title organised by the Museum of Contemporary Art, Los Angeles (MOCA), London: Thames and Hudson.

Holborn, M. (1995), *Isamu Noguchi*, Cologne: Taschen.

Hollander, A. (1993), *Seeing Through Clothes*, Berkeley and Los Angeles: University of California Press.

Honour, H. (1981), *Romanticism*, London: Penguin Books.

Honour, H. and J. Fleming (1992), *A World History of Art*, London: Macmillan.

Huizinga, J. (1979), *The Waning of the Middle Ages*, Harmondsworth: Penguin Books.

Hulten, P., N. Dumitresco and A. Istrati (1998), *Brancusi*, Paris: Flammarion.

Il Libro del Sarto (della Fondazione Querini Stampalia di Venezia) (1987), Modena: Edizioni Panini.

Jackson, A. and A. Jaffer (2004), *Encounters: The Meeting of Asia and Europe 1500–1800*, London: V.&A. Publications.

Johnson, D. (2006), *Jacques Louis David: New Perspectives. Studies in Seventeenth and Eighteenth Century Art and Culture*, Newark: University of Delaware Press.

Kahnweiler, D. H. (1971), *My Galleries and Painters: The Documents of 20th Century Art*, London: Thames and Hudson.

Kearney, R. (1999), *Modern Movements in European Philosophy: Phenomenology, Critical Theory, Structuralism*, Manchester and New York: Manchester University Press.

Koda, H. and A. Bolton (2007), *Poiret*. The Metropolitan Museum of Art, New York, New Haven and London: Yale University Press.

Kristeller, P. O. (1965), *Renaissance Thought II: Papers on Humanism and the Arts*, New York: Harper Torchbooks.

Lacroix, P. (1874), *Manners, Customs and Dress During the Middle Ages and During the Renaissance Period*, London: Chapman and Hall.

Laver, J. (1969), *A Concise History of Costume*, London: Thames and Hudson.

Laver, J., A. de la Haye and A. Tucker (2002), *Costume and Fashion: A Concise History*, 4th edn, London: Thames and Hudson.

Lehmnann, U. (2000), *Tigersprung: Fashion in Modernity*, Cambridge, MA and London: The MIT Press.

Levey, M. (1966), *Rococo to Revolution: Major Trends in Eighteenth Century Painting*, London: Thames and Hudson.

Lévy, B. H. (1995), *Adventures on the Freedom Road: The French Intellectuals in the 20th Century*, London: Harvill Press.

Lidwell, S. (2004), *Pietro Bembo: Lover, Linguist, Cardinal*, Montreal and Kingston: McGill Queen's University Press.

Lindey, C. (1990), *Art in the Cold War*, London: The Herbert Press.

Madar, H. (2011), 'Before the Odalisque: Renaissance Representations of Elite Ottoman Women', *Early Modern Women: An Interdisciplinary Journal*, 6 (Autumn): 1–49.

Mafai, G. (2011), *Storia del Costume dall'età romana al Settecento*, Milan: Skira.

Mahiques, R. G. (2008), *Iconografía é iconología: La Historia del Arte como Historia Cultural*, 2 vols, Madrid: Encuentro.

Mainardi, P. (1989), *Art and Politics of the Second Empire: The Universal Exposition of 1855 and 1867*, New Haven and London: Yale University Press.

Maria, de B. (2010), *Becoming Venetian: Immigrants and the Arts in Early Modern Venice*, New Haven and London: Yale University Press.

Martin, R. (1999), *Cubism and Fashion: The Metropolitan Museum of Art*, New York: Distributed by Harry N. Abrams.

Maurois, A. (1954), *The Women of Paris*, London: The Bodley Head.

McCauley, E. A. (2012), 'Photographic, mode et culte des apparences', in G. Groom (ed.), *L'Impressionnisme et la Mode*, Paris: Skira Flammarion.

McGregor, N. (2014), *Germany: Memories of a Nation*, London: Allen Lane.

McKenzie Satterfield, A. (2007), 'The Assimilation of the Marvelous Other: Reading Christoph Weiditz's Trachtenbuch (1529) as an Ethnographic Document' (Thesis submitted in partial fulfilment of the requirements for the degree of Master of Arts, Department of Art and Art History College of Visual and Performing Arts), University of South Florida. http://scholarcommons.usf.edu/etd/2353/

McNeil, P. and S. Miller (2014), *Fashion Writing and Criticism: History, Theory, Practice*, London: Bloomsbury.

Mendes, V. and A. de la Haye (1999), *20th Century Fashion*, London: Thames and Hudson.

Miller, S. (2011), 'Fleeting Fashions', *Apollo*, June 2011.

Miller, S. (2014), 'Taste, Fashion and the French Fashion Magazine', in D. Bartlett, S. Cole and A. Rocamora (eds), *Fashion Media: Past and Present*, London: Bloomsbury.

Miller, S. (2018), 'Fashioned from Nature', exhibition review, *Burlington Magazine*, 160, June: 497.

Miller, S. (2020), Book review: Aileen Ribeiro, *Clothing Art: The Visual Culture of Fashion 1600–1914*, *Fashion Theory* (the *Journal of Dress, Body and Culture*, 24, Issue 1: 141–57), Abingdon-on-Thames: Routledge (Taylor and Francis Group).

Minning, M., N. Rottan and T. Richter, eds (2019), *Dressed for Success: Matthäus Schwarz. Ein Modetagbuch des 16 Jahrhunderts*, Herzog Anton Ulrich Museum, Kunst Museum des Landes Niedersachsen: Sandstern Verlag.

Morini, E. (2006), *Storia della Moda: XVIII–XX secolo*, Milan: Skira.

Myers, B. S. (1967), *Art and Civilization*, London: Paul Hamlyn.

Newton, S. M. (1975), *Renaissance Theatre Costume and the Sense of Historical Past*, London: Andre Deutsch.

Newton, S. M. (1988), *The Dress of the Venetians: Pasold Studies in Textile History, 7*, London: Scolar Press.

Nii, R. (2002), '20th Century. Second Half', in Akiko Fukai (ed.), *The Collection of the Kyoto Costume Institute: Fashion. A History from the 18th to the 20th Century*, 509–712, Cologne: Taschen.

Norberg, K. and S. Rosenbaum, eds (2014), *Fashion Prints in the Age of Louis XIV: Interpreting the Art of Elegance*, Texas: Texas Technical University Press.

'Oscar Wilde on Fashion and Dress Reform' (Articles from The *Woman's World 1888–1890*). See: Tara Maginnis: 'The Costumier's Manifesto' at: OnlineCostumeStorecom (text provided by Project Gutenberg e-Text).

Panofsky, E. (1955), *Meaning in the Visual Arts*, Harmondsworth: Penguin Books.

Panofsky, E. (1972), *Studies in Iconology: Humanistic Themes in the Art of the Renaissance*, New York, San Francisco and London: Icon Editions.

Panofsky, E. ([1943] 2005), *The Life and Art of Albrecht Dürer*, Princeton: Princeton University Press.

Pater, W. (1971), *The Renaissance*, Introduction and Notes by Kenneth Clark, London and Glasgow: Fontana/Collins.

Paulicelli, E. (2014), *Writing Fashion in Early Modern Italy* (From Sprezzatura to Satire), London: Ashgate.

Payne, M., ed. (1997), *A Dictionary of Cultural and Critical Theory*, Oxford: Blackwell Publishers.

Penn, I., M. Holborn and I. Miyake (1999), *Irving Penn Regards the Work of Issey Miyake: Photographs 1975–1998*, London: Jonathan Cape.

Pérez Sánchez, A. E. and N. Spinosa (1992), Catalogue of the exhibition *Jusepe de Ribera: 1591–1652*, New York: Distributed by Harry N. Abrams Inc (September–November, 1992, at the Metropolitan Museum of Art).

Petrie, B. (1974), 'Boccioni and Bergson', *Burlington Magazine*, March: 140–7.

Pevsner, N. (1976), *The Englishness of English Art*, Harmondsworth: Penguin Books.

Pignatti, T. (1971), *Giorgione: Complete Edition*, London: Phaidon.

Poli, D. (1987), 'Fashion in "A Tailor's Book"', in *Il Libro del Sarto (della Fondazione Querini Stampalia di Venezia)*, Modena: Edizione Panini.

Preziosi, D., ed. (1998), *The Art of Art History: A Critical Anthology*, Oxford: Oxford University Press.

Proust, M. (1981), *Rememberance of Things Past*, vol. 1, trans. C. K. Scott-Moncrieff and Terrence Kilmartin, London: Penguin Books.

Quicherat, J. (1875), *Histoire de Costume en France, depuis les temps les plus reculés jusqu'à le fin de XVIIIe siècle*, Paris: Hachette.

Racinet, A. (2016), *The Costume History* (1888), Cologne: Taschen.

Reynolds, A. (2013), *In Fine Style: The Art of Tudor and Stuart Fashion*, London: Royal Collection Trust.

Ribeiro, A. (1988), *Fashion in the French Revolution*, London: Batsford.

Bibliography

Ribeiro, A. (2017), *Clothing Art: The Visual Culture of Fashion 1600–1914*, New Haven and London: Yale University Press.

Richardson C., ed. (1988), *Clothing, Culture 1350–1650*, London: Ashgate.

Rieff-Anawalt, P. (2007), *The Worldwide History of Dress*, London: Thames and Hudson.

Robinson, J. with Gracie Calvey (2015), *The Fine Art of Fashion Illustration*, London: Francis Lincoln Limited.

Roche, D. (1994), *The Culture of Clothing: Dress and Fashion in the Ancient Régime*, Cambridge: Cambridge University Press.

Rosenberg, J., S. Slive and E. H. ter Kuile (1972), *Dutch Art and Architecture 1600–1800*, Harmondsworth: Penguin Books.

Rosenthal, M. F. and A. R. Jones, eds (2008), *The Clothing of the Renaissance World: Europe, Asia, Africa, the Americas. Cesare Vecellio's Habiti Antichi et Moderni*, London: Thames and Hudson.

Ross, J. B. and M. M. McLaughlin, eds (1978), *The Portable Renaissance Reader*, Harmondsworth: Penguin Books.

Roxburgh, D. J., ed (2005), *Turks: A Journey of a Thousand Years, 600–1600*, London: Royal Academy of Arts.

Rublack, U. (2010), *Dressing Up: Cultural Identity in Renaissance Europe*, Oxford: Oxford University Press.

Rublack, U. and M. Hayward, eds (2015), *The First Book of Fashion: The Book of Clothes of Matthäus and Veit Konrad Schwarz of Augsburg*, London: Bloomsbury.

Russell, B. (1982), *History of Western Philosophy: And Its Connection with Political and Social Circumstances from the Earliest Times to the Present Day*, London: Unwin Paperbacks.

Saglio, C. (1913), 'Le cinquantenaire de La Vie Parisiene', *La Vie Parisienne*, Samedi 4 Janvier 1913, 51é année, nr. 1: 3–4.

Saxl, F. (1987), 'Costume and Festivals of Milanese Society under Spanish Rule', in *Il Libro del Sarto (della Fondazione Querini Stampalia di Venezia)*, Modena: Edizione Panini.

Scharf, A. (1974), *Art and Photography*, Harmondsworth: Penguin Books.

Scott, M. (2011), *Fashion in the Middle Ages*, Los Angeles: The J. Paul Getty Museum.

Seeling, C. (2000), *Fashion: The Century of the Designer: 1900–1999*, Cologne: Könneman.

Shaw, H. (1843), *Dresses and Decorations of the Middle Ages: From the Seventh to the Seventeenth Century*, London: William Pickering.

Smart, A. (1972), *The Renaissance and Mannerism Outside Italy*, London: Thames and Hudson.

Steele, V. (2008) 'Fashion, Death and Time', in V. Steele and J. Park, *Gothic: Dark Glamour*, New Haven and London: Yale University Press.

Steele, V. and J. Park (2008), *Gothic: Dark Glamour*, New Haven and London: Yale University Press and the Fashion Institute of Technology.

Stevens, M. (2000), '"The Exposition Universelle" this Vast Competition of Effort, Realization and Victories', in Robert Rosenblum, M. Stevens and A. Dumas (eds), *1900: Art at the Crossroads*. London: Royal Academy of Arts.

Stevens, M. and L. Lehmbeck (2013), 'Catalogue Entries', in *Manet: Portraying Life*, London: Catalogue for the Exhibition Held at the Royal Academy of Art, 26 January–14 April 2013.

Bibliography

Taylor, L. (2004), *Establishing Dress History*, Manchester: Manchester University Press.

Thoré, T. (2012), 'Salons de W. Bürger (1861 à 1868), 2. vols., Paris in: Jules Renouard, 1870, t.1, p. 139. Quoted by Elizabeth Anne McCauley: "Photographic, mode et culte des apparences"', in G. Groom (ed.), *L'Impressionnisme et la Mode*, Paris: Skira Flammarion.

Tinterow, G. and P. Conisbee, eds (1999), *Portraits by Ingres: Images of an Epoch*, New York: The Metropolitan Museum of Art.

Tortora, P. G. and K. Eubank (2010), *Survey of Historic Costume: A History of Western Dress*, Fifth edn, New York: Fairchild Books.

Vasari, G. (1970), *Lives of the Artists*, London: Penguin Classics.

Vasari, G. (1550, 1997), *Le vite dei più eccellenti pittori, scultori e architettori*, Rome: Grandi Tascabili Economici Newton.

Warnock, M. (1965), *The Philosophy of Sartre*, London: Hutchinson University Library.

Weaver, M., ed. (1989), *The Art of Photography (1839–1989)*, New Haven and London: Yale University Press.

Weiditz, C. (1927), *Das Trachtenbuch des Christoph Weiditz (und seinen reisen nach Spanien (1529) und den Niederlandedn (1531–2)*, edited and with an introduction by Dr. Theodor Hampe, Berlin: de Gruyter.

Wilcox, C., ed. (2007), *The Golden Age of Couture: Paris and London 1947–57*, London: V.&A. Publications.

Wilenski, R. H. (1973), *French Painting*, New York: Dover.

Williams, G. (2017), *Pietro Bembo on Etna: The Ascent of a Venetian Humanist*, Oxford: University Press, Oxford.

Winkel, de M. (2006), *Fashion and Fancy: Dress and Meaning in Rembrandt's Paintings*, Amsterdam: University of Amesterdam Press.

Wittkower, R. (1975), *Art and Architecture in Italy 1600–1750*. The Pelican History of Art, Harmondsowrth: Penguin Books.

Wollen, P. (1998), *Addressing the Century: 100 Years of Art and Fashion*. Catalogue of the Exhibition of the Same Title: 1998–9, London: Hayward Gallery Publishing.

Wood, G., ed. (2007), *Surreal Things: Surrealism and Design*, London: V.&A. Publications.

Index

'95 Theses or Disputation on the Power of
 Indulgences' (Luther) 71
100 Years of Fashion Illustration
 (Blackman) 18

Abraham's gazar 218
Abstract Expressionism 210
abstraction, realism *vs.* 210
Addressing the Century (100 Years of Art
 and Fashion, Wollen) 227
Adrian VI 98
Aertsen, Pieter 69, 130
 Market with Christ and the Woman
 Taken in Adultery 70
aesthetic dress 177, 182
Aesthetic Dress Movement 182
aesthetic theory 14
Afterwords (autumn/winter 2000–2001,
 Chalayan) 245, 247–8
Agustin, Lenny 250
Aillaud, Émile 206
à la Lévite 141, 142, 144
Alberti, Leon Battista 23
 istoria 22–3, 25
 On Painting 22, 34
Aldegrever, Heinrich 74
alienation concept 243–4
allegorical subjects 125
Allocution of Alfonso d'Avalos, Marquis
 de Vasto to His Troops, The
 (Titian) 55
Amberger, Christoph 92
Amman, Jost 82
 Gynaeceum 83
 Habitus praecipuorum populorum
 64–8, 82

 Theatrum Mulierum 74
Ancien Régime 144, 153
Ancients 142
Andrée, Ellen 158, 159
Anthonisz, Cornelius 55
anthropological fascination 74
anti-fashion 222–5
 grunge 234–5
anti-fashion movement 177, 179, 181, 182
antipathetic fashion 12
aphorism 155, 179
Apollinaire, Guillaume 191
'Apotheosis of James I, The' (Rubens) 125
Aretino, Pietro 33
aristocratic portraits 230
aristocratic style 177
Armani, Giorgio 226
Arnault, Bernard 241
Aron, Raymond 210
Art Déco 202, 204
Art et Décoration (Poiret) 201, 213
art exhibitions 172
Artforum 227–8
art history 1–2, 4, 8, 13, 171, 189
 iconography in 6–11
artistic rebellion 225
Art of Art History: A Critical Anthology,
 The (Preziosi) 6
Aspland, Alfred, *Theatre of Women*
 designed by Jobst Ammon,
 The 83
atelier (Brancusi) 228–9
Athalie (Racine) 141–3
A – UN (Miyake) 229
austere formalism 230
authentic art 14

Autumn (Manet) 164–6
avant-garde fashion design 226

Babylonian Captivity of the Church
(Luther) 96
Bab Zuwayla 89
baggy pants, Turkic tribes 86
'Bakou' 201
Bakst, Leon 198, 202
Balenciaga, Cristobal 212, 216–20
dress and coat 217, 219
Ballarin, Alessandro 30–2
Ballet de la Nuit 103, 239
balletic movements 204
ballets de cour 239
Ballets russes 189, 198
Balzac, Honoré de 157
Banqueting House 125
Barbier, Georges, *Madness of the Day,*
The 199
Bardot, Brigitte 218, 220
baroness dress 161–2
Barthes, Roland 15, 124, 202, 216
and cover of *Paris-Match* 17
critic of capitalist system 13
Fashion System, The 17, 166
'Iconographie de l'abbé Pierre' 12
iconography 17
image-clothing 18, 166
myth 12, 17, 124
Mythologie 11, 16–17
structural analysis of image 17
technological garment 166, 202
written clothing 17, 18, 166
Bartlett, Djurdja, *Spectre That Haunted*
Socialism, The 208–9
Baudelaire, Charles 158–60, 164,
170, 177
modernity 155, 157, 161, 165
Baudrillard, Jean
'Procession of Simulacra, The' 250
virtual reality 250
Bayezid, Sultan 88
Beaton, Cecil, immortal photograph
224–5

Beauvoir, Simone de 211, 216
Second Sex, The 212
Beethoven, Ludwig von 37, 170
Being and Nothingness (Sartre) 210
Bellini, Gentile 25, 68, 77, 88, 89
St. Mark Preaching in Alexandria 88–9
Bellini, Giovanni 25, 89
Bembo, Bernardo 34
Bembo, Pietro 28
Gli Asolani 27–31, 33
History of Venice 88
Prose della volgar lingua 28–9, 33
Benois, Alexander 198
Bérain, Jean 105
Berenson, Bernard 30, 35
Bergson, Henri 204
Bertelli, Ferdinando, *Omnium Fere*
Gentium Nostrae Aetatis
Habitus 19, 64, 75
Bertelli, Pietro, *Diversarum Nationem*
Haubitus 64
Berthélémy, Jean Simon 140
Between (spring/summer 1998, Chalayan)
245, 246
Beuckelaer, Joachim 69, 130
bias cut 204
Biba shop 221
Bidou, Henri 201–2
binary oppositions, Freud, Sigmund 232
Bing, Siegfried 226
Birth of Venus (Botticelli) 34, 35
Black and White Vogue Cover 230
Blackman, Cally, *100 Years of Fashion*
Illustration 18
bliaud 46–8
Bloomer, Amelia 177
Blow, Isabella 38, 40, 237
Boberg, Otto Gustaf 163
Boccioni, Umberto
force-lines 204
Technical Manifesto of Futurist
Sculpture 204
Boileau, Nicolas, *L'art poétique* 142
Bonaparte, Napoleon 196–7
Bonnart, Henri 111, 129

Bonnart, Jean-Baptiste 116, 129
Bonnart, Nicolas 110–12, 116
Boquet, Louis-René 140
Borromeo, Renato (Prince) 52, 61, 63
Borromeo, S. Carlo 61
Bosch, Hieronymus 96
Bosse, Abraham 109, 117
 Cries of Paris, The 117, 119, 129, 131
 Ratcatcher, The 13, 118–20
Botticelli Re-imagined 39
Botticelli, Sandro 39
 Birth of Venus 34, 35
 mythological paintings 9, 35
 Neoplatonism 34, 35
 Primavera 34, 35
Boucher, François 67, 222
 History of Costume in the West, A 18,
 46, 92
bouffant effect 200
braies 47
Brancusi, Constantin
 aphorisms 229
 atelier 228–9
branding 233
Braque, Georges 189, 191
Brecht, Bertolt, Mother Courage and Her
 Children 117, 118
Breton, Richard 89
Breydenbach, Bernhard, Peregrinatio in
 terram sanctam 89
Brocardo, Antonio 32, 33
Brocardo, Marino 32
Brun, Jean Antoine 141
Brutus (Voltaire) 139
Budi, Felicia 250
Burckhardt, Jacob, Civilization of the
 Renaissance in Italy, The 8
Burne-Jones, Edward 182
Burning Down the House (LaChapelle),
 case study 41
Buy my Dutch biskets 127, 128

Cabaret 'Voltaire' 234
Café, The (The Absinthe Drinker)
 (Degas) 159

caftan 194
Calandria (da Bibbiena) 240
Callot, Jacques 109
 Miseries and Misfortunes of War 117
Calvesi, Maurizio 24
Calvet, Louis-Jean 12
Calvey, Gracie, Fine Art of Fashion
 Illustration, The 19
Cameria, portraits of 84, 87
Camille (Monet) 156–8
Campbell, Naomi 40
Camus, Albert 210, 211
Canossa, Ludovico 240
Canova, Antonio 135
 Pauline Borghese as Venus Victorious
 135
capitalism 208, 244
Caracci, Annibale 128
Cariani, Giovanni 30
Carlos, Don 55
Carlos I 80
Carnaby Street 222
Carpaccio, Vittore 88, 89
carte de visite 161
Carter, Ernestine 214, 216
Cassirer, Ernst 10
Castiglione, Baldassare 240, 242–3
 portrait of 4
Catholic Church 61, 71, 96, 100
Catholicism 95
 vs. Protestantism 101–2
Cavalcaselle, Giovanni Battista 8, 29
Cavalli, Mario 54
Cazalis, Anne-Marie 211
Century of Louis the Great, The (Perrault)
 142
Chair Mender, The 128
Chalayan, Hussein
 Between (spring/summer 1998)
 245, 246
 Afterwords (autumn/winter 2000–
 2001, Chalayan) 245, 247–8
Charles I 97, 125
 reign of 239
Charles II 121, 125

Persian vest in 113
printed page during the Restoration 125–31
Charles V 52–6, 59–61, 71, 99–100
Charles VIII 27, 34
chemise dress 148
children's attire 180
Chrieger, Christoph 84
Christianity, converting to 79–80
Christian, Willy 214, 216
chromolithography 173, 175
Churchill, Winston 208
Cinquecento 61, 63
Civilization and Its Discontents (Freud) 232
Civilization of the Renaissance in Italy, The (Burckhardt) 8
Clark, Kenneth 24, 26
classical art, Greek 171
classical dress, exaggerated version of 149
classical heroes on stage 140
classicism 135
Clement VII, Pope 71
Clothing Art: The Visual Culture of Fashion 1600–1914 (Ribeiro) 3
Clubfoot, The (Ribera) 118, 120
Coello, Alonso Sanchez 56–7
Coiffure en porc-épic et a la Titus 149
Colbert, Jean-Baptiste 103
Column of Diocletian 89
Comédie Française 138–9
Comédie Italienne 140
comedies larmoyantes 139
Comines, Philippe de 27
commedia dell'arte 139
commercialism and fashion magazines 169
commercial magazine 169
communism 208, 209
Communist Manifesto 209
Concert (Giorgione) 30, 36
Constitution style dress 147
contrapposto posture 110–11
Cook, Herbert 29, 30
copiousness 22

Cornaro, Caterina, portrait of 27
Cornu, Paul 201
Cortès, Hernan 21
Cortez, Ferdinand 76, 77
costume books 5, 21, 51, 72, 74, 76, 78, 84, 88, 89, 105, 169
Council of Trent 100, 101–2
Counter-Maniera 101
Counter-Reformation 6, 54, 61, 64, 97, 99, 120
consequences of 102
cultural and religious movements of 101–2
Courrèges, André 192
'Space Age' collection (1964) 222
court dress and costumes 52
Court of Versailles 103, 111
Couturiere élégante 152, 153
Couturier, Robert 206, 207
Cowles, Virginia 183
Cranach, Lucas the Younger 52
Crécy, Odette de 159, 167–8
Cries of Paris, The (Bosse) 117, 119, 129, 131
crinoline 156, 161, 176, 177, 180–1, 195
Croce, Benedetto 9
Cromwell, Oliver 125
Crow, Thomas E. 137
cubism 191–4, 203. *See also* fauvism
orderly geometry 201
Cubism and Fashion 191–2
Culture of Clothing: Dress and Fashion in the Ancien Régime (Roche) 19

da Bibbiena, Bernardo Dovizi, *Calandria* 240
Dadaism 225, 234
Daguerre, M. 160
daguerreotype 160, 161
Damisch, Hubert
iconography 15
modern art 14
'Semiotics and Iconography' 13
Danses polovtsiennes du Prince Igor 198
Daphnis 31

Index

Das Capital (Marx) 244
Das Trachtenbuch des Christoph Weiditz 74
d'Avalos, Alfonso 54–5, 59
Davanzo, Doretta, 'La Moda del Libro del Sarto' 63
David (Michelangelo) 93–4
David, Jacques-Louis 135
 Oath of the Horatii, The 135–8
David to Delacroix (Friedlaender) 136
da Vinci, Leonardo 73, 239
'Day at Girton College, A' (Donaldson) 178–9
'Death, War, Pestilence and Destruction' 96
Debord, Guy, 'Society of Spectacle' 241
'deconstructed' garments 231, 233
deconstruction 231, 233, 234
'Deconstruction Fashion: The Making of Unfinished Decomposing and Re-assembled Clothes' (Gill) 233
Degas, Edgar, *Café, The (The Absinthe Drinker)* 159
De gli habiti antichi et moderni di diverse parti del mondo (Vecellio) 21, 64, 83–90
del Conte, Gian Giacomo 52
del Piombo, Sebastiano 31
Demeulmeester, Ann 233
de Meyer, Baron Adolf 229, 230
demi-mondaine 159
Derrida, Jacques 14
 deconstruction 231, 233, 234
des Garçons, Comme 233
deshabillé 110, 111
Desprez, François 19, 20
 Recueil de la diversité des habits 66, 68, 84, 89–90
Desrais, Claude-Louis 151
'Detox Catwalk' 250, 251
devotio moderna 95
Diaghilev, Sergei 198
dinner dress 178
Dionisotti, Carlo, *Leggi della compania degli amici* 30

Dior, Christian 212, 214, 217, 218
 model 214, 215, 217, 218
 and 'New Look', the 213–16, 230
diplomatic relationship, France and Siam 114
direct carving 228
Directory album, Iribe, Paul 194–6
Directory period, sartorial dress during
 in fashion magazines 140–8
 in painting 135–8
 on stage 138–40
Directory style 134
 genesis of 148–50
 Poiret, Paul 195
Disdéri, André-Adolphe-Eugène
 photography 161–3
Diversarum Gentium Aetatis (Vico) 64
Diversarum Nationem Haubitus (Bertelli) 64
Dom Modelei 209
Donaldson, M. F., 'A Day at Girton College' 178–9
Doncieux, Camille 156, 157, 159
'Donna turca in casa' (Vecellio) 85
Donneau de Visé, Jean 103, 105, 107, 108
'Donzella di Granata' (Vecellio) 81, 88
Doric columns 136
'Dosso Dossi of Ferrara' 31
double portrait 30–2
Doucet, Jacques 188
drames bourgeois 139
draped hose 46
Dress becomes Body becomes Dress collection of 1997 (Garçons) 231
Dressing Up: Cultural Identity in Renaissance Europe (Rublack) 19–20, 93
Dreyfus, Alfred 210
Dufy, Raoul 189–91
 textile designs 193
Dürer, Albrecht 64–5, 68, 73, 96, 97
 Feydal 20
 Fine Art of Fashion Illustration, The 19
 self-portraits 19
Dutch genre paintings 130

Eckhart, Meister 95
Edizioni Panini 51
Edward VII 183
Egger, Johann N. 75
ekphrasis 36
ekphrasis of the scriptures 102
Ellis, Sean 237
Engels, Engels 209
England
 'Arts and Crafts' movement 226
 capturing elegance in 121–5
 fashion in
 Rebellion and reform 175–83
 Wilde, Oscar and 177–83
English Civil War 125
English costume 149
English fashion 144
Englishness of English Art, The
 (Pevsner) 176
Enlightenment 133, 135, 170
epistemology 13
Establishing Dress History (Taylor) 18
Esterel, Jacques 218, 220
ethnographic costume 173
ethnography 77
Europe
 ideological division of 208–10
 Japanese arrival in 226–31
 power of 183
Evans, Caroline 235, 237, 243, 244
 *Fashion at the Edge: Spectacle,
 Modernity and Deathliness* 241
Evelyn, John 113
existentialism 210–12
 Sartre, Jean-Paul 210–12
Existentialism and Humanism
 (Sartre) 210
exotic costume 89
*Exposition Internationale des Arts Décoratifs
 et Industriels Modernes, the* 203
extravagant attire 88–9
Eyck, Jan van 174

Fabriano, Gilio da 102
Famous Dutch Woman, The 128

Farhana, Hanna 251
farthingale 181
fashion 164–8
 1980s 225–6
 1990s 232–7
 aphorism 155, 179
 and art
 Bidou, Henri 202
 Vionnet, Madeleine and Thayaht
 202–8
 children's attire 180
 deconstruction in 231, 233, 234
 dolls 151
 in England
 Rebellion and reform 175–83
 existentialism, feminism and 210–12
 and first avant-garde movements
 190–4
 historians 2
 illustrations 18, 50, 104, 168, 202
 protest against 175–83
 theory 221
 as visual sources 148
fashionable absurdities 179
*Fashion at the Edge: Spectacle, Modernity
 and Deathliness* (Evans) 241
Fashioned from Nature 250
fashion images 108, 169
 iconography and 15–16, 18–22
 semiotics and 16–18
fashion magazines 17, 18, 103–6,
 149–51, 153, 159, 162, 166–70,
 182, 209, 230
 commercialism and 169
 eighteenth century 168
 and French Revolution 144–6
 sartorial dress in 140–8
 writers 166
fashion photography 168, 200–2, 250
 Penn, Irving 230
fashion plate 19, 105, 108, 109, 121, 144,
 156, 158, 168
 modernism on 187–90, 194
 revolution of 150–3
fashion prints 107–8

fashion shop 105
fashion show 239, 240
 Between (spring/summer 1998)
 245, 246
 Afterwords (autumn/winter 2000–
 2001) 245, 247–8
 commercial aspect 241
 Highland Rape (Autumn/Winter
 1995/6) 242
 moresca 240
 pioneer 241
 sculpture and 244, 245
 as spectacle 241, 244
 spring/summer 1999 242–3
fashion studies 11–12, 233
Fashion System, The (Barthes) 17, 166
Fath, Jacques 212
fauvism 189–91. *See also* cubism
'Favorita del turco' (Vecellio) 84–5
female dress reform 177
feminism 212, 213
'Femme de qualité en désabillé détoffe
 Siamoise' 114, 115
Ferdinand II 78, 79
fetishism of the commodities 244
Feydal (Dürer) 20
Feyerabend, Sigmund 20, 76, 82, 83
Ficino, Marsilio 33–4
figurative creation 9
Fincher, Terry 217–19
Fine Art of Fashion Illustration, The
 (Calvey and Dürer) 19
fine arts 172, 206
'Fine Arts: the Daguerrotype' 160
Fiocco, Giuseppe 30
first avant-garde movements 189–90
 fashion and 190–4
*First Book of Fashion: The Book of Clothes
 of Matthäus and Veit Konrad
 Schwarz of Augsburg, The*
 (Schwarz and Schwarz) 83,
 90–5, 98, 100
First Estate 151, 153
'First Manifesto of Futurism, The' 203–4
First World War 206

Florence 33
Florentine painting 34–5
'Four Horses of the Apocalypse' 96
fowling 49
France 103, 151, 176, 183
 fashion magazines 153
 fashion plates 153
 society life in 148
Frankel, Susannah 227
French Directory (1795–9) 195
French fashions 56, 144, 151, 195
French military uniform saluting 17
French peasant woman 68–9
French racism 17, 124, 216
French Revolution 134, 135, 149, 151
 dress code for three estates 146
 fashion magazines and 144–6
 tricolore of 146
French West Indies 148
Freud, Sigmund
 binary oppositions 232
 Civilization and Its Discontents 232
 uncanny 42–3
Friedlaender, Walter, *David to Delacroix*
 136
Frith, William Powell, *Private View at the
 Royal Academy 1881* 182
Fugger, Anton 99, 100
Fugger, Jacob "the Rich" 92–5
 black attire 97
Fuggers 96–8
futurism 203–5

Gagarin, Yuri 222
gallant journalism 104
Galliano, John 241
Garçons, Comme, *Dress becomes Body
 becomes Dress* collection of
 1997 231
Garzoni, Tomaso, 'Piazza universale
 di tutte le professioni del
 mondo' 63
Gay, John, *Trivia or The Art of Walking the
 Streets of London* 126
Gazette de France 105

268 *Index*

Gazette du bon ton 201, 203, 204
Gazi, Orhan 87
gentilhomme 129
Geoffroy, Louis 161
George I. *See* Ludwig, Georg
German female costume 73
German skirt 64
gesamtkunstwerk 65
Getrevi, Paolo 51
Giacomo, Gian 52
Gide, André 209
Gill, Alison 233
 'Deconstruction Fashion: The Making
 of Unfinished Decomposing and
 Re-assembled Clothes' 233
 grunge 234
Giorgione
 authorship 30, 32
 bizarre painting 30
 compare with LaChapelle's images 40
 Concert 30, 36
 double portrait 30–2
 Herbert Cook's attribution to 29–30
 landscape paintings 24–5
 La Tempesta, case study 22–43
 painting 41, 42
 Pala de Castelfranco 30
 Portrait of a Young Woman 30
 portrait of Brocardo, Antonio 32–3
 portraits 27, 30
 Sleeping Venus, The 25
Giorgionesque dimension 36, 37
Gli Asolani (Bembo) 27–31, 33
globalization 232–3
Gombrich, Ernst 24
Gothic attire 65
Gothic: Dark Glamour (Steele) 237
Gothic fashion 237
Goya, Francisco 117
 La gallina ciega 174
Granada 77–81
Grand Palais 187
gravitas 98, 99
Greco, Juliette 211, 212
Greek chiton 134, 135, 194

Grimani, Cardinal 25
Grouès, Henri 12
grunge 234–5, 242
Guicciardini, Francesco, and *Storia
 d'Italia* 26–7
Guys, Constantin 155
Gynaeceum (Amman) 83

Haberton, Lady 179
Habich, Georg 75
Habit d'Hyver 105
Habiti Antichi et Moderni (Vecellio)
 52, 81
Habitus praecipuorum populorum
 (Amman) 64–8, 82
Hale, John 73–4
Hampe, Theodor 74–81
Harlow, Shalom 242, 244
Harper's Bazaar 207, 230
Hartley, Dorothy, *Medieval Costume and
 Life* 47
Hartt, Frederick 42
Haussmann, Georges Eugène 159
haute couture 163–4, 168, 188, 202, 218,
 222, 231
 trade 241
Haweis, Mary Eliza 179
hawking 49
Hayward, Maria 93
Hedingham Castle 39
Hegel, Georg Friedrich Wilhelm 170
 historicism 171, 173, 175
 history of art 171
Heidegger, Martin 234
Heldt, Sigmund 20, 72–3, 76, 81, 82
Henriot, Henriette 159
 toilette de ville 157–8
Henry II 55–6
Henry VIII 121
'heroin chic' 235, 237, 242
Herzog Anton Ulrich Museum 92–3
Highland Rape (Autumn/Winter 1995/6)
 (McQueen) 242
historical costume 169–75. *See also*
 Racient, Auguste

on stage 140
historicism 170
 Hegel's 171, 173, 175
historicizing styles 195
histories of dress 3, 138
history
 of art 1–2, 4, 8, 13, 171, 189
 iconography in 6–11
 of culture 8
 of dress 177
 of philosophy 171
History of Costume in the West, A
 (Boucher) 18, 46, 92
History of Venice (Bembo) 88
Hoffmann, E. T. A. 170
Holland 100, 129–30
Hollander, Anne 148, 222–3
Hollar, Wenceslaus
 Aula Veneris 122
 Four Seasons, The 122–4
 Ornatus Muliebris Anglicanus 121–2
Holmes, Sherlock 217
Holy Brotherhood 79
Homme en robe de chambre 110–12
Honnecourt, Villard de, Sketchbook of
 45–8
 Lord and Lady 48
 Wrestlers 47
hoop 181
House of Dior 241–2
Houssaye, Arsene, *la Parisienne* 155–7
Howard, Thomas (2nd Earl of
 Arundel) 121
Huguenots massacre 102
Huizinga, J., *Waning of the Middle Ages,*
 The 49
hunting 49
Hunt, William Holman 182

Ibn Tilun Mosque 89
Iconografia e Iconologia: La Historia del
 Arte come Historia Cultural
 (Mahiques) 8
'Iconographie de l'abbé Pierre'
 (Barthes) 12

iconography 1–2, 4, 5, 14
 definition of 7
 epistemological bases 13
 and fashion images 15–16, 18–22
 iconology 15, 23
 Panofsky, Erwin 2, 7, 9–11, 13, 15, 23
 and semiotics 12–15
Iconologia (Ripa) 6
iconology 5–11
ideological division of Europe 208–10
Il Libro del Sarto (della Fondazione
 Querini Stampalia di Venezia,
 Saxl)* 15–16, 51–65, 74
image-clothing 18, 166. *See also*
 technological garment;
 written clothing
Imitation of Christ (Kempis) 96
Impassioned Singer (Giorgione) 30
Imperial Diet 98, 99
Incroyables 149
Indian ethnograpy 21
Indians 76, 77
indigenous Americans 77
Ingres, Jean Auguste Dominique 161–2,
 168
institutionalized uniformity, Louis XIV 107
In the Age of Giorgione 29
invention
 of haute couture 163–4
 of photography 160–3
Iribe, Paul 189, 190, 202
 Directory album 194–6
 Les robes de Paul Poiret racontées par
 Paul Iribe 194, 196
'Iron Curtain' 208
Irving Penn: Centennial 230
Irving Penn: Recent Work, Photographs of
 Cigarettes 229
Isabella I 79
Iseult (Queen) 46–7
Islamic architecture 89
istoria 22–3, 25, 26

Jacobs, Marc 235
Japanese aesthetics 229, 231

Index

Japanese arrival in Europe 226–31
Jeanneret, Charles-Edouard 203
jeunesse doré 149
Jones, Ann Rosalind 51
Jones, Inigo 239
Josephine, Empress 195, 197
Journal de Savants 105
Journal des Dames 169
jupe pantalon 200
justaucourps 111

Kákay-Szabó, Gyürgy 32
Kant, Immanuel 133
Karan, Dona 233, 235
Karina, Indita 250
Kawakubo, Rei 192–3, 227, 231, 233
Kempis, Thomas à, *Imitation of Christ* 96
kimono 194
Kinderen-Besier, Johanna 2
Klaidungsbüchlein or Trachtenbuch (Schwarz) 90–100
Klein, Calvin 233, 250
Kyoto Protocol 232

la Bruyère, Jean de 107
LaChapelle, David
 Burning Down the House, case study 22–43
 compare with Giorgione's images 40
 early life 39
 images 39, 40
 photograph 40–1, 43
 Provocateurs, The 37
 Rape of Africa 40
 Rebirth of Venus 39, 40
La crieuse de ballets 116, 117
La Dèrniere Mode (Mallarmé) 164–6, 169
La diversié des habits di François Desprez 64
Lady Hamilton, Emma 196–7
Lady's World, The 178
La Gallerie des modes et des costumes français 150, 152
La gallina ciega (Goya) 174
Lagerfeld, Karl 233

Lalaing, Philippe de 55
'La Moda del Libro del Sarto' (Davanzo) 63
landscape in Venetian painting 24
landscape paintings 24–5
La Parisienne 162, 164, 220
 Houssaye, Arsene 155–7
 Monet, Claude 158, 159
 Paris and 155–60
 Renoir, Pierre-Auguste 157–9
la Perse, Poiret, Paul 191, 192
la recherché du temps perdu, À (Proust) 164, 167
La Révolution Surrealiste 189
Laroon, Marcellus, *Marcellus Laroon's Cries of the city of London after the life* 126–9, 131
L'art poétique (Boileau) 142
Last Judgement (Michelangelo) 102
La Tempesta (Giorgione) 22–43
Lauren, Ralph 226, 233, 235
Laver, James 94, 183
La Vie Parisienne 166–7
le bals des Victimes 149–50
Le Cabinet des Modes 140–1, 143, 153
Leclére, Pierre Thomas 151
Le Costume Historique (Racient) 173–5
Lectures on Aesthetics (Hegel) 171
left-wing philosophy 211
Léger, Fernand 210
Leggi della compania degli amici (Dionisotti) 30
Le Journal de la mode et du goût 141, 145, 147, 148
le Journal des dames et des modes 149
Le Magazine des Modes nouvelles françaises et anglaises 141, 144, 145
Le Mercure galant 103–5, 109
Le Nouveau Mercure galant 104–6
Lepape, Georges 190
 Les choses de Paul Poiret 194, 197
 Orientalist album 197–8
Le Pautre, Jean 105
Le Pavilion d'Armide 198

Les choses de Paul Poiret (Lepape) 194, 197
Les Demoiselles d'Avignon (Picasso) 188–9
Les Fleurs Du Mal 198
L'esprit nouveau 203
Les robes de Paul Poiret racontées par Paul Iribe (Iribe) 194, 196
le style Sultane 199
Levey, Michael 136–7
Lévy, Bernard-Henri 210
Libro dei capovalori 64
Life and Art of Albrecht Dürer, The (Panofsky) 20
'Life of Titian' 84
L'Illustration (newspaper) 172
Lives of the Painters, Sculptors and Architects (Vasari) 25
London, street fashion (1960s) 220–2
'London, the Swinging City' 220
Longhi, Roberto 30, 31
'Lord and Lady' or 'Lovers' or 'Youth' 48
Louis XIV 104, 108, 239
 Act for printmakers in 1660 109
 institutionalized uniformity 107
 and king of Siam 114
 legacy 106–7
 luxury and fashion 107
 printed image at the French Court 107–17
 reign of 103, 109, 110
 royal marriage, sarcasm of 107
Louis XVI 137
Loyola, St. Ignatius 121
Ludwig, Georg 131
Lutheran Schmalkaldic League 99–100
Luther, Martin 98
 '95 Theses or Disputation on the Power of Indulgences' 71
 attacks against the Catholic Church 71, 96
 Babylonian Captivity of the Church 96
 To the Christian Nobility of the German Nation 96
 Reformation 71, 95, 96
Lyotard, Jean-François 14

McLaren, Malcolm 223
McMenamy, Kristen 235, 237
McQueen, Alexander 37–8, 41, 241, 244
 Highland Rape (Autumn/Winter 1995/6) 242
 spring/summer 1999 242, 243
Madness of the Day, The (Barbier) 199
Mahiques, Rafael Garcia 11
 Iconografia e Iconologia: La Historia del Arte come Historia Cultural 8
maison de couture 163
Mallarmé, Stéphane 159, 166, 168
 fashion 164–6
 fashion magazine 167
 La Dèrniere Mode 164–6, 169
 technological object 166
 transitoriness 165, 166
Mallet-Stevens, Robert 206
Mancini, Domenico 30
Manet, Edouard 158, 159, 168
 Autumn 164–6
mannequins 241
Mansueti, Giovanni 77, 88, 89
Marcelin, Êmile-Victor Harvard 166, 167
Marcellus Laroon's Cries of the city of London after the life (Laroon) 126–9, 131
marchande des modes 105
Margiela, Martin 232–3
 deconstructed signature 234
 reductionism 234
Maria, Henrietta 239
Market with Christ and the Woman Taken in Adultery (Aertsen) 70
Martin, R. 194
Marxism–Leninism–Stalinism 208
Marx, Karl 176, 209
 alienation concept 243–4
 Das Capital 244
 'fetishism of the commodities' 234
mass culture 14, 16–17
mass media 15

Index

Matisse, Henri 14
'Mauretana in domestico vestita betica
 sive Granatensis' (Weigel) 82
'Mauritana in Betica sive Granatensi
 regno' (Weigel) 82
Maximilian (Emperor) 20
Maximilian I 53
Maximilian II 65–8
Maynald, Willy 214, 216–18
mechanical doll 59–60
Medici Academy 34
Medieval Costume and Life (Hartley) 47
medieval dress 182
Mehmet II 68
Melchior, Baron, *Le journal de modes* 201
Memling, Hans 174
Memorie della illustre famiglia dei
 Freschi Cittadini Originari
 Veneti 63–4
Ménageot, François Guillaume 140
Merleau-Ponty, Maurice 210, 211
Merveilleuses 149
meta-matics 244
Métamatics (Tinguely) 244
Meurent, Victorine 159
Michahelles, Ernesto 202
Michelangelo
 David 93–4
 Last Judgement 102
Michel, Elizabeth St. 126
Michiel, Marcantonio 24
 Notizia d'opere di disegno 24–5
Mihrimah. *See* Cameria
Milanese lady
 costume 56
 in red dress 58, 59
Milanese tailors 55
Millais, John Everett 182
'mini' dress 221, 222
'Minimal Art,' Rose, Barbara 233
minimalism 233
Mirecourt, Eugène de 161
Miseries and Misfortunes of War (Callot)
 117
Mitelli, Giuseppe Maria 128

Miyake, Issey 227–9, 231
 A – UN 229
 'pleats please' 229
Mme. Récamier 195
 portrait of 135
modern art 14
modernism 14–15, 205
 on fashion plate 187–90, 194
modernist aesthetics 14
modernity 155–7, 159, 161, 165
'Modes et frivolités' 201
Molfino, Alessandra Mottola 51, 61, 63
Molinier, Emile 187–8
Monet, Claude 168
 Camille 156, 157
 La Parisienne 158, 159
Montijo, Eugénie de 163
moral dimension 73
moral geography 20
'More is Less,' Rose, Barbara 233
Morelli, Giovanni 8
Morelli, Jacopo 24
'More Radical Ideas Upon Dress Reform'
 (Wilde) 181
Morisco woman 78–83, 88
Morisot, Berthe 159, 164
Moroni, Giuseppe, *Tailor, The* 61
Morris, William 182
Mother Courage and Her Children
 (Brecht) 117, 118
Mukhina, Vera, monumental bronze
 sculpture 210
Mullins, Aimee 242
Munkácsi, Martin 229, 230
Murad III 67, 68
Murat III 87
Musée des Arts Decoratifs 229
Muslims 79
myth 12, 17, 124
mythological paintings 9, 35
Mythologie (Barthes) 11, 16–17

Nadar
 photography 160–2
 studio 157

naked Venus sleeping 25
Napoleon III 158–9, 163, 172
Nazi Germany 206, 207
Negro 17
neoclassical outfits 195
Neoplatonism 34, 35
'new' art 202
'New Look', the, Dior, Christian
 and 213–16, 230
Newton, Helmut 217–18
Newton, Stella Mary 2, 3, 41
 *Renaissance Theatre Costume and the
 Sense of Historical Past* 19
Nicolay, Nicolas de 85
 Travels in Turkey (1951) 85
nihilism 234
Noguchi, Isamu 228–9
non-European dress 89
non-fashion 222
non-Western clothing traditions 232
Notizia d'opere di disegno (Michiel) 24–5
Nouveau Réalisme movement 244
Nuremberg 97–8
 culture 20–1
 dress 21

Oath of the Horatii, The (David) 135–8
Odette de Crécy 164
*Omnium Fere Gentium Nostrae Aetatis
 Habitus* (Bertelli) 19, 64, 75
One Thousand and One Nights 198
Onigo family 29–30
Onigo, Giovanni 29
On Painting (Alberti) 22, 34
on stage, sartorial dress in 138–40
Oriental gowns 142
Orientalist album, Lepape, Georges
 197–8
Orientalist phase 189, 198, 199
Oriental textiles 111
Osman 87
ostentation 183
ostentatious 'bling' 232
ostentatious display 49–50
Ottoman Empire 85

Ottoman women's costume 85–7
Ozenfant, Amedée 203

painting 168
 rules 102
 sartorial dress in 135–8
Pala de Castelfranco (Giorgione) 30
Palais de l'industrie 172
Palais des Beaux-Arts 172
Pall Mall Gazette 181
Pan, Kosa 114
Panofsky, Erwin 8, 11, 39, 55, 61
 iconographic studies 13
 iconography 2, 7, 9–11, 13, 15, 23
 iconology 5, 6, 23
 Life and Art of Albrecht Dürer, The 20
 *Studies in Iconology: Humanistic
 Themes in the Art of the
 Renaissance* 2, 7, 10
 synthetic intuition 37
 three levels of interpretation 2–3, 7,
 10, 12
Papacy 100
Paquin, Jeanne 188
paragone 166
Paris
 and *La Parisienne* 155–60
 street fashion (1960s) 220–2
Parisian fashion 188, 227
Paris-Match cover 17
'Paris Sketchbook Highlights Recent
 Collections of Balenciaga and
 Givenchy' (Balenciaga) 216
Pater, Walter 26
 Giorgionesque 36, 37
 Renaissance, The (1873) 35
 Renaissance, The (1888) 35
 'School of Giorgione, The' 35
Paulicelli, Eugenia 52
 *Writing Fashion in Early Modern
 History: From Sprezzatura to
 Satire* 52
Paul III, Pope 101
Pauline Borghese as Venus Victorious
 (Canova) 135

274 *Index*

Pavillon de l'électricité et de la lumière
(Pingusson and Mallet-
Stevens) 206
Pavillon de l'Élégance 188, 206
'Peaceful Reign of James I, The'
(Rubens) 125
Peasants' War (1522–3) 71
peasant women 68–71
peintres couturiers 156
pen drawing 20, 21
Penn, Irving 229, 231
austere formalism 230
fashion photography 230
Pepys, Samuel 113, 126
Peregrinatio in terram sanctam
(Breydenbach) 89
Pergola 212
Perrault, Charles, *Century of Louis the
Great, The* 142
Persian vest 111
Pesaro, Niccolò 88
Petit Palais 187
Pevsner, Nikolaus, *Englishness of English
Art, The* 176
Pharos lighthouse 89
Philip II 59–61, 97, 100
photography 168, 169
of costume 201
daguerreotype 160, 161
Disdéri, André-Adolphe-Eugène
161–3
fashion (*see* fashion photography)
invention of 160–3
Nadar 160–2
'Piazza universale di tutte le professioni
del mondo' (Garzoni) 63
picaresque 71–2
Picasso, Pablo 191, 210
Les Demoiselles d'Avignon 188–9
Pierre, Abbé 12
hairstyle 12, 17
iconography 14
*Pietro Bembo e l'invenzione del
Rinascimento* 29
Pignatti, Terisio 24, 30, 32

Pillar of Pompey. *See* Column of Diocletian
Pingusson, Georges 206
Pio de Savoia, Cardinal Carlo Emanuele
31
Pirckheimer, Willibald 97
platonic love theory 33–4
'pleats please,' Miyake, Issey 229
pochoir 194, 197, 204
Poiret, Paul 164, 168, 190, 191, 195,
199–200, 203, 206, 213, 226
Art et Décoration 201
Cubism 191–4
design series 194
Directory style 195
exotic and oriental fascination 197
la Perse 191, 192
modernism on fashion plate
187–90, 194
Orientalist phase 189, 198, 199
Poli, Doretta Davanzo 51, 64
Pollock, Jackson 210
Pont Alexandre III 187
Popova, Liubov 209
popular culture 11, 15, 17
'porcupine' hairstyle 149
Portrait of a Young Man and His Servant
29, 30
Portrait of a Young Man, The 31
*Portrait of a Young Man with a Green
Book* 29
Portrait of a Young Woman
(Giorgione) 30
*Portrait of Elisabeth of Valois, Queen of
Spain,* 1560 56–7
portraits 3
Baltassare Castiglione 4
Borromeo, Renato 63
Brocardo, Antonio 32
Cameria 84, 87
Charles V 54
Cornaro, Caterina 27
d'Avalos, Alfonso 54–5
Doncieux, Camille 156
Elizabeth of Valois 57
Henriot, Henriette 157

Lady Hamilton, Emma 196–7
Laurent, Méry 164, 165
Marcelin 167
Maximilian II 66
Mehmet II 68
Mme Récamier 135
Onigo, Giovanni 29
Rothschild, James de 161
Roxolana 84, 87
Titian 87
post-modernism 14–15, 231
postmodernist aesthetics 14
post-structuralism 14–15, 231
post World War II, art history 13
'power' dressing 225–6
pre-iconographical level, Panofsky,
 Erwin 2, 7, 10
Pre-Raphaelite Brotherhood 182
Preziosi, Donald, *Art of Art History: A
 Critical Anthology, The* 6
primary or natural subject matter level
 4, 5, 7, 10, 24, 37, 39, 48, 52, 54,
 55, 59, 66–8, 70, 78, 81, 85, 86,
 94, 98, 111, 114, 117, 118, 120,
 122, 128, 136–8, 141, 144, 145,
 151, 156, 168, 174, 194, 196,
 197, 204, 214, 217, 222, 224,
 235, 242, 245
Primavera (Botticelli) 34, 35
printed image
 capturing elegance in 107–17
 capturing the everyday in 117–21
 during the Restoration 125–31
printed page, Restoration during 125–31
Private View at the Royal Academy 1881
 (Frith) 182
'Procession of Simulacra, The'
 (Baudrillard) 250
Promenade 151, 153
Prose della volgar lingua (Bembo) 28–9, 33
Protestant art 100
Protestantism 73, 100
Proust, Antonin 164
Proust, Marcel 168
 À la recherché du temps perdu 164, 167

Provocateurs, The (LaChapelle) 37, 38
prozodezhda 209
pseudo-hieroglyphs 89
punk clothes modelling 224
punk fashion 222–5, 234

Quant, Mary 221
Quattrocento Venetian narrative
 paintings 88, 89

Racient, Auguste 170
 analysis of images 173–5
 chromolithography 173, 175
 court, city and war costume 172
 Izba image 174–5
 Le Costume Historique 173–5
 royal and ducal costume 172
Racine, Jean, *Athalie* 141–3
racism 17, 124, 216
radical linguistic theory 11
Rape of Africa (LaChapelle) 39, 40
Raphael, on Rembrandt's self-portrait 4–5
Ratcatcher, The (Bosse) 118–20, 131
rational dress 177, 181–2
Rational Dress Movement 177, 179,
 181, 182
Ravaglia, Emilio 31
Ray, Man 206
realism *vs.* abstraction 210
Rebellion and reform, fashion in
 England 175–83
Rebirth of Venus (LaChapelle) 39, 40
Recueil de la diversité des habits
 (Desprez) 66, 68, 84, 89–90
*Recueil de modes de la cour de
 France* 107, 109–12, 115, 116
*Reflections on the Imitation of Greek
 Works in Painting and Sculpture*
 (Winckelmann) 134
Reformation, Luther, Martin 71, 95, 96
Régime, Ancien 134
religious painting 69, 102
Renaissance 6, 8, 19, 45, 91, 93, 121,
 213, 239
 dress 182

Renaissance books of costume 50–1, 83–90
Renaissance tailors 5, 169
Renaissance, The (1873, Pater) 35
Renaissance, The (1888, Pater) 35
*Renaissance Theatre Costume and the Sense
 of Historical Past* (Newton) 19
Renner, Narziss 92–4
Renoir, Pierre-Auguste, *La Parisienne*
 157–9
Report of the National Assembly Sessions
 148
Restany, Piere 244
Restoration, printed page during 125–31
revolution 134
 of fashion plate 150–3
 French (*see* French revolution)
 in sartorial fashion 134–5
Ribeiro, Aileen 2, 3, 5
 *Clothing Art: The Visual Culture of
 Fashion 1600–1914* 3
 Rembrandt's self-portrait 4
Ribera, Jose de, *Clubfoot, The*
 118, 120
Ripa, Cesare, *Iconologia* 6
robe à la créole 148
robe d'Armenian 110
robes de chambre 109, 111
robes de cour 109
Robinson, Julian 19
Roche, Daniel, *Culture of Clothing: Dress
 and Fashion in the Ancien
 Régime, The* 19
Roerich, Nicholas 198
Romance of Tristan 46–7
Roman costumes 138
romanticism 170–1, 175.
 See also historicism
Romney, George 196–7
Roosevelt, Franklin D. 208
Rose, Barbara
 'Minimal Art' 233
 'More is Less' 233
Rosenberg, Jakob 4
Rosenthal, Margaret F. 51
Rossetti, Dante Gabriel 182

Rothschild, James de 161
Rousseau, Jean Jacques, *Social Contracts*
 144
Roxolana, portraits of 84, 87
Rubens, Peter Paul, allegorical canvases
 125
Rublack, Ulinka 64, 65, 72, 73, 94
 *Dressing Up: Cultural Identity in
 Renaissance Europe* 19–20, 93
 moral geography 20

Sack of Rome 71
Saglio, Charles 167
Saint-Aubin, Augustin de 151
Saint Francis 121
Saint Jean, Jean Dieu de 108, 114, 115
St. Laurent, Yves 218
St. Mark Preaching in Alexandria (Bellini)
 88–9
St. Mark's Basilica 89
Sale du Petit-Bourbon 239
Salon (1846) 170
Salon (1861) 156
Salon (1879) 156
Sansovino, Francesco, *Venetia città
 nobilissima et singolare* 88
Sargent, John Singer 230
sartorial dress during Directory period
 in fashion magazines 140–8
 in painting 135–8
 on stage 138–40
sartorial fashion 180
 revolution in 134–5
Sartre, Jean-Paul 216
 Being and Nothingness 210
 existentialism 210–12
 Existentialism and Humanism 210
Satterfield, Andrea McKenzie 77
Saussure, Ferdinand de
 structuralism 11
 triad of concepts 12
Saxl, Fritz 6
 *Il Libro del Sarto (della Fondazione
 Querini Stampalia di Venezia)*
 15–16, 51–65, 74

mechanical doll 59–60
women's garments 56–9
Scarpa, Vittore 89
Schaeufelein, Hans Leohard 74
Schéhérazade 198
Schiaparelli, Elsa 207, 209
Schiavoni, Alessandra 51
Schlegel, Karl Wilhelm Friedrich 171
'School of Giorgione, The' (Pater) 35
Schwarz, Matthäus 74
 First Book of Fashion: The Book of
 Clothes of Matthäus and Veit
 Konrad Schwarz of Augsburg,
 The 83, 90–5, 98, 100
 Klaidungsbüchlein or Trachtenbuch
 90–100
 manuscript 92
 in Nuremberg 97–9
 Renner, Narziss and 92
 Way of the World, The 91
Schwarz, Veit Konrad, *First Book of*
 Fashion: The Book of Clothes
 of Matthäus and Veit Konrad
 Schwarz of Augsburg, The
 (Schwarz) 83, 90–5, 98, 100
secondary or conventional subject matter
 level 7, 10, 12, 48, 53, 55, 59,
 66, 68–70, 79, 85, 94, 111, 114,
 118, 120, 124, 128, 138, 142,
 146, 153, 156, 174, 175, 195–7,
 204, 216, 217, 222, 224, 235,
 243, 245, 247, 250, 252
Second Estate 151, 153
Second Sex, The (Beauvoir) 212
Second World War 213
 ideological division of Europe and
 208–10
self-portraits 3–4, 19
Sellèque, Jean Baptiste 149
semiotics
 and fashion images 16–18
 iconography and 12–15
'Semiotics and Iconography'
 (Damisch) 13
'Sex Pistols' 234

Sforza, Muzio 59, 61
'Shepherdess' 201
Shirley, Robert 113
Shockihudo, Koshige 227, 228
Siamese negligée 114
'Siamoise' 114
Sigmund Hagelsheimer. *See*
 Heldt, Sigmund
Sischy, Ingrid 227
Sketchbook, of Honnecourt, Villard
 de 45–8
 Lord and Lady 48
 Wrestlers 47
'Slaves of Fashion' 181
Sleeping Venus, The (Giorgione) 25
Slive, Seymour 4, 5
Snow, Carmel 230
Social Contracts, Rousseau, Jean
 Jacques 144
'Society of Spectacle' (Debord) 241
Soviet Russia 206–8
'Space Age' collection (1964)
 Courrèges, André 222
Spanish etiquette 54
Spanish fashions 56
spectacle 239, 241
Spectre That Haunted Socialism, The
 (Bartlett) 208–9
spring/summer 1999 collection
 (McQueen) 242–3
Stalin, Joseph 208
 aesthetics 209
 fashion ideal 209
Steele, Valerie 231
 Gothic: Dark Glamour 237
Steichen, Edward 168
 fashion photography 200–1, 213
Stepanova, Varvara 209
Stevens, Alfred 164
Storia d'Italia 26
 Guicciardini, Francesco and 26–7
street fashion. *See also* anti-fashion
 London and Paris in 1960s 220–2
street sellers 126, 128, 129
'street' style 149, 221

278 Index

structural analysis, women's clothing 17
structuralism 11, 14–15
Studies in Iconology: Humanistic Themes in the Art of the Renaissance (Panofsky) 2, 7. 10
Süddeutsche Zeitung 235
Sui, Anna 235
Suleiman the Magnificent 67, 84, 86
Sultana Rossa. *See* Roxolana
sultan's clothing 85
surtout 111
symbolic art, Egyptian 171
synthetic intuition 37

Tabou 212
Tailor, The (Moroni) 61
Takada, Kenzo 226–7
Talma, François Joseph 139
Taylor, Lou, *Establishing Dress History* 18
Technical Manifesto of Futurist Sculpture (Boccioni) 204
technological garment 166, 202
Teller, Jürgen 235, 237
Tempest, The. See La Tempesta (Giorgione)
ter Kuile, E. H. 4, 5
Testelin, Henri 5
text-based 'written-clothing' 166
Thatcherism 225–6
Thayaht
 fashion and art, case study 202–8
 Un manteau de Madeleine Vionnet 204–5
theatre costumes 138–40
Theatre of Women designed by Jobst Ammon, The (Aspland) 83
Theatrum Mulierum (Amman) 74
Theory of the Leisure Class, The (Veblen) 221
Third Estate 146, 148, 151, 153
Thirty Years War (1618–48) 100, 117, 118
Thoré, Théophile 161, 163
Tinguely, Jean, *Métamatics* 244

Titian 25, 54, 55, 83, 84, 86–7
 Allocution of Alfonso d'Avalos, Marquis de Vasto to His Troops, The 55
 portraits 87
toilette de ville 157–8
Torquemada, Thomas 79
To the Christian Nobility of the German Nation (Luther) 96
Tournachon, Gaspar-Félix. *See* Nadar
Trachtenbuch 20, 21
 Weiditz, Christoph 72–83
 Weigel 65–72
trade relationship, France and Siam 114
trans-culturalization 20
transculturation 73
transitoriness 155, 165, 166
Travels in Turkey (Nicolay, 1951) 85
Trivia or The Art of Walking the Streets of London (Gay) 126
Truman Doctrine 220
Turkic tribes 85–6
Turkish Cypriot 245
Turkish Sultan 67, 68
Turkish women costume 85–7
Turriano, Juanelo 59
Tuscan masters 25

uncanny 42–3
'Uniform of official' 148
'Union of the Crowns, The' (Rubens) 125
Universal Exhibition
 of 1900 187, 189
 of 1937 206, 207
Universul (newspaper) 200
Un manteau de Madeleine Vionnet (Thayaht) 204–5
utopian fashions 209
Valla, Lorenzo 34
van der Weyden, Rogier 174
van Dyck, Anthony 113, 122
Vanity Fair 230
Van Noten, Dries 233
van Ostade, Adriaen 130
van Rijn, Rembrandt 2, 3, 5
 self-portrait 4

Index

van Thienen, Frithjof 2
Vasari, Giorgio 25–7, 84, 86–8
 Lives of the Painters, Sculptors and Architects 25
Vauxcelles, Louis 190, 191
Veblen, Thorstein, *Theory of the Leisure Class, The* 221
Vecellio, Cesare 55
 De gli habiti antichi et moderni di diverse parti del mondo 21, 64, 83–90
 'Donna turca in casa' 85
 'Donzella di Granata' 81, 88
 'Favorita del turco' 84–5
 Habiti Antichi et Moderni 52, 81
velocità 203
Vendramin, Gabriele 24
venery 49
Venetia città nobilissima et singolare (Sansovino) 88
Venetian costume 73
Venetian fashions 64
Venetian *gentildonna* 64
Venetian painting 24
Venetian Quattrocento painting 88, 89
Venetian skirt 64
Venice 33, 88
Venturi, Lionello 24, 26
'Versace' 235
vertugadin 181
Vico, Enea 21
 Diversarum Gentium Aetatis 64
Vionnet, Madeleine 193, 226
 fashion and art, case study 202–8
 fashion revolution 203
virtual reality 250
visual arts 34, 157, 174
visual-based 'image-clothing' 18, 166
Vivarino, Luigi 89
Vogel, Lucien 201
Vogue 229, 230
Voltaire
 Brutus 139
 tragedies 139

wabi-sabi concept 231
walking dress 158
Waning of the Middle Ages, The (Huizinga) 49
Warburg, Aby 8
 research issues 8–9
Warburg Institute 15
Watteau, François-Louis-Joseph 151
Way of the World, The (Schwarz) 91
'Weiditz Book of Costumes.'
 See *Trachtenbuch*
Weiditz, Christoph 21, 88, 130
 Trachtenbuch (1560–80) 72–83
Weigel, Hans 20, 82, 130
 'Mauretana in domestico vestita betica sive Granatensis' 82
 'Mauritana in Betica sive Granatensi regno' 82
 Trachtenbuch (1577) 65–72
Westwood, Vivienne, as queen of punk 222–5
Wilde, Constance 179
Wilde, Oscar 156, 177–9, 223
 'More Radical Ideas Upon Dress Reform' 181
 Rebellion and reform against fashion 177–83
 'Woman's Dress' 181
Winckelmann, Johann Joachim 135, 138
 noble simplicity 134, 135
 Reflections on the Imitation of Greek Works in Painting and Sculpture 134
Winkel, Marieke de 1–5
Winterhalter, Franz Xaver 163
Wittgenstein, Ludwig 13
Wölfflin, Heinrich 65
Wollen, Peter, *Addressing the Century* (100 Years of Art and Fashion) 227
WOLS (Alfred Otto Wolfgang Schultze) 207
Woman in a Green Dress, The. See Camille (Monet)
'Woman's Dress' (Wilde) 181
Woman's World, The 178, 180, 181

women's garments 56–9
Worth, Charles Frederick 163–4, 166, 188
Writing Fashion in Early Modern History: From Sprezzatura to Satire (Paulicelli) 52
written clothing 17, 18, 166

xylography 52, 55

Yamamoto, Yohji 227, 231
Yohji Yamamoto: Juste des Vêtements 227
'Young man of fashion' 145
yuppies 225–6

Zola, Émile 159, 164, 210
Zono, M. Niccolo 84

CPSIA information can be obtained
at www.ICGtesting.com
Printed in the USA
LVHW020312080523
746384LV00005B/194